The Illustrated
History of Art

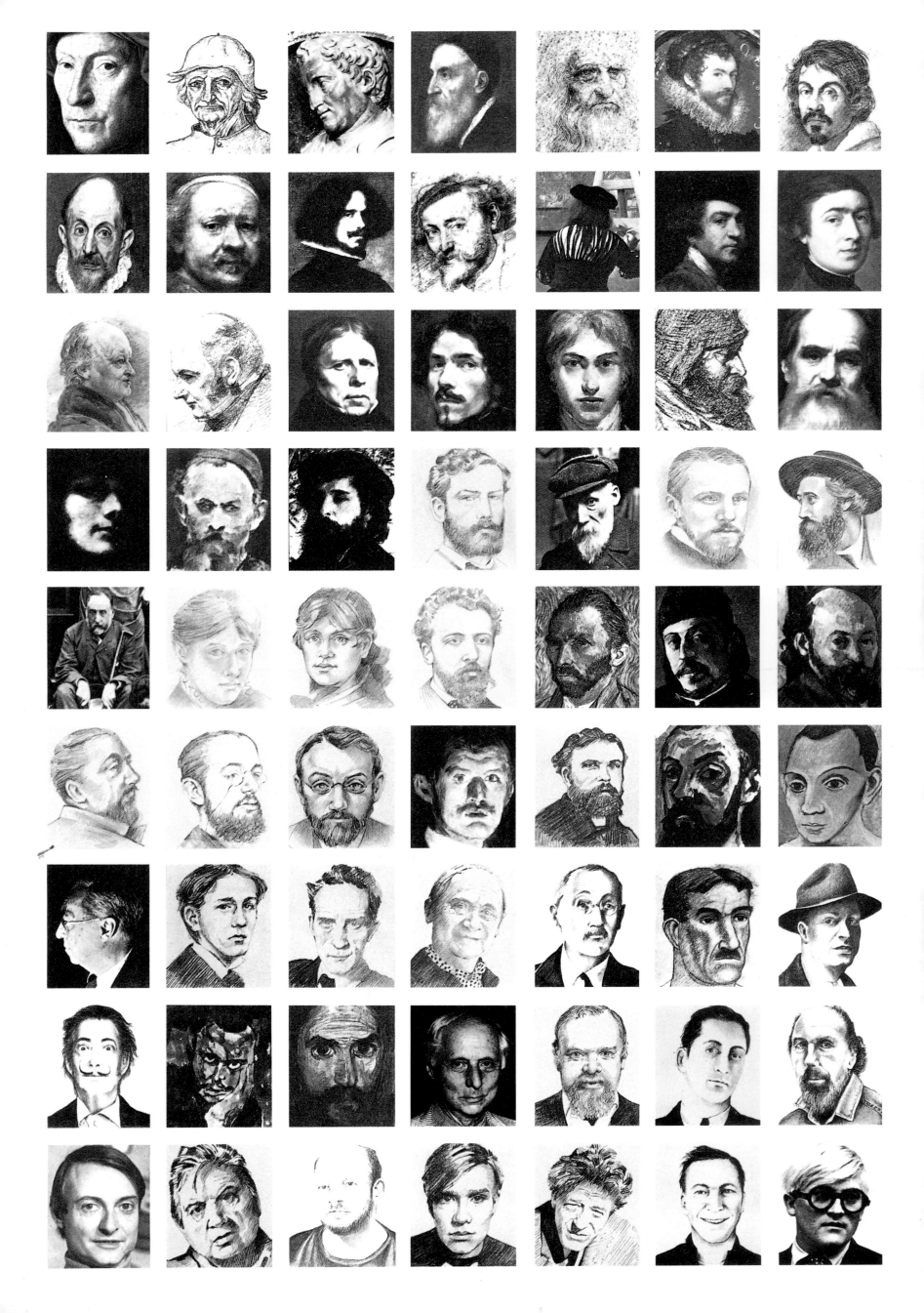

The Illustrated History of Art

J u d i t h C l a r k

Eagle
Editions

A QUANTUM BOOK

Published by
Eagle Editions Ltd
11 Heathfield
Royston
Hertfordshire SG8 5BW

Copyright ©MCMXCII
Quintet Publishing Ltd.

This edition printed 2007

ISBN 978-1-84573-343-8

QUMWHA

This book is produced by
Quantum Publishing Ltd.
6 Blundell Street
London N7 9BH

Printed in Singapore by
Star Standard Industries Pte Ltd.

CONTENTS

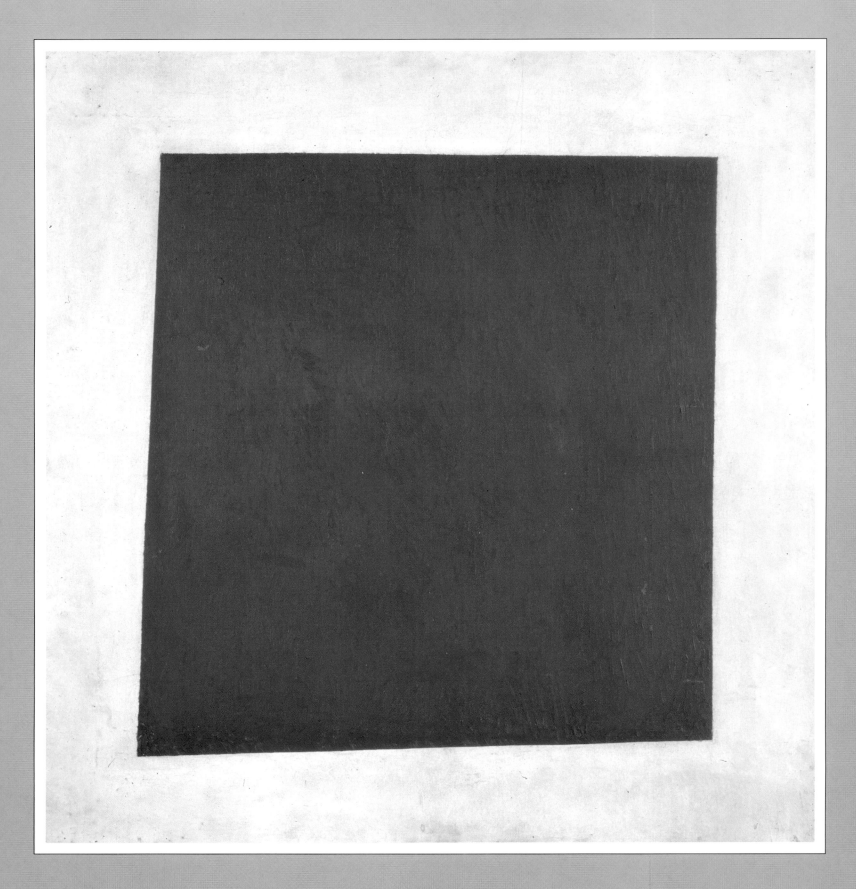

ABOVE *Between 1914 and 1917 Kasimir
Malevich jettisoned realism, and also
confronted the spectator with a new form of
visual expression, one he believed was
appropriate to his time, as Masaccio had done
for his. Red Square (1925), too, was intended
to give the spectator an intensely religious and
mystical experience, as if it were a 20th-
century icon.*

INTRODUCTION

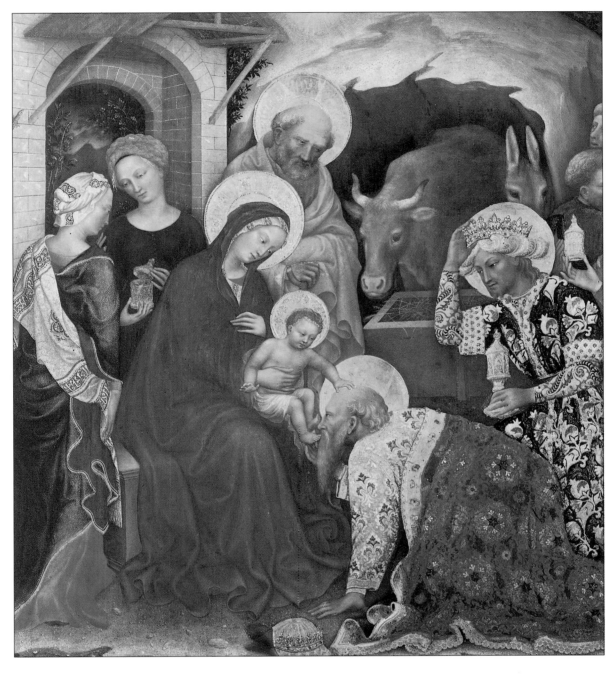

The art of today, so different from the art of the past, stems from the same necessity – to make visible those ideas and concerns that are beyond ordinary speech. All art grows out of its parent culture, not as a miraculous vision, but created within a social and economic climate. Art is a chronicle of its time, and a spectacle of ideas made real and permanent. Influenced by the social and economic setting, artists seek to make the spirit of their times tangible and permanent, and to give expression in symbolic form to human needs and desires, in a search for order that can give shape and meaning to our lives. Often rooted in ancient beliefs and a continuity with the past, art can also project ideas that are indicative of change, or resistance, of future possibilities as well as present actualities. As an act of imagination, the works of artists can embody attitudes and values below the painted surface.

ABOVE *Religion and mysticism have been the most consistently recurring themes in art. Gentile Fabriano's* The Adoration of the Magi *(detail) of 1423 reflects the Church's influence over and involvement in society and politics. Its allusions to the riches and expanding wealth brought about by burgeoning trade, fitted in around the religious event, pay compliments to the ruling powers of the day – the Church and wealthy statesmen.*

Inevitably, as in any history, events, descriptions and explanations are seen through a "rear-view mirror" – reflected but distorted by the journey forwards. It is almost impossible for us to see things as they happened through the eyes of the actual participants or spectators.

We can only try to imagine the shock or revelation at the time, that new developments in art provoked – the astonishing realism of Masaccio in the 15th century, or even in more recent times Picasso's Cubist compositions – which heralded the break-up of an old order.

The aim here is to chart changes in style, technique and subject-matter in painting, yet to recognize continuities in art. This paradox – the inter-relation between art and society, where art may both support the *status quo*, and be a catalyst or symptom of radical change – is the main theme underlying the narrative.

THE ARTIST AS GENIUS

Beginning in the Renaissance, the artist emerged from medieval guild status, where the craft-worker of the palazzo or cathedral, dedicated to practising traditional skills, was largely anonymous.

By the High Renaissance, the role of the artist as "genius" had been invented, with a status far beyond that of the skilled artisan or craftsman who was confined to the "Mechanical Arts". The increasing status of artists elevated them to the "Liberal Arts", associated with the activities of the mind, and the emergent Academy. The essential qualifications of "genius" were uniqueness, personality and an art which released creative energy and gave freedom to the artist to challenge the weight of historical precedent. Western culture since the Renaissance has been driven by this belief in progress and inevitable change as a way of life.

Up until about two hundred years ago, artists often reflected the view of those in power, intellectually and spiritually. They served the state and the Church. They glorified God or rulers by producing works of grandeur, dignity and power, exhorting the spectator to allegiance, whether to the gods of Olympus, to the Holy Trinity – or to Napoleon.

Only in recent times has the artist turned away from the norms of society, retreating into a private world, a world of inner experience and obsession. Taking up a position of isolation and self-justification, the artist pursues the ultimate in a subjectivity that has its origins in the Renaissance and the birth of the "modern" spirit.

Increasing awareness, and self-confidence in the potential of humanity to shape its own destiny accompanied Florence's rise to commercial power and wealth. The growth of trade and capital in Italy led to an increasing curiosity about the world and to the accumulation of knowledge.

New skills and new techniques were required to exploit these opportunities. Inventions led to intellectual and material progress. Widening opportunities led to an inquiring and calculating mind that responded to rational thinking. Astronomy and navigation charted new horizons of verifiable fact. Anatomy and mechanics created new understanding of nature and the physical world. Mathematics and optics gave access to new perceptions which challenged ancient beliefs.

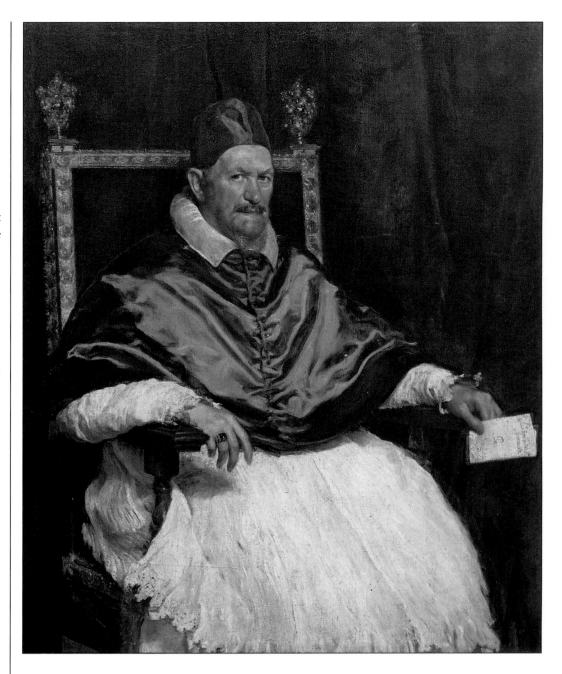

ABOVE *Diego Velázquez' portrait of* Pope Innocent X *(1650). For all the fine texture of crimson velvet and paper-fine lace, Velázquez' composition insists on the sitter's weight and substance, his presence, particularly in the penetrating treatment of the pope's expression and posture. The pope himself said the picture was* troppo vero, *that is, "too truthful".*

Gutenberg's Bible was printed at Mainz in Germany in 1451-6, using the new method of moveable type. As book production rapidly multiplied, releasing knowledge from the limitations of the scribes of the monastery, new-found knowledge, ideas and opinions were disseminated more and more widely and quickly. The artist took his place at the centre of these intellectual developments, as an equal of the writers and thinkers, creating works of *genius*, as Vasari wrote of his great hero, Michelangelo – the artisan had become the artist, made famous and sometimes rich.

REALISM AND ROMANTICISM

Realism and rationality replaced the myth and mysticism of the Dark Ages, as the power of human thought was harnessed by the analytical methods of scientific observation. Seeing was objectified, made more real by the technique of perspective, and the more detailed rendering through the new medium of oil-paint.

The skills of the artist were at a premium,

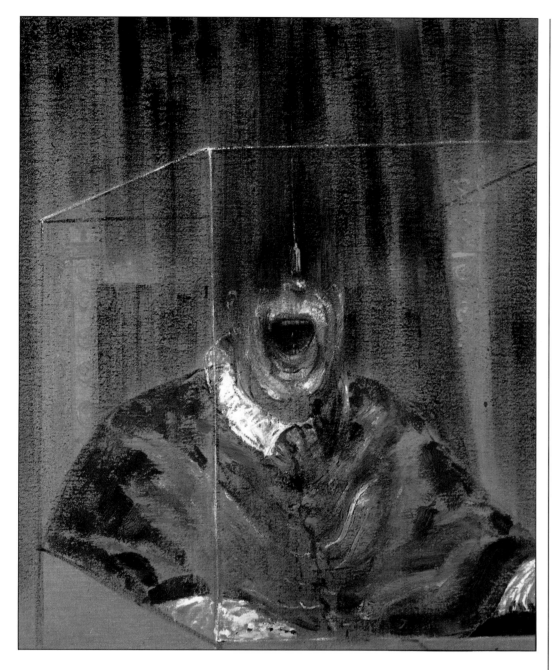

able to create illusions of space and movement on a flat static surface. The greater the optical illusion, the more insistent the presence, the likeness of the sitter, or the actuality of the scene depicted.

This drive towards pictorial realism reached its peak in the Baroque period, and the *trompe l'œil* effects of Dutch still-lifes, and the final stage came with the invention of photography. The Age of Reason was made visible through these technical innovations and shifts in cultural perspective.

This shift of attitudes marked a watershed in Western culture, and artists responded with new subjects depicted in increased realism: secular portraits of the new patrons, studies of nature, scenes of everyday life and intimate domestic settings and possessions.

Late in the 18th century and running into the 19th century, in a hostile reaction to the age of innovation that was leading to industrialization and mechanization in northern Europe, the Romantics saw the artist as a unique creator of individual works. They resisted change by re-investing in a "golden age" that had never existed except in the imagination of the artist or poet. Searching for new experiences in the

ABOVE *Three centuries later, Francis Bacon's obsessive and brutal vision is executed in correspondingly violent brushwork. The imagery is intimidating – the soundless, endless scream, the white clenched hands and the figure trapped in a dark, claustrophobic space with no prospect of relief.*

fertile imagination rather than the tangible soil of experience, made art increasingly a private province, for the artist alone.

In this stand against progress, art was "privatized", made distinct from the public domain. The artist came to be seen as divorced from ordinary life and people. The image of a lonely, misunderstood and heroic figure battling against indifference and practical commonsense – perhaps slightly mad – was exemplified by the personality of van Gogh, the archetypal Modern artist.

The shift from realism to romanticism can be seen in the reworking of a famous 17th-century portrait of the Pope – a painting of objective likeness and detailing, and subtle rendering – which is transformed in paint into a subjective expression of the artist, not the sitter, a reversal of seeing from outward to inward viewpoint through the use of pictorial gesture and technique.

In 1650, Velázquez painted a portrait of Pope Innocent X. The fluency of brushwork conveys the texture of his clothing, his weight and substance. The penetrating treatment of the Pope's expression and posture, in particular, conveys his dominant and manipulative personality. Three centuries later, Francis Bacon painted a series of canvases that reflected his obsession with the Velázquez portrait, but transformed by 20th-century "angst", and the alienated personality of Bacon himself. Like the torments of a character from Kafka, the alienation of the individual in the modern world is expressed almost unbearably.

Bacon has matched the compelling presence of the Velázquez in an unforgettable image that speaks directly to us in a 20th-century idiom. Velázquez *Pope* towers over the world he controls, but Bacon's figure is vulnerable, uncertain and oppressed. Many aspects of the painting are "ugly", but its painterly rendering is "beautiful". Such a contradiction is disturbing, not reassuring, and often confusing.

Should art be reassuring? Or beautiful? Questions like this have been addressed since the 1880s in works that set expressive power above all else. In mid-19th-century France, Courbet, a "Realist", had complained that Manet's paintings were as "flat as playing cards". Fifty years later Picasso would make even a playing card difficult to recognize, and within a century after Courbet, Jackson Pollock would challenge the viewer to recognize a definable figure of any kind in his works.

THE AGE OF MASS CULTURE

Today it is no longer possible to evaluate progressive art in terms of skill in naturalistic representation. But, after all, great art has never been entirely about technical mastery alone, and the display of virtuosity. It has been more concerned with perception, insight, or vision than accuracy of depiction.

In an age of mass culture the role of art changes. Description and information is disseminated by newspapers, advertising, radio and television widely and quickly. Photography can document social realities more efficiently and more convincingly than painting. The speed of change has accelerated to the present day. A unified culture, stable in its certainties, was rapidly replaced by doubts and anxieties. The artist became his own subject, certain only of his own obsessions and genius. The inspiration of his work came from within and was expressed in paint by his own individual style and unique "signature" of brushmarks.

Contradiction and complexity have replaced the unity of previous ages of certainty. Established standards and criteria have been undermined. Value judgements today are made difficult without specialized knowledge and exposure to the artistic "issues". Like science, art has invented its own private language which excludes the majority, and even makes them feel inadequate. Much hostility to the Modern movement stems from this sense of exclusion.

During the Cold War years, artists faced up to the possible annihilation of the world. The end of the art-object, its "dematerialization", was proposed in the practice of Minimalist and Conceptual art. Art took the modernist principle of "less is more" to extremes, as words and manifestos replaced the visual image.

Pollock claimed it was impossible to paint images of "things" in a world shattered by the atom bomb and transformed by modern communications systems. However, like Picasso, he withdrew from complete abstraction, re-introducing a figurative element into his painting. Picasso had at one stage reached the point of visual disintegration of the image, known as "analytical cubism", only to revert to depiction in works like his drawing of Ambroise Vollard, which is remarkable for its deftness of line.

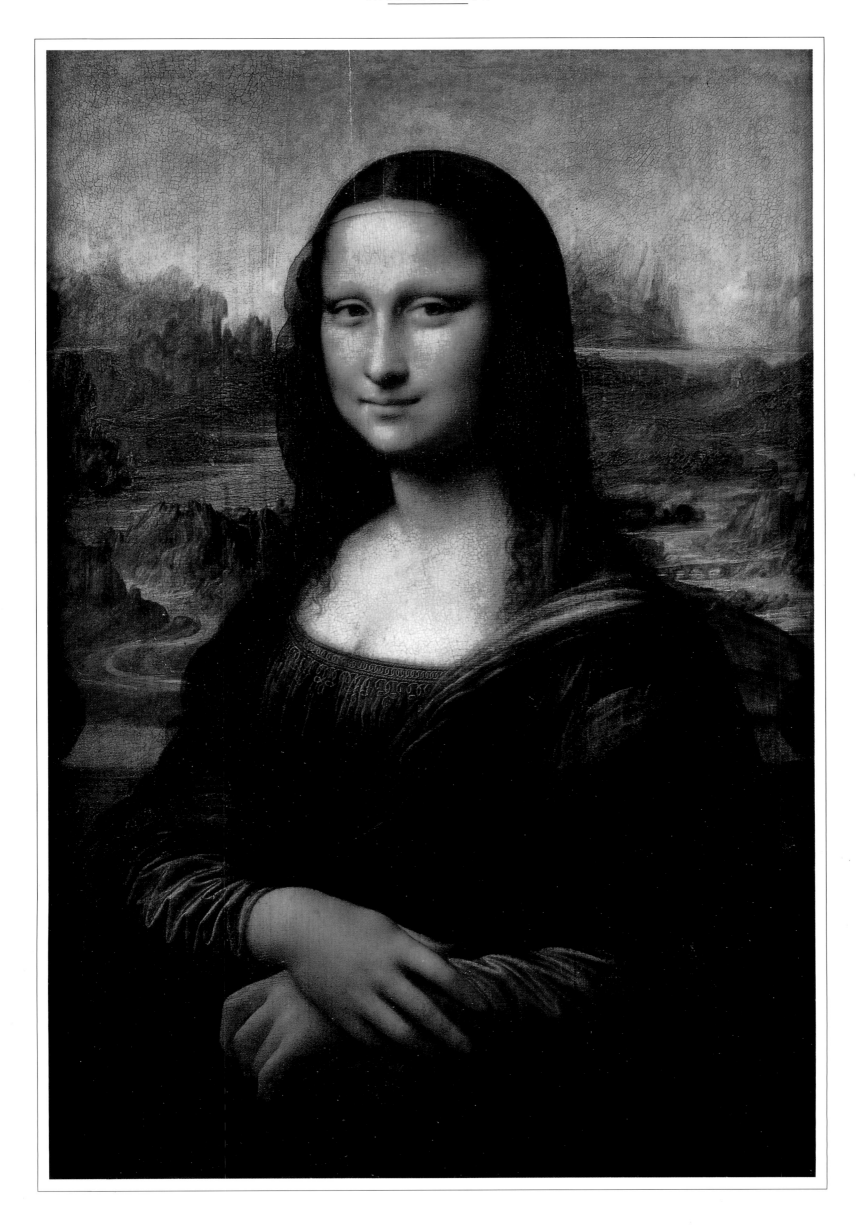

RIGHT *In the early 20th century, Marcel Duchamp painted a moustache onto a copy of Leonardo's* Mona Lisa. *His iconoclasm is not merely gratuitous vandalism, like rude graffiti on a wall, but questions the autocracy of art.*

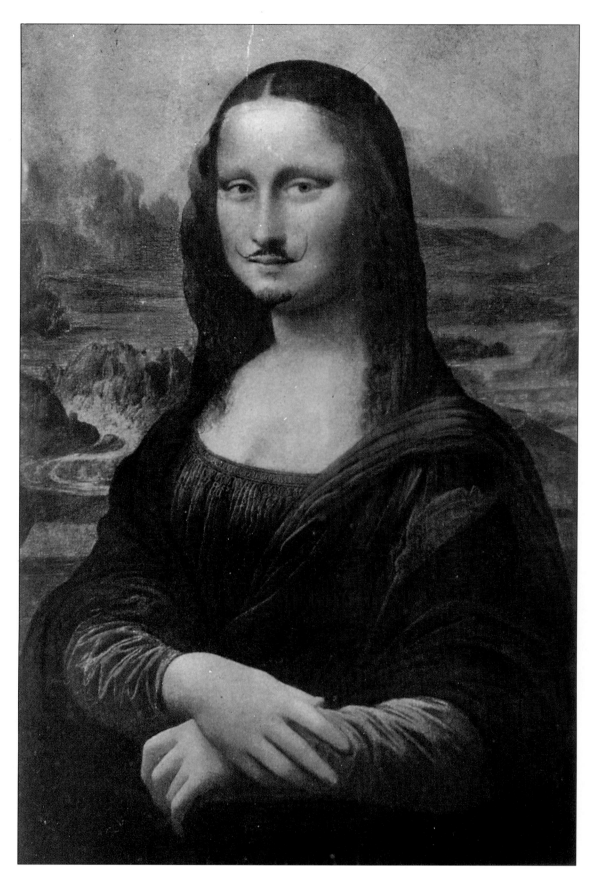

BELOW *In the 1960s, Andy Warhol took the degradation of the "art-object" further by producing copies of the Mona Lisa in multiple images, using the silk-screen process as for a "special offer" in the supermarket.*

AVANT-GARDE AND THE POPULAR

In spite of avant-garde attacks on the old order, and a state of continuous cultural revolution and change, continuity survives, to connect with the historical past. Art is infinitely adept at moving with the times, if not too far ahead. It is the visual laboratory of new ideas, which will later enter popular culture. Capitalist culture has the capacity to acclimatize threateningly radical ideas and popularize them with the sting removed. Surrealist attacks on establishment values have in this way been appropriated by designers who are employed on campaigns to sell cigarettes or toothpaste.

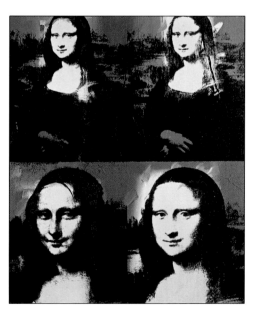

As style replaces style, the culture has become fragmented and pluralistic; many styles co-exist. The boundaries between "high" and "popular" art dissolve as the media are mixed and the historic past is raided for motifs and metaphors to exploit. Art, craft and design practice are fused. Under the umbrella of "Post-Modern" practice anything goes.

Post-Modernism brings figurative and gestural expression in painting back out of the cold, just as colour and decoration returned to building design in the 1970s and 1980s.

With art in constant flux, the spectator needs to be flexible to keep up, and to be tolerant of shifts in style and values. Under

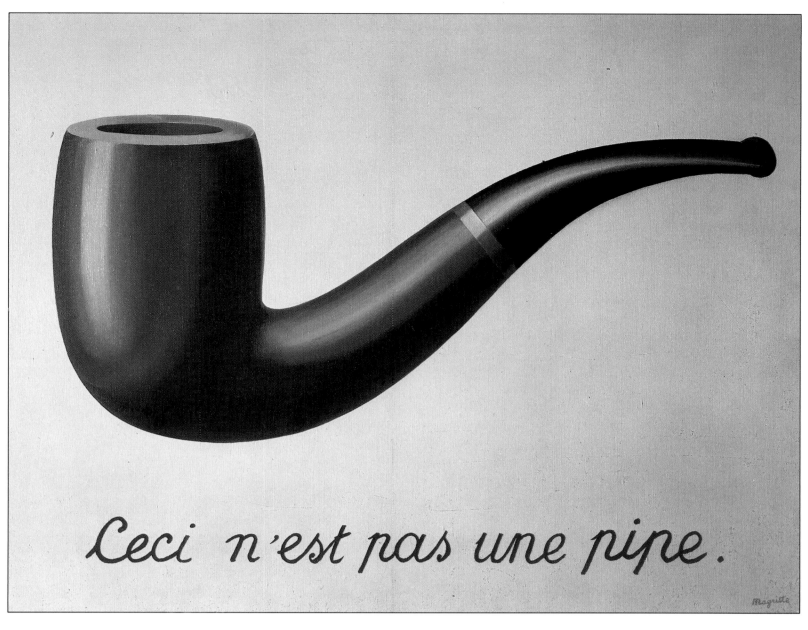

Ceci n'est pas une pipe.

the Post-Modern condition, there are no absolute "truths" – only contradictions.

When the surrealist, Marcel Duchamp painted a moustache on a copy of the most famous painting in the world, Leonardo's *Mona Lisa,* he added a punning title which undermined her enigmatic charm by suggesting she was sexually available. In doing so he made a disrespectful gesture towards the solemnity of attitudes to art, and the idea of the "artist as genius". He suggested that anything could be "art", if the object was seen in a gallery, and was "made" by the hand of an artist with that intention. The art *object* was simply the substance of the art *idea.*

Andy Warhol took this further. By producing copies of the *Mona Lisa* in multiple images, using a commercial silk-screen process, he brought the exclusiveness of the priceless masterpiece of the Louvre down to the level of produce in the supermarket.

Duchamp had already exhibited a urinal, entitled *Fountain,* in the major European avant-garde exhibition seen in America in 1917. He signed the "found object" with the pseudonym "R. Mutt". A utilitarian ceramic bowl was elevated from its commonplace use to the status of a revered object of contemplation – an object that

ABOVE René Magritte manipulates the spectator's expectations of the painting in his smoothly illusionist illustration of a commonplace object. The Use of Words tells us – in words – that "This is not a pipe". In other words, it is a painting! The spectator is confronted by a paradox: that words can "lie", can contradict our perception, although we are conditioned to believe them; and that visual "realism" is merely an artistic convention, a convincing illusion which we accept unquestioningly.

would be "unmentionable" in the polite society of 1917. It created a scandal, as was intended by Duchamp, in exploding myths about "art" as tasteful and aesthetic.

Magritte used the paradox of the image – both materialized in paint and imagined by the spectator – to play games with the viewer about the nature of representation and symbol. "This is not a pipe", he says of *La Pipe,* yet we see a perfectly modelled image of a pipe. Magritte reminds us that this indeed is not a pipe, but merely a thin layer of oil paint on canvas, yet it conforms to our expectations. Advertising imagery combines visual representation and sloganized words to create a powerful effect. Magritte's rhetoric offers a happy hunting ground for ad-men.

Roy Lichtenstein also appropriated his imagery from popular culture. He raided advertising posters and pulp-literature. After painting many blown-up versions of images from comics and magazines, Lichtenstein turned to subjects from high culture, making the élite area of Greek mythology accessible to a mass audience by using popular idioms. The tension between the two cultures is clearly meant to be ironic: "it's just another image", instantly consumed and disposable – like Superman, no more, no less.

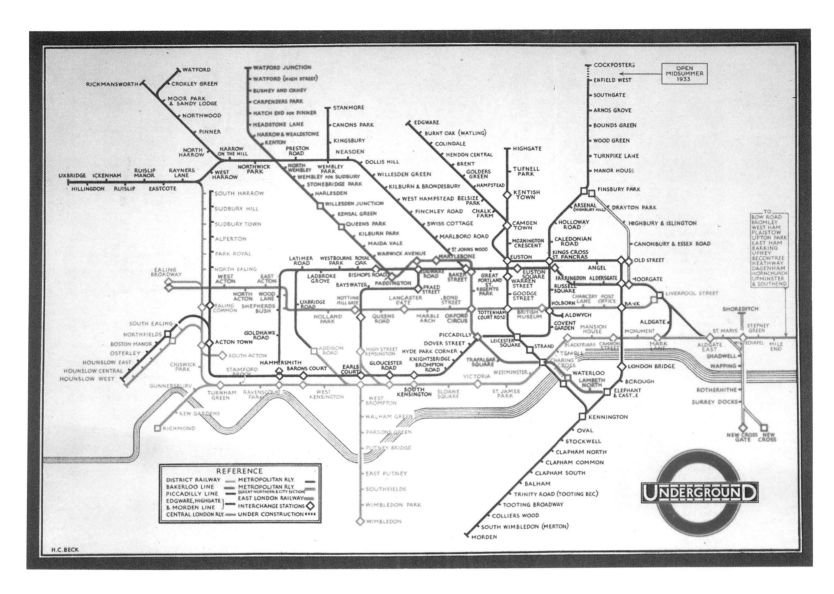

REFERENCE

DISTRICT RAILWAY	METROPOLITAN RLY.
BAKERLOO LINE	METROPOLITAN RLY. (GREAT NORTHERN & CITY SECTION)
PICCADILLY LINE	
EDGWARE, HIGHGATE	EAST LONDON RAILWAY
& MORDEN LINE	INTERCHANGE STATIONS
CENTRAL LONDON RLY.	UNDER CONSTRUCTION

H.C. BECK

THE CONTINUITY OF ART

This chronological survey, beginning in the late 14th century, maps the twists and turns of the road, and the odd detour along the way, that leads to our own times. Great paintings are linked to their cultural landscape: placing some, as in 17th-century Holland, in domestic ordinariness and the pleasures of plenty, while others hang in state in grand country houses, or in the austerity of monastic peace.

Art, which became "modern" in the Renaissance by taking the human condition as its central theme, was at that time as much at the heart of cultural activity as the religious belief that focussed on Christ's sacrifice and suffering. Art, today, is centred more on the artist, not as visionary, but as "outsider". Consequently art itself has become secularised and removed to the margin of society as a "provocateur" to challenge cultural norms, and act as the "cutting edge" of a culture that is dominated by received ideas propagated by the mass-media with its huge audiences.

Mondrian's *Broadway Boogie-Woogie* (1942-3) is apparently similar in its angularity, systematic forms and pure colours to the London Underground map of 1931, though mapped on the grid street-plan of New York – but of no actual use in the city. It is symbolic of an idea, not informational. It refers to art ideas, in the context of

ABOVE The London Underground Map (1931), designed by Harry Beck, was influenced by modernist ideals, schematic rather than "realistic" in scale or representation. Rendered in geometric form, it simplified an increasingly complex system of interchanges to project an image of a "rational" modern system of transportation.

Mondrian's earlier works. Modern art is first and foremost *about art*. Unlike the London Underground map, which is specific to a place and time, art speaks in generalities, of timeless ideas of the spirit, of belief and commitment; it is often utopian in its idealism. Mondrian and Kandinsky wished to purify art from direct reference to things in the world. Their aim was to construct a metaphor and stimulus for the betterment of the whole person, to create awareness of possibilities, stimulate the imagination, and engage in the life-enhancing potential of visual pleasure – and so enrich everyday experience of life.

The apparent gap between the art of our own time, as seen in the grid-lines of Mondrian which exemplify the urban nature of modern life, and the stained-glass windows of the great cathedral with their primary colours, or the spirituality of the Madonna's serene gaze, is not as great as one might think.

So it is paradoxical that today, in a democratic society, in an open culture, at a time of maximum access, art is so isolated from the majority and so apparently difficult to understand. In abandoning "realism", in becoming too "theoretical", has art lost touch with a broad audience? Does it speak only to a closed community of artists and followers, thus excluding others?

Reading unusual or abstract images presents a problem to the viewer, where

one's frame of reference is inadequate, or stretched to breaking-point. General knowledge and everyday experiences let one down. It is easy enough to relate to Giorgione's world of the *Concert Champêtre*, with its naturalistic representation, without understanding all the cultural or symbolic references, but faced with abstract works, such as those of Barnett Newman, the absence of reference makes heavy demands on the spectator. To get a purchase on works like these, explanations are felt to be needed, motives elucidated.

This is still clinging to the idea that images are narratives and motivated by rational thinking. With knowledge about the artist, the source of his ideas and who his mentors are, one can open up that initial experience, and gain a deeper understanding. Many artists however, work from their

BELOW *Piet Mondrian's* Broadway Boogie-Woogie *(1942–3), is apparently similar in its angularity, systematic forms and pure colours, to the London Underground Map, but is only superficially referential to the street-plan of New York City – without any use-value in the actual city. It resembles an aerial view, looking down on regular blocks and intersections, with traffic, including New York's yellow cabs, moving along the streets. Yet this painting is symbolic of an idea. It is not informational, but referential to art-ideas, contingent with Mondrian's earlier works. Modern art is firstly and foremost about art. Unlike the Underground Map, which is specific to a place and the everyday, art is concerned with ideas of the spirit and mind, of belief and commitment, often other-worldly or utopian in its idealism.*

obsessive interest in painting first, intuitive in their incorporation of ideas into their images, which in great art is fused together in an intellectual and sensual experience.

The possibility for strange juxtapositions has been exploited in Surrealist imagery, where, like a dream, everything flows together in a continuum. Nor is it only the artist who constructs meanings by his manipulations of technique and style; the audience, too, brings its own imagery, associations and preconceptions to the work.

The great themes in art have not changed: concern about the nature of existence, the problem of mortality, and issues related to social and moral dilemmas inherent in Western culture, are still apparent in the work of many artists today. The language and the symbols may be in constant flux, but the human condition remains constant.

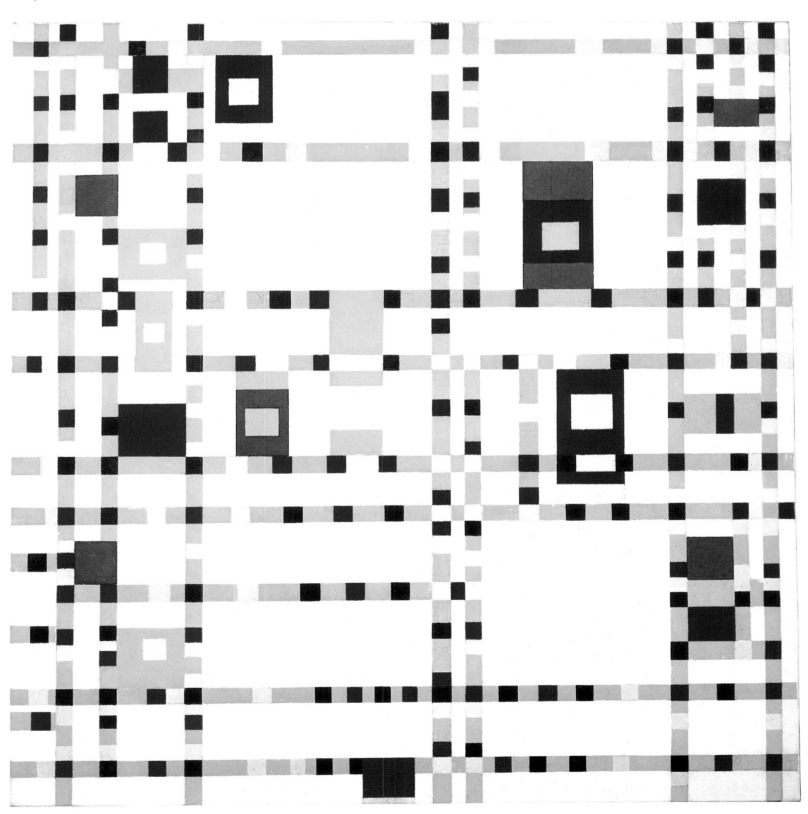

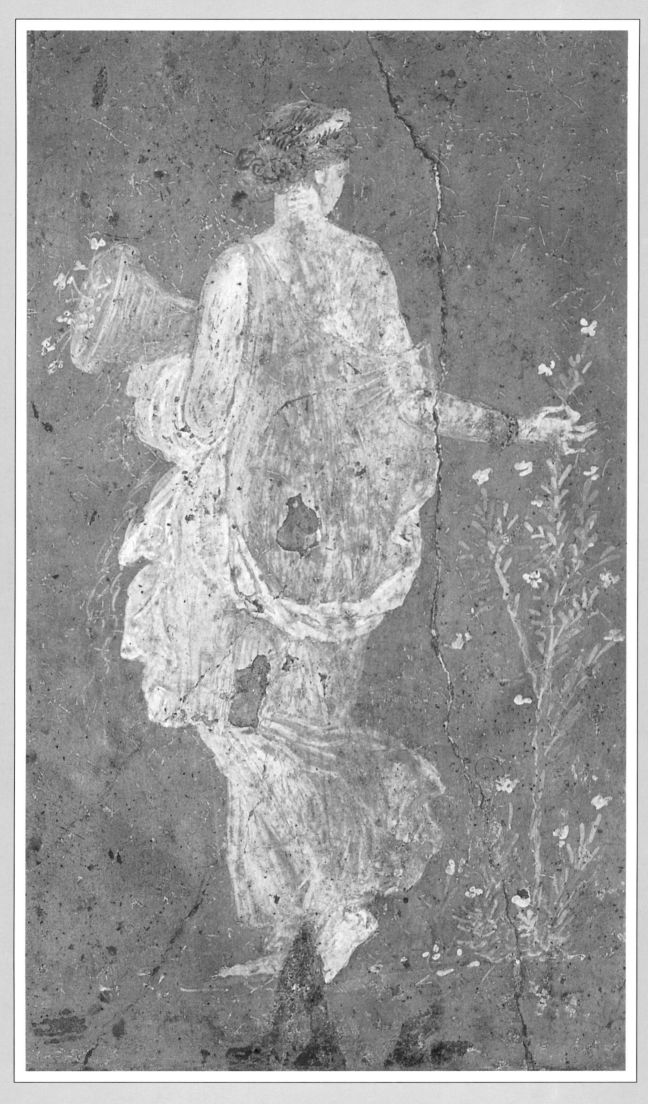

ABOVE *Roman frescos, like this one of* Flora,
*the spirit of spring (1st century AD), were
painted in a vigorous, open style that breathes
life and air into the subject. This naturalness
and vivacity would be eroded over the
centuries, formalized and styled into
Byzantine rigidity.*

CHAPTER ONE
THE RENAISSANCE

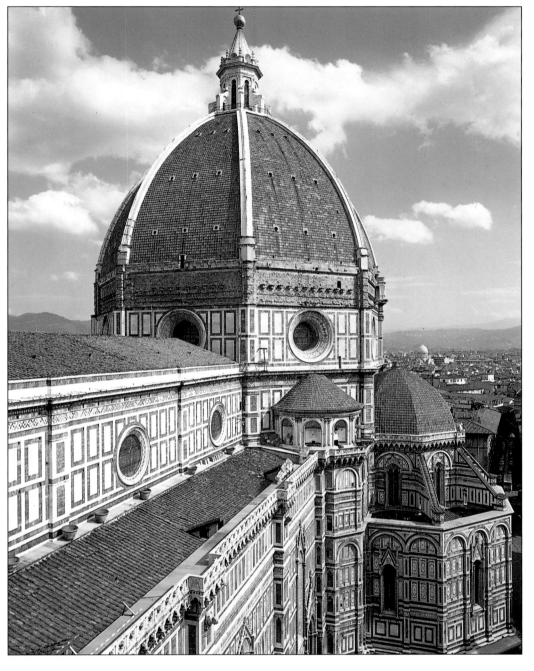

ABOVE *Filippo Brunelleschi's huge dome for Florence Cathedral, constructed between 1420 and 1430, demonstrates the new confidence that marks off the Renaissance from the Middle Ages. A combination of material wealth and power, and a renewed interest in the classical world, sparked the "rebirth" of art and culture in the city-state of Florence.*

The Renaissance developed through a combination of historical and cultural factors, and was driven by ideas about the nature of society, and motivated by aspirations for an ideal world. These ideas were crystallized in the art of the period, which has subsequently provided inspiration for further developments in Western art and culture, up to the present day. It was influential in redirecting the focus of art to the human form and originating a fascination with the visible world around us. The works of artists such as Masaccio in early 15th-century Florence, and Dürer, nearly a century later in Germany, emphasized the richness and diversity of this life, rather than the after-life of religious teaching. Although the art of the Renaissance was initially devoted to the celebration of religious beliefs and to the telling of biblical stories, its significance was, paradoxically, that it invested everyday life with meaning beyond that of religious prescriptions. Future generations of artists were to develop a secular art based on moral and aesthetic values which began to be formulated in this period.

The idea of a rebirth, or "Renaissance", of the world of Greece and Rome surfaced several times during the nine hundred years between the collapse of classical civilization in the 5th century and the 1400s. As early as the 6th century, the only recently barbarian Frankish kings were already fostering a brief interest in classical imagery.

Their successor Charlemagne, who ruled a large area of western Europe in the early 9th century, saw himself as a latter-day Roman emperor and patron of classical learning. He commissioned works of art, and built his palace chapel at Aachen, in

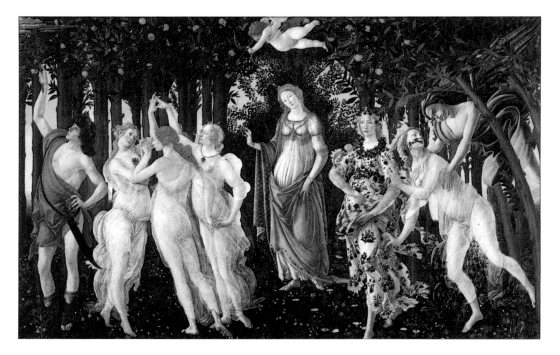

ABOVE *The wealthy Florentine banking family, the de' Medici, is renowned for promoting the study of the classical world and supporting a circle of poets, scholars and artists. Sandro Botticelli's paintings on mythological themes, including the Primavera, were commissioned by Lorenzo di Pierfrancesco de' Medici in this ethos. Classical references are infused with Gothic grace and movement, enlivening the scene with an unworldly refined beauty.*

what he believed to be a Roman idiom. Again, a century and a half later, two German emperors (Otto I and II – hence the "Ottonian Renaissance") patronized the revival of some classical concepts in architecture and sculpture.

These were modest revivals, limited in scope. It was impossible – in spite of the copying of some surviving manuscripts in the monasteries of Europe – to recreate classical culture out of the impoverished tatters of civilization that remained after so many invasions. The sacking of Rome by the Goths in 410 had left the city largely abandoned. When the movement we know as the Italian Renaissance was beginning to flower in the early 15th century, most of the ancient city was still covered by trees and undergrowth, its ruined monuments ignored by the medieval pilgrims going to the shrine of St Peter.

The impulse for the really large-scale revival of classical ideas and knowledge – which meant the thorough study of the original texts in Greek and Latin – was in large measure due to the enthusiasm of the Florentine poet Petrarch in the 1330s. Petrarch looked for a more enlightened source of knowledge and understanding to replace the Scriptures, and found it in what remained of classical literature. This readiness to question traditional attitudes and dogmas was the characteristic of the new intellectuals and artists, who were called the "Humanists".

The study of the classical past (known as "antiquity") was the key to the Renaissance spirit. It was a break with the recent past (the "Middle Ages") and led to the beginnings of what we see as modern civilization.

However, knowledge of the "antique" was patchy and muddled. No clear distinction was made yet between Greece and Rome, or between the different phases of each civilization. The architect Filippo Brunelleschi studied and drew plans of Roman ruins to create a measured har-

monious architecture attuned to the proportions of man – not God – but even he thought the medieval 12th-century Baptistry in Florence was a Roman building.

FLORENCE – BREEDING GROUND OF THE RENAISSANCE

By the late 14th century, Florence had become a thriving commercial and banking centre. A culture emerged which attempted to inspire its citizens with the civic virtues of republican Rome, creating an incentive for scholars to discover more about "the antique" (as they called it), and to promote philosophy and the arts in a mixture of neo-Platonism and humanism which saw human beings as the centre of the world. Judgement and learning were to elevate Florentine civic life to the level achieved by ancient Rome. The city's wealth enabled the leading citizens to think ambitiously

PAINT MEDIUMS

The Greeks, Romans and other ancient civilizations used wax as a medium. Known as encaustic painting, this method survived into the eighth century. An egg medium was the commonest form of binder until the fifteenth century, when oil paint, bound with linseed oil became commonplace.

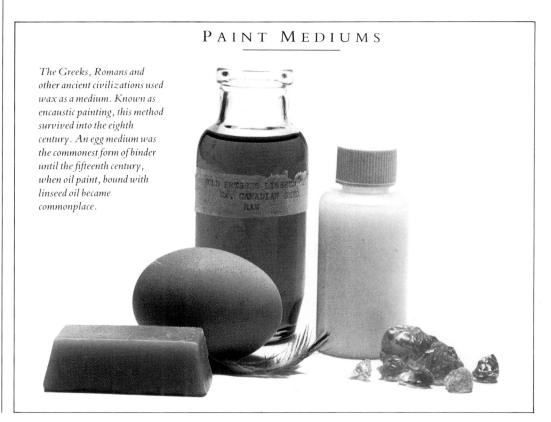

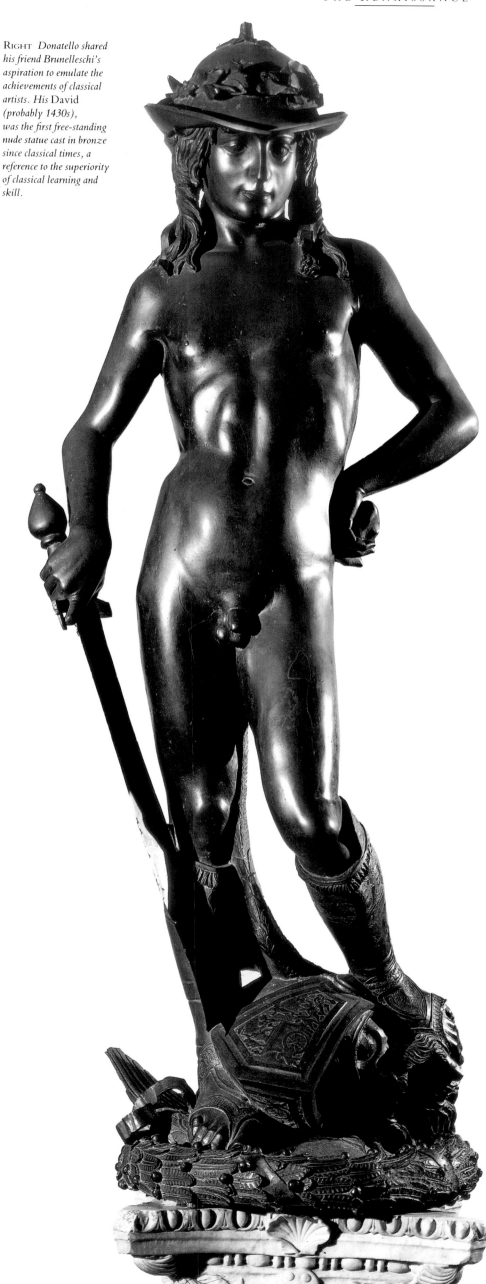

RIGHT *Donatello shared his friend Brunelleschi's aspiration to emulate the achievements of classical artists. His David (probably 1430s), was the first free-standing nude statue cast in bronze since classical times, a reference to the superiority of classical learning and skill.*

and expansively, and to commission buildings and artworks, to reflect its glory and wealth. Because there was no settled dynasty of rulers, it was important for rich patrons to show restraint rather than display grandeur. Therefore, many works of art were presented to the city itself, or to churches, rather than to glorify individuals and their achievements directly. Church dignitaries and guilds commissioned many great works, and Brunelleschi's huge dome on the cathedral is symbolic of Florentine civic pride.

Of course, Florence was just as Christian as the rest of Europe, but the citizens saw no difficulty in combining Christian devotion with pagan art. Indeed, by the later 15th century, the church of San Francesco in Rimini, which Leon Battista Alberti remodelled as a mausoleum for the Malatesta family, was called the "Tempio Malatestiano". Like a Roman temple, it was decorated inside with sculpted gods and goddesses, sibyls and graces. In the houses of Florentine bankers and at the courts of the rulers in other Italian city-states, poets composed, songs were sung, and new ideas permeated intellectual life – including studies of mathematics and astronomy – all inspired by "antiquity". Palazzi and villas were built to provide the appropriate setting, where scholars strolled with princes in gardens or courtyards of the new architecture, adorned with the "antique" sculptures that were now being discovered in old structures and in the countryside. Lorenzo de'Medici and his heirs, who made themselves rulers of Florence, fostered the spirit of classical learning, encouraging artists to think beyond the traditional repertoire of Christian subjects. Botticelli painted many works picturing pagan idylls and peopled with "antique" gods and goddesses, recalling myths of a Golden Age of antiquity.

Fear of judgement day, and a medieval feeling of helplessness before God were replaced by belief in humanity's own achievements, and in the benevolence of nature – and in the permissibility of the pleasures of this life. Humanist scholars and poets celebrated the sensual experiences of the body as well as the achievements of the mind through inquiry and scholarship.

The perfection of the human body in "antique" sculpture, provided an ideal model of the unclothed figure. Donatello's *David* was the first nude sculpture modelled since classical times, and was even more innovative in being the first free-standing bronze statue to be cast since the 5th century. Such monumental figures were symbolic of a new-found confidence, and represented the freedom of Renaissance man from the medieval past, at ease with himself and the world that he could understand and, ultimately, command.

THE ART OF EGG TEMPERA

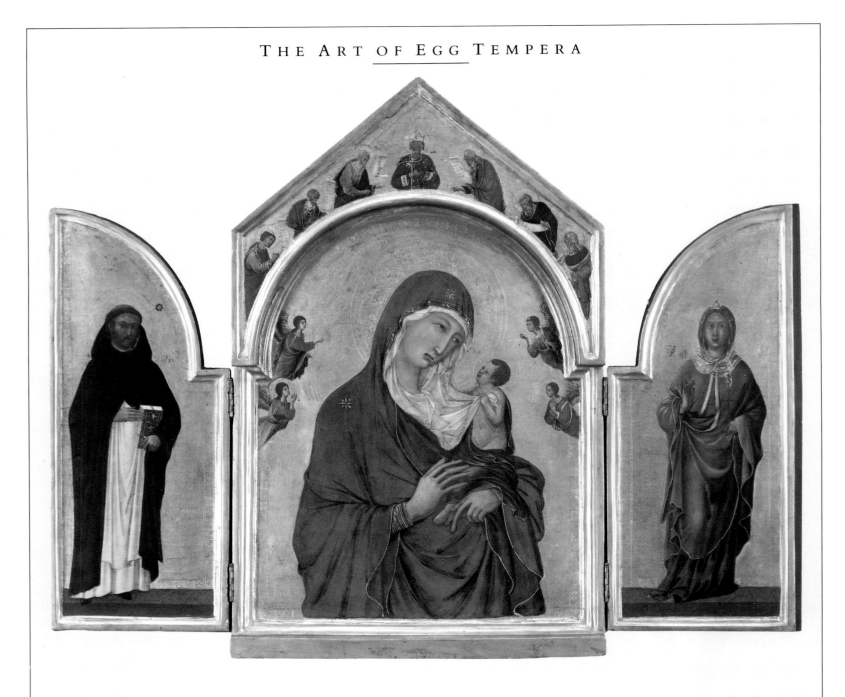

Tabernacles were painted and decorated inside and out. The shutters protected the image when it was not being venerated. The close similarity between this tabernacle and another by Duccio indicates a degree of mass production by carpenters for painters. Not all paintings were commissioned, and it is likely that a workshop would have kept some panels in stock. Painting of this period can only be understood if it is realized that "Duccio" was also a trademark. A master coordinated a workshop with apprentices and assistants, and a painting was a collaboration involving the distribution

1 Painters and carpenters were organized in different guilds. A carpenter would have completed the bare wooden structure to order and delivered it to Duccio's shop.

2 Faults in the wood were corrected and often a layer of linen was put over the entire structure. This was then covered with up to eight coats of gesso.

3 The gesso layer was scraped and polished smooth, and the design then defined in paint. Contours and major drapery folds were incised with a metal point.

4 Up to six coats of red bole bound with egg white were brushed on and gold applied leaf by leaf. The gold was burnished and designs inscribed or punched onto it.

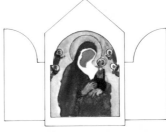

5 Drapery painting was completed before flesh painting began. All flesh areas were underpainted in one or two coats of green earth and lead white. The green earth was intended to be left uncovered in the shadows.

6 The flesh colours were finally painted in details reinforced in black and sinoper. Gold lines were applied on top of the drapery by adhering scraps of gold to a sticky oil mordant.

of work during all stages of production, even on small paintings. In tempera painting, the complex combination of different materials – wood, gesso, gold, and pigments bound by egg yolk – required a particularly orderly and methodical technique. This remained little changed by several generations of artists. Writing around 1437, Cennini described with pride the technique as it had been handed down from master to pupil since Giotto. The technique of painting in tempera was founded on an intimate understanding of the individual properties of the materials used.

THE MEDIEVAL HERITAGE

The ideas derived from the Renaissance have altered the perceptions of all of us who live in later centuries, and it is difficult to see these works as though through the eyes of the Renaissance spectator – whether artist, patron or peasant.

For example, when we consider the first great Renaissance painter, Giotto, it is essential to remember the paucity of pictorial sources that were available to him. Wall painting had been practised since ancient times, but very little Roman wall-painting was accessible at this time.

Giotto's ambitious fresco-cycles should be seen in the context of a tradition based on Byzantine forms, especially icons. These were devotional objects, symbolising the power of God and the life of the Church. Their distant origins were in the pre-classical art of the Greek world. In this stylized line of descent the artist no longer looked at nature. As a result, icons and panel-paintings conform to a formula, in which the holy figures have no individuality of expression, and are without naturalistic solidity. Although flat and linear in style, and lacking in realism, they have a particular expressive quality which is appropriate to spiritual contemplation and prayer. Their lack of realism gives them an other-worldliness which invested the icons with a status as holy objects in themselves. Icons were also valuable in a material sense, being enriched with precious gold-leaf and the most expensive pigments. The blue of the Madonna's robe was made from crushed lapis lazuli, a material as costly as gold, and other brilliant colours came from rare sources. The idea of a painting as a valuable object persisted well into the Renaissance, particularly for altar-pieces, which tended to be commissioned according to tradition, and where the artist had little scope for individuality of treatment. Only when skill became appreciated for itself, as a more realist style demanded, would surface decoration such as gold-leaf become inappropriate, and the practice would start becoming redundant.

One of the changes in the mid-15th century is that artists' contracts placed less emphasis than before on the exact quality and quantity of materials to be used, and correspondingly more on the skill of the artist. This shift encouraged experimentation and the acquisition and demonstration of visual and technical skills. In the process the medieval artisan was elevated to the status of "artist".

Successful artists maintained workshops of craftsmen and apprentices to carry out the routine work, but contracts often insisted that the master artists should execute the work by their own hand. The unique quality of a work autographed by a

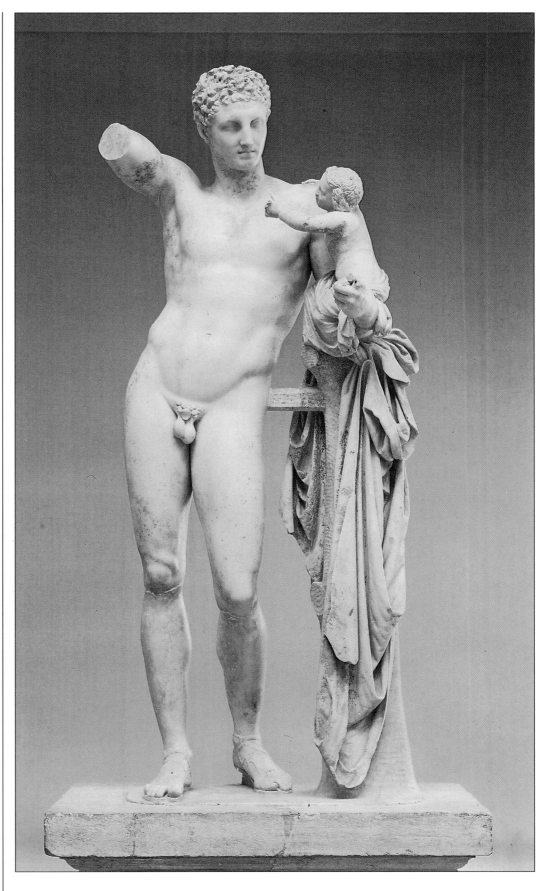

ABOVE *Classical statuary, like Praxiteles' Hermes and Dionysus (c340 BC), constituted the ideal to which Renaissance artists aspired, although in the 15th century this Greek ideal was mediated through late Roman copies.*

known master had been acknowledged in ancient Greece, as seen in the case of Praxiteles, and this had not entirely disappeared in the Middle Ages, but most art was produced by artisans in workshops. The workshops were controlled by guilds, rather than by individual artists, and their work was generally anonymous.

The Renaissance placed increasing emphasis on that individuality in conception and execution (even when assisted by pupils), which persists to our own day. The equating of great art with its originator, and awe of the artist regarded as a "genius", displaced the idea of God as the source of creativity.

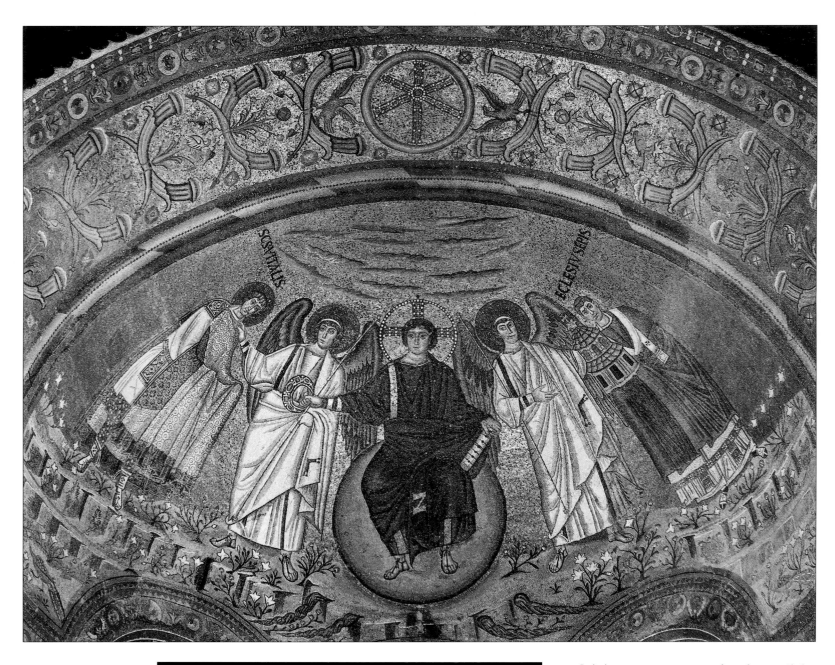

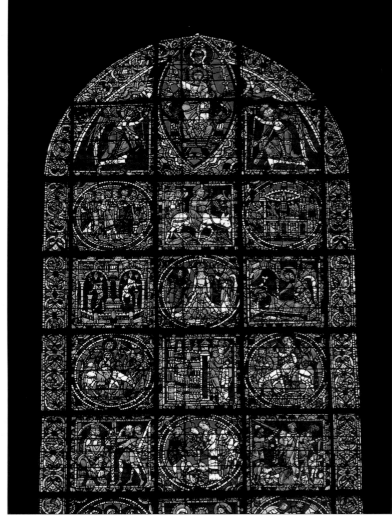

ABOVE *The Byzantine-style mosaics of Ravenna recalled little of Roman realism. Their unchanging, stylized form stood for a world fixed under the rule of the emperor, who was invested with spiritual as well as temporal power. His Christ is a parallel autocratic ruler, austere and resolute, an unforgiving judge dwarfing humanity below.*

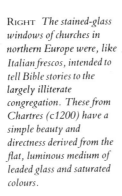

RIGHT *The stained-glass windows of churches in northern Europe were, like Italian frescos, intended to tell Bible stories to the largely illiterate congregation. These from Chartres (c1200) have a simple beauty and directness derived from the flat, luminous medium of leaded glass and saturated colours.*

It is important to remember that until the Renaissance, the sole purpose of art was felt to be to glorify God, dating from the Byzantine presence in Italy. The mosaic of "Christ enthroned, with Saints", can be seen in the Basilica of San Vitale, Ravenna. In Mediterranean countries mosaic was used extensively for large images, painted panels for small ones. God appears as king and judge, and in subsequent mosaics the emperors, both eastern and western, are treated in a similarly hieratic way, associating them with godly powers. It is only with the humanism of the Renaissance, that we begin to see a more accessible God, one with sympathy, forgiveness, and humility. For the medieval mind, God and His apostles were a spectral bench of magistrates.

In northern Europe, under greyer skies, large windows were needed to illuminate church interiors, and, instead of fresco or mosaic, the holy stories were told in stained glass. This medium by its technique and construction tends towards visual stylization and simplification, as can be seen at its most successful in the late 12th-century windows at Chartres.

Throughout the Middle Ages, and even into the 15th century, illuminated manuscripts were the medium in which the skills

of painting and drawing developed. Monasteries and abbeys were the main centres of learning and each cultivated its own characteristics and style. Some, especially in the Celtic lands, were so stylized as to be almost abstractions. The illuminations have a visual brilliance, where the use of rare pigments and gold leaf give them a glowing mystical intensity. This love of exquisite detail, realized on an intimate scale, enhances their preciousness and jewel-like quality, and was to culminate in the International Gothic style, as late as the 15th century, competing with Renaissance realism.

In palaces and castles, tapestry was the most familiar form of wall-decoration. This costly and laborious medium, with its own integral structure, was to influence subsequent art practice. In warmer climes, in fact, fresco was used as a cheap substitute for tapestry. Quick to execute, it was not subject to the mould which limited the use of frescos in the north.

In construction, the richly detailed images or decorative patterning of each tapestry had to be completely planned before a stitch was woven. Executed on a grand scale, they were generally filled with detail or decoration, leaving no large empty spaces, a practice that was echoed in painting in the Gothic style.

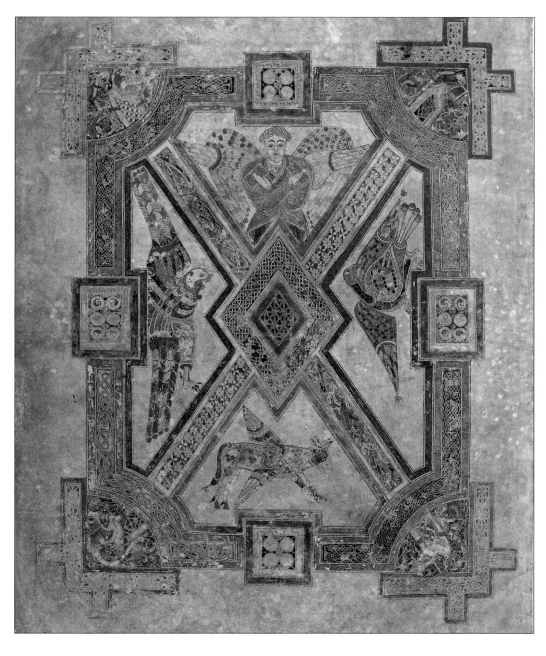

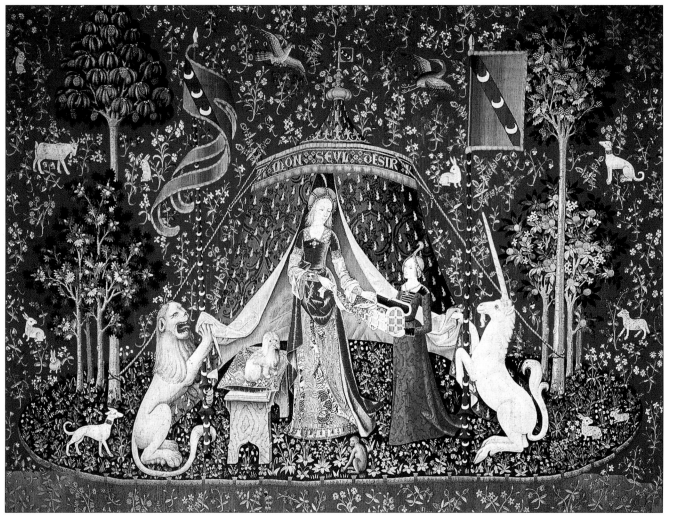

ABOVE *Throughout the Dark Ages, learning persisted in cathedrals and monasteries where scholars, scribes and illuminators passed on their refined skills in copying ancient books. Dedicated to God, the holy books were exquisitely decorated in the most intricate patterns with costly colours and gold-leaf. The Book of Kells (late 8th century) was illuminated in a style based on Celtic decorative patterns, and the human form became so stylized as to be merely symbolic.*

LEFT *Tapestries, a major art-form of northern Europe throughout the centuries, gave a flat, immobile and decorative effect with their intricate, densely worked surfaces, and were costly, prestigious objects seen only in castles and palaces. La Dame à la Licorne (c1480) serves this function with a subject of a fairytale princess, floating on a flower-spangled meadow.*

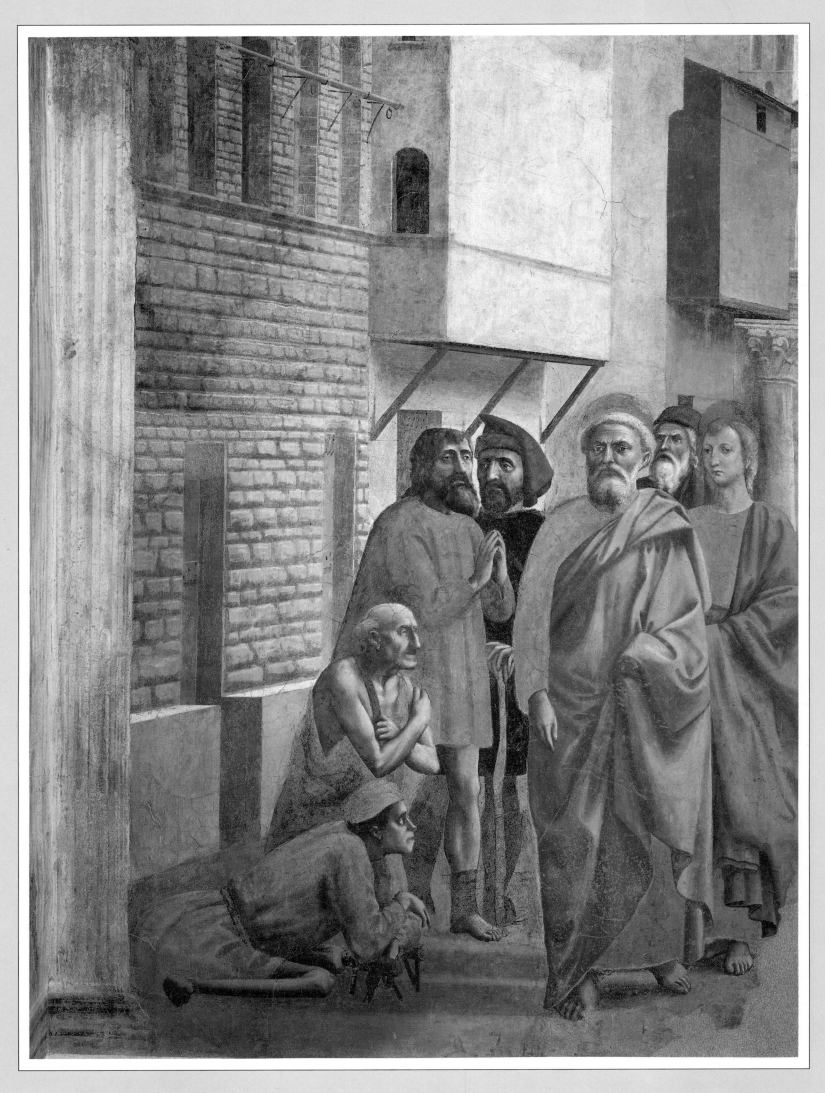

ABOVE *Masaccio was to develop Giotto's
move towards a naturalistic style with his
frescos in the Brancacci Chapel, Florence
(1425–8). In St Peter Healing with his
Shadow Masaccio creates the shock of
revelation because the figures are so solid and
convincing, and because they seem to walk
towards us, out of the Florentine street, and
into the church itself.*

THE QUEST FOR REALISM AND HUMANITY

In painting, the Renaissance began with Giotto (?1267–1337), who was the first artist to be famous as a person since the classical period. Florence was proud of him, he became rich and honoured: Dante admired him, and Petrarch singled him out as the greatest artist in Florentine history. A century after his death, the greatest of the many patrons of the arts in Renaissance Florence, Lorenzo de'Medici, commemorated Giotto's burial place with a bust.

Giotto brought a new dimension and animation to his subjects: he astonished those who saw his work with the life-like figures and natural settings. Suddenly the familiar biblical stories had real and

BELOW In comparison with the flat, expressionless formulae of Greco/Byzantine art, Giotto sought a new and more realistic style that would make the biblical events seem more dramatic, and involve the spectator's emotions. The anguish of Mary in the Lamentation, from the Scrovegni Chapel (c1305/6), can be shared by the viewer.

immediate meaning, and the expressive means demanded a new kind of response from its audience. When Mary cries in anguish over the dead Christ, she draws the viewer to share in her experience of grief.

In order to achieve this effect, and like most changes in art practice, Giotto built on tradition. He was trained in the medieval way, yet he knew that the time was ripe for new departures, for greater realism in place of repeated formulae. Dante played his part, by showing that the culture of their times, and the Italian language, were worth attention, and that art should reflect everyday experience. Giotto must have looked at Romanesque sculpture of the 11th and 12th

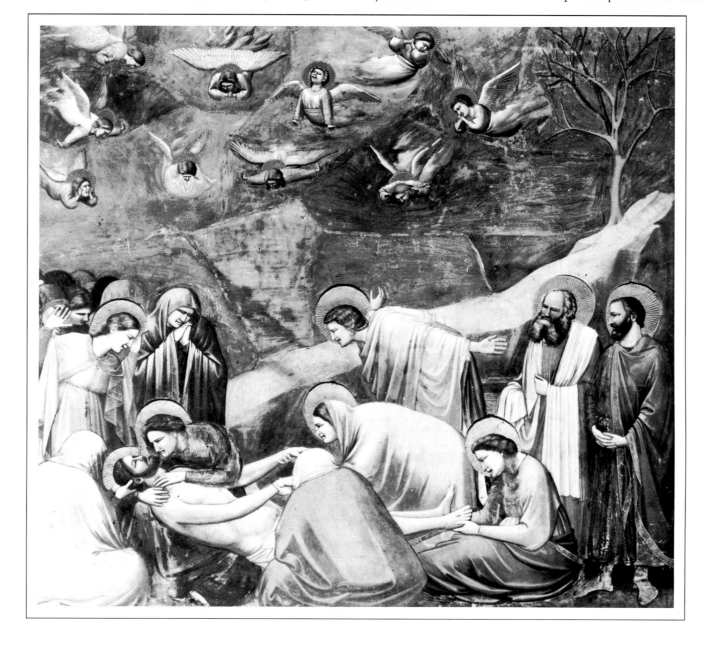

THE ART OF FRESCO BY GIOTTO

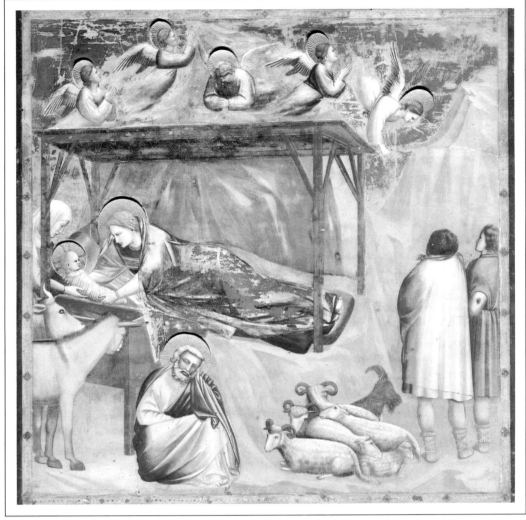

In fresco painting, the work was divided into daily sections, the giornate. This was because the paint had to be applied to the intonaco layer while it was still wet. The edges of each day's section were undercut to help dovetail the joins. The daily stages in The Nativity *are shown (right).*

The adjustment made to the upper contour of the reclining Virgin's body is clearly visible. The final form, painted using secco fresco, is visibly lower than was intended when the layer of plaster was applied and the under-drawing painted in. The red under-modelling is also visible on the figure of the Virgin where the blue paint has flaked off. Around 1390, Cennino Cennini wrote the earliest known Italian treatise on painting techniques. It is a valuable source of information on both fresco and tempera techniques.

Day 1 4 7 5 3 2 8 9
6

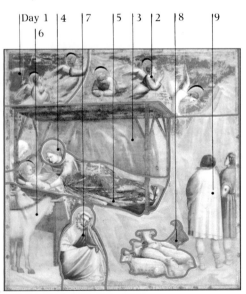

 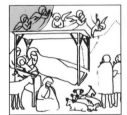 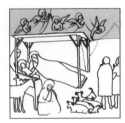

1 The bare masonry was first covered in a coarse, thick layer of lime and sand plaster, called the *arriccio.*

2 The composition may then have been drawn in on the plaster. This stage is called the *sinopia* because of the red earth pigment, sinoper, which was used generally mixed with ochre.

3 The painter then applied as much smooth plaster, the *intonaco,* as he could paint in one day and rapidly redrew the outlines. The normal painting process began at the top left-hand corner.

4 On day two, angels and the top of the mountain were painted. The artist worked systematically across the wall and downwards. The sky was added later in *secco fresco* after the *intonaco* had dried.

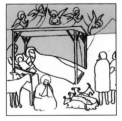 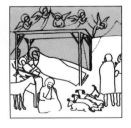 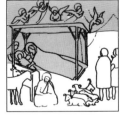 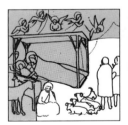 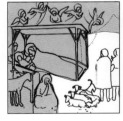 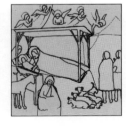

5 On the third day, the large, but relatively uncomplicated area of the stable and background was executed.

6 Day four was devoted to painting the Virgin's head.

7 On day five the figure of the Virgin was worked on. The figure was underdrawn in *buon fresco,* and the blue robe then painted in *secco fresco* which did not follow the contours of the under-painting.

8 On day six the ox and ass were painted.

9 On day seven the figure of Saint Joseph was painted. His blue tunic was executed in *secco fresco.*

10 On day eight the sheep were painted, followed by the shepherds on day nine.

centuries (genuine Greek and Roman remains were rare at this time) and seen how the fall of light and shade makes the figures appear solid. Correspondingly, he clothed his figures in heavy woollen cloaks with softly flowing folds, which, enhanced by effects of light, give dignity as well as solidity to even the most humble shepherd.

Giotto revived the essential idea of classical art which had been lost for a thousand years: that man is the centre of his world. In all his works, people are the focus of Giotto's attention, and this idea remains central, a constant inspiration to Italian artists for centuries to come. Giotto's new approach is most evident in his frescos.

What was it that made Giotto look for a new realism in fresco painting? Part of the answer lies in the technique itself: fresco obliged artists to work rapidly, to make large confident gestures, and to work mainly in earth colours, with their more natural effects. Conversely throughout the period, altar-pieces continued to be made according to the traditional formulae of tempera, painted with minute layered brushstrokes in brilliant and intense colours, enriched with gold – both Giotto and Masaccio painted such works, although both extended the genre.

Previously, large-scale wall-decorations were mainly in mosaic, a technique with distinct limitations: the results were likely to be flat, rigid and stylized because of the materials employed. In contrast, fresco brush-strokes allowed the artist to make subtle transitions in tone and colour, and to work more freely.

Giotto's two main fresco schemes are in the Scrovegni Chapel in Padua and in the Upper Church of the Basilica of St Francis at Assisi. His developing interest in telling stories in a natural and accessible way can be followed in them. The figures in the scenes from Christ's life are boldly drawn as solid forms in a simple uncluttered way, which contrasts with the Gothic architecture and decoration. We recognize these forms as real people, taking part in events which changed the world.

Giotto groups his figures to dramatic effect. There is a unity, not only of shared involvement in the tragic scene after Christ's death, but amongst the people represented. Mary and Jesus are treated in the same way as everyone else: the Byzantine tradition dictated they should be larger than ordinary mortals, and they should be set apart from (generally above) the rest. Strict hierarchy was followed, which ran through the Holy Family, saints and angels. The naturalistic composition we see here would have been impossible within these conventions. Scale and space and naturalistic anatomy would have no place in works of mainly symbolic meaning.

Giotto set out to tell Bible stories that were compelling and meaningful. If the cathedrals, as Umberto Eco, the author of *The Name of the Rose*, suggests, were the television of the Middle Ages, then the fresco schemes were in a way the documentary programmes of their day. The altar-pieces might strike awe into the heart, but the frescos sought *specific* responses: they demonstrated actions and values that

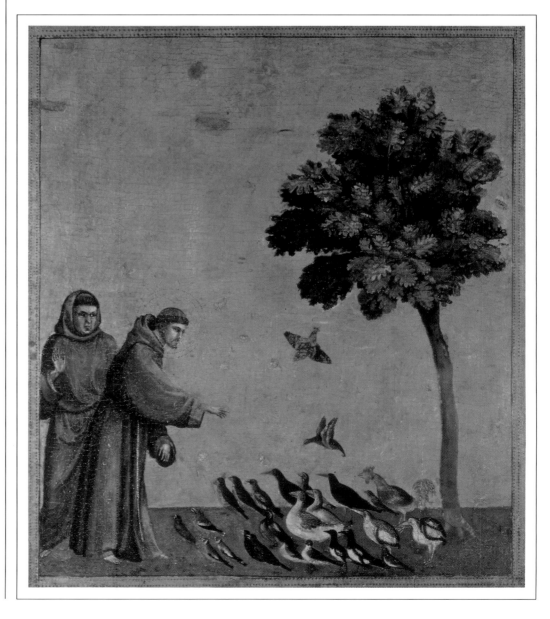

BELOW St Francis Preaches to the Birds. *The frescos by Giotto in the Upper Church of St Francis, Assisi, demonstrate his skill in telling stories in a natural and accessible way. They also reflect a new kind of Christianity in which St Francis sets an example of humility, love and poverty.*

the spectator was expected to emulate. This is most apparent in Giotto's frescos of the life of St Francis of Assisi. St Francis' death in 1226 was followed two years later by the construction of a new church to honour him. It was built on two levels, and the interior was decorated with frescos commemorating his life. In its day the Franciscan movement offered a radical example of humility, love and poverty. St Martin of Tours, a prince who gave up his crown and wealth to follow Jesus's call to self-abnegation was another much-painted saint at this time. The image of a punitive, austere God becomes old-fashioned – St Francis preaches to the birds, and smiles on all of God's creation.

This change of attitude, from the medieval belief that life was a vale of tears, and the only hope of happiness lay in heaven, to one where life on earth was valued in itself, is a central factor in the new art.

But Giotto's figures are not yet organized in a coherent space. They overlap one another. There is space only for gestures, and no room for movement. The figures seem to be pinned against flat and unspecific backgrounds. It is to Masaccio, a hundred years later, that we must look to find a consistent, unified treatment of figures in space and a correspondingly increased potency of expression.

THE COMMERCIAL CULTURE OF FLORENCE

Giotto painted at a time of increasing stability and optimism. For his native Florence, life was improving as a direct result of efforts in commerce and banking. But soon after his death, internal rivalries and inter-city wars, a famine in 1347, and the plague known as the Black Death which followed, brought with them fears and uncertainties – and doubt. Was God punishing the city? In art, this engendered a return to traditional hieratic forms: God abandoned the tainted earth, and His saints were no longer set in the Tuscan landscape. He was viewed against celestial blue, remote and intangible again. In Siena, where the plague had been devastating, Gothic art with its spiritual "otherness", persisted for two centuries, as in Giovanni di Paolo's *The Martyrdom of St John the Evangelist*. By contrast, a renewed optimism in Florence resulted from a period of peaceful prosperity under the increasing dominance of the Medici family, who were to show enlightened patronage of art. Florentine success in business demanded the kind of rational, pragmatic thinking that we now take for granted, but which was a departure from medieval otherworldliness.

Trading was based on a sound grasp of mathematics – not only the ability to handle

ABOVE *The Death of St Francis (c1320) is one of the cycle of frescos in the Sta Croce, Florence. Giotto has combined an entirely new feeling for realistic expression of emotions, and his increased naturalism and humanity bring the subject into the realm of human experience.*

BELOW *In Siena, Gothic art, with its spiritual "otherness", persisted. Giovanni di Paolo's* The Martyrdom of St John the Evangelist *is decorative and small scale, in contrast to Giotto's grave and monumental Florentine spirit.*

large numbers, and make up tables of profit and loss, but to gauge volume by eye. Perspective studies grew from the realization that buildings, objects and people must take up space in paintings, in the way that they do in the real world and each artist attempted to better his predecessors.

In Florence, confidence in man's ability to shape his destiny had ebbed, then gradually returned – but always shadowed by guilt, and fear of death, and Judgement.

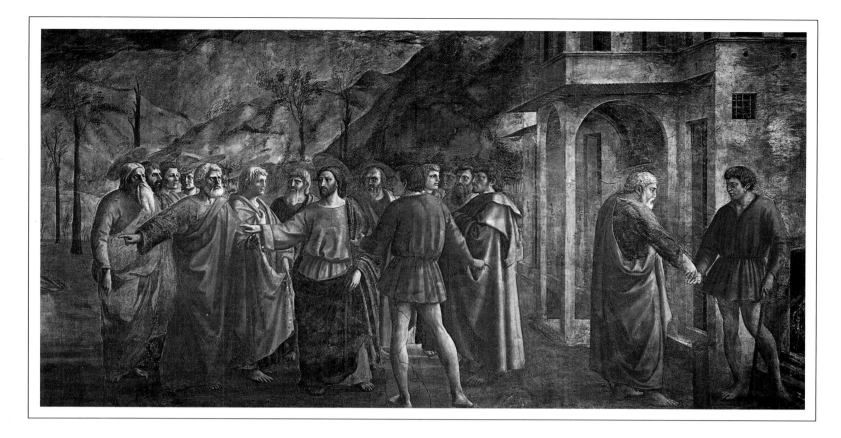

THE FIRST RENAISSANCE MASTER

Masaccio (1401–28) whose early death has left us with little detail of his life, began as an assistant to the Gothic artist Masolino, with whom he worked on some of the frescoes for the Brancacci chapel in the Church of the Carmine in Florence. Masaccio's frescos were paid for by a donor who hoped to win a place in heaven and to have his worldly sins forgiven. Many great works of art in this period were commissioned by those engaged in usury – a sin in the eyes of the Church. Lending money made men rich and powerful, and in return they financed art for the glory of the Church. Of course, they liked to be depicted kneeling at the Virgin's feet, or watching respectfully as Christ performed miracles. The light that falls on Him also bathed them with rays of immortality.

Masaccio's frescos depict solid figures, situated in space, where the surroundings increase the credibility of the Bible stories. Light seems to flow from the central altar over the scenes on either side of the chapel, unifying the separate events depicted.

Extending the range and treatment of subjects initiated by Giotto, Masaccio tackled dramatic scenes impossible with medieval or Gothic technique: *St Peter healing with his Shadow* is clearly dependent on the viewer's belief in the light which generates the shadow, and in its divine source. St Peter's shadow falls across the crippled beggar, all the more abject in his ugliness, and instantly transforms the everyday scene into one of eternal significance.

Masaccio creates the shock of revelation because the figures are so solid and real, and because they walk towards us from a

ABOVE The Tribute Money in the Brancacci Chapel, Florence, demonstrates Masaccio's control over light and pictorial space, creating a stage on which the figures can move, gesture and act out the events, and intensifying their monumental dignity and grandeur. The tax collector, with his back to us, appears to be stepping into the picture-space, encouraging the viewer to enter, and participate in the miraculous event.

typical Florentine street, correct in scale and perspective, and including telling, familiar scenes and details from everyday life. For the contemporary spectator, St Peter and his retinue would have seemed to be about to step out of the pictured street – beyond the picture plane – and speak to or bless the assembled congregation. It was a miracle of transformation from bodily pigment to a moment of spiritual grace.

The emotional impact of such a scene could be expected to convince the spectator of the truth of the Bible story, and of its enduring message. As with other Church art, the spectator would know the story recalling the past events – but only art could make it visible, alive and present, in a startling and compelling illusion that denied disbelief.

In *The Tribute Money*, Masaccio again combines aspects of tradition with a new way of seeing. The familiar story is told using continuous narration: we see St Peter three times, as the episode unfolds. First, Jesus tells him and the other apostles that they must "render unto Caesar that which is Caesar's" before entering the city. Jesus directs Peter to the lake on the left, where he is next seen, stooping to extract the money miraculously from the fish's mouth. And finally, Peter gives the money to the tax collector in the scene depicted on the right.

Examples of this sequential device of pictorial story-telling abound. It was familiar and well understood, but Masaccio revitalizes the form, and gives it a new dimension and focus by means of dramatic effects.

Masaccio has used perspective to construct a receding space, like a hollow cube or box, in which the figures can move,

gesture and act out the events, giving vitality to the scene. The action is staged against buildings which are set obliquely, insisting on their depth, and spatial recession is also apparent in the size of the trees receding to the far distance. The trees are depicted in wintry leaflessness. This was the first time that trees in winter had been painted, giving added realism to the portrayal, as well as suggesting the barren world that Christ transformed.

The simplicity and economy Masaccio has employed increases the monumental presence of the figures. They stand solidly before us, mostly impassive, so that the few gestures that are represented have increased power. As with Giotto, the figures have a dignity and grandeur – and weight. Their physical presence contrasts vividly with the Gothic decorative surfaces, and complements the dynamics of the movement portrayed.

For the contemporary spectator, direct involvement in the otherwise flat, frieze-like scene is engaged by the tax collector in the centre, as he is dressed in contemporary Florentine style, which contrasts with the classical robes worn by Christ and the apostles. Further, he is depicted apparently entering the picture-space (his heel overlaps the border from our time and space into that of the narrative). This encourages the viewer to stand behind the tax collector and enter the scene.

Masaccio's quest to achieve realism in his paintings prompted him to include nude human figures. In earlier medieval art, the human figure was, with few exceptions, depicted clothed. Setting aside traditional formulae and convention, Masaccio studied anatomy, most likely from antique sculpture, and rendered his nudes in a sympathetic and natural manner seen in the figures of Adam and Eve in the *Expulsion from Paradise*.

Later in Renaissance art, treatment of the nude shows an increasing emulation of the rediscovered and idealized sculpture of the classical world (Michelangelo, for instance) but Masaccio shows human bodies as he must have observed them – vulnerable, with soft flesh, far from perfect.

Always, Masaccio employs his skills in realism to increase the emotional and spiritual impact of the religious scene represented, and never more than in a work of uncompromising grandeur, *The Holy Trinity with the Virgin and St John* in Sta Maria Novella in Florence. Masaccio combines accurate, convincing perspectival space, and monumental figures, in a strikingly symmetrical composition. As in *The Tribute Money*, Masaccio uses traditional devices but sets them in a believable context. This is the first time that perspective had been constructed accurately, according to rules set out by Filippo Brunelleschi, the

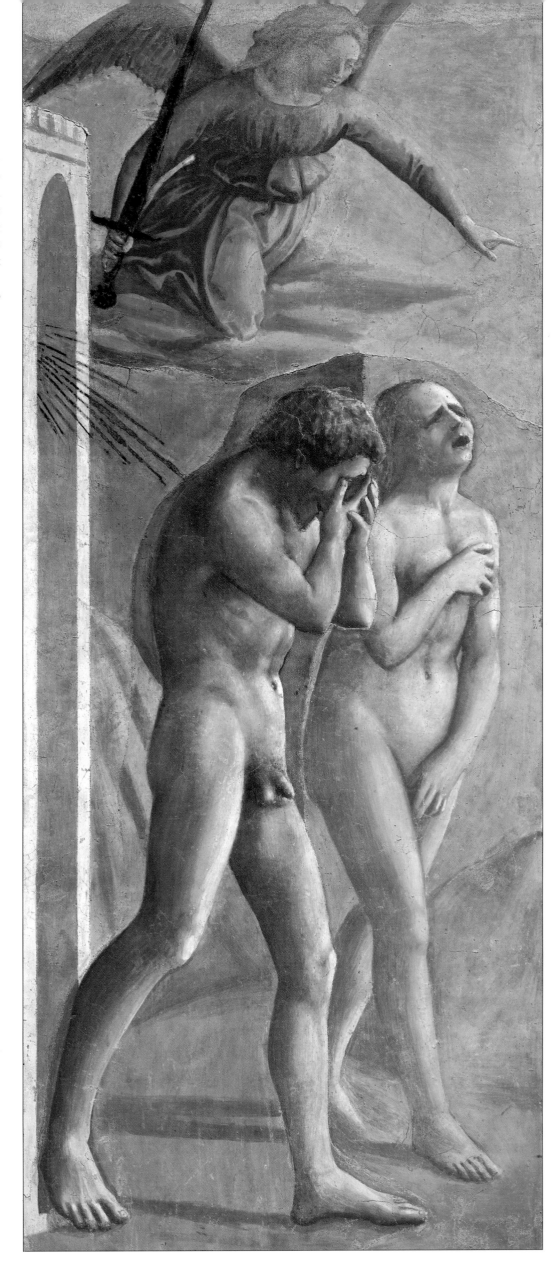

architect who studied and measured Roman ruins. Together with the life-size scale of the figures, it must have astounded Florentines when it was first seen.

The perspective of the barrel-vaulted chamber implies a private chapel, receding into the wall on which the fresco is painted: it creates a spiritual space, that we know is not real, but the inhabitants of that space are themselves supernatural.

Masaccio has played with the real/unreal in the way he painted the central figures. We must look up at Christ, as he looks downwards towards humanity, but God the Father stares straight out of the picture. He is not subject to rational rules, but remains austere and aloof. The Holy Spirit is conventionally represented as a white dove, interposed between God and Christ.

Below, in strict hierarchy, are Mary on the left, and John the Baptist, on the right, each in their traditional colours – deep blue and red respectively. Although below the Holy Trinity, they occupy the imagined space inside the painted niche – they are outside our time and space. Mary, however, links the spectator with the crucifixion, gesturing towards the dying Christ while looking down at the spectator and inviting us to share her grief.

This is one of the paintings in which perspective is employed to control the spectator: to see the work properly, we must stand precisely before it – and below it as located in its church setting – to get the optimum effect intended. Masaccio also employs perspective symbolically; the figure of God the father is not affected by the rules of single point perspective, and He is not governed by our realm of time and space. The spectator is physically manipulated, to effect a response of equal intensity.

Outside that imagined space kneel the donors. Through the use of perspective, they seem to be in our space, yet are fixed forever in the painting, and are vital elements in the triangular composition.

Below them is a tomb, with a painted skeleton, and the inscription –

"What you are, I once was: What I am, you will become."

A *memento mori*, grim reminder that death comes to all, high and low, faces the viewer at eye level. As you look up, you see ever more spiritual beings, stage by stage, leading to God. The power of the fresco is realized in the combination of the composition and the realism of the figures – unfolding into a dramatic revelation, striking awe into the soul of the spectator, then as now.

Soon after completing his masterpiece, Masaccio went to Rome where he met his untimely death at the age of 27. Who knows what he might have painted in another ten years?

OPPOSITE *In his pursuit of realism Masaccio studied anatomy, setting aside the medieval tradition of heavily draped, formalized figures. In* The Expulsion from Paradise, *Masaccio has rendered his nude Adam and Eve in an unidealized manner, exposed and vulnerable.*

LEFT *The Holy Trinity with the Virgin and St John (1427/8), in Santa Maria Novella, Florence, combines Masaccio's confident handling of anatomy, light and space with the system of linear perspective devised by his friend, the architect Brunelleschi. Masaccio employs these skills to increase the emotional and spiritual impact of the crucifixion in a work of uncompromising grandeur which transfixes the spectator.*

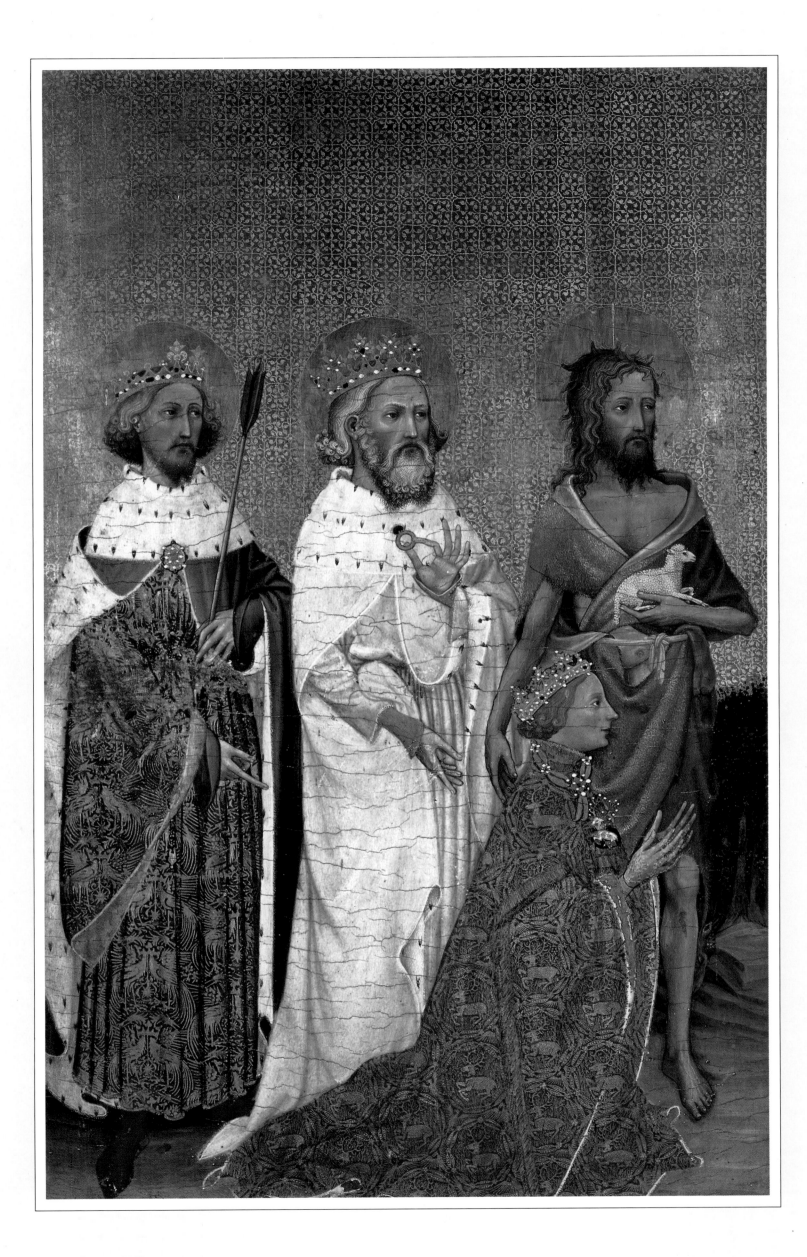

INTERNATIONAL GOTHIC:
DECORATION AND GRACE

Opposite The "Wilton
Diptych" is a hinged pair
of small-scale panel
paintings, painted by an
unknown artist c1400.
Here, in the left panel,
King Richard II of
England is immortalized in
the portrait, resplendent in
his gilded finery. His
temporal power is aligned
with the spiritual, for as he
kneels before the Virgin,
his kingship seems to
emanate from her, whose
attendants all wear his
insignia, a white hart (on
the right panel).

At the same time as Masaccio was making his breakthrough in pictorial realism, the Gothic style was actually growing in popularity in the Italian states, in France and in eastern Europe. It was considered to be the "modern" style, and is called by art historians "International Gothic".

SIENA

Siena, only 30 miles (48 km) from Florence, maintained a distinct tradition throughout the formative period of the Florentine Renaissance. Duccio was a contemporary of Giotto, yet his work remains resolutely stylized, using forms inherited from Byzantine models. The changes seen in Sienese art are an increasing refinement of technique and treatment, with influences from International Gothic. Masaccio's realism was slow to filter through.

An outstanding Sienese artist was Simone Martini (1285–1344) whose *Annunciation* (1333) for the cathedral in Siena is an exquisite example of Gothic delight in delicate and beautiful things. The figures are serene, and their gestures graceful. The curving lines that characterize all Gothic art are just one element in a decorative scheme that transports the holy figures into a realm of burnished gold. Martini was justly famous in his own time, not least for the first equestrian portrait in Western art since classical times, that of Guidoriccio da Folignano, who had just won a great victory for the Sienese.

The work of subsequent Sienese artists, including Ambrogio (1319–48) and Pietro Lorenzetti (1320–48) and Sassetta (?1392–

Above *In* The Annunciation *(1333) by Simone Martini, serene figures, with their graceful gestures, take their place in the decorative scheme of curving lines and arabesques.*

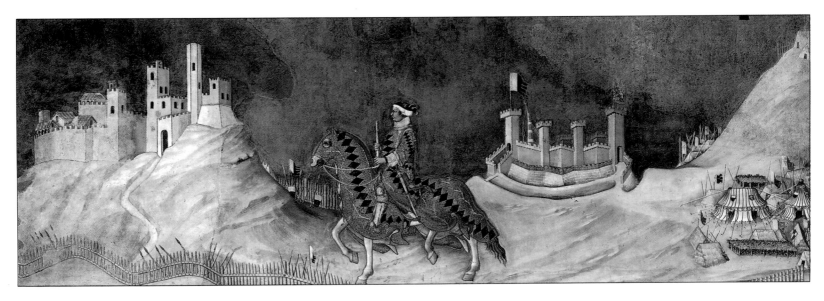

Simone Martini combined an heraldic sense of pattern with a closely observed portrait in his official painting of Guidoriccio da Folignano (detail below), a condottiere, *or mercenary general, who had won a great victory for the Sienese. An ambitious work, it was the first equestrian portrait since classical times.*

1450), show a mixture of influences from Giotto's style and Gothic. In place of the flat, iconic Byzantine style, elements of realism in detail and of observation of things in the world, become apparent. Just as Simone Martini gives us a clear portrait of the burly and belligerent Guidoriccio da Folignano, yet sets it in a decorative heraldic pattern, so we see increasing references to observed aspects of the world.

Minute observation was a characteristic of Gothic art, growing from the detailed treatment of illuminated manuscripts in the Middle Ages; small, portable, but refined works, jewel-like in intensity, often embellished with gold-leaf, and painted in costly pigments. An example of the refinement of miniature work is *Très Riches Heures* painted in France for the Duc de Berry about 1410, by the Limbourg Brothers. A calendar in a prayer book, it shows scenes characteristic of the months of the year, each compressed into a tiny space. A magnifying glass is necessary to appreciate the detail – and one was probably used to paint the finely blended brush-strokes.

Few panel paintings survive from this period in northern Europe (even for kings, life could be short and uncertain, and the portability of valuables was essential). Perhaps the finest example extant is a small diptych (two panels which could be folded for transportation), the *Wilton Diptych*. On one panel is shown King Richard II of England, and on the other the Virgin and Child with angels; painted in about 1400, probably by a French master. The king, sponsored by his patron saints, kneels humbly before the Virgin, but the Virgin's attendants all wear the king's insignia, a

Ambrogio and Pietro Lorenzetti also worked on official commissions for the Sienese state, and their comparative versions of the effects of Good and Bad Government *provide historical insights through their close observation of people and their activities. In its architecturally flattened setting, it contrasts vividly with Masaccio's achievements early in the next century.*

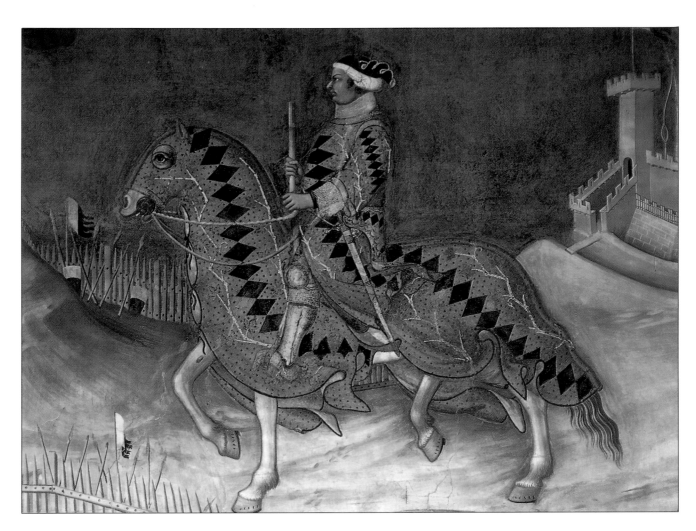

white hart: intimating a clear linkage between kingship and divinity. Despite the hieratic nature of the panels, the king kneels on a meadow strewn with tiny flowers – a departure into nature.

A much more refined form of International Gothic is achieved in the works of Gentile da Fabriano (*c* 1370–1427) and Pisanello (*c* 1395–1455). Both worked in various centres in northern Italy, and

together they painted frescos in Venice. Their work demonstrates a repertoire of Gothic conventions – flat, cursive forms assembled in a decortive pattern – combined with an intense realism.

THE BOOK OF THE HOURS

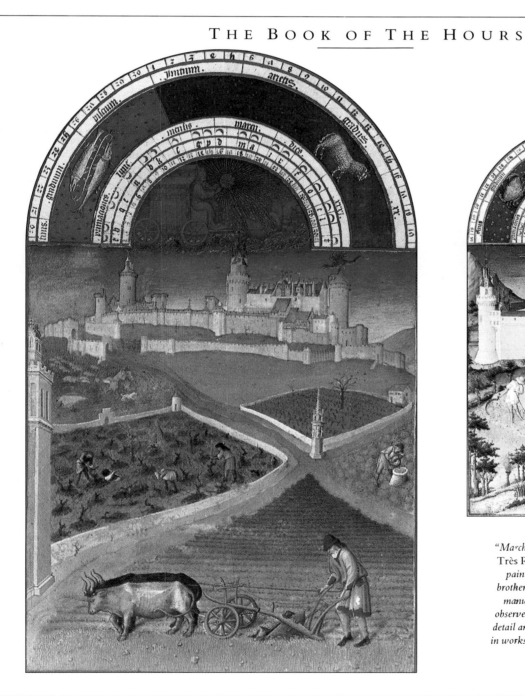

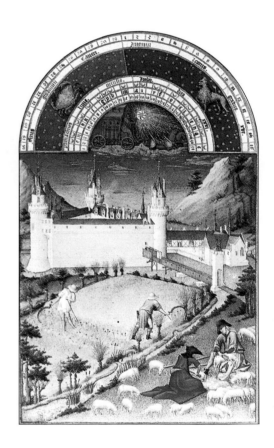

"March" (left) and "July" (above) from the Très Riches Heures of the Duc de Berry, painted c1413–1416 by the Limbourg brothers, exemplify the highest skills of the manuscript illuminator, in the minutely observed, densely worked surfaces. The fine detail and precise craftsmanship are combined in works of jewel-like brilliance and intensity.

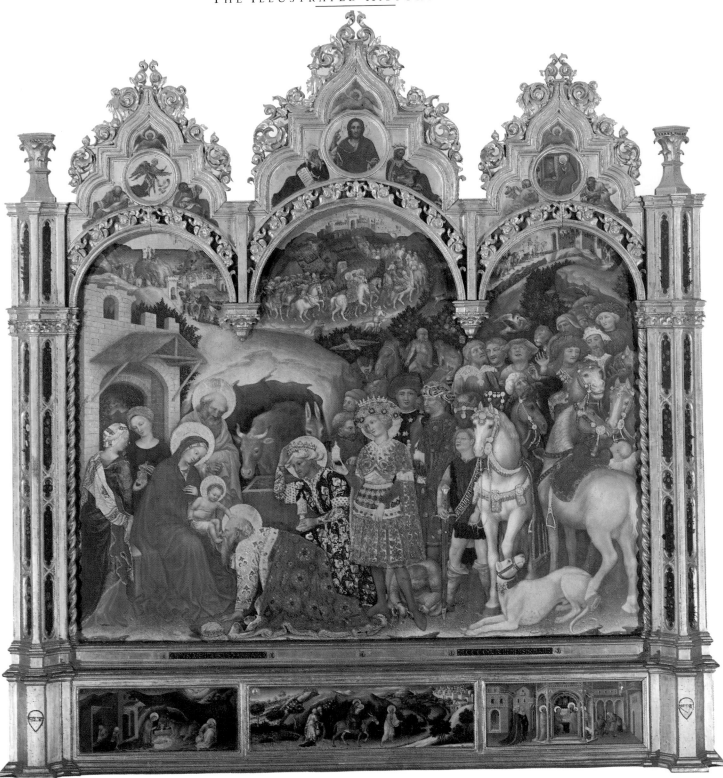

In Gentile da Fabriano's *Adoration of the Magi*, 1423, the procession winds its way in a sinuous pattern across the painting's surface – a perfect example of Gothic *horror vacui* (meaning a fear of empty spaces in paintings). Every inch of the painted surface is packed with people, animals, and objects, even the sky is crowded out. The exquisite costumes of the kings overwhelm the Holy Family, who are squeezed into the bottom corner. How different this is from Masaccio's bold and simple compositions, which focus attention and direct emotion. Here the narrative literally unwinds, as in a real journey, instead of being compressed into one dramatic instant. Everywhere, there are animals and descriptive detail – which attest to the artist's close observation of the life around him. The rendering of the horses demonstrates the newly acquired skills of foreshortening, but Gentile subordinates pictorial space to dominant surface decoration. Pisanello's drawings demon-

strate similar technical skills proving that the Gothic artists were sophisticated and capable of technical virtuosity, but their aims were different from Masaccio's realism.

Many of Pisanello's highly detailed drawings survive, and show his consuming interest in everyday things, with a sharp eye for intimate observation of people, animals and objects. His drawings, when compared to those of a near contemporary, Leonardo, distinguish Pisanello's flat, meticulous but decorative rendering from the rounded vibrant forms conceived by Leonardo da Vinci.

In Pisanello's *Madonna and Child with Saints* the holy figures are represented as an apparition, hovering in the sky, like an icon, above the saints. Pisanello's realism of observation is restricted to the sweeping forms of St George's armour, where Gothic cursive shapes imply continuity around the figure in this essentially spiritual event, yet provide a decorative interest.

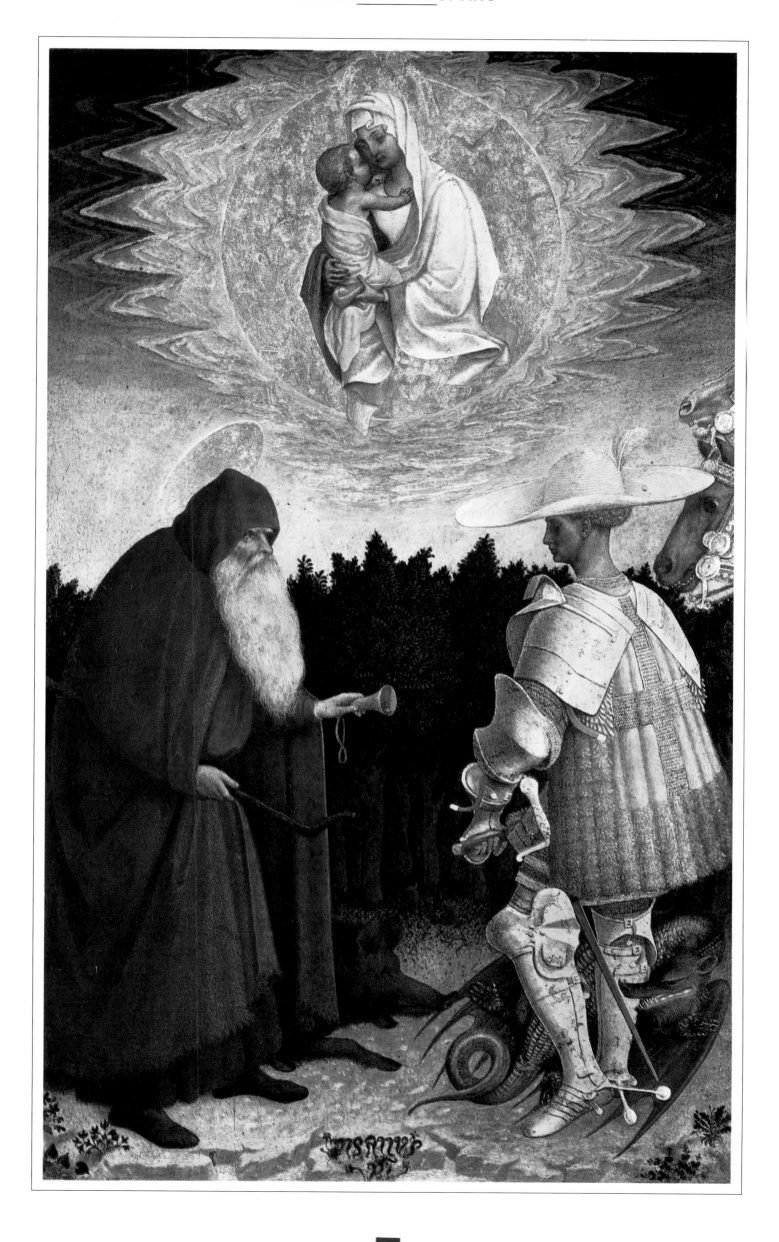

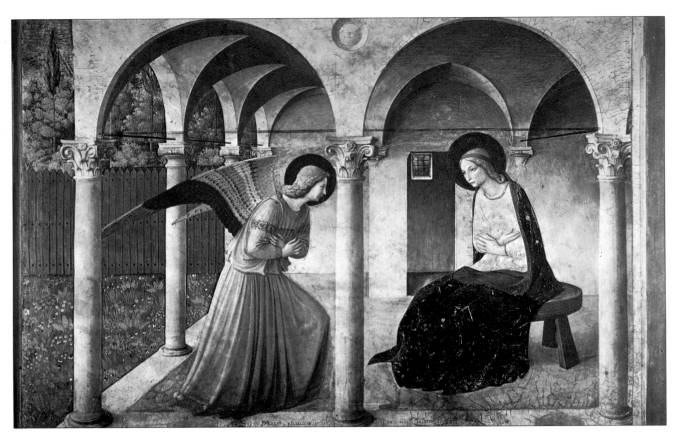

FLORENCE

Rooted in the decorative idiom, artists gradually embraced the International Gothic style by incorporating naturalistic detail and some perspective into their inherited Gothic designs. Gentile worked in Florence at the same time as Masaccio, and his style had much more impact on other artists, of whom, initially, Fra Angelico was his immediate heir. But even in his work, something of Masaccio's understanding of space is noticeable.

The *Annunciation* of Fra Angelico (c 1400–55) is a simple, pious work, a demonstration of uncomplicated faith by a monk. His graceful figures live in a world of bright, even light, where no shadows or sombre colours threaten this vision of medieval certainty, yet he has used perspective to give a feeling of space to the colonnade. It separates Mary from the angel Gabriel, increasing the visual power. In comparison with Simone Martini's *Annunciation* this scene is charged with the significance of the event unfolding. Martini's figures are too slight to convey emotion, they are symbolic, evoking a spiritual domain quite distinct from our world of light and space.

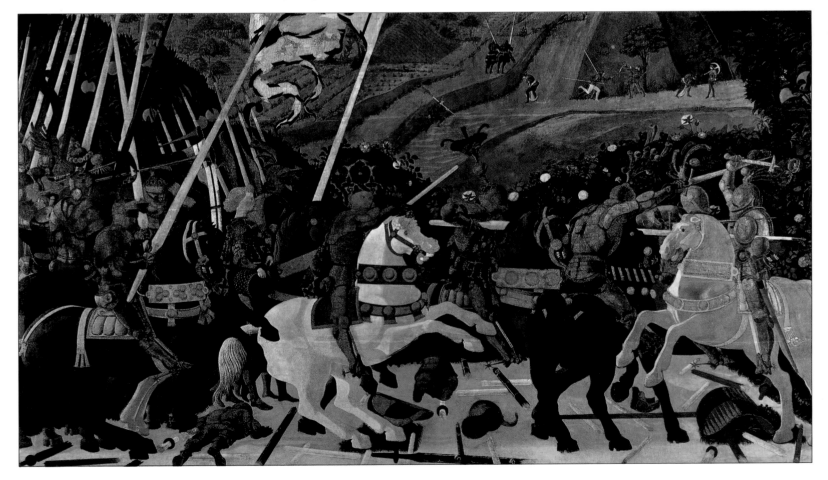

UCCELLO

The Florentine artist reputed to be obsessed by perspective, Paolo Uccello (1396/7–1475), worked ceaselessly on diagrams to perfect the new and unfamiliar geometry, unwilling to stop even for meals in his quest for mastery over perspective.

However, when applied to his paintings, the results are curious – an uneasy amalgam of the Gothic and the new mathematics. In the panel painting, *The Rout of San Romano*, a linear grid has been imposed on the scene, marked by fallen lances all pointing to a notional vanishing-point near the head of the Florentine leader, Niccolò da Tolentino, which puts him at the centre of the complex action. The improbability of the fall of the lances, and the inaccurately foreshortened dead soldier, lend an unintended humour to the scene. Again, the perspective on the shape of Tolentino's hat is correct, but the horse on which he charges appears static and wooden, the result of applying a "realistic" study to an unconvincing scene.

The whole panel, one of three on this

THE ART OF PERSPECTIVE

Paolo Uccello was obsessed by perspective, according to his first biographer Vasari. Vase is one of many precisely calculated diagrams which demonstrate the mathematical orientation of Florentine culture.

subject intended for Lorenzo de'Medici's private rooms, was conceived as a decorative object, as well as a reminder of Florence's recent victory over Siena in 1432. Having the appearance of a tapestry, it is filled from top to bottom with interesting but immobile figures. A pageant unfolds: Florence triumphs without a clash of weapons or a drop of blood or even a scream. The swirling pennants, the golden fruit and silver-leaf on the armour underline the decorative function of this massive work. Yet Uccello's small panels also demonstrate a Gothic emphasis on curving lines that can animate the picture-surface, without need of movement or gesture by the figures represented. The fairytale *St George and the Dragon* reminds us that the realism of Masaccio was not consistently adopted and there was no purposeful development towards a unified aesthetic in Renaissance art in this period. Realism was regarded as a pictorial device, to be used on occasion, or relinquished, depending on the nature of the individual commission, the cultural ethos, or the artist's inclination.

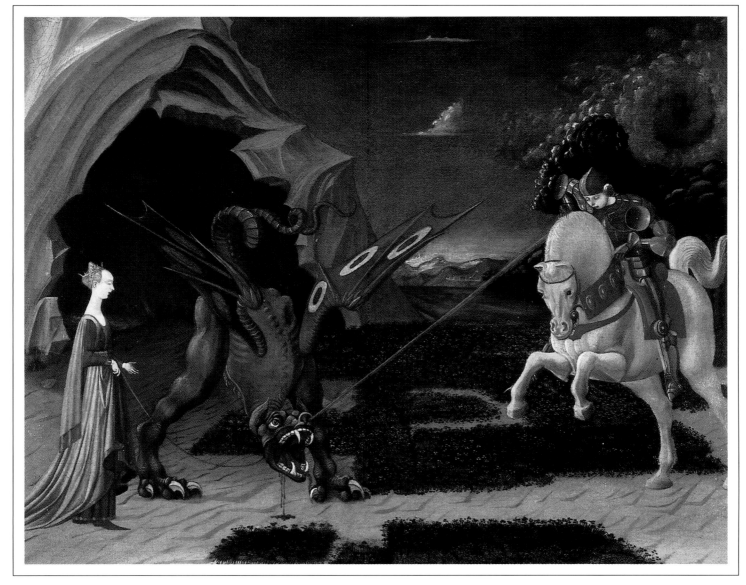

ABOVE *The fairytale* St George and the Dragon *reminds us of Uccello's Gothic heritage and the enduring popularity of this style for secular commissions, to give pleasure to patrons and their guests.*

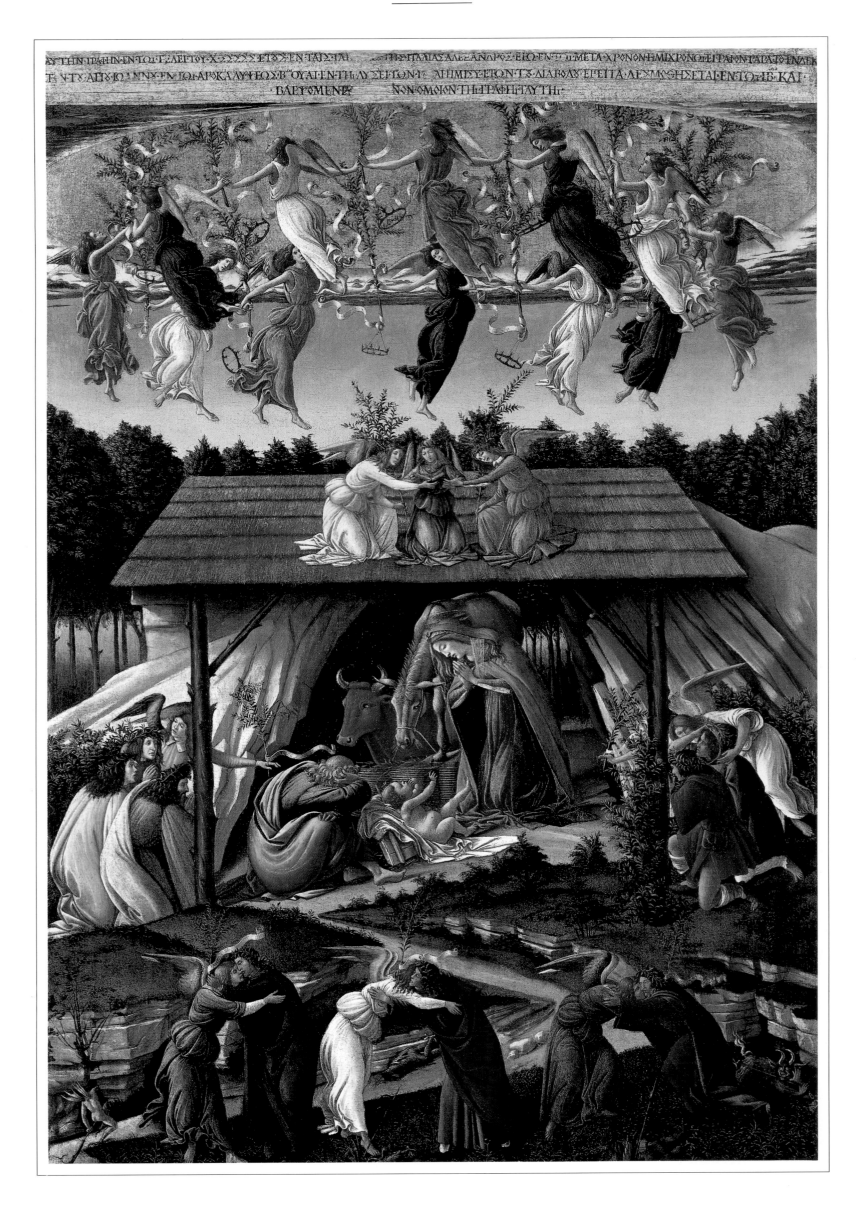

BOTTICELLI

Sandro Botticelli (1444/5–1510) also exemplifies this inconsistency of style. His teacher, Fra Filippo Lippi (1406–69), had actually begun to paint in Masaccio's naturalistic style, but had veered towards a linear, Gothic stylization.

Seductive in their charm and decorative beauty, combining faultless grace with skills of natural observation, Botticelli's paintings combine the flat pictorial surface of the Gothic, with the humanist emotion and spatial illusions of Florentine art – spiritual mysticism fused with earthly sensuality. His panel paintings may look very different from Masaccio's frescos, but they employ the same pictorial devices in directing the viewer's gaze, and in drawing the attention of the viewer into the scene, involving the emotions as well as the senses.

Having mastered these skills, Botticelli made subtle use of them in his most famous paintings, the *Primavera*, and the *Birth of Venus*, painted as private commissions for the Medici. These secular commissions enabled artists to widen their subjects beyond the standard religious repertoire, on which previously they had been dependant for their livelihood. The new merchant class required art to furnish their palazzi, decorative art-works that would add beauty to their surroundings and display their power and wealth.

The stark intensity of Masaccio would be daunting in a domestic environment. Gracious settings required suitable subjects and treatment, and the revival of Greek and Roman mythology provided new inspiration, with which educated patrons could identify. Classical motifs in architecture and sculpture, and paintings that illustrated themes from the new repertoire of humanism, had both intellectual and aesthetic appeal.

Botticelli painted portraits, as well, for the portrait was an important new genre. Those who achieved temporal fame and wealth wanted to be immortalized on their own behalf, and not just to be depicted as minor players in religious scenes, like the donors in Masaccio's *Holy Trinity*. Indeed, Pisanello became most famous in his own time for his penetrating portrait medallions, cast in bronze, which endowed the newly rich with the aura of emperors like Caesar or Augustus.

The confident, golden years of Medici power in Florence ended in a revolution, and a new instability, political and commercial, led to a period of spiritual anxiety. The preacher Savonarola derided luxury goods as ungodly: huge "bonfires of the vanities" were piled high in the piazzi with paintings, jewels and books. Botticelli, caught up in the wave of guilt, is said to have destroyed many of his "pagan" works; and, as an act of atonement, he returned to painting only religious themes.

His *Nativity* signals a return in form and spirit to the Gothic. It is possessed by an ecstatic spirituality: the picture surface is animated by agitated figures, where even the sky is filled with a ring of dancing angels, endlessly singing God's praises.

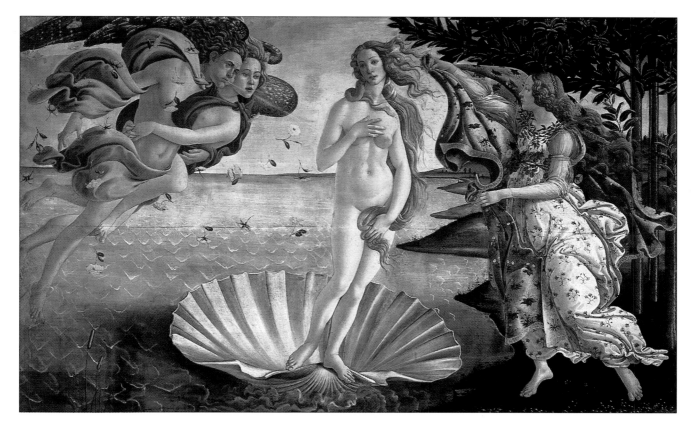

RIGHT *Botticelli's series of mythological paintings and allegories of the 1470s illustrate the sophisticated humanist learning of Medici scholars and poets, translated into Botticelli's refined aestheticism. The seductive charm and grace of the* Birth of Venus *flows from his linear style, originating in the Gothic.*

OPPOSITE *Botticelli's later work signals a change in mood from earthly sensuality to mystical return to the Church, recanting his "pagan" works. In* The Nativity *of 1500, the earth and heaven are alive with figures rejoicing in the Incarnation.*

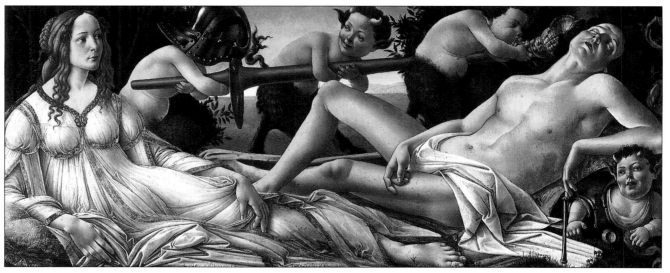

RIGHT *Mars and Venus was also intended for private delectation, with its symbolic references to the patron. Playful and intimate in mood, it perhaps represents Botticelli at his most sensuous. The purging influence of Savonarola was to curb this form of expression in his later works.*

THE BAPTISM OF CHRIST BY PIERO DELLA FRANCESCA

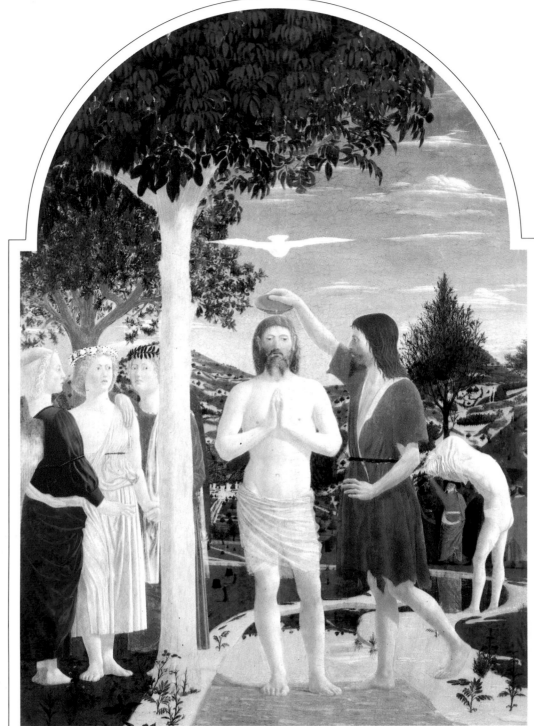

The Baptism of Christ (c.1442) is painted on a panel constructed of two wide poplar planks with a vertical grain. The panel has been prepared with a thick and unusually hard ground which suggests a high proportion of glue in the gesso. The preliminary drawing is simple; however, Piero probably made full-sized cartoons for some of the more complicated details, although none of these have survived. The pigments used are standard for the period. For example, the robe of the angel on the left was painted with ultramarine, the foliage is verdigris and the flesh areas have been underpainted in the traditional green earth. That a number of forms have been painted on top of one another indicates Piero's unusual tendency to complete forms even when they were to be later covered over.

1 Two poplar wood planks with vertical grain were covered with white gesso. A final coat of glue was perhaps added.

2 The underdrawing was done in black, simply defining the main outlines and features, which were drawn in with fine lines without hatching or shading.

3 The more complicated details were most likely transferred on to the gesso by "pouncing", a technique popular at the time.

4 The pale blue sky was probably then added and the wreath blocked in without details. Drapery was completed but not decorated. The wings were blocked in without gold highlighting and the hair without details.

5 The flesh was completed allowing some of the green underpainting to show through. Leaves were put in the background and gold was added.

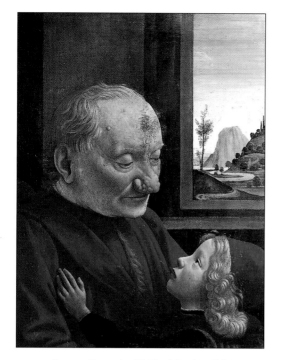

ABOVE *Domenico Ghirlandaio adopted the finely detailed oil-paint technique that had been developed into a clinical realism in Netherlandish art. Yet he imbued it with a gentle humanity, in this unusual portrait,* Old Man with his Grandson.

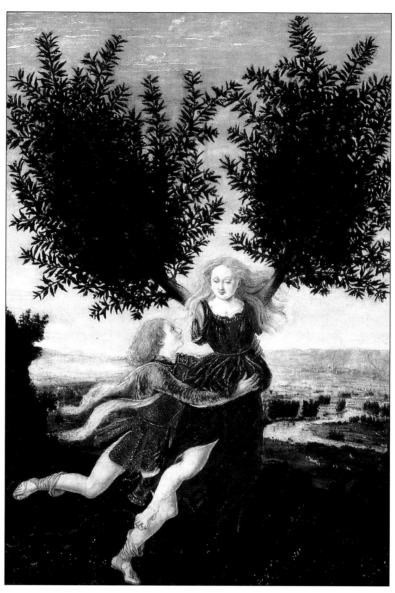

LEFT *The Pollaiuolo brothers introduced a hazy type of landscape setting for their subjects so that when they adopted the classical idiom, as in* Apollo and Daphne *(1475), the painting evoked a magical charm.*

BELOW The Martyrdom of St Sebastian *(1476) is a tour de force of the skills achieved by the Pollaiuolo brothers, not only in constructing a landscape that recedes convincingly, but in the sharply observed anatomy of the figures. The tensed muscles and dramatic poses of the archers, and their expressions, make for a particularly forceful image.*

PERSPECTIVE AND ANATOMY

The legacy of Florentine intellectuality, manifested in linear perspective, finds its ultimate form in the work of Piero della Francesco (*c* 1410–92), an Umbrian who trained in Florence. Piero demonstrated an absolute command of perspective, and devoted his last years to writing treatises on mathematics and perspective.

As with other aspects of realism, such as the knowledge of human anatomy, the greatest practitioners used these skills to go beyond the descriptive, and invested their works with a quality that was particular to them alone – the mark of the artist as a genius. Where Masaccio had emphasized the dramatic moment, Piero's scenes have a crystalline clarity and stillness, transforming the momentary into the eternal.

He achieves this effect in the *Baptism of Christ*, where the symmetrical composition is derived from a balance of verticals and horizontals. The light tonality that floods Piero's works combines with the sculptural qualities of his figures, giving them a statuesque monumentality. It is recorded that Piero draped clay figures with damp cloth to observe the play of drapery, as can be seen in the group of angels at the left.

Piero's perspective is best observed in the enigmatic *Flagellation*, where the bland tonality of the *Baptism* gives way to the richness of oil painting – a medium introduced to Florence from northern Europe late in the 15th century. When the Italians saw Hugo van der Goes' *Portinari* altarpiece of 1475/6, the possibilities of the medium became evident; it enabled vibrant, saturated colour, and blended brush-strokes to

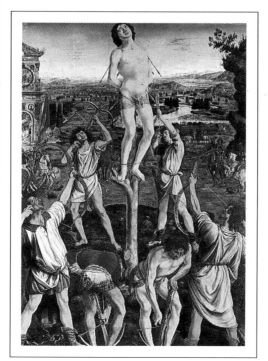

simulate lifelike textural effects of fur, flesh or silk.

Domenico Ghirlandaio (1449–94) adopted the candid realism of observation used for van der Goes' shepherds, with sympathetic tenderness of feeling in his *Old Man with his Grandson*. Yet most of his work had a rather staid, old-fashioned appearance, compared with his contemporary Botticelli.

The Pollaiuolo brothers, Antonio (*c* 1432–98) and Piero (*c* 1441–1496), were innovative contemporaries much more in tune with their times. As well as pioneering a realistic type of landscape setting, their paintings demonstrate a more thorough grasp of anatomy than Masaccio had. Indeed, Piero is thought to have dissected corpses, years before Leonardo did, in order to achieve a better understanding of the human body.

The Pollaiuolo workshop produced many sculptures, and Antonio's gift for conveying the intensity of expression and physical exertion of a body in movement or under strain is apparent in the flexed muscles of the two archers in the *St Sebastian* altar-piece. They combine a sculptural solidity of form with a crisp linearity that parallels Botticelli, and looks forward to the virtuoso works of the High Renaissance by Michelangelo.

CHAPTER FOUR
THE HIGH RENAISSANCE AND MANNERISM

OPPOSITE *Michelangelo devoted his enormously productive life to rendering, in sculpture and paint, his sole subject: the human figure. Even in his* Madonna and Child with St John, *the group of holy figures have a striking athleticism. Michelangelo had absorbed the Greek idea that a perfect body indicated a perfect soul: the figures are super-human ideals, gods in flesh and spirit.*

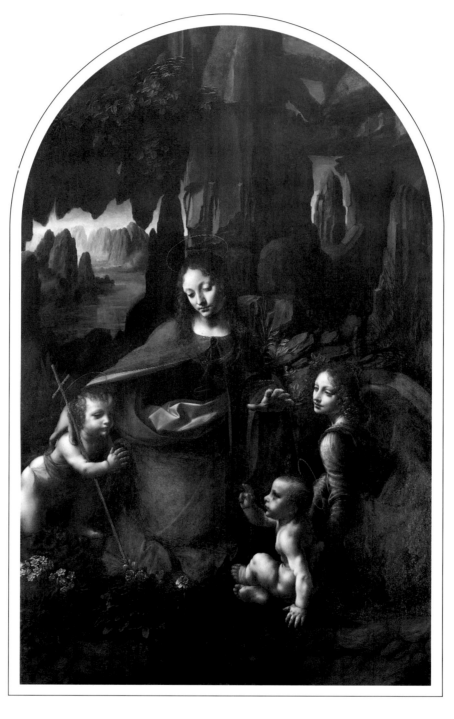

LEFT *Leonardo da Vinci became the Renaissance ideal, a "universal man", possessing a totality of knowledge and skilled in fields as diverse as art, music, and scientific endeavour. His knowledge of plants, rocks, the human body, and aerial perspective (that gradual hazy blueing of distance) are all apparent in the* Virgin of the Rocks *(c1508) yet are transcended by the unifying grace of expression in the figures. The whole is further blended into a pictorial unity by Leonardo's sfumato technique, a gradual shading of light to dark, which omits clear contours, merging all the shaded areas into pools of darkness, and lending a palpable softness to human flesh.*

Leonardo da Vinci (1452–1519) is established as the epitome of a Renaissance Man not just for the handful of paintings that have survived and the countless drawings, but because of his total command of artistic skills, his intellectual curiosity and his inquiries into the physical world. In a time when learning was still concentrated in narrow areas based on religious studies and a fragmentary survival of the intellectual concerns of ancient Greece and Rome, it was possible for an individual to be *l'uomo universale* – a universal man, familiar with all knowledge, and skilled in all the "arts", which at this time meant astronomy, geometry, music, rhetoric, and poetry. The intellectual powers of Leonardo were instrumental in giving painting the status of "art", instead of one of the "mechanical arts", as the craft guilds were categorized, and he himself created the idea of the artist as genius.

LEONARDO'S NOTEBOOKS

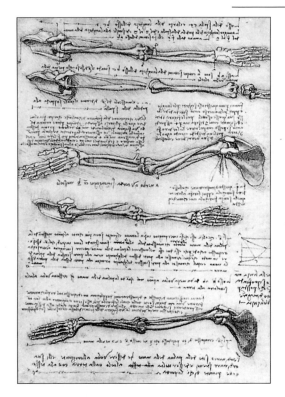

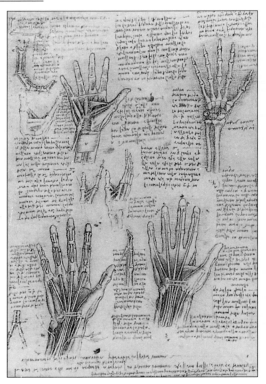

Leonardo produced huge quantities of drawings which testify to his enquiring nature, investigating not only human anatomy but many of the mysteries of the physical world. He drew them because he wanted to know how things worked, at a time when everything was perceived as a mechanism or machine, including the human body.

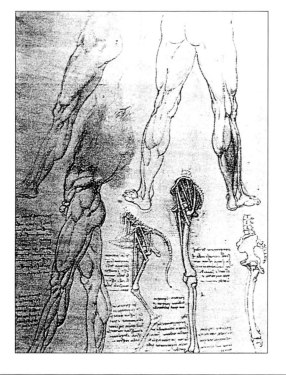

BELOW *In this study for his painting of the Adoration of the Kings (1481), Leonardo da Vinci has taken great care in setting up his perspective system, so that the turmoil of the action can be given a solid structure and the picture space is well-defined. The grid makes it possible to place the figures to scale in the space.*

Leonardo showed that thought and learning were essential to a great artist, and that although artists worked with their hands their minds were capable of as much accomplishment and polish as was then expected of a courtier. Leonardo himself spent his last years at the French court, and in later centuries both Rubens and Velázquez served as diplomats to kings – even though it reduced Velázquez' output of paintings. The prestige thus conferred on these individuals was considerable, and led to great honours, Rubens, van Dyck and others being knighted in England.

The totality of Leonardo's knowledge, and a culture which encouraged scholarship, prompted his enquiring mind to explore the phenomenal world. He would dissect humans, animals and plants, to uncover

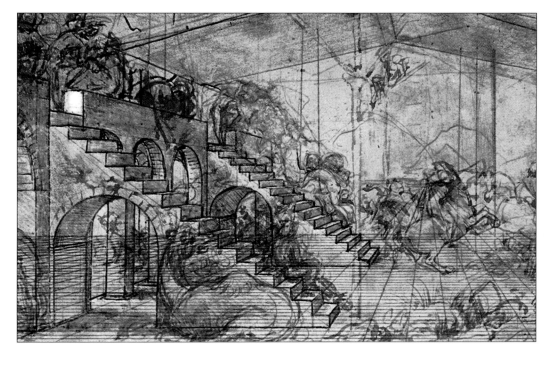

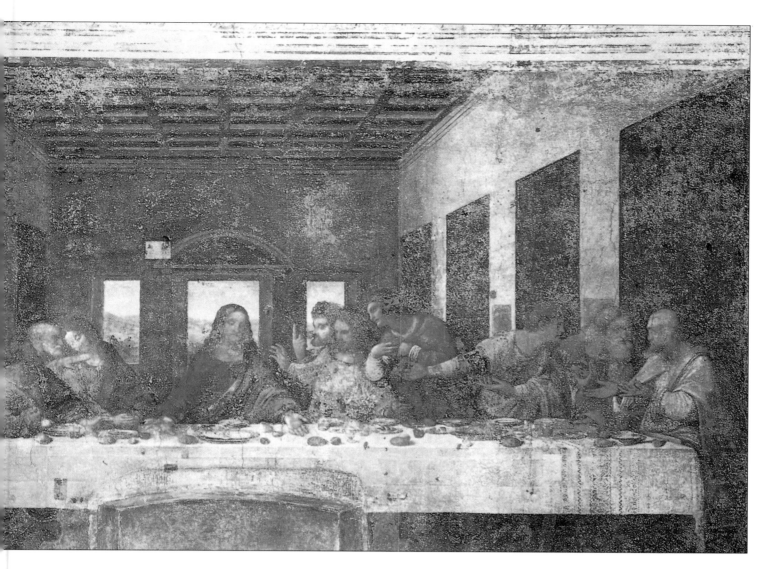

their internal structure in order to discover how they worked, and speculate on the laws of nature. Men like him were treating the physical world as a mechanical system, to be understood by dissection and analysis, and by the mental processes of logic and mathematics. Galileo and Francis Bacon, in the next generation, attempted to discover by observation and measurement the laws of astronomy and physics, and formulate scientific principles to replace previously unquestioned dogma with a more rational system of belief.

At this time science and artistic enquiry were hardly differentiated, as both were widening human knowledge about aspects of the natural world and our relation to it. Leonardo's anatomical drawings are a prime example of this unity. Most previous artists – and many who followed – were only interested in appearances, the external surface of things, such as the depiction of the human form.

Even Michelangelo, renowned for his extraordinary skills in drawing the human body, did not investigate beyond muscle and bone structure in order to make more convincing representations. But Leonardo wanted to find answers to his questions – how does the eye see? How do birds fly?

How are storms generated? How are mountains formed? To test his observations and theories, he constructed mechanical models, using levers and screws to replicate mechanical flight, or submersible ships in imitation of fish.

The restless quest for knowledge set Leonardo apart in a time when knowledge seemed to promise untold power. Never again in the history of European civilization, would man have such a belief in the absolute power of knowledge, and confidence in the possibility of exerting control over the natural world – that "man was the measure of all things".

THE WAY LEONARDO PAINTED

1 It is not possible to say exactly how Leonardo painted his works; however, a possible sequence can be worked out. First a panel would have been covered with a layer of gesso.

2 It seems that Leonardo may have first roughed in the figures on the panel.

3 The major forms may have been modelled in a brownish tone, defining shadows and highlights.

4 Leonardo used his fingers and palms as well as a brush, particularly for the under-modelling. This was not an unusual practice at the time.

5 Intricate details were then put in with great precision and delicacy using fine minever brushes, similar to modern-day sable brushes.

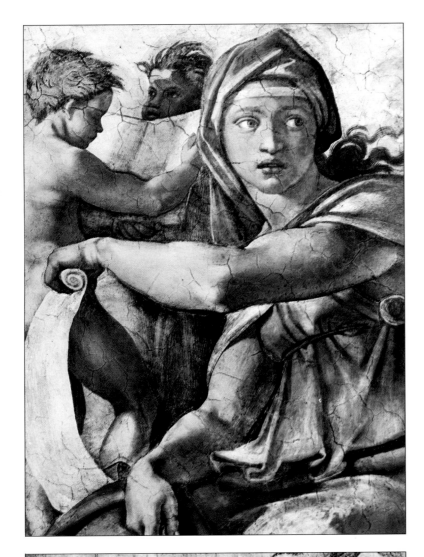

MICHELANGELO

Similarly, the reputation of Michelangelo Buonarroti (1475–1564), who displayed great learning and literary prowess in his sonnets, gave sculpture a new status. Despite this, the great manual strength required, and its association with stone masonry and craft guilds, placed sculpture, unlike painting, outside the accepted attainments of a gentleman.

Michelangelo was remarkable for his enormous achievements in sculpture, architecture and painting. Where many of Leonardo's ambitious projects were never realized, or failed (like the new paint-medium he devised for the wall-painting of

ABOVE *In the figures for the ceiling of the Sistine Chapel (right), Michelangelo displayed the full range of his virtuosity, as in the exaggerated* contrapposto *(twisting of the body for expressive effect) in the Delphic Sibyl of 1511 (top left). The Sibyl's head and eyes turn away from the movement of her arms, and her Herculean musculature and face are derived from classical sculpture. In Study of the Torso of Adam (bottom left) Michelangelo displays his knowledge of human anatomy. But he does not let his expertise in anatomy override his art: in the final painting the musculature is simplified so as not to detract from the highly charged emotional moment depicted.*

the *Last Supper* which began to decay almost immediately), Michelangelo went from strength to strength in rendering his prime subject – the human figure. His enormous output encompasses the figure as an instrument of expression – whether of strength, joy or grief – illustrated by the figures carved for the tomb of Pope Julius II. An integral part of this exploration of the expressive potential of sculpture was Michelangelo's development of the technique of carving in marble. His skills were recognized early, and his monumental and dignified works conferred prestige on their sites, from his early *David*, intended to enoble the city of Florence standing in the open in front of the city hall, onward.

Michelangelo was called to Rome by Pope Julius II, who realized that this artist's works could increase the actual power and significance of the papacy. It was in Rome that he executed his master works: the unprecedentedly demanding projects for painting the Sistine Chapel ceiling – which he completed in only four years, 1508–12 – and, after an interval of 22 years, the end wall with the *Last Judgement* (1534–41). Only someone with Michelangelo's energy and confidence, and his fluency with grand gestures in the demanding fresco medium, could have taken on such projects, and even he had to be cajoled, almost forced, into embarking on such a task.

Each figure is posed differently, according to their significance in the grand design, which treats Old Testament themes. But, whatever their role, each figure, whether old or young, is represented as an ideal archetype. Even the ancient crone has the muscularity of an athlete, and Adam reclines like a Greek god. In this, Michelangelo had absorbed the essential idea of Greek statuary: that perfection of outward form mirrors inward perfection; a perfect body indicates a perfect soul. In the belief that the body spoke for the spirit, they created supra-humans, leaving the faces unperturbed. But Michelangelo diverged from

classical Greek practice when he increased the potency of his figures by giving them expressive gestures, and facial expressions, when *in extremis* facing death, or struggling against impossible odds.

MANNERISM

The gestural style of Michelangelo was copied by other artists with increasing exaggeration, but without his authority or poise. These were often works of empty rhetoric, which did not live up to the standards of the master. The sculptural work of Vasari (whose contemporary biographies of the great Renaissance artists are constructed to "peak" with Michelangelo) is typical of the somewhat decadent and self-conscious display of virtuosity of the period. But amongst so many others, Vasari needed to find a style that would use the great man's devices in order to appear "modern". This is characteristic of the period which followed the High Renaissance, known as "Mannerism" after the Italian *maniera* ("style" or "stylishness"). Michelangelo's mature work tended towards Mannerism in the extremes of physical contortion. The twisted *contrapposto* posture became his trademark, but his work always displayed grace, poise, facility

BELOW *His fame was such that Raphael was summoned to Rome by Pope Julius I in 1508. He brought together in his polished work the qualities of Leonardo's and Michelangelo's painting, as in the orchestration of the numerous figures in the* Disputa *(1511) from the cycle of frescos in the Stanza della Segnatura in the Vatican.*

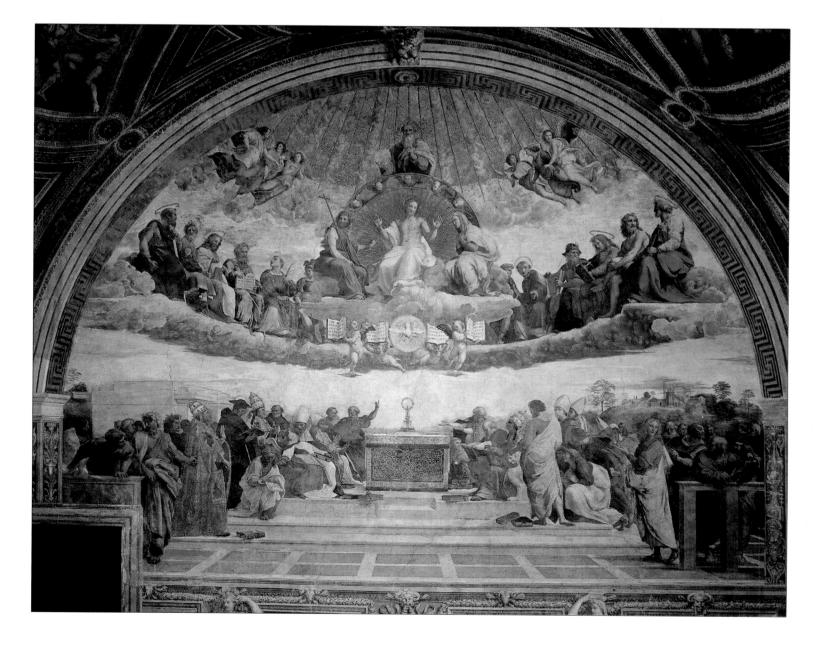

MOTHER AND CHILD

*O*bjects and images of fertility have featured in most cultures, often as icons of mother and child, but Christianity endowed the Madonna with a special kind of mystical significance.

The impassive, remote Madonna of countless icons, the immutable symbolic presence, was little changed until the artists of the Renaissance transformed Mary, mother of Jesus, into a more realistic human figure, of flesh and blood.

Although still regal in Masaccio's altar-piece, she was a direct link between divinity and humanity. Masaccio achieved this through the solidity of his figures, and by the naturalness of anatomy, gesture and expression. Leonardo, at the height of the Renaissance, endowed Mary with an expression of benevolence for humanity, manifested in part by her tenderness towards her infant son. The symbols of the Queen of Heaven have been relinquished, but Leonardo's delicate shading technique, sfumato – meaning "like a mist dissolving" – maintains her intangible otherworldliness. Since then almost all renderings of this emotive subject contain some reference to the spiritual, even in our modern times. Picasso's many versions of the subject retain a recognition of the special relationship between mother and child; in each, they form an enclosed group, cut off from the world.

ABOVE
Giotto, *Madonna and Child Entroned* (detail)

ABOVE RIGHT
Michelangelo, *Taddei Tondo*, C1505

BELOW
Mary Cassatt, *Sleepy Baby*, 1910

OPPOSITE RIGHT
Leonardo da Vinci, *The Virgin and Child with Saint John the Baptist*

RIGHT Pablo Picasso, *Woman and Child on a Beach*, C1901

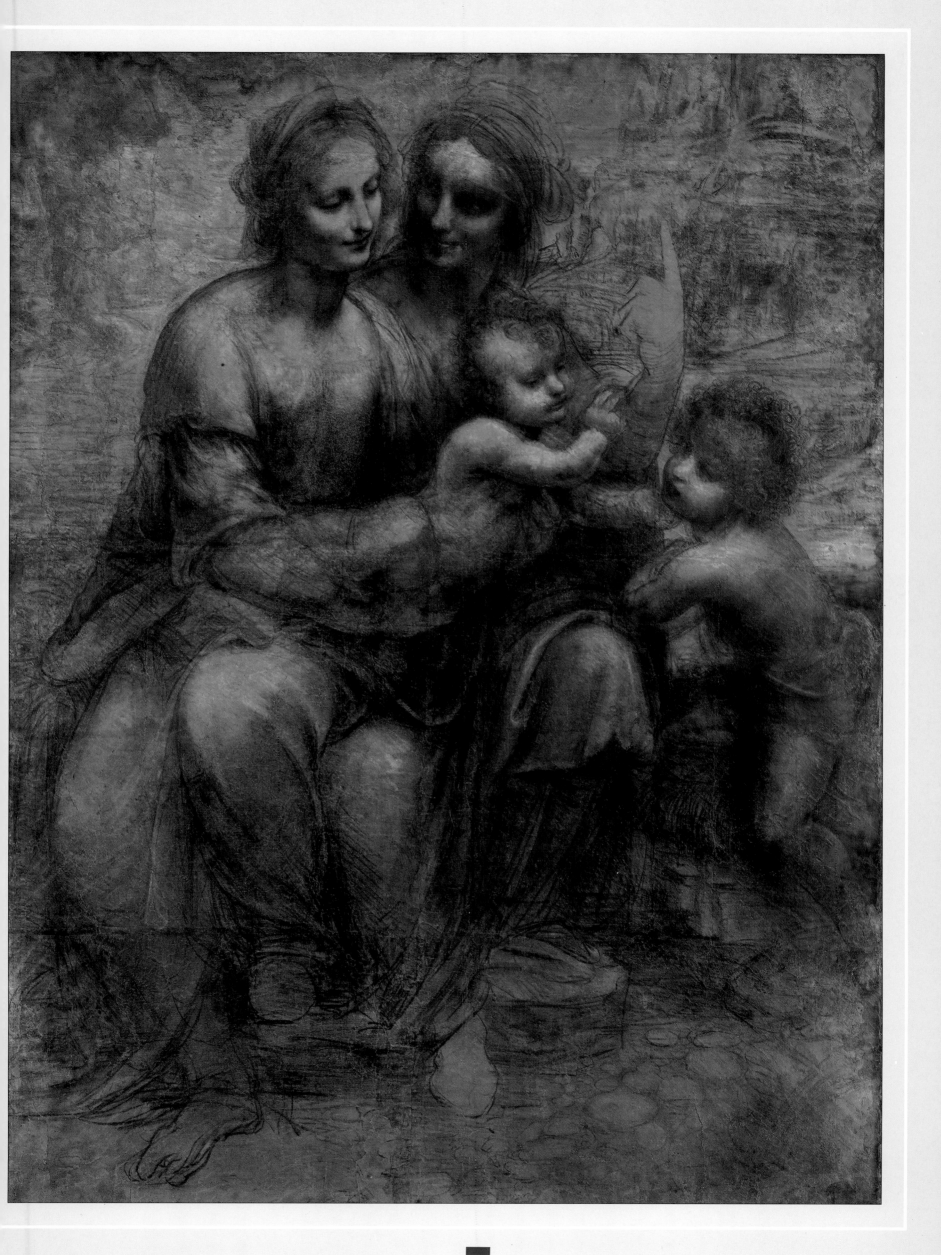

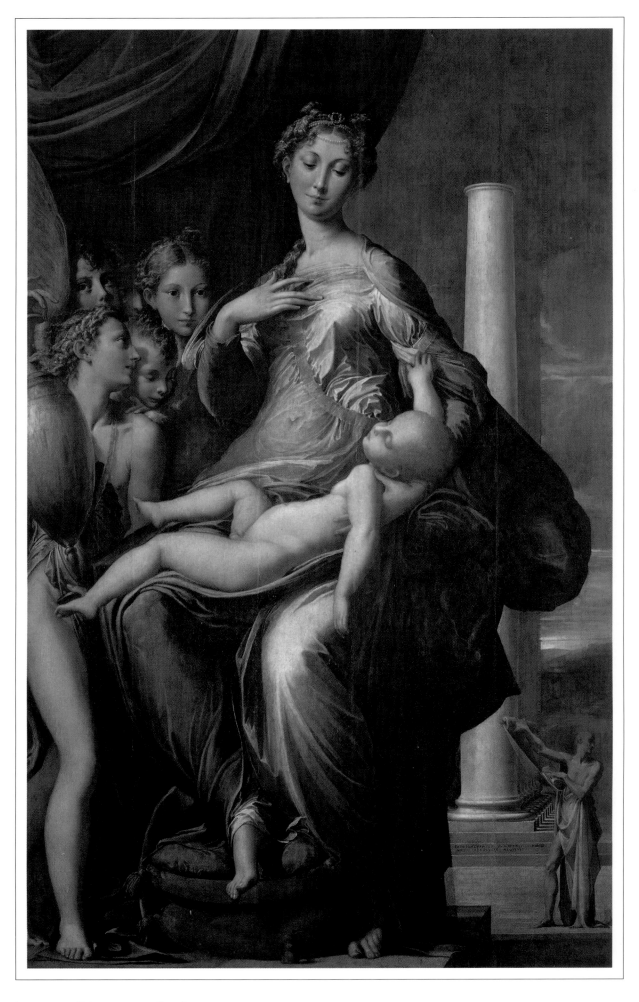

and sophistication – qualities not easily shared by lesser imitators.

Raphael (1483–1520) was rich and famous in his lifetime, and, according to his biographer Vasari, loved and admired by all those who knew him. His reputation as the greatest painter who ever lived persisted until the end of the 19th century, because of his facility in synthesizing the qualities of Leonardo and Michelangelo, and his skill as

ABOVE *Parmigianino's exaggeration of gesture and graceful disposition is apparent in* the Madonna with the Long Neck *(c1535). Typical of the generation after Raphael, Parmigianino emulated the master's virtuosity and facility in an increasingly sophisticated style. Such "Mannerism" was often superficial, drained of the real feeling that enlivened the works of the great masters – Leonardo, Michelangelo and Raphael – during the High Renaissance (c1500– 1520).*

a colourist. His figures are graceful yet lyrical, and his colour was rivalled only by Titian. His portraits combined a vivid likeness with uncanny characterization, as in his *Baldassare Castiglione.*

In company with the other great artists of the Renaissance, Michelangelo and Leonardo, Raphael was well educated, and classical learning informs his great cycle of frescos in the Stanza della Segnatura in the

Vatican. The *Disputa* disposes a large group of theologians in a composition that combines grace and grandeur. Raphael's astounding virtuosity and facility was to have an effect on the next generation of artists comparable to that of Michelangelo.

Mannerism in painting displayed exaggerated gestures and heightened emotionalism, but clothed in an exquisitely graceful and sophisticated facility. It is the superficial display of virtuosity that drains real feeling from the works of lesser Mannerists, in the period *c* 1520–1600. Pontormo (1494–1556) and Parmigianino (1503–40), for all their refined poise, display a self-consciousness that distinguishes them absolutely from the profundity of the High Renaissance, yet their works sometimes have a moving quality that points towards El Greco's extreme emotionalism.

At the other extreme, the cold clarity of Agnolo Bronzino (1503–72), is also Mannerist. The adopted son of Pontormo,

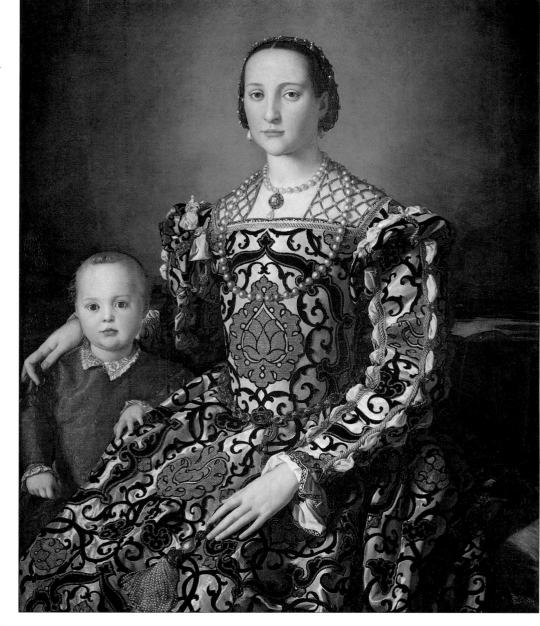

ABOVE *Agnolo Bronzino's Mannerism takes the form of a cold clarity, devoid of feeling. Eleanora of Toledo and her Son (c1550), regal and remote, is a superficial display of virtuosity that appealed to his patrons at the Medici court.*

LEFT *Only Gianlorenzo Bernini, a century after Michelangelo, would match his power of expression in figure-sculpture. Bernini's work is characteristic of the Baroque in its confidence, opulence and vitality. In David (1623), Bernini's consummate mastery of the medium charges his sculpture with dynamic energy which goes beyond Michelangelo in its emotional resonance.*

he adapted the grace and facility of his father, but in a form devoid of feeling. The resulting disdainful demeanour he gave the sitters in his Medici court portraits is exemplified in *Eleanora of Toledo and her son*. The air of superiority visible here was so much appreciated by those portrayed that it would set the tone for court portraits for the next century.

Michelangelo had set such extraordinary standards that all subsequent figure-sculptors had to measure their achievements against his example. Only one could match his power of expression: Gianlorenzo Bernini (1598–1680), in a period when the Mannerism of the 16th century drifted into Baroque. Baroque permeated all of the visual arts: architecture, sculpture, painting and décor, and is a staging for effect, an opulent scheme which is orchestrated to create a state of ecstatic feeling and well-being.

Bernini's sculpture encapsulates the qualities of Baroque: the figures in his sculptures are rendered in dynamic movement, and convey high emotional states, but they achieve their effect because of his consummate mastery of the medium. Bernini was also an architect, and therefore could fully exploit the Baroque style.

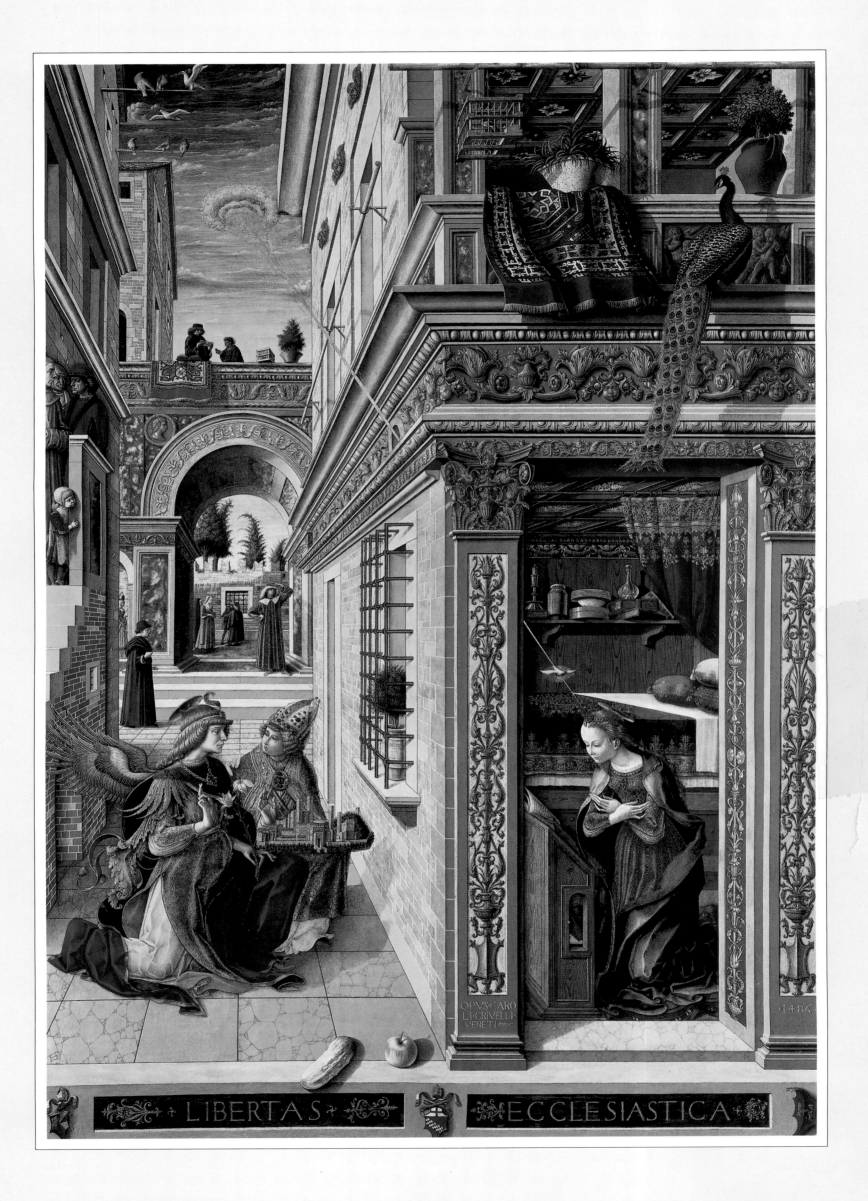

LIBERTAS · · ECCLESIASTICA

VENICE AND NORTHERN ITALY

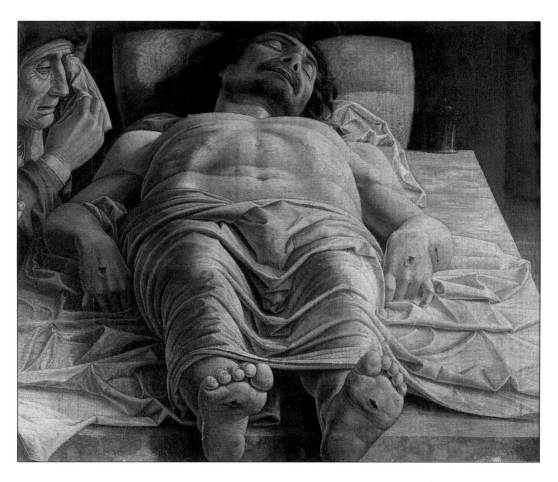

Opposite *Carlo Crivelli was inspired by Mantegna's linear emphasis and his* Annunciation *(1486) also employed Mantegna's dramatic exploitation of perspective. The richly detailed scene epitomizes the Venetian love of luxury, the Oriental and the exotic.*

Where Florentine values called for restraint and decorum, in Venice a love of grand gestures and luxurious display were reflected in the art and architecture. Extravagant public processions were funded by the civic leaders, and elaborately decorated palaces and church commissions formed part of the public display of wealth. Maritime power and trade had made Venice rich over the centuries, and it was impossible to foresee in the 15th century the decline that would overtake Venice's fortunes during the next 200 years.

In Florence there was a careful, hardworking spirit, and even the rich wore only black: public and private life were dominated by an intellectual asceticism. In Venice, the rich wore glorious costumes of gold and velvet brocade, embellished with silks and furs from the Orient. The sumptuous garb expresses the spirit of Venice, where life was lived to the full, unstintingly.

MANTEGNA AND BELLINI

This style of luxurious enjoyment is apparent in the works of the High Renaissance in Venice, especially in Titian's portraits and allegories. But the story begins with the more austere works of Mantegna and Bellini.

Andrea Mantegna (1431–1506) worked in Mantua for the Gonzaga family, bringing to his work an incisive style that is reminiscent of statuary. Inspired by humanist learning, he increasingly emulated Roman reliefs, and his paintings in *trompe-l'œil* monochrome look, at first sight, as though they had been carved out of ancient marble. Like Piero della Francesa, also of northern Italian origin, he combined statuesque figures with a flawless application of perspective; but where Piero achieves a limpid serenity, Mantegna's dramatic compositions fill his paintings with a steely energy.

Calvary (or *Crucifixion*) demonstrates Mantegna's skills in perspective, as well as his unwavering attention to detail, whether in the geology of rock formations, or in the armour of the Roman centurion. The whole scene is lit with lucid clarity, and shows a warm tonality of colouring, perhaps influenced by his Venetian brother-in-law Giovanni Bellini.

Giovanni Bellini (*c* 1430–1516) was correspondingly influenced by Mantegna, as

Above *Andrea Mantegna's* The Dead Christ *(c1480) demonstrates the artist's exceptional mastery of foreshortening. This depiction of the body of Christ is a* tour de force: *such a viewpoint could easily result in a bizarre and indecorous effect (as in Uccello's depiction of the dead soldier in* Rout of San Romano*) but Mantegna retains Christ's dignity and presence in a work recalling the monumentality of Roman sculpture that he studied so avidly. The effect is achieved by the volumetric, sharply delineated style, which has the appearance of crisply chiselled marble.*

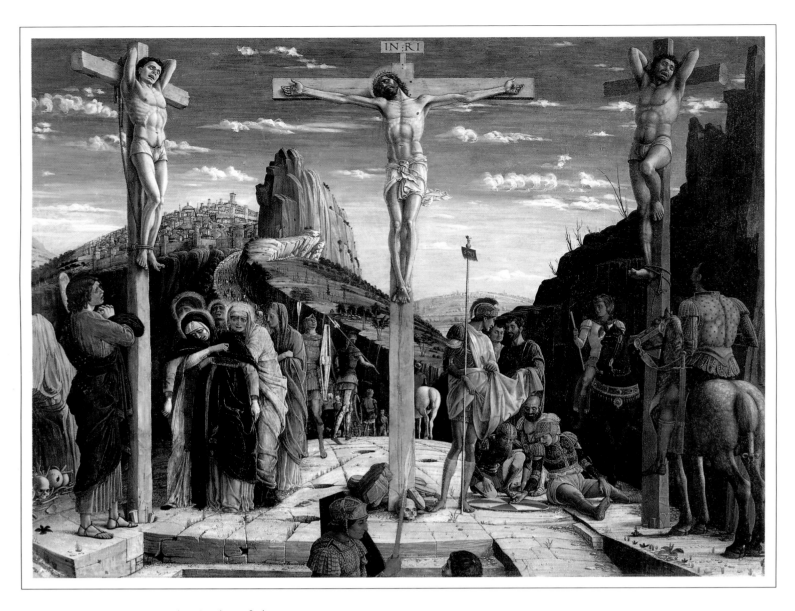

can be seen in his *Agony in the Garden* of 1459. Mantegna also painted this subject in his precise and analytical style, but Bellini introduces a lyrical feeling and rosy colouring. Bellini was one of the first to master the new technique of oil-painting, and developed the potential of this medium for subtle transitions and poetic colouring. He was the seminal figure of the Venetian School. Giorgione and Titian were his pupils, and he gave them a love of rich colouring, and an inventive attitude to subject and composition.

Mantegna's linear style was also an inspiratioin to a younger Venetian artist, Carlo Crivelli (active 1457–1493). Although lacking Mantegna's genius, Crivelli's work has an elaborate, painstakingly detailed appearance and is distinctive in his application of Mantegna's use of perspective, particularly in the *Annunciation*.

At first sight, it is not the biblical event that strikes the viewer, but the minutely rendered detail of the house and its furnishings. Crivelli often incorporated gesso into the paint to increase ornamental effects, and material richness of texture.

As depicted by Crivelli, Mary, far from humble, learns her fate in a setting of gaudy wealth. The peacock steals the scene, along with the Persian carpet, reminding us of the Venetian love of luxury and their trading connections with Asia, which infused

ABOVE *Andrea Mantegna's* Calvary *(c1450) is executed in an incisive, linear style of absolute clarity. The figures have the volume and weight of statuary, and a monumental quality that belies the small scale of this panel. Mantegna's dramatic view-point and command of perspective invest the work with compelling energy and immediacy.*

BELOW *Giovanni Bellini's* Christ Blessing *(c1460) conveys his mastery over this type of religious subject, in its blend of a devotional image with naturalistic attributes.*

Venetian culture with an exotic flavour. The dizzying perspective gives the richly worked surface a brittle animation, so that the eye is eventually drawn to Mary and the angel, dwarfed as they are by the scale and magnificence of the setting. The painting is symbolic of Venetian materialism, focussed on attainable rewards on earth, rather than on the promises of heaven.

GIORGIONE

The poetic qualities of Venetian painting, first evident in the work of Giovanni Bellini, are brought to fruition in his pupil Giorgio Barbarelli (or da Castelfranco) but called Giorgione (1476/8–1510).

The Tempest is as enigmatic as Bellini's *Sacred Allegory* but here the mood is evocative of somnolent summer days. There is a heavy weight to the foliage, and lightning cracks over the distant town, counterpointing the timeless serenity of the figures. The subject of the painting is thought to be allegorical, but the lack of a clear narrative draws one's attention to the atmospheric qualities of the setting.

Giorgione's religious works also have an other-worldly air about them. There is always something oblique, something unspoken but felt, that gives them a magical quality. This is evident in *Concert Champêtre* (sometimes also attributed to Titian).

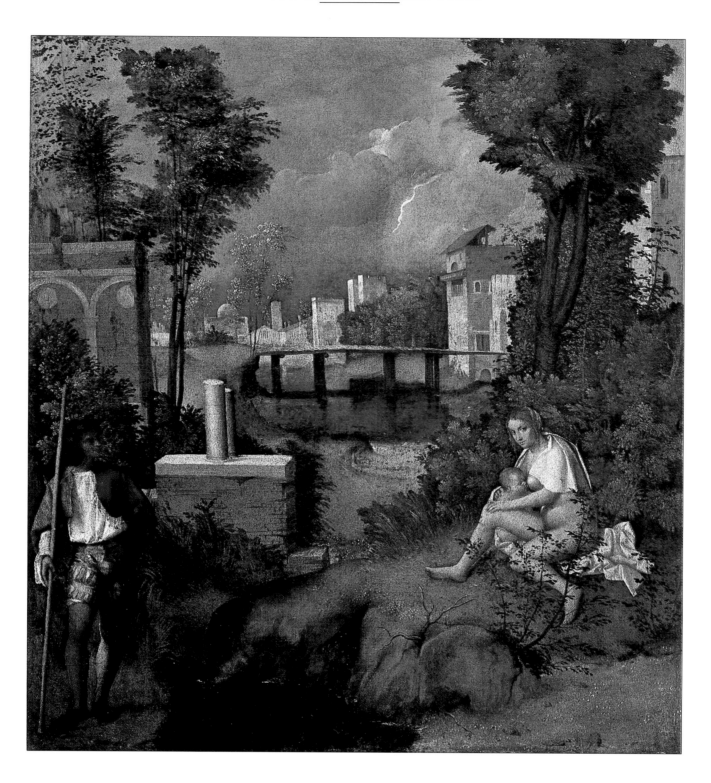

ABOVE *Giorgione was to bring Giovanni Bellini's developments in Venetian painting to fruition. The Tempest (c1505–8), above, is as enigmatic as Bellini's* Sacred Allegory, *right, but here the mood is evocative of somnolent summer days, heavy and sultry, with a distant thunderstorm.*

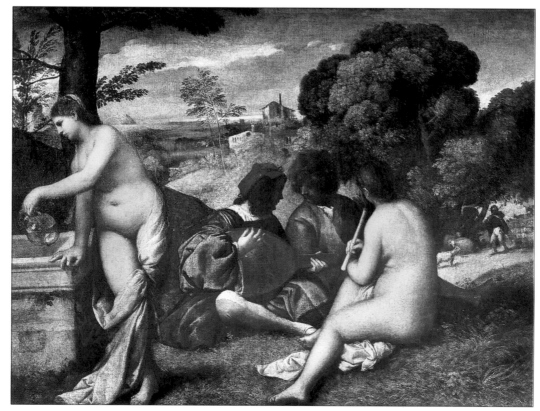

In "landscapes of mood" like Concert Champêtre *and* The Tempest, *there is a lyrical, poetical and musical feeling evoked by the atmospheric effects, derived from Leonardo's technique of subtle shadowing called* sfumato.

Giorgione was one of the earliest artists to specialize in cabinet pictures for private collectors, rather than ecclesiastical or public works, and this accounts for both the small scale, and the intimate character of his works.

In the *Concert Champêtre* (*c* 1510), the figures are foregrounded, but the subject is no more clear than in the *Tempest*. For his contemporaries, and for us, his paintings hold their secrets. The juxtaposition of female nudes with male figures in contemporary clothing was innovative, if not shocking, and has provoked speculation about an allegory on a classical theme. So intriguing is such a departure from established conventions in painting and social discourse that the subject has been reworked by later artists, as in Poussin's *Et in Arcadia Ego* (*c* 1630 and *c* 1640), but more notoriously in Manet's *le Déjeuner sur l'Herbe* (1863), when 19th-century mores found the grouping scandalous.

Where Manet's group actively confronts the spectator's gaze, Giorgione's treatment

ABOVE *Titian inherited the evocative colour and feeling for poetic mood from his master Giovanni Bellini and from his colleague Giorgione, although his robust virtuosity in handling oil-paint was his own. In Bacchus and Ariadne (1520–23) the mythological figures have an energy and individuality of expression that complements the bold and vibrant reds and blues.*

is quite passive: the group turns inwards, seemingly oblivious of the spectator. Their gestures and expressions are calm and graceful, detached from the world. The painting's romantic feeling is redolent of poetry, but also of music – a combination of associations that gives the work its lyrical ambience. It is a witness to a timeless episode, where atmosphere is the real subject, and where the figures animate the scene.

The atmospheric effect that was first realized by Giorgione, and which was the source of his fame during his lifetime, ranking him with Leonardo, also makes him particularly popular in our own time, where the elusive, dream-like charm strikes a nostalgic chord in modern, urbanized viewers.

Much of the mood is conveyed through Giorgione's use of Leonardo's *sfumato* technique, a subtle blending of tones that dispenses with clear outlines in favour of more enigmatic shadows.

TITIAN

Despite the similarity of style that has confused attribution of some works, the mature work of Titian is unmistakable. His direct sensuality separates him clearly from the idyllic remoteness of Giorgione's paintings. Titian (Tiziano Vecellio, *c* 1485–1576) is noted for his masterly colour sense and virtuosity in handling oil-paint. His free and expressive brushwork is most evident in the later works, as was noted by his contemporary Vasari, who remarked on his "bold, sweeping strokes". The consummate abilities were evident from the first, and can be recognized in the mythological works of 1520–23 for Alfonso d'Este, of which *Bacchus and Ariadne* is the finest.

Titian's ambitious composition sets the group in a landscape reminiscent of Giorgione (Titian called this type of work *poesie*) but his figures have a corporeality and energy that almost bursts from the frame. The brushwork captures fleeting expressions ranging from the playful charm of the infant satyr with his puppy to the tortured features of Laocoön – a reference

TITIAN AND CANVAS

Titian used a variety of different weights and weaves of canvas during his career, but in his later works he favoured a fairly rough, course-grained surface, which gave him an opportunity to exploit the texture to create broken-colour effects.

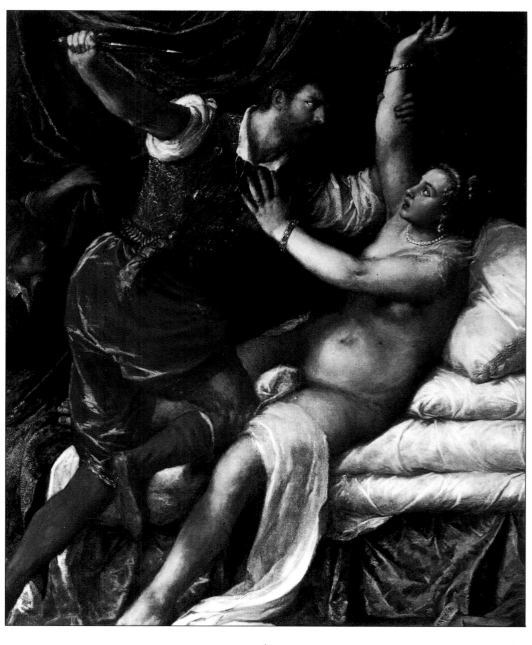

ABOVE AND BELOW Tarquin and Lucretia. One of Titian's later paintings in which he abandoned the traditional smooth, white gesso ground, and used instead an oil ground into which he mixed a reddish pigment. As a result the weave of the canvas is apparent, and the light areas stand out from the shadows.

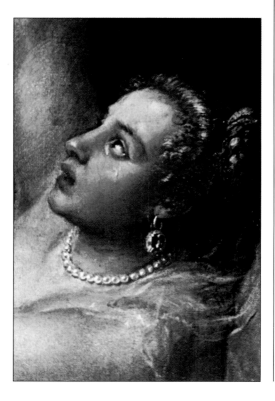

to the recently rediscovered sculpture of the late Greek style, which opened up the possibilities for rendering contorted figures at the limits of physical exertion and pointed the way to Mannerist exaggeration. Titian's use of colour was bold and innovative. Strong blues and reds contrast vibrantly in his earlier work, while later paintings show subtle use of related colours.

Titian's mastery of all fields of paintings brought him early fame and wealth. He succeeded Giovanni Bellini as official painter to the Venetian republic in 1516, Giorgione having died young of the plague in 1510. Later, he was court painter to the emperor, Charles V, and to his son, Philip II of Spain.

In the field of religious subjects, *The Entombment* demonstrates Titian's ability to convey intense feeling. The body of Christ hangs heavy and immobile, white against the strong limbs of those who carry him, their life and vitality counterpointing his lifelessness. Titian has given grandeur and monumentality to the scene, eliciting a response in the viewer. Even in such a sombre subject, Titian's vibrant brushwork and handling of light and shade where the darkness threatening to envelope the scene is effortlessly symbolic, makes this one of the most compelling pictures of the period.

RIGHT Pope Paul III and
his Grandsons *(1546) are
tellingly characterized: the
cunning old man and his
scheming grandsons
merging into a pool of
shadow, the counterpart of
their web of intrigue.
Titian's rendering of the
old man's frailty, his thin
body weighed down by the
heavy robes of rose velvet
and ermine, is tempered by
the indications of enormous
power and control in the
bright suspicious eyes of the
Pope and his fist clenched
over the chair-arm.*

BELOW *Titian's
command of the expressive
potential of oil-paint is
manifest in* The
Entombment *(c1525–
32) in his vibrant
brushwork and handling of
chiaroscuro (contrasting
light and shade), where
darkness shrouds the scene,
drawing the spectator in to
share the burden of those
who bear the heavy and
immobile Christ.*

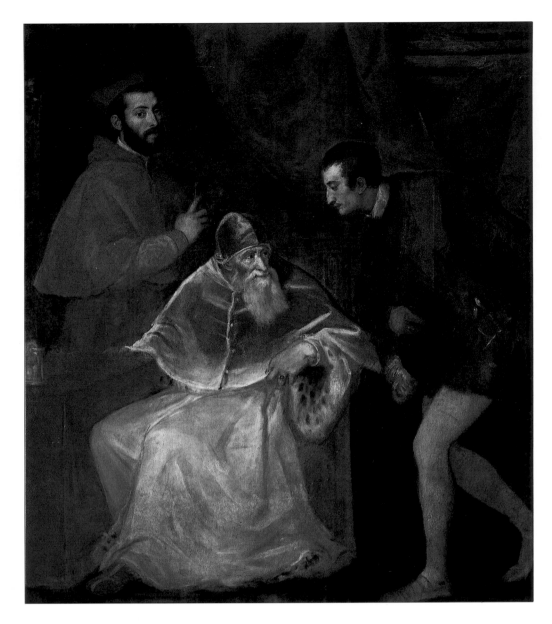

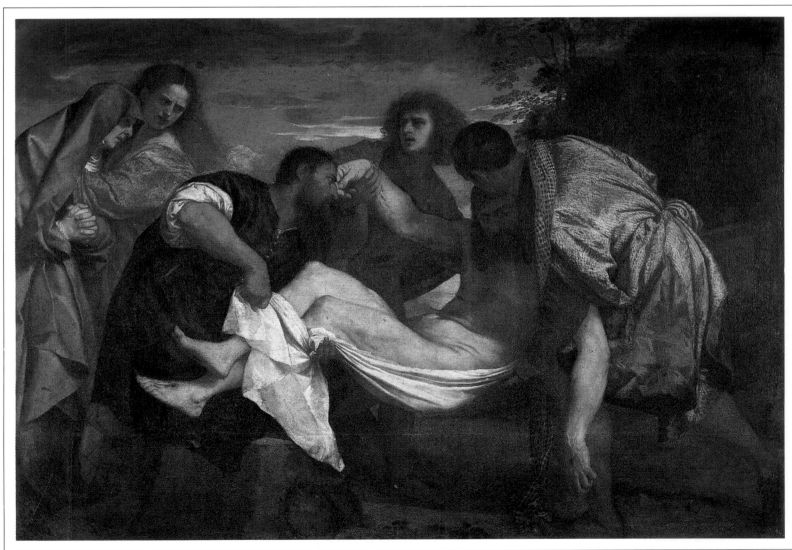

TITIAN'S STYLES

A comparison of this detail from the *Pesaro Altarpiece* (begun in 1519) with the one below shows the difference in style and treatment between Titian's early and late works.

By 1553, when the *Danaë* was begun, the brushwork had become looser, freer and more expressive.

In the foreground foliage of *Death of Actaeon* form is suggested by directional strokes of a paint-laden brush.

Titian lived to a great age, and painted many portraits of astonishing vivacity. The sitters are tellingly characterized, and their garments boldly brushed in with rich colour in an arresting manner that is the counterpart of their personality. The exuberant yet worldly Pietro Aretino, a close friend of Titian, stares out with a forthright gaze.

TINTORETTO

Tintoretto (Jacopo Robusti, 1518–94) was, with Veronese, one of the most successful Venetian painters in the generation after Titian. He may have been Titian's pupil, but his mature style is characteristic of Mannerism with its dynamic perspectives, dramatic lighting, and extreme foreshortening. Titian's worldly spirit gives way to an emotive style, whose energy resides in the exaggerated perspective of the architecture, the incandescent lighting, and the violent gestures that can be seen in *The Finding of St Mark's Remains*.

Although Tintoretto's style was his own, he did acknowledge his heroes in the inscription on the studio wall: "the drawing of Michelangelo and the colour of Titian". Yet his drawing was more dashing and economical than Michelangelo's, and his colour more sombre than Titian's. Tintoretto's dramas were carefully planned, using waxwork models arranged on a stage, and he experimented with strong lighting effects to carry the compositions. When observed closely, Tintoretto's bravura handling and rough brushwork contribute to the heightening of drama and tension.

BELOW Susanna Bathing *(c1560).* *Tintoretto's mature style is characteristic of Mannerism. His sense of theatre often led him to work out a composition with wax figures in a model stage.*

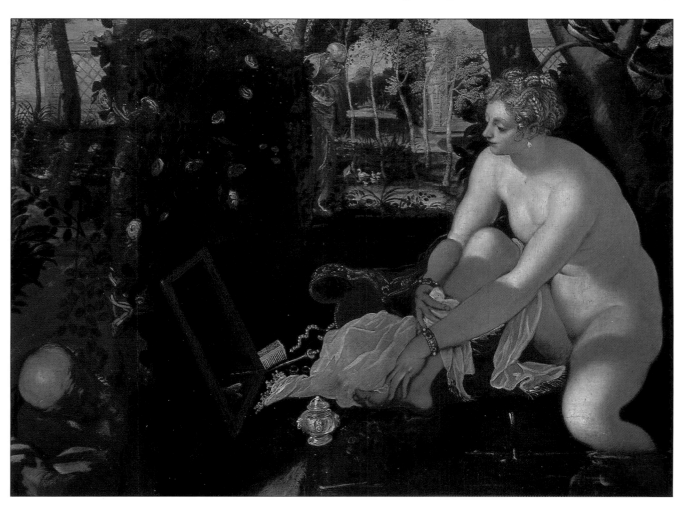

EL GRECO

The spiritual energy and intensity of his work was extended by El Greco (Domenikos Theotokopoulos, 1541–1614), a Cretan who travelled to Venice in 1566. Tintoretto's restless surfaces were invested with a more visionary quality in El Greco's works, and the plunging perspectives are replaced by compositions that defy temporal space or time.

Christ Driving the Traders from the Temple confronts the spectator with the figure of Christ bursting forward from the picture-plane, propelled by the dynamic diagonals of the composition, and its compressed space. Movement is inherent in the dynamics of composition and supernatural lighting, and accentuated by the elongated limbs of the figures and their ecstatic expressions.

El Greco moved on to Toledo, where he lived the rest of his life, and his increasing use of flame-like figures, with waxen skin, painted in cold, bluish colours convey the mystic rapture and awesome, truly terrifying spirit of Spain and its religious fervour at this time. It would be another 200 years before Goya exposed the underlying nightmare in Spanish mysticism. With the rise of Expressionism in the 20th century, interest in El Greco's style has increased, responding to his intensely personal vision and gestural brushwork.

EL GRECO'S EQUIPMENT

El Greco is known to have used both a coarse hog's hair brush and an early kind of palette knife. Hog's hair brushes were first popularized in Venice because it was unsatisfactory to use softer brushes on the coarse canvas which was a common painting support in that area. The knife would have had a flexible wooden blade and a wooden handle.

Venetian architectural background influenced by Italian Renaissance stage design.

Small clay models probably used to work out the design, perhaps suspended from pieces of string.

Lead tin yellow.

Lead white mixed with red lake overlayed with red glaze.

Warm brownish ground.

LEFT AND BELOW *El Greco developed the spiritual energy and intensity of Tintoretto's work. Christ Driving the Traders from the Temple (c1600) seems to explode outward at the spectator. Religious fervour is conveyed by the ecstatic expressions, the elongation of forms and the waxen pallor of the participants in El Greco's handling of the subject.*

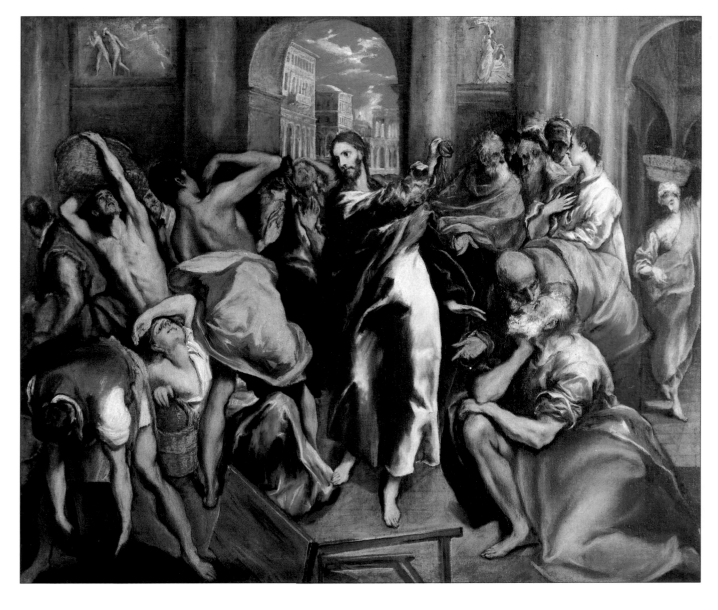

CARAVAGGIO

After the empty virtuosity of much 16th-century Mannerist painting, the Carracci and Caravaggio revived Italian painting by introducing a new strength and immediacy which had been lost since the High Renaissance. Caravaggio (1571–1610) came from the town of that name, near Bergamo, and studied under a pupil of Titian; his mature work was painted in Rome. His astounding advances in composition and his combination of dramatic action and arresting lighting brought him fame and notoriety at once. While his ability was breathtaking, contemporary spectators were sometimes appalled and affronted by his renditions of biblical stories.

St Matthew and the Angel was only one of the paintings that were rejected by the Church because of lack of decorum or appropriateness. Caravaggio's startling effects of light and drama were intensified by his allegiance to veracity. His saints looked like real men, battered by life and labour. St Peter in *The Supper at Emmaus* was too reminiscent of actual fishermen for the tastes of the ecclesiastical patrons. In this painting Caravaggio's amazing pictorial vision can be seen: Christ confronts us, and his disciples, in one moving instant. Caravaggio ignored tradition and convention and presented religious subjects in compositions of extraordinary force and economy as can be seen in *The Conversion of St Paul*.

Here, too, Caravaggio's invention in the power of *chiaroscuro* can be seen. Literally, "bright-dark", this term describes the sudden transitions from light to dark, which highlight dramatic aspects of each composition, plunging the rest into gloom. Caravaggio's *chiaroscuro* is distinguished from the pioneering work of Leonardo, who had evolved the technique of *sfumato*, a more subtle blending of tones which gave mystery as well as volume to his figures.

TIEPOLO

Caravaggio's influence was immediately felt and continued to inspire the greatest artists of the 17th century – Rembrandt, Rubens and Velázquez – in the dramatic power of composition and the use of *chiaroscuro*. However, it was Tiepolo, in the 18th century who gave the Venetian style its last flourish. Giovanni-Battista Tiepolo (1696–1770), brought the monumental fresco tradition which began with Giotto, to an end, rounding off the history of Italian decorative painting on a grand scale. His fresco cycles draw on a wide knowledge of painting, and display masterly technical accomplishment.

He could make the most ponderous or unpromising subjects come to life, endow-

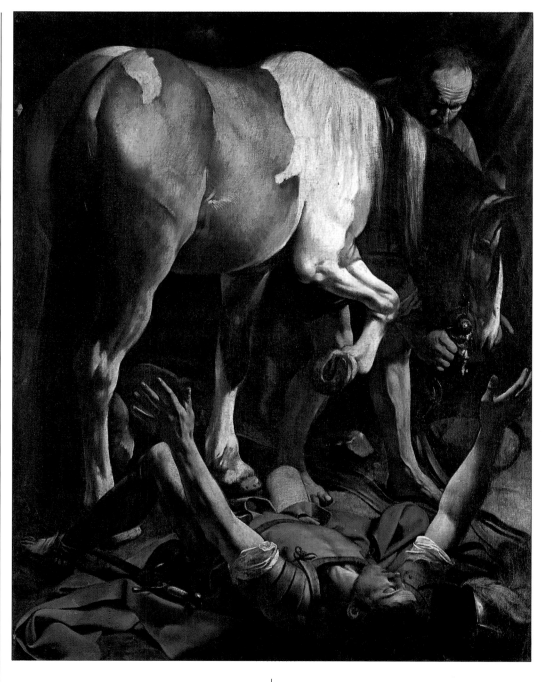

ABOVE *Caravaggio's freshness and immediacy of vision, dramatic action and arresting effects of light brought him fame but also notoriety. The Conversion of St Paul (1600–1) illustrates his totally unconventional compositions, which have a truly revelatory force.*

ing them with grandeur mingled with humanity. In *The Banquet of Antony and Cleopatra*, the scale and monumentality of his work is evident, as is the clear light and glowing, brilliant colours that, complemented by fluency of brushwork, animate his paintings. Tiepolo demonstrates a confidence that is characteristically Baroque.

RIGHT *Giovanni-Battista Tiepolo, over a century later, brought the great Italian fresco tradition to its climax. In* The Banquet of Antony and Cleopatra *(c1750), Tiepolo's grandeur of conception and the humanity with which he handles the characters in the scene, are typical of the Baroque.*

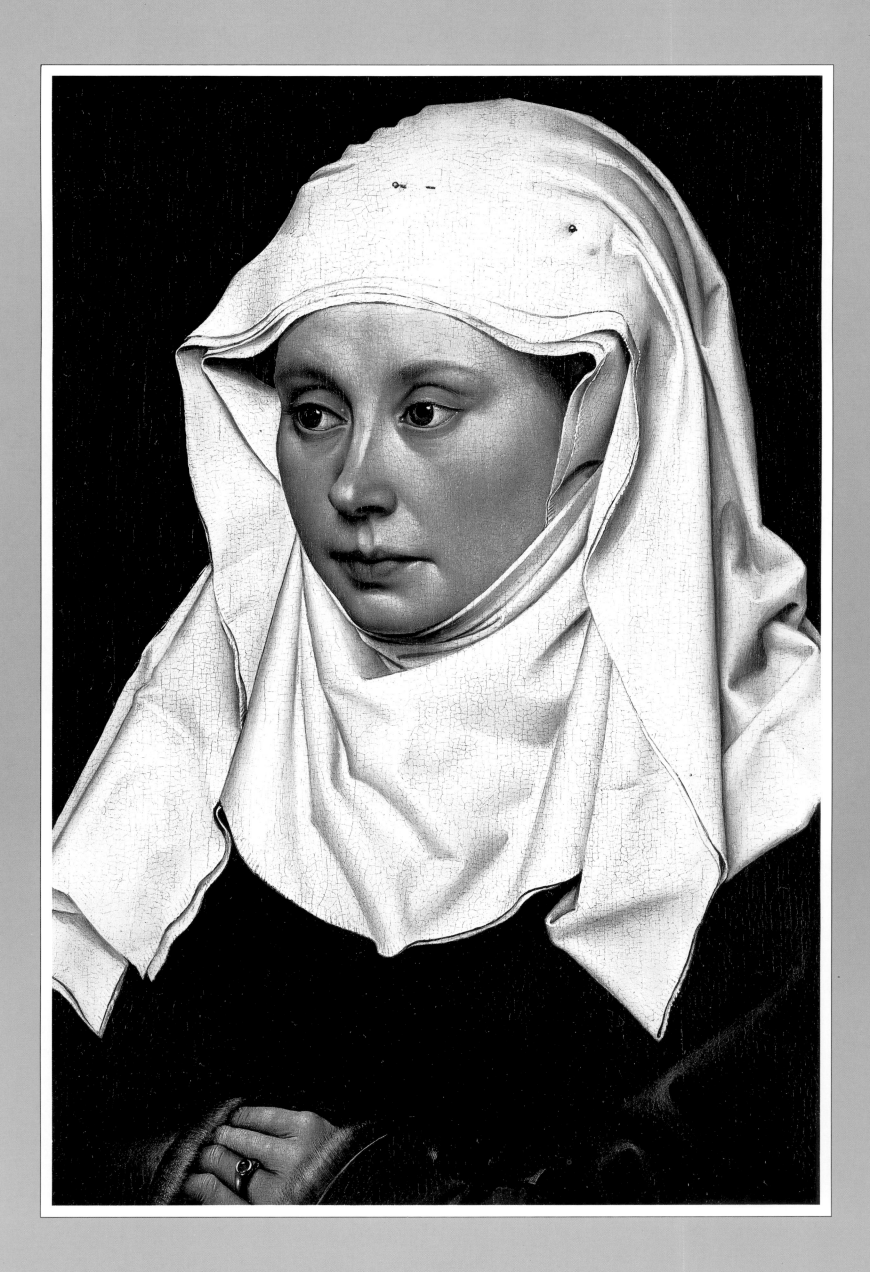

THE RENAISSANCE IN NORTHERN EUROPE

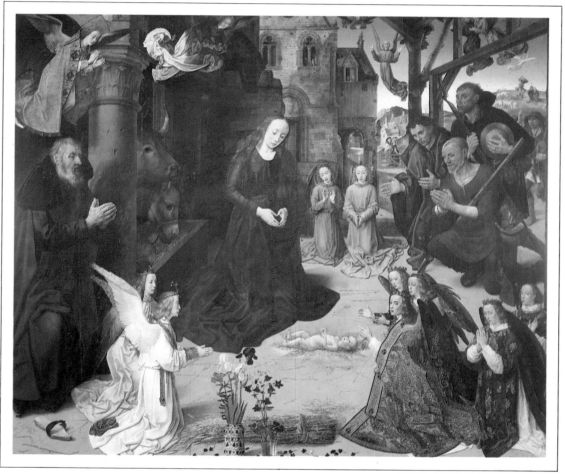

Renaissance ideas spread just as unevenly outside Italy as they had in Italy. Each country assimilated the particular aspects that fell in with their indigenous style and culture.

Well before 1500, the time of the final flourish of the High Renaissance, Italian influences were felt in Germany and The Netherlands. Busy trade and travel between Flanders and Italy had already made the work of Jan van Eyck (d. 1441) and Hugo van der Goes known in Italy, where their expertise in the new medium of oil-paint was admired and the medium was soon widely adopted. In particular, two aspects were noted: the intense attention to detail allied to a close observation of nature, previously seen in Gothic art, and the technical means to achieve such detail, and to simulate richly coloured and textured surfaces in oil-painting.

Just as the characteristics of Gothic had grown from small, jewel-like manuscript illuminations, so northern European panel painting was executed on a small scale, packed with incident. The works of Jan van Eyck mark a new standard of skill in handling oil-paint, whether in conveying the shimmer of light on gold brocade, or the delicate recession of a landscape.

The flow of influence was not one-way, however. Essential to this astonishing realism was an understanding of pictorial space, derived, in turn, from Florentine art. Van Eyck made use of linear perspective and adopted ideas of proportion and effects of the play of light in a coherent manner so as to give his figures a virtual space to occupy in the picture space. These innovations are today taken for granted, but at the time they were a revelation and inspiration to the new art. Without these pictorial devices

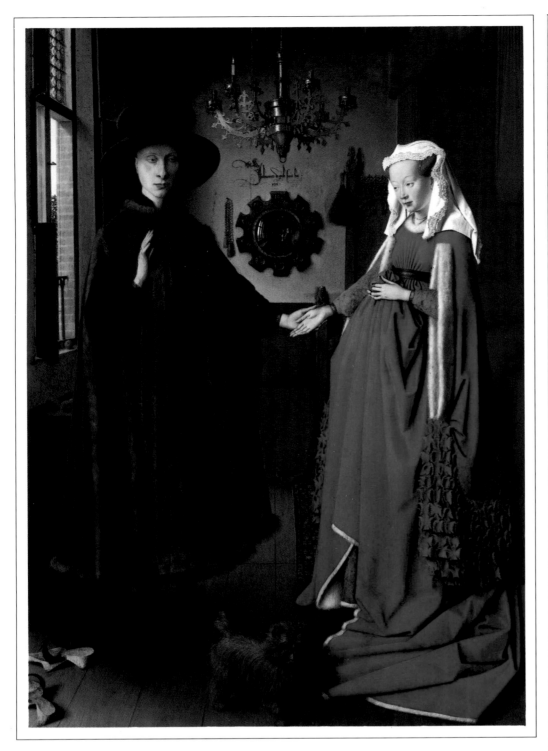

1 The painting was executed on a panel made of two pieces of oak with the grain running vertically. Oak has a close grain.

2 The animal skin glue and chalk ground was applied in a uniform layer, and polished smooth. It totally obscures the wood grain.

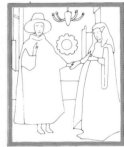

3 Van Eyck next began the underdrawing which was very detailed. It was painted on in an aqueous medium with a fine brush.

4 Van Eyck next made the ground non-absorbent by applying a film of drying oil.

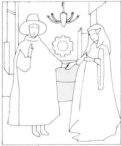
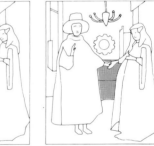

5 Van Eyck's technique can be described in general terms. In the lower layers of the painting the colour areas were blocked in. The pigment was mixed with a limited amount of opaque white.

6 A middle tone was achieved in a second layer, which used less white and proportionately coloured pigment.

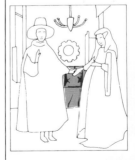

7 The final description of form and volume was created in the upper layers using transparent pigments which, by their varying thicknesses, enhanced the modelling.

8 The back of the panel was covered by a thick white layer containing vegetable fibres which was covered by a thin, black painted layer. This helps prevent the panel from warping. It is not known if this layer is original.

and technique, images look flat and unsubstantive, as can be seen in the Limbourg Brothers' *Book of Hours* plates, which for all their decorative beauty and precisely recorded observations do not appear convincingly realistic.

The Renaissance has given us a new pictorial language, and in turn a new perception attuned to looking through "a window on the world". Renaissance values revered mathematics and order, which dictated a way of seeing that made objects in paintings and the space they occupied seem tangible.

In van Eyck's *Arnolfini Marriage* the illusion of space is breathtakingly realized, as though one could walk into the room and pick up the fruit, or hear the floorboards creak.

This optical illusion, based on scientific and mathematical principles, and an increased awareness of the physical world, is reflected in a parallel materialistic outlook concerned with ownership of goods, and accumulation of wealth by the mercantile classes of Flanders and Italy.

It was these classes who commissioned and owned paintings as symbols of their status in the emergent capitalist societies. The abundance of increasing material wealth was expressed in still-life paintings and those of domestic interiors – climaxing in 17th-century Holland. Their seductive realism can be contrasted with the unreality of Gothic or Byzantine works, where the image was a devotional object itself, rather than a "window" into a private room. In those works the painting was not only the repository of spiritual values, but was a valuable object in terms of the gold and expensive pigments used. When such expensive materials were no longer used the value of the painting rested in the skill of the artist and the subject depicted. The contract, or dialogue, between the painting and the viewer could now be a private one,

OPPOSITE *The Arnolfini Marriage (1434) shows Jan van Eyck's understanding of Florentine ideas about perspective and consistent lighting to create a convincing pictorial space – not only for the figures to stand in, but to draw the viewer in, as if standing next to the artist at work, whose presence is indicated in the convex mirror on the rear wall. The fruit and the lapdog are tangibly real, although their presence serves a symbolic intent.*

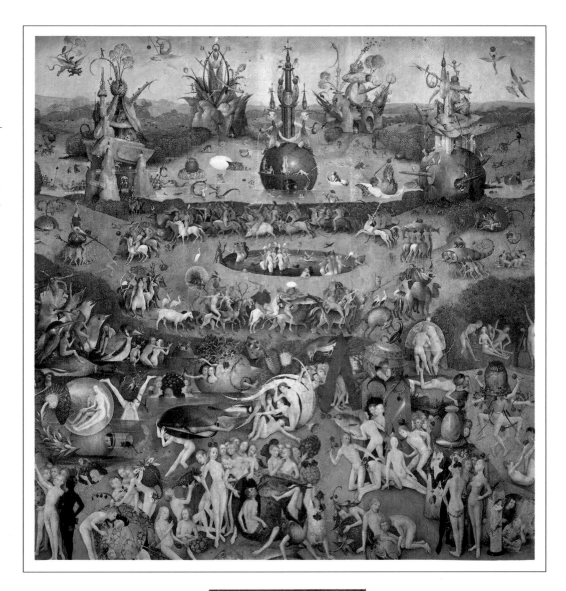

LEFT *Hieronymus Bosch's bizarre and demonic creatures of evil and wicked temptation populate dream landscapes of seductive colour. The Garden of Earthly Delights (c1505–10) is full of contradictions, repellent yet strangely compelling and beautiful.*

BELOW *Jan van Eyck's Polyptych of the Adoration of the Lamb (1432) is jewel-like in the brilliance of colours that cover each panel. Oil-paint enabled artists to use rich, saturated colours to achieve sumptuous effects, especially when combined with gold-leaf.*

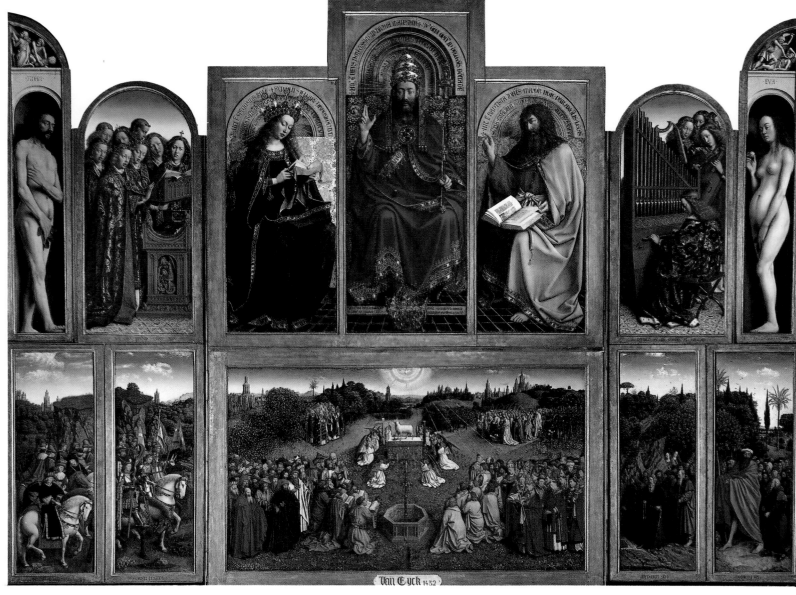

INTERIORS

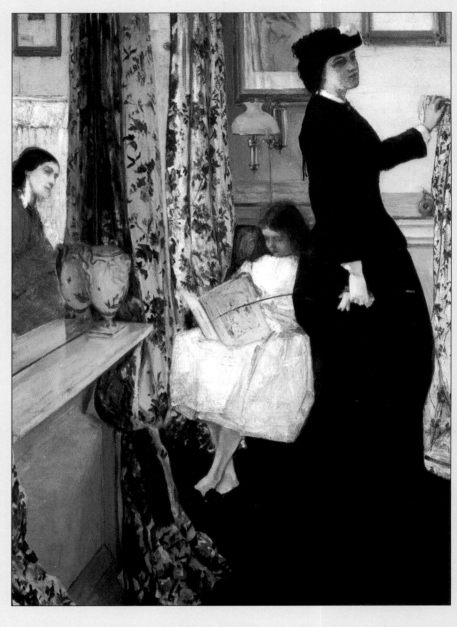

*D*epictions of interiors, of spaces, or of domestic rooms, are a relatively modern subject in Western art. Like landscapes, they first appeared as settings for important figures, and only in 17th-century Holland became suitable subjects for art in themselves.

In a Protestant-dominated culture that had turned away from the emotional excesses of religious painting, preferring to see God's spirit in all of creation, there was an opportunity to look more closely at the scenes and objects that constitute the everyday world.

Yet in the work of the most enduring artists, the mundane subject is transcended. A figure in an ordinary room becomes, in the hands of Vermeer, a poetic, resonant theme, in which cool light and clear colours convey a measured tranquility.

Two centuries later, Whistler attempted a similar parallel with music, composing works according to his ideas of harmony and tonal balance.

The late 19th century saw a revitalization of this theme in French Impressionist and Post-Impressionist works. Many of their subjects were drawn from contemporary life in and around Paris, and their interiors demonstrate a concern with the expressive possibilities of dramatic lighting as well as with the typical characters who inhabit them in each setting, whether dance studio, bar or brothel.

Caillebotte and Degas provide insights into contemporary working life. High- or low-life, commodity dealers or labourers – each scene is so informally composed that it rings true, and draws the spectator intimately into the room.

Van Gogh's interiors demonstrate his ideas about the use of colour to express mood. In contrast to the joyful hues chosen for the bedroom at Arles, he deliberately used heavily saturated colours in dissonant combinations, and employed a raking perspective to convey the alienation he associated with the Night-Café. Modern man, it seems, has no refuge from his own fears and anxieties: his life is lived as publicly as in 17th-century Holland, but is denied the cosy conviviality and stable values of past times. The freedoms of modern life have been bought at the price of isolation, as represented symbolically by the interior space of this room.

ABOVE Edgar Degas, *Cotton Exchange in New Orleans,*
1873

ABOVE Vincent van Gogh, *Night-Café,* 1888

secular and sensual, as well as one of public morality. The gaze was set outwards, in the here and now of the present, rather than inwardly focussed towards a remote and legendary past.

Robert Campin (active 1406–44) was probably the artist also called the Master of Flémalle. He is ranked, along with van Eyck, as one of the beacons of Flemish art: his *Portrait of a Woman* confirms the new values and attitudes. The sitter looks out at us, confident in her own importance within society. She is not royalty, or the Virgin Mary – she is simply being herself, and Campin has depicted her with a crisp clarity that insists on her actuality and presence.

Rogier van der Weyden (1399/1400–64) was, like Jan van Eyck, much admired in Italy. His work was characterized by a new refinement of expression, giving the figures and events depicted both force and spirituality. Where van Eyck records the objective world around him, Roger van der Weyden closes in on human emotions.

Although the style and typical subjects of van Eyck and van der Weyden were dominant in what is termed Netherlandish art until around 1500, an artist of a very different temperament appeared in this period. Called Hieronymus Bosch (*c* 1450–1516) after his native town of s'Hertogenbosch in North Brabant, his real surname was van Aken.

The fantastic and often grotesque subject-matter of his paintings is both repellent and fascinating, full of contradictions, both ugly and strangely beautiful. The works have struck a vein of sympathy, especially with the Surrealists, in the 20th century. They seem to invite psychological explanations, or to suggest a symbolic programme, but attempts to unravel Bosch's imagery remain inconclusive.

Bosch's vision was taken up and extended in the work of Pieter Bruegel the Elder (*c* 1525–69). Although sometimes characterized as a yokel, "Peasant Bruegel" was, like many of his patrons, a cultured man who mixed in diplomatic circles and travelled extensively in Italy. Like Bosch, Bruegel painted apocalyptic scenes, as in the *Triumph of Death*, in addition to more sympathetic depictions of everyday peasant life which exploit his powers of observation and attention to ironic detail. Bruegel is similar to Bosch in his "diagrammatic" use of a high viewpoint, where the figures and multitude of small events and incidents are isolated, and spread out across the painted surface. This composition enables the viewer to look down, like God, on the horrific or ludicrous scenes enacted before him.

Hunters in the Snow is one of the series of *The Months*, of which five survive today. Here, close observation of the natural world is combined with a remarkable sense of form and composition. The crisply outlined

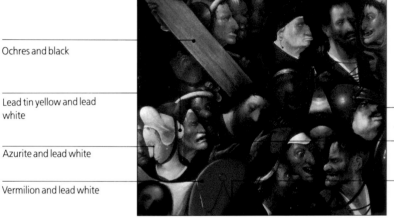

Ochres and black

Lead tin yellow and lead white

Azurite and lead white

Vermilion and lead white

Under drawing visible

Azurite and red lake with lead white

Copper resinate glaze over malachite and lead white

ABOVE *While Bosch fascinated his contemporaries with his inventions of monsters and chimeras, he was also intensely religious and the depth of his feeling is conveyed in* The Carrying of the Cross *(c1510–16).*

figures stand out sharply from the snow, and the leaden sky is reflected in the frozen lake, in a painting seemingly drained of colour by the biting cold of January.

In Germany, the most consistent attempt to emulate the spirit and the style of the Italian Renaissance can be found in the work of Albrecht Dürer (1471–1528). The majority of his works are woodcuts and engravings, a discipline where precision of line and attention to detail are paramount, emphasizing the linear qualities so characteristic of northern art.

However, Dürer had absorbed the ideas of Italian humanism, and made many studies in which his concern with perspective, proportion, harmony and the concept of ideal beauty are evident. His theoretical studies, mainly on proportion, were collected and published in four books. Together with his interest in theory, like Leonardo, he was fascinated by the natural world, and made meticulous water-colour studies for his own interest and pleasure.

RIGHT *Hunters in the Snow is one of the "Months" series painted by Pieter Bruegel the Elder in 1566. The icy January weather can almost be felt in the dull colour of the sky.*

BELOW *Albrecht Dürer displayed a curiosity about the world around him similar to Leonardo's. His watercolours show a meticulous attention to detail and* The Hare *(1502) emphasizes the linear qualities so prevalent in northern art. Here he conveys his own natural empathy with the quivering alertness of the small wild creature.*

Mathis Grünewald (c 1470–1528) was a contemporary of Dürer, but his work demonstrates an exclusive interest in religious themes, executed in an expressive manner, in contrast to Dürer's intellectual humanism and curiosity about the visual world. Grünewald's most famous painting, the *Crucifixion* from the Isenheim altar-piece, is a work of extreme emotional intensity, concentrating on Christ's physical agonies, his body distorted and torn. Christ's suffering parallels the fate of the plague-sufferers,

ABOVE The spirit of Mathis Grünewald's work is Gothic in contrast to Dürer's humanism, and this is evident in his expressive treatment of religious subjects. The Crucifixion (1515) from the Isenheim altarpiece is depicted with an unflinchingly northern realism of detail.

OPPOSITE TOP In George Grisze (1532), one of Hans Holbein's great portraits, the details of the sitter's workplace tactfully tell us about his professional success.

who would see it in the hospital of the Abbey for which it was painted. The accompanying *Resurrection* depicts Christ's triumph over suffering. In it he appears entirely whole again – a message of hope for the sick and dying.

Hans Holbein (1497/8–1543), born in Germany, spent most of his early working life in Basle, then later in England. Although he painted both religious and secular subjects, he is regarded as one of the greatest of all portraitists. His painting of *George Grisze*

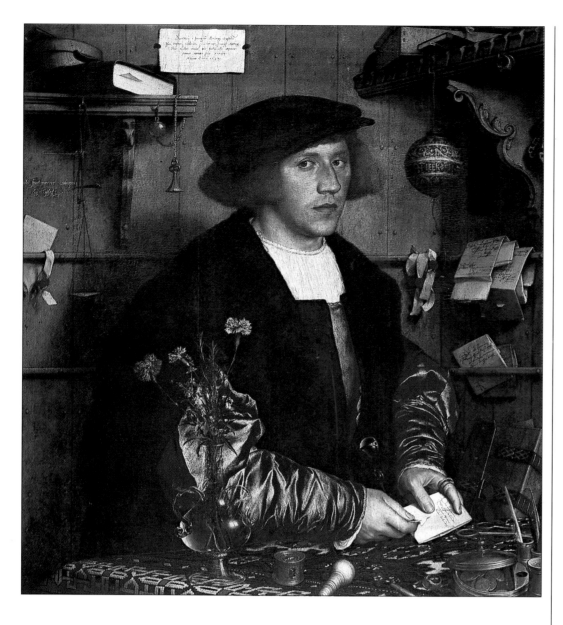

uses the device of showing the sitter in his study or with the attributes of his trade, which allowed Holbein to show his skills in detailed observation, while endowing the sitter with calm dignity.

Holbein's portraits of Henry VIII and the members of his court are noted for their subtle yet penetrating characterization. His drawings show a skill with line that is emulated by the miniaturist Nicholas Hilliard (1547–1619), whose portraits convey the individuality of each sitter. Trained as a jeweller, and appointed Goldsmith to Queen Elizabeth I, Hilliard employed a craftsman's delicate decorative touch with an exquisite sense of detail. *Young Man among Flowers* portrays the figure in a graceful pose, evocative of Shakespearean sonnets and the artificial game of love at the Elizabethan court. He sighs and looks downcast, but his manner is as much an aspect of fashion as is his refined dress.

Sophisticated in execution and conception, the painting refers to the secular culture of the Tudor court of the 15th century, but stylistically, in its limpid colour and clarity of line, it still has much in common with the Gothic qualities of the *Wilton Diptych*. Clearly Hilliard, like other northern artists, had absorbed only those aspects of the Renaissance that were comfortable in a culture that felt close to the medieval world.

NICHOLAS HILLIARD MINIATURES

1 Hilliard would use a playing card cut into an oval shape, covered with sized vellum and primed with a pale flesh tint. He would work from life rather than preparatory sketches.

2 With no preparatory drawing, Hilliard would then lay in a light ground.

3 Using a series of coats of fluid colour to build up tone, the colours would be illuminated by the pale vellum beneath.

4 As the delicate surface of the vellum made correction difficult, Hilliard would use a pencil dipped in a flesh tint to indicate lines for further development.

5 To test whether there was enough gum arabic in the medium, Hilliard would expose it to sunlight to check for crumbling and peeling.

6 Hilliard would add the final details with minute dabs and strokes, freely applied.

Hilliard used a limited palette and tried to avoid muddy colours. He preferred to use ultramarine from Venice (**1**), red (**2**), green (**3**), yellow (**4**) and murrey, a reddish purple colour (**5**). He used three types of white (**6**) – one for faces, another for linen and satin and a third, which was called "whitlead" for body colour. He also used three types of black (**7**), preferring burned ivory for the eyes. Hilliard would have ground his pigments on a crystal block and mixed them with distilled water and gum arabic.

ABOVE *Nicholas Hilliard's miniatures employ a craftsman's delicate decorative touch in works as jewel-like as the golden gems he crafted for Queen Elizabeth I. Young Man among Flowers (c1587) portrays a courtier cast in the rôle of "love-lorn swain".*

CHAPTER SEVEN
LIGHT BEYOND THE ALPS

N o artistic period begins or ends neatly, and many overlap, reminding us of the very different kinds of society that co-existed across Europe at this time. In Italy the followers of Caravaggio and the Carracci developed the Baroque style that emanated from Rome as the "official art" of the Counter-Reformation. Rome was the artistic capital of Europe in the 17th century, and Baroque exuberance and emotional intensity spread throughout Catholic Europe. Just as the Renaissance spirit had been adapted to local tradition, so it was with this new departure, which had evolved from Mannerism.

The Baroque flowered in Catholic Flanders in the hands of Rubens, while in France Louis XIV saw its potential for glorifying not the Church, but himself. The Palace of Versailles remains a comprehensive example of the power of the Baroque arts of architecture, painting, sculpture and landscape gardening co-ordinated in the service of the king.

Rome retained its heritage of Michelangelo and Raphael, and most ambitious artists were drawn to Rome to catch some of its spirit – an urbane blend of Catholic splendour and the grandeur reflected from its imperial past. Already, however, the political power of Rome as a centre of a united Catholic Europe had waned.

Art is inevitably in the service of political and economic forces, and implicated in the balance of power between conservative and radical forces – disseminating the message of its patrons, whether they are kings, clerics or dissident voices. The enclosed world of artistic activity is never immune from social or political conditions.

After the Protestant revolution in the north, the nations of Europe became increasingly distinct and nationalistic. Simultaneously, the hub of economic and mercantile power shifted north to Holland, France and England, and away from Venice, which went into decline. The fortunes of art followed the new magnet of capitalism.

FRANCE

In the work of Georges de la Tour (1593–1652), the influence of Caravaggio is immediately recognizable. It must have reached him via Holland, as de la Tour is not believed to have travelled beyond his native Lorraine.

The dramatic, highly contrasted light that is so characteristic of his work is inspired by Caravaggio's example, as is the stark simplicity of conception, where the figures are strongly foregrounded in a composition uncluttered by decoration, or distracting background. In contrast to Caravaggio's astonishing revelations, de la Tour avoids drama and rhetoric, substituting intense concentration on static forms, which approach a geometric simplicity, in which the mood is contemplative and silent. Nocturnal scenes lit by candlelight intensify the mood of monumental stillness, and bring to a tight grouping a poignant intimacy, as in *St Joseph and the Angel*. Here another aspect of Caravaggio's realism is adopted in the vulnerable humanity with which the elderly Joseph is rendered. Any doubts about the derivation of the style from Caravaggio may be dispelled if this mature style is compared with de la Tour's early works.

In *The Cheat*, the clear outlines and boldly presented figures are bathed in pearly light in a daytime scene which reveals a very different character from the later religious works. The feeling here is much more in tune with Dutch genre scenes of domesticity: ephemeral and unportentous, depicting worldly manners and dress. His later style is considered to represent the spirit of 17th-century French classicism, in its stillness and restraint – complementing Poussin.

Nicolas Poussin (1594–1665) dedicated himself to recreating the spirit of Rome in works that echo his own moral and emotional austerity. For him, ethics were

ABOVE *In one of La Tour's earlier works,* The Cheat *(c1635), the influence of Caravaggio is less than that of the Dutch genre masters. The scene is observed with a cynic's cold eye.*

more telling than religion. Whether he treated Christian or Roman subjects, the same intellectual rigour is apparent. Poussin moved to Rome in 1724, and remained there for most of the rest of his life, painting for patrons as learned and serious as himself. In his mature works there is a stern gravity in the subject matter, and a cool, rational ordering of the picture surface.

Orpheus and Eurydice recounts the moment when Eurydice is struck by a snake, but only she and the fisherman are aware of the fatal event. Orpheus plays on, unaware that their idyll is shattered. Poussin uses a horizontal landscape formula in many of his works, exemplified by this one: dark masses of rocks or trees enclose the action in a stage-like setting and direct the spectator's gaze towards it.

This underlying geometry gives the scenes their elegant serenity, immobilizing and idealizing the elements of nature. Poussin's ascetic reticence contrasts with the exuberance of Tintoretto's dynamic perspectives or Rubens' swirling Baroque compositions.

ABOVE *The realism with which La Tour depicts the frail old man in* St Joseph and the Angel *is another debt to Caravaggio.*

LEFT Orpheus and Eurydice *(1650) by Nicholas Poussin uses a landscape formula of dark masses of rocks or trees on either side. The idealized landscape recedes in parallel planes which structure the depth of the painting, while clear vertical and horizontal accents give increased stability to the work. This underlying geometry gives the scene its elegant serenity.*

RIGHT *Poussin's treatment of the menacing forces of nature in* The Deluge *(1640) looks forward across two centuries to the Romantic sensibility of Delacroix and Turner.*

In these later works, Poussin distances his figures, as though they have stepped back in time. Across a limpid green lake the citizens of an ideal Italianate city carry on their lives, oblivious to the momentous event. Poussin's colours are appropriately cool and muted. Bright accents serve only to enliven the surface.

Claude le Lorrain (1600–82) approached the ideal landscape from the opposite point of view. Where Poussin had sought a vehicle for classical themes, Claude was a landscapist first, and employed distant groups to animate and give scale to the scene. Above all, the figure groups are intended to enhance the sylvan mood that he portrayed so expertly. Claude, too, spent most of his life in Rome and absorbed a reverence for its classical past, but in a different manner from Poussin. Instead of intellectual rigour, he brought a dreamy, poetic evocation to his subjects. Classical characters stroll in the Roman Campagna, making the past live in the present. The mood evoked is nostalgic and elegiac.

Landscape with the Arrival of Aeneas at Pallanteum demonstrates the similarity in technique between Claude and Poussin, but even here, Claude's landscape recedes smoothly into a bluish hazy distance which stirs the imagination. Claude's device, even when treating religious subjects, of hiding the nominal subject in the background, and arranging languid shepherds and their companions in the foreground, enhances the effect.

The Campagna of Poussin and Claude is Arcadia: a sun-filled paradise where nature offers up her bounty and the spectre of the drudgery of labour is not allowed to mar the dream. Another two centuries must elapse before the "worked" landscape would appear in "high art" with the work of John Constable, in the spirit of Virgil's *Georgics.* Claude's paintings became extremely popular with connoisseurs from northern Europe, especially England, who found them irresistible as symbolic of the classical past, a Golden Age, when they embarked on the Grand Tour.

Claude's charming paintings lent distinction to the walls of mansions and country houses, and endorsed the owner's taste, confirming his classical learning. In fact, they were in such demand that opportunists forged his work, so in 1635–6 he compiled his *Liber Veritatis* (Book of Truth), documenting and authenticating his output. He was the first artist to do so.

Compared to landscapes produced in the late 17th century by Dutch painters, the artificiality becomes apparent. Here is the emergent ideal of the "picturesque" according to which country gardens were landscaped for the British aristocracy in the 18th century by William Kent and "Capability" Brown.

Occasionally Poussin painted the darker side of the idyll as in the *Deluge.* A sudden storm surprises the Arcadian figures. Their isolation in the landscape emphasizes their vulnerability before the scale of nature and demonstrates man's helplessness against the enormity of the elements. (Turner is known to have returned again and again to study this work when he visited the Louvre, in Paris, on his first journey abroad during his youth.)

Poussin's and Claude's paintings – one recalling the heroism of ancient Rome, the other the pastoral poetry of Virgil or Ovid – were mostly small in scale, suitable for the private study in the houses of discriminating collectors.

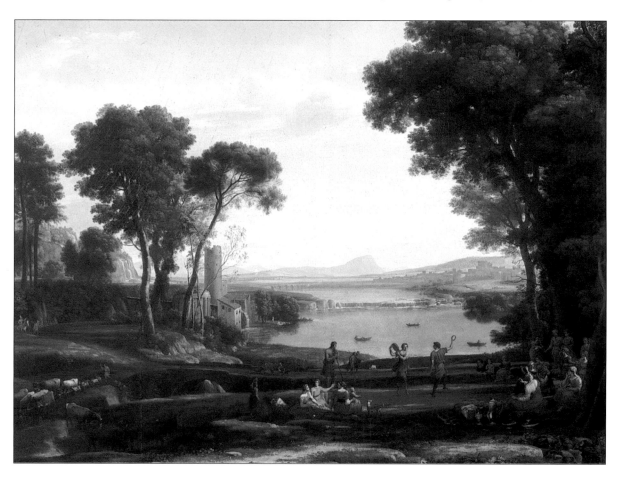

LEFT *In* Landscape with the Arrival of Aeneas at Pallanteum *(1675), Claude le Lorrain approached the ideal landscape from the opposite point of view to Poussin's. Instead of telling a classical story, Claude's painting evokes a poetic mood in the Roman landscape.*

FLANDERS

A grander vision characterizes the work of Rubens (1577–1640). His vast compositions, teeming with animated figures, are on a monumental scale only suitable for palaces and churches.

Rubens, too, had spent years in Italy, visiting Rome in 1600 when he was just 23 years old. He most admired the grandeur of Italian art which he incorporated into his own work, blending the compositional facility of the Carracci with the uncompromising candour of Caravaggio, in an art of supreme confidence. His dashing self-assurance and prolific output in various media, including designs for tapestries and architecture, encouraged him to write in 1621:

"My talents are such that I have never lacked courage to undertake any design, however vast in size or diversified in subject".

As with the later Tiepolo, Rubens could take on any subject and give it life and dignity. In *Marie de Médicis Queen of France, landing in Marseilles* the life of the cunning Marie was elevated to the style of a glorious mythological pageant. In this dramatic invention, Rubens employed all his skills and virtuosity to ennoble the scene and its protagonist, thus sanctioning her pretensions, in one of a series of 25 enormous paintings depicting her life.

Here, a complex composition is handled with freedom and ease. Although the painting is crowded with a multitude of figures, there is more movement, more light, and more space than in previous artists' works. The low viewpoint increases the regal attitude with which Rubens has invested the queen, and the merely temporal arrival is transformed into an event of timeless significance. Rubens' references to the Renaissance by the inclusion of Tritons and Nereids who emerge from the depths to honour the new queen, give an air of classical allegory. They appear as actors on a stage, reminiscent of classical values where harmony of composition, with poised and balanced groupings of figures, is the overriding concept.

The whole enterprise teeters on the edge of the ludicrous, but Rubens' bravura carries the day, with his broad vigorous handling of the paint giving a unity to the surface, imbuing the actuality of the event with the grandeur of his realization.

The times in which Rubens lived were troubled by the religious and social tensions between the commercially energetic Protestants and the Catholic powers which would produce the Thirty Years' War. Rubens' allegiance was to the Catholic world, to a rich and ambitious Church, and to the absolute monarchs, sustained by the Church. For his services, he was knighted by Charles I of England, and honoured by

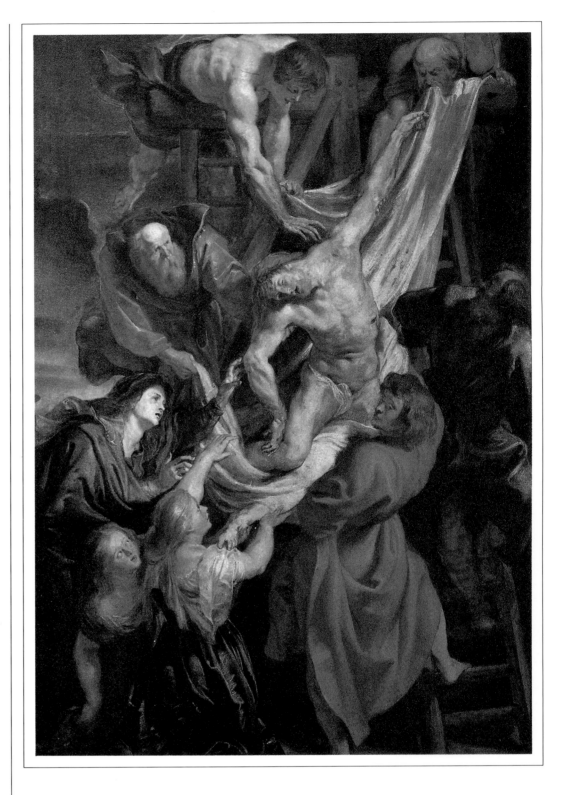

ABOVE *The composition of* The Descent from the Cross *(1611–14), painted by Rubens for Antwerp cathedral, almost has the effect of a carved monument.*

OPPOSITE ABOVE Marie de Médicis Queen of France, landing in Marseilles *(1622–6).*

OPPOSITE BELOW *Ruben's Allegory of Peace and War was painted specifically as a presentation gift by the diplomat-artist to King Charles I. This followed the successful conclusion of a peace treaty between Spain and England, and was a gesture that honoured Charles' role as a peacemaker among nations.*

other noble patrons, in a life where his activities as a diplomat often over-shadowed his art.

His home was Antwerp, the centre of the Counter-Reformation in the north, where artists were commissioned to propagate the ideas and beliefs of the Catholic Church through the emotional power of its imagery. This was in striking contrast to the iconoclastic austerity of the new Dutch republic.

Rubens gave his religious subjects the same emotive power as his secular themes. *The Descent from the Cross* for Antwerp Cathedral echoes the spirit of the scene with its downward plunge. Christ's awkward, heavy body with its bluish tone contrasts with the busy activity that surrounds him. The sculptural modelling, and overall sculptural grouping lends a substance to the figures that confronts the viewer with an incontrovertible, momentous event. Rubens blends the timeless idealism of the

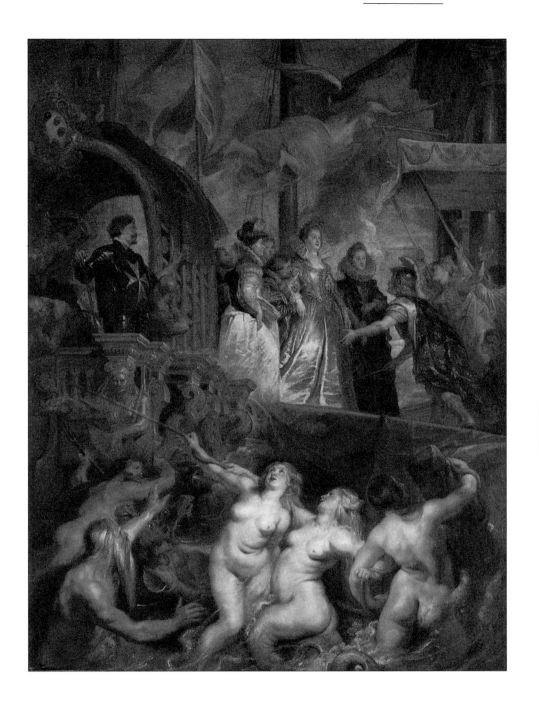

Renaissance with the Flemish fascination with the world we see and recognize. The exaggerated dynamic poses are borrowed from the repertoire of Mannerism, but Rubens ties them with a unified composition, subject to a mood of human sympathy that transforms the grand rhetoric into a moving scene that holds conviction.

An altogether more sybaritic spirit characterizes the *Allegory of Peace and War*, painted by Rubens as a gift for Charles I of England to celebrate the reconciliation of England and Spain (largely effected by Rubens' diplomacy). The painting smoothly expresses the key ideas: the benefits of Peace are symbolized by wealth, gold and the cornucopia of luscious fruit; while War, personified by Mars dressed in contemporary armour, is driven into the darkened landscape beyond. The message is clear: both Spain and England would now enjoy the bounties afforded by peace. The sumptuous rendering echoes the subject with Rubens' painterly virtuosity: the leopard's fur, the translucent gleam of grapes, and the stiff folds in heavy brocade are captured with accustomed mastery.

Antony van Dyck (1599–1641) worked in Rubens' studio for two years, and acquired a similar feeling for surfaces and texture, and for confident pictorial statements. However, van Dyck's travels to Italy in 1621 prompted him to relinquish Rubens' robust style for one more elegant and delicate, making him a much sought-after portraitist, able to endow the sitter with a refined aristocratic air.

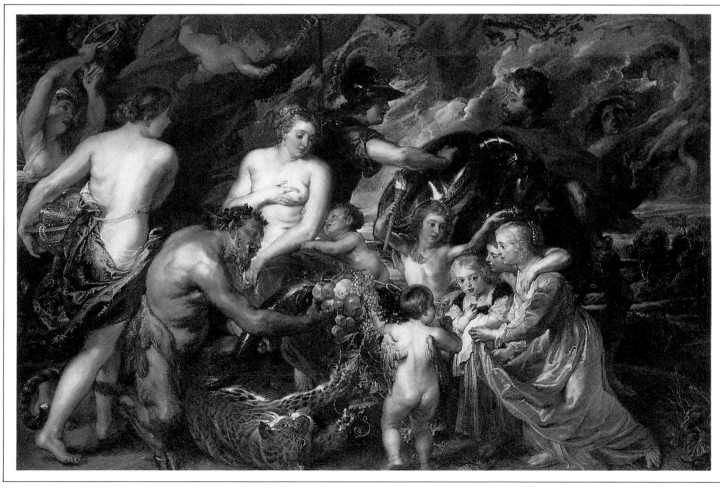

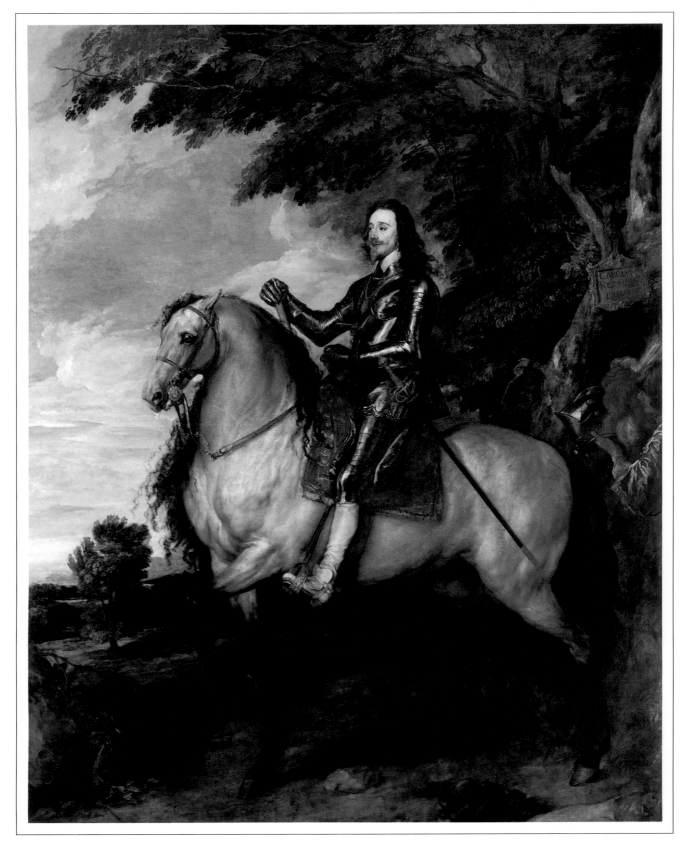

ENGLAND

Charles I of England exemplifies van Dyck's manner. The King stands in an elegant yet assured pose; he looks out at the viewer with mingled urbanity and disdain. Van Dyck rejects the conventional symbolism of power that equestrian portraiture represents, preferring to endow Charles I with a wistful, thoughtful attitude, while the servant and thoroughbred horse indicate his elevated social position. A Rubensian love of luxuriant textures is apparent, whether in the horse's mane, or Charles' soft kid boots, or his silken jacket. Van Dyck's refined touch with the sheen of silk and its subtle colour attests to his skill and sensitivity of touch.

ABOVE *With his* Charles I of England *(1630s), Antony van Dyck's refined, rather ethereal manner makes him the prince of image makers for his era.*

A century later Watteau would display a similar refined skill, equally popular with aristocratic patrons. Van Dyck's proud yet ethereal rendering won him a knighthood from Charles, and made him the most sought-after portrait painter of the age. Indeed, it is through his eyes that King Charles and his court are remembered. Soon the precious, unworldly luxuriance personified here was to be shattered by the Civil War and Charles' execution.

Van Dyck's style was to be profoundly influential on English portraiture, with sitters trying to make their contemporary fashions look as much as possible like the costume of van Dyck's day for the next 150 years. Gainsborough, in particular, emulated van Dyck's style.

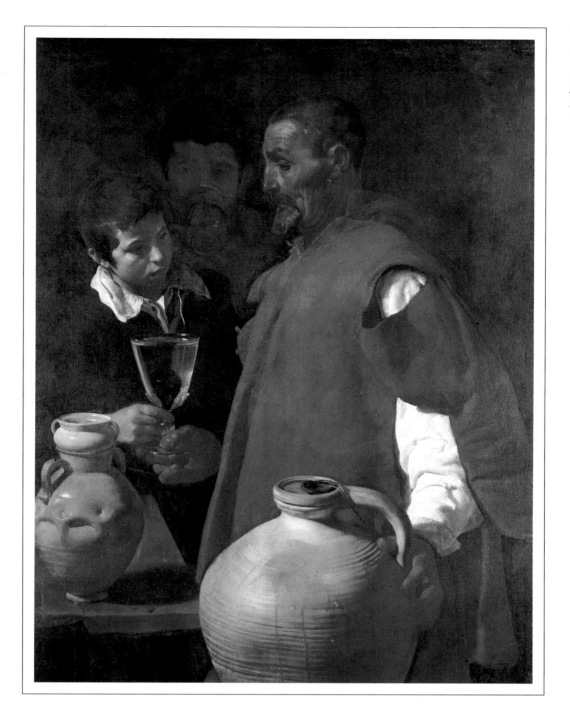

SPAIN

Diego Velázquez (1599–1660), the first great Spanish painter, depicted a court as different from that of Charles I's as was the manner in which it was recorded.

Born in Seville, he had a talent that was so exceptional that he was soon called to Madrid, where he established himself as a court painter to Philip IV in 1623. He later became a courtier-diplomat similar to Rubens, who visited the Spanish court in 1628/9, becoming a friend of Velázquez.

In 1620, before achieving this elevated status, Velázquez painted a series of *bodegones*, a type of genre scene, depicting ordinary people engaged in everyday tasks. *The Waterseller of Seville* is typical of Veláz-quez' serious approach to his subjects, which are recorded with dispassionate attention and intensity. Velázquez brought a new dignity to the genre, and a Caravag-gesque lighting. The dramatic chiaroscuro spotlights the figures with a clarity that gives them real presence, surrounded by an enveloping velvety shadow. Each person is depicted with an unidealized, unsentimental

VELAZQUEZ' WATERSELLER

1 Velázquez often chose fine, regular weave canvas which he covered with a dark brown ground using a palette knife.

2 The main composition and areas of light and dark would be blocked in using a fairly large bristle brush.

3 Using softer brushes, Velázquez would develop the somewhat roughly applied large areas of colour.

4 The softness of the water seller's tunic suggests that Velázquez went over the area with a blending brush.

5 Small details, like the ridges on the pitchers, would be added with a fine pointed brush probably made of ermine or stoat.

PORTRAITS

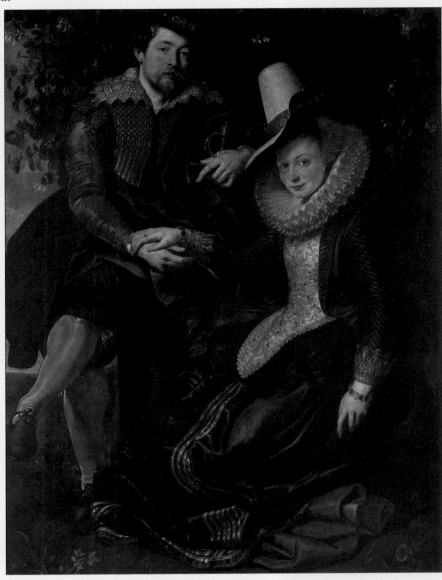

Portraits have a direct appeal. When we look at these representations we feel engaged with the subject, whether we like or dislike the sitters, or experience an affinity with them as if engaged in a dialogue.

Often this is particularly apparent with portraits from another time and place. We expect to learn something or achieve some insight, from the sitter's gaze or the artist's interpretation, that cannot be read from dry historical facts. Eye contact can bridge the centuries, and put us in the presence of history, but on our own terms.

Doge Loredan's set, tight-lipped expression gives nothing away. He was the representative of the Venetian republic at the zenith of its power: wrapped tightly in a shell of gilded finery, he contemplates the spectator with absolute indifference.

What does Bellini's meticulous rendering really tell us? Compared to Picasso's cubist portrait of the art-dealer Vollard (see Introduction, page 10), it seems to offer an immediate contact of recognition – a relationship, however distanced, with the doge, and his distinctive features. Yet, by the time of Picasso's portrait, photography had rendered conventional painted portraiture nearly obsolete.

Instead, Picasso offers fragmentary aspects of Vollard's appearance which provide a composite of a stocky, balding man. To this we can add the observation that Vollard's pose suggests a man confident in his identity and importance, and in his personal endorsement of the Cubist idiom.

Together these factors comprise a complex and challenging representation, one consistent with the climate of change and doubt that is characteristic of 20th-century culture.

Nowhere are the conventions of art and society more apparent than in portraiture, particularly in those of married couples. The rigid, formalized poses of Arnolfini and his wife are echoed in their dress and in their possessions displayed in the room. The portrait is a formal affirmation of their marriage vows, in contrast to the relaxed intimacy seen in Rubens' own marriage portrait.

Evidence of Rubens' wealth and success abounds in his confident demeanour, as well as his costume. There was no need to give an inventory of the richness of his possessions. Here, Rubens set a style that would be adopted by other great portraitists in the 17th and 18th centuries, from van Dyck to Reynolds.

Others followed a parallel strand of portraiture that indicated social and economic status by a direct display of material wealth and power. Mr and Mrs Andrews by Gainsborough, is linked to Mr and Mrs Clark by Hockney of 200 years later: both couples are measured by what they possess, they are what they own, just as portraits in advertising photography today say "I am what I consume".

ABOVE Rubens, *The Artist and his Wife in a Honeysuckle Bower,* C1609–10

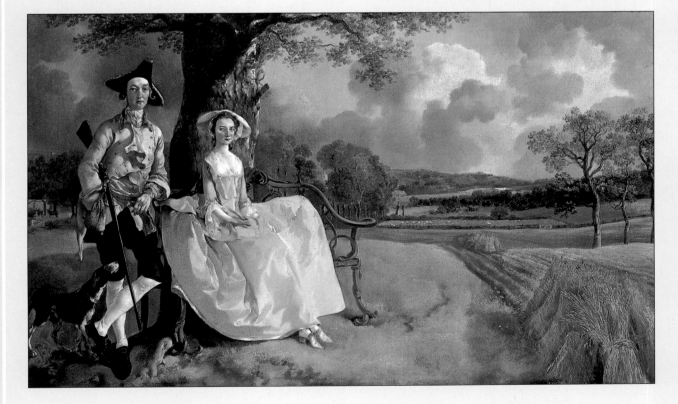

LEFT
Thomas Gainsborough,
Mr and Mrs Andrews

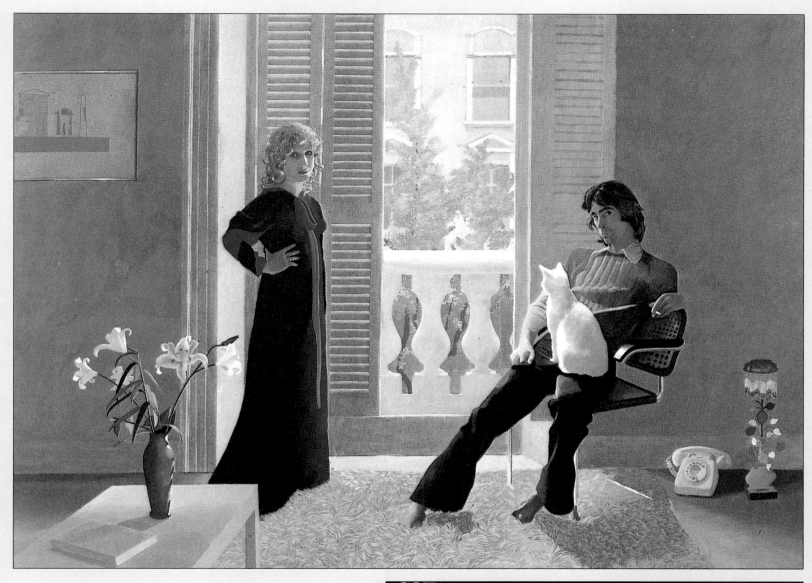

Above David Hockney, *Mr and Mrs Clark and Percy*, 1970

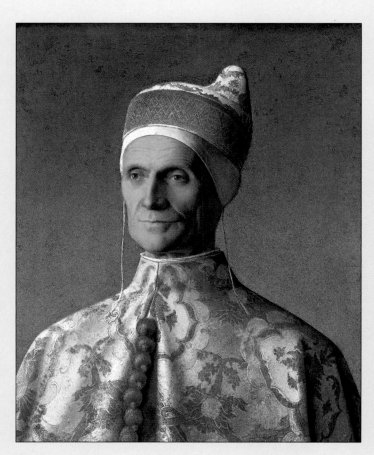

Above Bellini, *Doge Loredan*, 1501

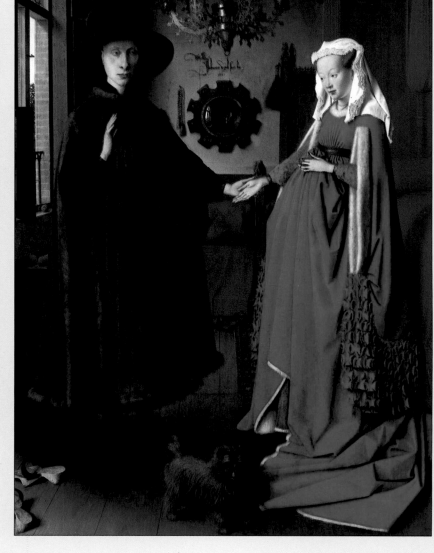

Right Jan van Eyck, *The Arnolfini Marriage*, 1434

directness that is consistent with the naturalism he had inherited from Caravaggio.

After his appointment as court painter, Velázquez became primarily a portraitist and his style changed. Influenced by the works of Titian he saw in the royal collection, and what he observed as the requirements of official portraiture, his brushwork became broader and more fluid. Velázquez made two visits to Italy, and on each he spent most of his time in Rome, studying the collections of paintings, which further encouraged him to loosen his brushwork in the later Italian style. On his second visit, in 1650, he painted the remarkable *Portrait of Pope Innocent X* (see Introduction), which is, by common consent, one of the supreme portraits of European art.

This masterpiece is distinguished by the confident freedom of handling paint and the incisive characterization. The Pope himself said the picture was *troppo vero*, that is to say, "too truthful". His belligerent ruthlessness is all too apparent. Such a penetrating commentary is accompanied by technical brilliance in depicting the reddish, fleshy complexion, the heavy satin cape and the lace surplice. Even here, Velázquez' mature style is evident in the evocatively rendered atmosphere, and the way that the detail is subordinated to the overall effect. Looked at closely, the individual forms are dissolved into a blur of brush-strokes, yet from a distance, the effect is of a vivid naturalness.

Velázquez' last great painting is regarded as an enigmatic work. In *Las Meninas*, the complexities of space, and the possibilities of interpretation of its meaning, have challenged art historians and been the subject of debate ever since Velázquez painted this apparently spontaneous portrait of the royal princess, the Infanta Margarita Teresa and her entourage in 1656.

In *Las Meninas* Velázquez stands at his easel, painting the portrait of a sitter, who is unseen; but closely observed by those portrayed in the painting. We are positioned in the place of the sitter. Who is the sitter, so visible to Velázquez, and the subject of this painting? The mirror on the far wall suggests two sitters, perhaps the King and Queen. Are they the subject of the large painting whose rear-edge can be seen in this painting? If so, their presence is at the centre of this picture, occupying our space.

Is the meaning of this painting a commentary on the nature of looking, the painter's art, or a visual illusion created by the trick of perspective? And who is the man who appears, momentarily, framed by the light in the open doorway?

The painting is a picture within a picture, containing other paintings, and mirror effects; like a Chinese puzzle containing many levels of optical space and many allusions as to its possible subject.

ABOVE *Velázquez' brushwork technique was to have a marked effect on the French Impressionist Manet.*

One allusion is to the painting by Jan van Eyck, *The Arnolfini Marriage* (1434), then in the Spanish royal collection. But there the spectator, also reflected in a mirror, appears to witness the solemn betrothal. Another allusion is to an "impression" of family life, an informal break from the suffocating ritual of the Catholic court, although the strict ranking of the court is observed in positioning the royal family towards the centre, and the servants, including the dwarf, a dog, and the artist on the periphery of the group. The Infanta is bathed in a radiant light, as her lively eyes engage the spectator.

But it was Velázquez' ability to create illusions in paint – effects of light, solid forms suggested by a fluid open brushwork, thin passages of paint accented with thick impasto – that makes him a master, one of the greatest of all painters.

One who thought so was Manet. Two centuries later. Manet, the first modernist painter in the 19th century, modelled his own technique on Velázquez' open painterly application of paint.

Bartolomé-Esteban Murillo (1617/8–82), also a native of Seville, came out of the same genre tradition as Velázquez, but never transcended it. While Velázquez is noted for his sharp actuality, Murillo's subjects have a sweet and sentimental air. Genre subjects were made charming and pleasing, as in *Boys with Fruit*, with their soft forms and gentle expressions, so different from the expression of Velázquez.

It is easy to see why Murillo was so popular in the 19th century when Victorian narrative paintings exploited many of his pictorial devices, turning them into empty, over-literary anecdote. After an inevitable reaction from this style in the Modernist period, Murillo's qualities are now being reassessed more favourably.

Humble objects are transformed into a vein of remarkable still-life paintings by Francisco de Zurbarán (1598–1664). Their mystical intensity of vision are influenced by the still-lifes of Sánchez Cótan (1560–1627), who painted in the still-life genre, exclusively, until he became a monk in 1603, after which he executed religious works of little interest. Zurbarán's still-lifes have a painterly touch, and a curious luminosity in the opaque treatment of the fruits. They are outlined with a dispassionate clarity reminiscent of Velázquez, but appear symbolic in their isolation.

Apart from this series of exquisite still-lifes, Zurbarán is noted for his restrained religious works.

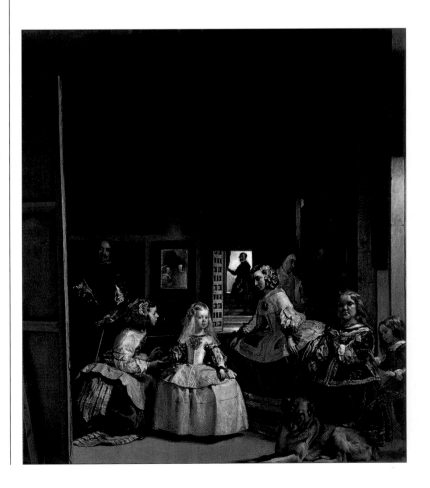

LEFT *In* Las Meninas *(1656) Velázquez teases the viewer: is it us to whom he shows himself painting? Certainly, it is not simply an informal portrait of the "Infanta Margarita Teresa, and her Entourage".*

ABOVE *17th-century Protestantism in Holland called for a small-scale, coolly rational type of genre art, one that rejected the excesses of the Baroque and Rubens' grandeur. In St Curena, Rhenen (1655) by Pieter Saenredam, we see a medieval church purged of its pious accretions.*

HOLLAND

The 17th century was the century of genre, and its brilliance unfolded in Holland as an expression of the people's emerging nationhood and growing awareness of their cultural identity.

The Reformation of the previous century had split Europe, politically as well as in divisions of Christian belief. In many Protestant countries the role of art itself was questioned. The visual and emotional exuberance of Baroque and its association with Catholic ritual was anathema to the Protestant ethic, in which self-denial and sobriety are emblematic of moral virtue. The denial of decoration in church architecture is graphically illustrated in *St Cunera, Rhenen* (1655) by Pieter Saenredam.

Without the patronage of the Church, and private commissions limited in the absence of aristocratic displays of wealth or grandiose works to decorate palaces, the central role of the artist was marginalized, and his professional status made insecure. Times were hard, with only portraiture as a mainstay. Even Holbein found economic survival difficult.

New opportunities were demanded, new markets developed. Small-scale, modest subjects were needed to match the times and modest size of the domestic rooms of the newly emerging mercantile class in Holland.

These genre paintings were the antithesis of the swirling grandeur of Rubens. Instead of cosmic visions suitable for a palace, the unexceptional daily routine is celebrated in a spirit of sober restraint, honouring the virtues of thrift and honest work and their just rewards. These subjects could not offend the puritanism of the churches, and were readily understandable in the rational, practical spirit of a mercantile society.

RIGHT Gipsy Girl
(1625–8) demonstrates
Frans Hals' ability to
capture a fleeting moment.
The painting is rapidly
executed, catching the girl's
movement and expression
vividly.

The Dutch wanted portraits of themselves, their homes, and their possessions – a reassuring catalogue of their lives and values made tangible and permanent. These requirements dictated a style of clarity of definition and a mastery of spatial relationships.

In a society where luxury was a sin, and where artists were once more seen as merely craftsmen, the financial rewards for the artist who could carry out these demanding tasks were hardly adequate.

Frans Hals (c 1580/5–1666), who was the first great artist of the 17th-century Dutch school, lived a life dogged by debt, and died receiving charity. The plight of this Dutch artist can be compared to his contemporary Rubens, in neighbouring Catholic Flanders, who was richly rewarded in every possible way.

Yet Hals' portraits were astonishingly bold and inventive in pose and technique. His treatment of individual sitters is noteworthy for a telling directness, and vivid portrayal of character, and his confident, rapid brushwork was on a par with the best of Rubens. But, where Rubens official portraits are paeans of praise, Hals' achievement rests on the lively and natural demeanour that he gives his subjects. Just as the genre works were freed from mystification and pretension, so were the portraits stripped of their sentimentality. Hals led

the way, to be followed by the supreme artist, Rembrandt.

Gipsy Girl is characteristic of Hals' ability to capture a sense of movement and changing expression, which endows all his subjects with a startling vivacity. The girl seems to be caught in a fleeting moment, the painting is executed in a spontaneous sketchy style which is dashed down rapidly with bold strokes.

Hals was one of the first to use the *alla prima* technique (painting all in one sitting, directly on the ground, without underpainting, and without finish or glazing later). This technique was not used widely until the mid-19th century when commercial paints of buttery consistency became available, the sketchy quality of which was admired by the Impressionists.

Rembrandt van Rijn (1606–69), is generally considered the greatest Dutch artist, transforming the subjects he treated by his technical mastery, whether in painting, drawing, or etching. Like those other 17th-century giants, Rubens and Velázquez, Rembrandt was inspired by the work of Caravaggio, but in his case absorbed indirectly through the Italianate works of Pieter Lastman. His Baroque paintings prompted Rembrandt to experiment with dramatically lit scenes, full of violent action, which truly capture the Caravaggesque effect.

BELSHAZZAR'S FEAST BY REMBRANDT

1 The canvas was sized with animal glue to seal it against the binding medium of the ground, which would otherwise have been absorbed and could have damaged the canvas.

2 A medium-brown ground was laid on consisting of ochre bound with resin and animal glue. Introduced by Titian, the use of a brown rather than white ground ensured that the artist had to work from dark to light.

3 Rembrandt left no sketches or preliminary studies. Composition and distribution of light and shade are mapped out in a monochrome under-painting. The completed image is not so much a sketch as a dead-colour painting ready to be worked up.

4 With the dead-colour painting as his guide. Rembrandt then applied the body colours working from background to foreground, leaving the figures at the front monochrome silhouettes until their turn came.

5 Where glazes are applied, they build up the rich blackness of the velvet worn by the figure on the extreme left and soften the contour of Belshazzar's body so that it recedes into the darkness under his outstretched left arm.

6 With the ground work completed, Rembrandt would set about applying the finishing touches to the painting as a whole. Working in stiff impasto, he dabbed in highlights so the twinkle of jewellery and shiny metal drew the composition together.

Belshazzar's Feast (c1637) shows how much Rembrandt, too, had absorbed from Caravaggio. The drama of this sensational moment is created by the painter's lighting effects.

Underpainting providing basic colour

Stiff impasto for highlights

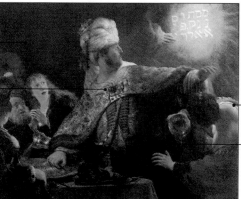

Smooth glazed black for dress

Cuff made from alternating dark and light strokes

Single brushstrokes for white edging of dress

Glazes built up

Light scoops the subject out of the surrounding darkness, a light that is supernatural in its brilliance, exposing Belshazzar's guilty hedonism to the symbolic intervention of God's will.

BRUSH STROKES

Rembrandt and Frans Hals were the first great masters of directional brushstrokes. The strokes which make up the cuff consist of alternating dark and light strokes, turned up abruptly at the ends to suggest the pleats and rounded off along the ruffled edge of the cuff with white highlights. A similar technique is less successfully used in the rather shapeless white bodice. The dress is made up of smooth, glazed black recreating the rich textures of velvet and receding deeply into the shadow under the woman's arm. The lace trimmings again consist almost entirely of highlights which stay firmly on the surface of the dress to suggest the texture of filigree decoration.

Belshazzar's Feast shows how much Rembrandt had learned – particularly how light could intensify the drama of a moment, rivetting attention on the reaction of Belshazzar as he is stricken by the vision. The light scoops the subject out of the surrounding darkness, and, in this scene, the light is supernatural in its brilliance, exposing Belshazzar's guilty hedonism to the symbolic intervention of God's will.

Rembrandt conveys the richness of Belshazzar's oriental dress, the jewelled cape and the decorative trappings, with dazzling virtuosity, using thick impasto. He literally models the gems and gilt brocade in relief.

The theatricality of this dramatic revelation contrasts with the disarming simplicity of his later work, where he eschews the rhetoric of Caravaggio, for a more sympathetic naturalism. As with Rubens, Rembrandt's northern heritage made him particularly attuned to Caravaggio's naturalism in painting recognizably human figures rather than idealized types. Even in this exotic scene the figures are convincing. Unlike Hals, who specialized to survive, Rembrandt was very versatile. He achieved

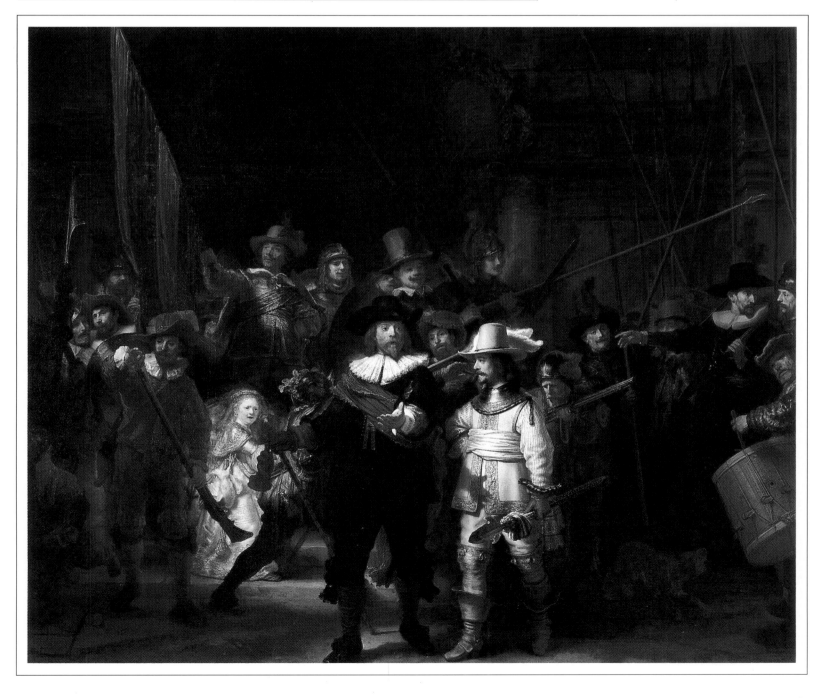

OPPOSITE *Rembrandt set a new convention for group portraits with the* Night Watch *(1642) and its stunning tableau.*

fame at an early age, winning many of his commissions in the 1630s.

Members of local committees wanted to celebrate their importance in a material form that could decorate the public rooms and impress future generations with their civic virtues. Group portraits were an impressive vehicle for larger-scale projects. The problem artistically was to give full value in likeness and dignity to each member portrayed, and a collective unity to the assembled group that would reflect their solidarity: a satisfactory solution was to be achieved by Rembrandt in *The Night Watch* (1642).

The title is based on an 18th-century description, at a time when the canvas was darkened with heavy varnish. It is in fact a daytime scene of a militia company. Unlike many group portraits, Rembrandt subordinated the individual portraits to the demands of the composition, creating an unprecedentedly unified and dramatic tableau, which was described by Hoogstraten, a contemporary, as "so dashing in move-

ment, and so powerful", that it made others in the genre "look like playing cards".

Despite early success, and fame which had spread beyond his own country, Rembrandt's fortunes declined from the 1640s onward. He received fewer portrait commissions, and turned to highly personal accounts of biblical stories, perhaps in response to the deaths of his wife Saskia, and of his mother. Certainly his work became increasingly uncompromising.

In the 1640s he took a serious interest in landscape, and made a series of drawings of the countryside around Amsterdam, adapting many to etchings. Rembrandt was content to record the scene as observed, as in most Dutch genres, rather than exploit its possibilities. In *View across the Nieuwe Meer*, the stillness of the water and sky lend a calm serenity to the scene.

Because of his directness, and his insistence on truth, regardless of conventional ideas of beauty, Rembrandt was criticised for his "vulgarity" and lack of decorum. He disowned any superficial charm and

finish, in favour of emotional depth and an expressive mastery of technique. As his experience grew, Rembrandt pursued an increasingly simplified style and colouring.

Young Woman Bathing shows the mature Rembrandt's seemingly effortless technique in rendering a simple subject memorable. The serene stillness of the later work is apparent in the woman's demeanour and is reflected in the limpid pool. Yet, when examined closely, the breadth of handling is reminiscent of Velázquez.

Honbraken, another contemporary, commented:

"in the last years of his life, he worked so fast that his pictures, when examined from close by, looked as if they had been daubed with a bricklayer's trowel."

The broad strokes of the woman's white shift, and the indications that represent her arms, illustrate this point: they are sufficient. Rembrandt himself insisted that a picture was finished "when he had achieved his purpose". In his late works Rembrandt was economical in his use of colour, working in

ABOVE *Rembrandt*, Jacob Blessing the Children of Joseph *(detail), 1656. In this painting, Rembrandt's extreme sensitivity has captured perfectly a poignant moment from the Old Testament.*

tonality, and *chiaroscuro*; relying on gesture and expression to create the underlying mood of each work.

Rembrandt's masterly restraint allowed him to concentrate on something other than surface appearances. His greatness lies in his sympathetic humanity which is embodied in the expressions, gestures, and poses of those figures he represented, whether real or imagined. The sum of human experience seems to inform his late self-portraits, where there is no vanity or posturing, only a candid observation of a man who had no illusions about life, and accepted it calmly.

Rembrandt, for all his youthful success, died poor. A combination of change in fashion in art, a depression in the Dutch economy, and poor management of his own affairs together contributed to his bankruptcy, but he remained famous and respected by his friends in Amsterdam. Like Hals, his plight testifies to the problems faced by artists in 17th-century Holland.

A society that was morally severe and Calvinistic in its intolerance, and at the same time dedicated to the Protestant work-ethic and single-minded in the acquisition of material goods and accumulation of wealth, was an enterprise culture that could treat its artists badly. Many struggled to survive, such as the incomparable Jan Vermeer. Even his star waned. Many lesser artists continually struggled, often taking a second job, like Jan Steen, who was a tavern-keeper. It is a paradox that in spite of these contradictions, Holland produced the greatest painters of the 17th century.

DUTCH "GENRE"

The "Dutch little masters", as the painters of everyday genre subjects and landscape were known, depicted intimate subjects, mostly on a small scale. This school of painting established the point that great art does not need "great" themes, and that art can be discovered in everyday experiences – that art is in the execution, in the eye and hand of the artist.

As in modern times, the Dutch genre artist had to produce works speculatively for the art-market, rather than by direct commissions, although portraits were clearly painted to order throughout this period. In such a market, with artist competing with artist, there was specialization within each genre subject, particularly in those areas that sold readily. Unlike previous practice, where artists would develop their skills across a range of subjects and techniques (as Rembrandt did), the genre painters became expert in one kind of picture, working in a narrow vein, building a reputation and establishing a market for their works.

ABOVE *Detail from Willem Kalf's* Still-life with Lobster *(below)*.

BELOW *Willem Kalf's* Still-life with Lobster *(c1665) is one of his small groups of decorative objects. Here they contrast with the gnarled and spiky forms and brilliant colour of the lobster.*

Still-life subjects were the easiest to sell, and the fastest-growing genre. Individual artists specialized in particular categories of the genre: a splendid array of nature's bounty, rendered in minute detail. The dining table, with the food partially consumed, with empty glass and scraps of broken bread was depicted, to provide a gastronomic narrative.

Others concealed allegories of time passing and with the fullness of life culminating in inevitable decay. A butterfly alighting on a flower in a vase, the sheen of newly caught fish, or the untouched bloom on the ripest of grapes – all could be interpreted, alongside specifically symbolic images, such as the tulip, which was associated with greed and folly, and was a reminder of the excesses of human weakness, even in an ordered world.

Willem Kalf (1619–93) is regarded as one of the greatest of still-life painters. *Still-life with Lobster* displays a decorative vision few have equalled, in its Baroque dynamic composition and sumptuous richness of textures. He specialized in painting small groups of valuable objects: here, Venetian

STILL-LIFE

The painting of still-life as a subject blossomed in 17th-century Holland, where the genre subjects of landscapes and interiors were also in vogue. They perfectly reflected the spirit of the times in a culture that valued modest pleasures: domesticity, the consumption of food and drink, cosy intimacy, the play of light from a window, colour and texture and the detailed surfaces of commonplace things. Yet these simple objects were often invested with a spirituality and a symbolic significance that is apparent in Kalf's, and Zurbarán's still-lifes, and that provided a model for later artists like Chardin, or even van Gogh, whose treatment of his familiar belongings is so personally evocative and poignant.

Still-lifes became established as a minor genre, one of the petites manières – the least important type of subject in art. Although considered suitable only for the bourgeois domestic interior, they were in great demand.

ABOVE
Francisco de Zubarán,
Still Life with Vessels,
1635–40

LEFT
Jean-Baptiste
Chardin, *The Skate,*
1728

LEFT
Goya, Still Life, *A
Butcher's Counter,*
C1800

ABOVE Vincent van Gogh, *Chair with Pipe,* 1889

ABOVE Paul Cézanne, *Still Life with a Basket*, c1888–90

BELOW Gustave Courbet, *Still Life with Apples and Pomegranate*, 1871

RIGHT Paul Gauguin, *Still Life with Portrait of Charles Laval*, 1886

It was Paul Cézanne, and his heritage in Cubism, that put the *petites manières in the foreground of modern art practice. For Cézanne, the apples and their accompaniments provided a fixed and unproblematic subject to analyse in terms of visual structure – the elements of form, colour, volume, and brushwork. Not for him the intensity of realization that we recognize in Courbet's apples – those symbols of life-force, hope and renewal painted in a prison cell – but a cerebral analysis of formal relations.*

Yet Cézanne's apples were to become a cliché in his own life-time, as we can see from Gauguin's Homage to Cézanne; and Magritte's mid-20th-century parody.

At the beginning of the 20th century, the Cubists adopted subject-matter similar to Cézanne's for much the same reasons and also because it was accessible and familiar. It provided easily recognizable visual clues to the spectator, who was initially baffled by the refracted planes of "analytical cubism". Picasso and Braque went further, in introducing real materials into their paintings by means of collage (gluing on) to increase the experience of visual paradox in art – the identification of the real and the illusion of the "real" – that which is perceived and that which is imagined.

In this way, the still-life became the focus for debates about the nature of art in a critical and formative period of the 20th century.

glass and Persian rug contrast with the exotic shape and brilliant colour of the lobster. Each is rendered vividly, comparable to Sánchez Cótan, but where his vegetables and fruits are observed as separate entities, Kalf's Baroque vision combines the various elements in a vibrant composition. The particular curve of the lobster's claws contrasts with the spiralling lemon-rind, just as the rich red complements the pale yellow: the totality is more than the sum of the parts – "an embarrassment of riches".

This pragmatic, down-to-earth outlook prompted Dutch artists to adopt a scientific attitude to observation, as in Kalf's still-life recording the fall of light across different kinds of surface: whether the reflective brilliance of silver, like points of light, or the matt, light-absorbing rug. The particular quality of light, as it shines through wine in a tinted glass, and is refracted onto the white cloth, demonstrates an accuracy of observation accompanying the Protestant idea that the humblest phenomenon in the world is as worthy of the painter's brush as the greatest historical event.

Jan Steen (1626–79) painted the world he knew best in the ever-popular vernacular tradition of peasant paintings that Bruegel had raised from the commonplace of illustration to high art. Many of his paintings employ a recurring repertoire of types and incidents, yet the paintings are accomplished, and the compositions unite the disparate groups in their good-humoured revels. The best works are notable for the play of

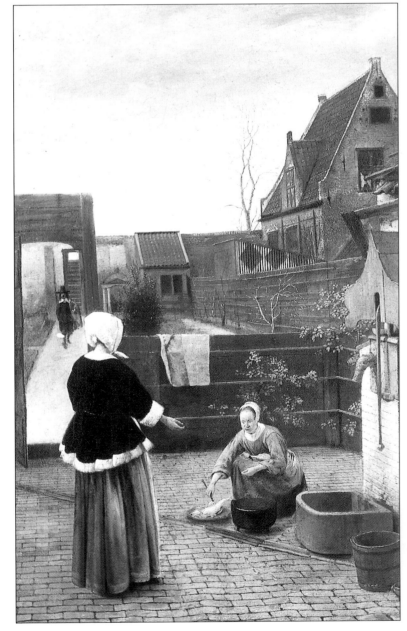

ABOVE Jan Steen, a tavern-keeper, painted everyday scenes. In A Country Inn *(c1660) Steen renders the scene in a lively way, but unifies the whole by the play of light.*

LEFT In A Woman and Her Maid *(c1660), Pieter de Hooch demonstrates the sometimes bizarre effects of the Dutch absorption with detail: the mundane drying-cloth draws our attention away from the narrative enacted by the figures.*

light descriptively outlining the figures and their setting.

Pieter de Hooch (1629–1684), painted domestic scenes with a cool, even light, his interiors reminiscent of Vermeer's in their placid air. In *Woman and her Maid*, an understated but inventive arrangement of interlocking brick surfaces recedes behind the courtyard in which the two women stand. The low-key setting complements the everyday encounter; de Hooch's attentive observation treats everything with the same curiosity. The water-pump and the drying cloth are of equal interest with the maid. This matter-of-fact account is a world away from Rembrandt's intimate profundity.

Jacob van Ruisdael (?1628–82) painted scenes from the forests that separated Haarlem from the sea, amongst many other landscapes, capturing the changing light on foliage and water and recording cloud formations. His senstivity to the changing scene produced a new kind of landscape, where the qualities of northern light and weather achieved a poetic resonance reminiscent of Claude's Italian scenes.

In *Extensive Landscape*, a patch of sunlight breaks through the scurrying clouds and fleetingly illuminates a distant meadow.

ABOVE *Jacob van Ruisdael showed how to endow the northern landscape, and the northern sky, with Claudean poetic resonance, as in* Extensive Landscape.

BELOW *The solitary figures in Jan Vermeer's distinctive works, like* The Lacemaker *(c1670), are depicted in cool, ordered simplicity, pearly tonality and lucid colour.*

The flat landscape acts as a foil to the lowering clouds, whose constant movement is counterpointed by the mood of stillness in the water.

Jan Vermeer (1632–75) painted only 35–40 known works. Like Jan Steen and most of the Dutch painters, he could not support himself by his paintings, and failed to achieve fame in his lifetime or to escape obscurity in subsequent centuries. His significance has been established only in the 20th century, where the cool, ordered simplicity of his compositions has been recognized.

Vermeer's exquisitive feeling for colour and texture has been compared to that of Kalf, but where Kalf's colours glow from a dark background, Vermeer's shine in the pearly luminosity that pervades his interiors. Cool colours dominate Vermeer's palette – cold yellows, blues and greys, all attuned to the northern light of Holland.

The works in the middle period are the paintings on which his reputation is based, and these invariably depict a solitary female figure in a domestic interior. A combination of harmonious composition, where horizontal and vertical accents balance one another to give a static effect, and a lucid ordering of colour, lift Vermeer's master-

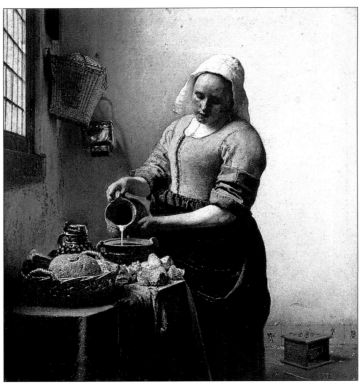

FAR LEFT *Vermeer's subjects, as in* Girl Reading a Letter by an Open Window, *are utterly ordinary events to which he gives a timeless presence.*

LEFT *Light fixes Vermeer's* Lady with a Milk Jug *(c1665) and dictates the overall tonality.*

LEFT *Jean-Baptiste-Siméon Chardin was an 18th-century French painter who seems to bring the Dutch genre tradition of Vermeer to its culmination, as in* The Copper Urn.

ABOVE *Chardin's* The Young
Schoolmistress *(1735), has a simplicity and
truthfulness which set Chardin apart from his
Rococo contemporaries.*

works out of particular genre description into universal greatness.

The subjects – a girl reading a letter, a woman pouring milk – are all scenes taken from the unremarkable events of daily life, but Vermeer invests them with a stillness and simplicity that gives them a timeless presence, despite their small scale. The mostly solitary figures are self-possessed and silent, maintained in a harmonious serenity, and bathed in a light from a window situated on the left.

Vermeer's subjects are transformed, as with other Dutch masters, by the quality of light. Light fixes the women, and dictates the overall tonality. Far from Rembrandt's light, which evokes the inner, spiritual light with a mystical intensity, Vermeer's light is open, and secular, revealing the beauty of ordinary, familiar experiences in the fullness of daylight.

Vermeer's rendering of light and space, and the way in which sparkling highlights sometimes appear slightly out of focus, are thought to result from his use of a camera obscura. His interest in optics and effects of light were shared with his friend, the scientist Antony van Leeuwenhoek, the

THE CAMERA OBSCURA

As used by Jan Vermeer, this camera obscura was a sixteenth century invention which consisted of a darkened box or chamber containing an arrangement of lenses and mirrors. These would project a reduced image, similar to that of a modern reflex camera, onto a flat surface from which an artist could trace a precise and detailed drawing.

inventor of the microscope, and testifies to his methodical Dutch curiosity about natural phenomena.

Jean-Baptiste-Simeon Chardin (1699–1779) was a French painter of the next century, yet he seems to bring the Dutch genre tradition to its final phase. He, too, painted the most ordinary, everyday subjects, yet also invested them with a dignity and presence that belies the humble subject. Figures or objects are rendered with an austere clarity that is a spiritual counterpart of Vermeer; simple and direct, yet deeply serious.

The *Young Schoolmistress*, like a woman in a painting by Vermeer, is represented free of sentiment or pretension. In the still-lifes Chardin produces a similarly restrained yet compelling effect. How different are these works from those of his French contemporaries, such as the comparatively frivolous conversation-pieces of court life painted by Boucher. Chardin's spirit of unaffected reticence contrasts dramatically with the restless brilliant surfaces of his pupil Fragonard and the gaiety of Rococo painting which opens the next phase of the evolution of art.

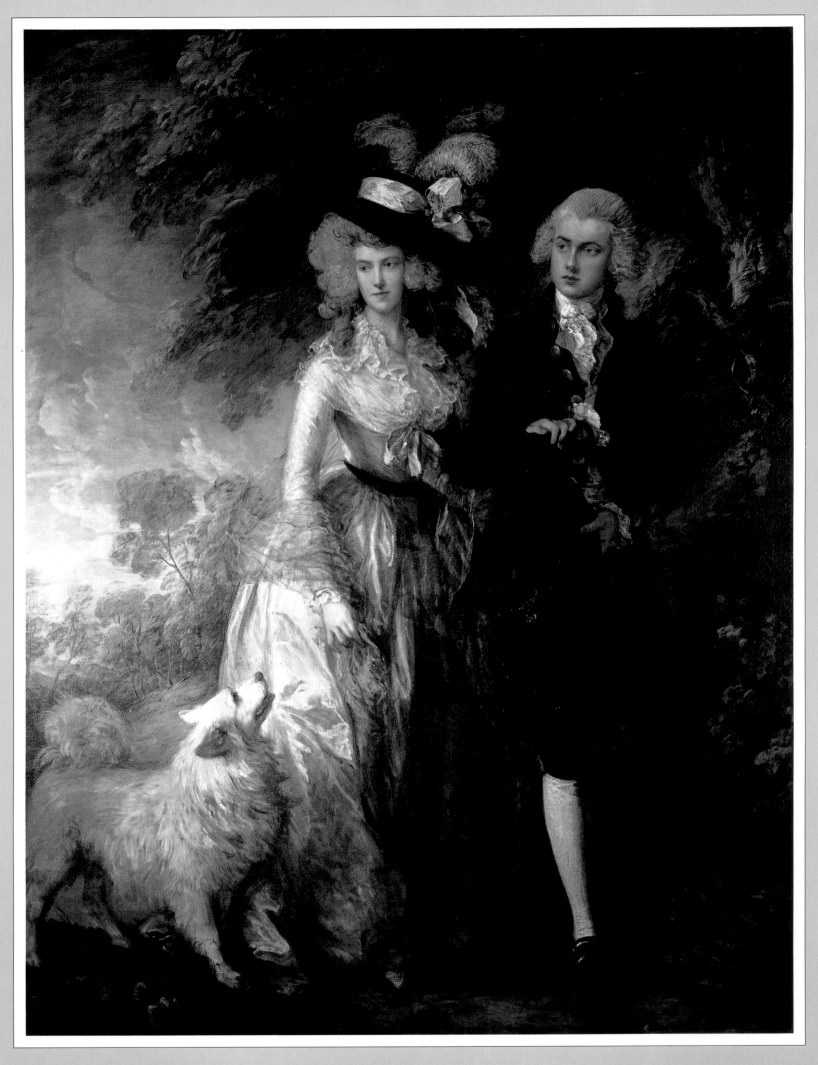

ABOVE *Thomas Gainsborough's sitters are
endowed with elegance. Their finery, as in
Morning Walk,* is rendered in every detail,
displaying his extraordinary technical skill.

CHAPTER EIGHT
REASON AND REACTION
(1700–1850)

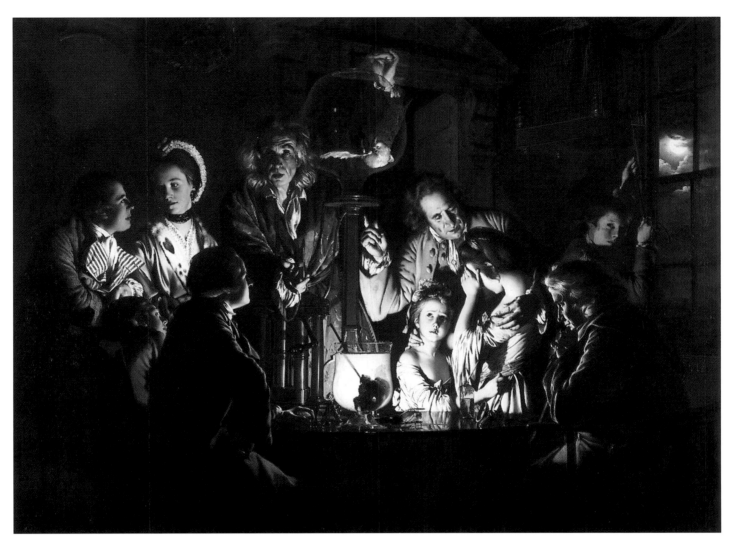

In the 18th century, in a culture characterized by its belief in rationality, economic and intellectual developments changed the role of art in society. A spirit of scientific scepticism, of experiment and enquiry, was to lead to contradictions and conflict before the century ended. Artistic activity would never again be so centrally significant to the power structures as in previous centuries.

Rational thinking about man and his place in the world, now free from the absolutism of Christianity under one Church as a result of changes brought about by the Reformation, ultimately led to a wider questioning of the order of society.

The revolutions in America and France were to demonstrate man's power to change his condition, and were accompanied by art and architecture which reprised the ideals and styles of the Roman republic.

Scientific and technological developments

ABOVE A spirit of scientific reason, characteristic of 18th-century thinking, is illustrated in Joseph Wright's An Experiment with the Air Pump *(1768). The lamp light is symbolic of clear intellectual perception – a lucidity that outshines the mysteries of the moon and ancient superstition.*

enabled the industrial revolution to get underway in England, marking an irreversible cultural shift which would transform western European societies forever. These social and political revolutions were paralleled in the cultural changes in philosophy, as art entered a period of self-questioning and accelerating innovation which was to culminate in the avant-garde movements of the 20th century.

The old order, rooted in the idea of permanence, was about to be overtaken by dynamic forces which created new divisions and increased complexity in all areas of daily life.

Until then, court-art continued in France and Spain with sublime confidence in the power of kings to employ the potential of painting for refined pleasure and delight to the eye, and as a reassurance of their place in the order of affairs.

FÊTES VÉNITIENNES BY ANTOINE WATTEAU

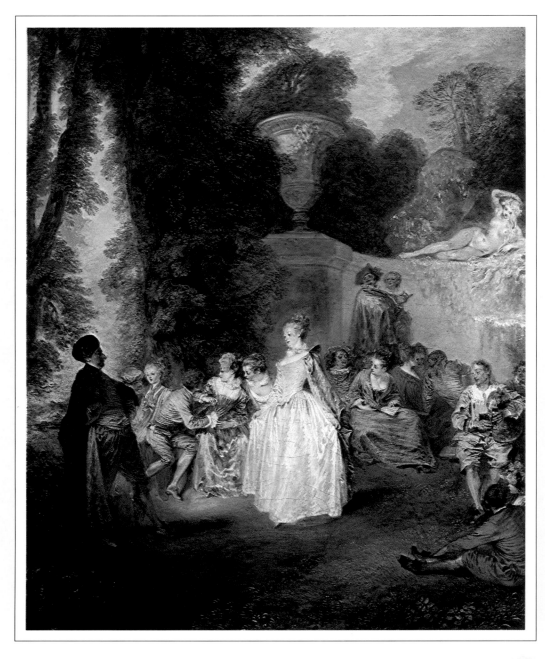

A mood of graceful ease is conveyed by the playful gaiety of Fêtes Vénitiennes *(1718/19) by Jean-Antoine Watteau.*

1 After the canvas was sized, a warm grey ground was applied.

2 If there was no preliminary drawing, Watteau would apply paint directly to the canvas. Watteau worked quickly.

3 Alterations and changes were made and painted over during the painting process.

4 Final glazes and shadows were painted with the same speed as the rest of the painting.

FRANCE

A mood of graceful ease is conveyed by the playful gaiety of *Fêtes Vénitiennes* by Jean-Antoine Watteau (1684–1721), with only a hint of bitter-sweet regret. Watteau painted scenes from the theatre, and characters from the commedia dell'arte: *Gilles* and *Mezzetin* are wandering clown and musician respectively, in whom the pathos of an outsider is conveyed. The mood was echoed 200 years later in Picasso's Rose and Blue periods, with their acrobats and emaciated dancers,

which were also created at a time of imminent social change. Watteau was himself a restless and unhappy individual, dogged by the tuberculosis that was to be the cause of his death at the age of 37. It is felt that the anticipation of his own demise infected his paintings with a tinge of melancholy, with the certainty that the sensuous pleasures of life he depicted are transient.

Watteau came from Valenciennes, originally part of the Spanish Netherlands, and was regarded as a Flemish painter. The Rubens' *Marie de Médicis* paintings were

influential in the formation of his mature style when he encountered them in Paris, and established a truly French, as opposed to Italianate, art.

Watteau is noted for his extraordinarily delicate touch, in which Rubens'-like skills at rendering surfaces – the sheen of flesh or satin – are distanced, evoking a dream-like world. This was the new genre of *"Fêtes Galantes"*, a category of art indicative of Watteau's originality of conception and freshness. These qualities are apparent in *Fêtes Venitiennes*. Characteristically, the

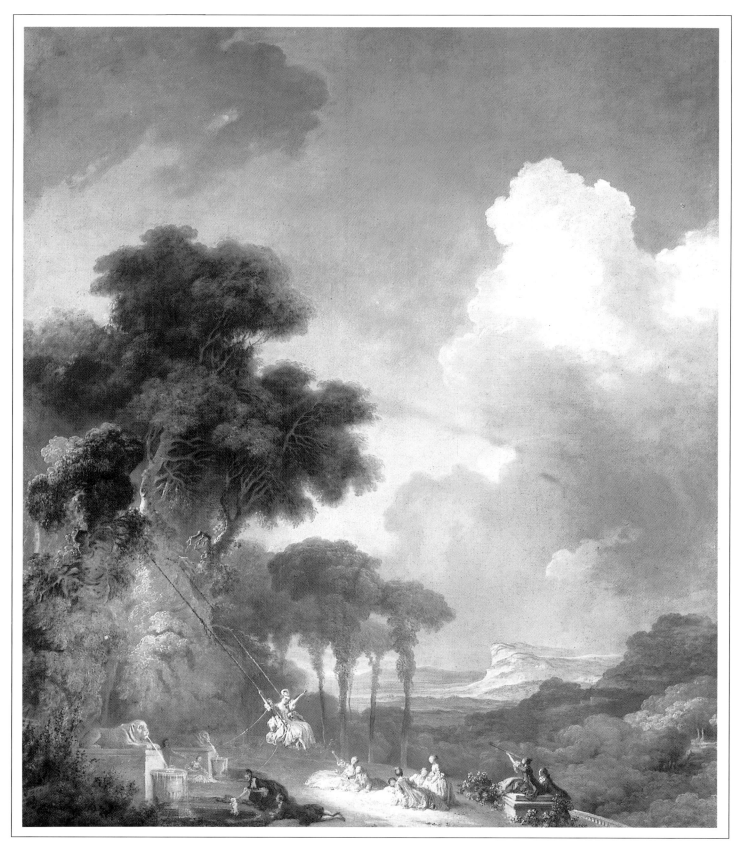

picnics and festivals are rendered in a state of exquisite perfection. The ladies are always graceful and beautiful, the sun always shines, and the unheard music measures every carefree action and gesture. The settings are romantic and pastoral, referring back, via Rubens, to Giorgione's *Fête Champêtre*, with its lovers in a parkland idyll.

The golden glow of a time that never really was pervades these scenes. Their prettiness and artifice characterize the Rococo style as a whole in architecture and decoration: a lighter, sweeter, more lyrical adaptation of the Baroque, manifested in subject, touch and colouring.

Watteau's masterly skills in colour harmonies, and his method of juxtaposing flecks of colour on the canvas to increase

ABOVE *Jean-Honoré Fragonard's women are charming and seductive, as the one in* The Swing *(1775), and the delicate suggestiveness of her motion here exemplifies the Rococo* douceur de vivre.

vibrancy, were to be taken up again in the 19th century by Delacroix, and then by the Neo-Impressionists. His touch is also remarkable for the fine brushwork, which conveys the elusive shimmer of silk or the crisp texture of starched ruffs, and gives a sense of well-being and self-indulgence.

There is an increasing note of exuberance and endless fluttering movement expressed in the works of Jean-Honoré Fragonard (1732–1906). The restful, precise pace of Watteau accelerates into a frantic swirl, a billowing cloud of excess of every kind. His women are charming and seductive, as in *The Swing*, where the floating figure kicks a satin shoe away, mirroring unseen ecstasy. Fragonard's paintings embody the frivolous Rococo spirit.

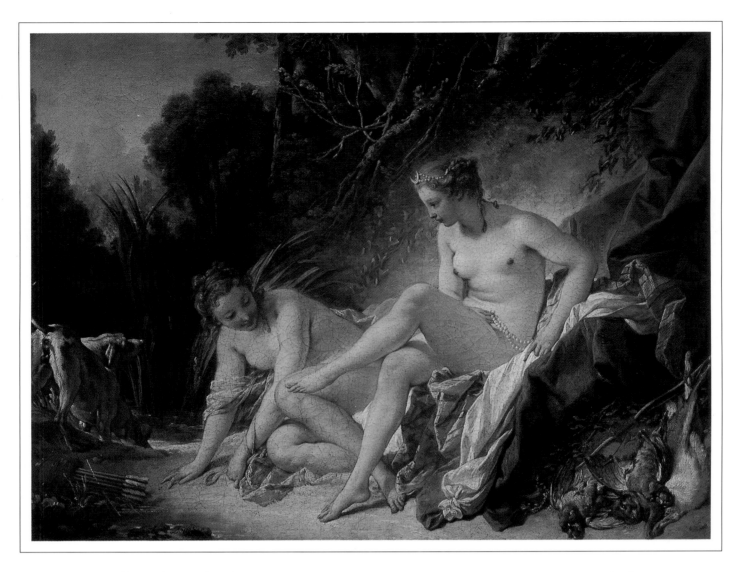

ABOVE *François Boucher's* Diana getting out of her Bath *(1742) takes sensuousness in painting flesh beyond Watteau, Fragonard or even Rubens.*

Francois Boucher (1703–70) was associated with Watteau, whose paintings he engraved. The influence of Watteau's lightness of touch, and colouring is apparent in Boucher's work. These skills enabled him to produce an art of elegant superficiality in tune with the French court of the mid-18th century. He was immensely successful thanks to the patronage of Mme de Pompadour, Louis XV's most famous mistress, whose portrait he painted several times.

The spirit of Boucher's paintings is much more sensual than those of Watteau. His *Scènes Galantes* were witty versions of traditional erotic themes, and his voluptuous nudes recall the fleshiness of Rubens' figures, taken to the limits of abandon.

French attitudes changed towards the end of the century: David's austere classicism set the tone, and the critic Diderot denigrated Boucher's work for artificiality and superficiality both in content and execution, in working to a formula, instead of painting from life.

Indeed, the extravagant times were coming to a close: Diderot and the spirit of rational control and morality began to exert their influence on the manners of the times: and art itself became more disciplined and lucid.

In a few years Jacques-Louis David (1748–1825) was to refine the transition to a neo-classical style in his painting of a portrait of Mme Recamier, every edge sharply defined in correspondence with a world of clear-cut decisiveness. It reflected a culture where analysis had replaced vagueness or equivocation, but whose own absolute morality was already in the process of being undermined.

David's portrait has none of the distracting background or intervening hazy atmosphere apparent in Boucher. Here, the dress is unadorned, in restrained "classical" style, apparently artless, yet consciously contrived. David's blend is both ascetic and flattering in its understated monochromatic appeal to reason rather than emotion.

LEFT *David the revolutionary idealist created the first and greatest icon of the Republic* – The Death of Marat *(1793) – to ennoble its greatest martyr.*

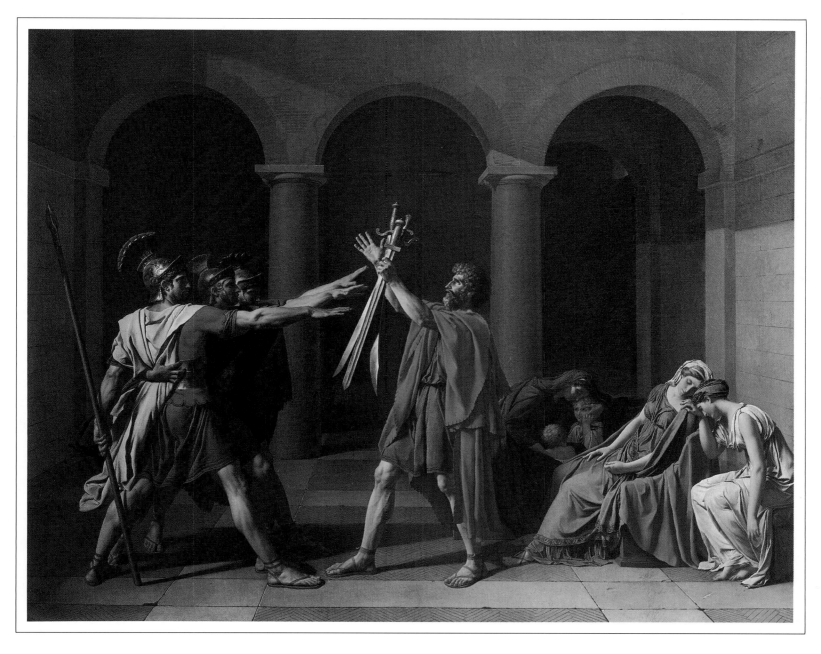

In the 1780s David personified the spirit of the revolution in a severe neo-classical (meaning, "renewed classical") style. His painting responded to the general attitude of moral rectitude and personal sacrifice that animated French society during the Revolution. *The Oath of the Horatii* demonstrates David's new departure into history painting. History painting was considered the most important branch of art practice, capable of inspiring the audience to follow the values set by great subjects – whether religious, mythological or the representation of actual historical events.

In David's work, an incisive line circumscribes each figure, as though it were a sculpted relief. For David, colour had to be subordinated to line, emotion subordinated to order. The brushstrokes, too, were smoothly blended into a uniform surface, in place of the sensual surface of Rococo works. A severity of style matched an austerity of outlook, and constituted a reaction against Rococo culture. David travelled to Italy, but what he chose to emulate was the "antique", not the Italian Renaissance traditions that his predecessors had admired. Where Boucher, his teacher, had been influenced by Tiepolo, David was inspired by the Roman remains, thought to possess "noble simplicity and quiet grandeur", and by artists like Gavin Hamilton, who initiated the 18th-century classical revival. The 18th-century's knowledge of classical design was much better informed than the Renaissance had been.

Accuracy of representation was based on archaeological finds, such as those at Pompeii and Herculaneum which had been excavated in the mid-century. David's austere rendering contrasts with the previous conception of classicism, which implied grandeur and sophisticatioin. For him, classicism meant Spartan simplicity and absolute integrity.

Correspondingly, David chose uplifting moral subjects, like *The Oath of the Horatii*, and *The Death of Socrates*: all representing the civic virtues of stoic self-sacrifice, personal integrity and devotion to duty. Although David's republicanism had led him to vote for the execution of Louis XVI, it was barely a decade before David immortalized Napoleon crowning himself emperor, with all the pomp and majestic splendour imaginable, in the richest costume and the most extravagant pageantry. The austere morality of the revolutionary period had given way to a new autocracy, and art, as ever, mirrored its values.

PORTRAIT OF THE ARTIST'S WIFE
BY THOMAS GAINSBOROUGH

Gainsborough would first work from the model in a dim light allowing him to lay in the general tones of the larger areas, working quickly in rough washes of very thin oil which served as an under- painting for the subsequent development of flesh and drapery. Allowing more light on the subject, he would complete the head of the model. In this case, the

eyes, nose and mouth appear to have been put in using a wet-in-wet technique, while the overall smoothness of the surface suggests the artist may have used a blender before applying the last touches as seen in the highlights in the eye, the strokes of red-brown in the curve of the eyelid, the line of the mouth and the dabs of colour for the nostrils.

1 Gainsborough would place his model in a subdued light so as better to assess the overall composition.

2 According to a contemporary, the artist would place himself and his canvas at a right angle to the sitter so that he stood still and touched the features of the picture at exactly the same distance at which he viewed the sitter.

3 Gainsborough would initially mark the position of the sitter's head in a chalk often held in a pair of tongs to allow him to stand back from the canvas. When the painting was near completion, he would again use the chalk to mark alterations.

4 He would then block in the painting in thin paint. His daughter claimed that his "colours were very liquid, and if he did not hold the palette right, would run over".

5 Having blocked in most of the composition in thin paint. Gainsborough would concentrate on the head and area around it, before returning to complete the drapery and background.

ENGLAND

By contrast, the high period of English portraiture was characterized by an easy charm. Aristocratic privilege was worn lightly, and the sitters relaxed confidently, as in Thomas Gainsborough's *Mr and Mrs Andrews*.

Although 17th-century English history had been eventful, with the Civil War and subsequent restoration of the Stuart kings, the role of art in the culture continued to be marginalized. Art was still essential to give splendour to the lives of the rich and powerful, but French and Italian art was considered suitably prestigious, in prefer-

ence to the indigenous product. For grand projects, artists came over from Italy.

However, the Baroque style, favoured by the Italians, did not suit the inherent moderation of the English character. As with the Dutch, modest, reasonable art was sought: nothing too excessive in subject, spirit, or scale.

And, as with the Dutch, the increasingly middle-class culture demanded portraits. Art was required to capture likenesses, to underwrite social positions, and to endow great dynasties with immortality. Van Dyck had set a pattern of graceful, flattering, yet relaxed portraiture that persisted in the mature work of Thomas Gainsborough (1727–88).

In *Mr and Mrs Andrews*, an early work, Gainsborough shows his natural painterly skills in clearly depicting the landed gentry, pictured confident in their class and quietly aloof on their estate. Behind them is the rich productive land which gives them their position, and is their inheritance.

Like van Dyck in his portrait of Charles I, Gainsborough does not show wealth too overtly; it is merely implied. Where lesser artists would have set the couple in closer proximity to their grand residence, Gainsborough relies on their aristocratic posture, bearing and assurance.

Gainsborough's love of landscape is evident in this painting. The rolling fields, the sheaves of wheat, the ancient oak, are all painted with an interest that rivals the sitters, conveying his feelings for his native Suffolk countryside. The Italianate model of the classical landscape is no longer followed.

Gainsborough, like Reynolds, his contemporary and rival for commissions, had to respond to the English taste and appetite for society portraits. He couldn't secure commissions to paint the landscape subjects he preferred and the endless demand of these portraits filled his days.

In his later works Gainsborough endows the sitters with poised elegance; and renders their finery with a technical skill comparable to van Dyck and Watteau. Light, airy brushstrokes of thin paint in exquisitely modulated tones of grey and pink characterize his style, as in *The Morning Walk*.

In contrast to the self-conscious poses of *Mr and Mrs Andrews*, this couple stroll with apparently unaffected grace. In this mature work his light, fluid touch renders every gesture, every fold of lace, every coiffed curl in a filmy haze that is almost dematerialized, and contrasts with the stiff folds that encase Mrs Andrews. Correspondingly, the all-too-real landscape of the earlier painting gives way to a silvery Claudian setting, a landscape as idealized as its inhabitants.

Gainsborough's extraordinary rapidity and fluency of technique were noted in Reynolds' homage to him:

"... all those odd scratches and marks, by a kind of magic, at a certain distance ... seem to drop into their proper places."

Where Gainsborough's natural skills shine through, the figures in Reynolds' portraits are more solid, and rooted in the world. Reynolds had been to Italy, and had acquired

JOSHUA REYNOLDS – ARTIST AT WORK

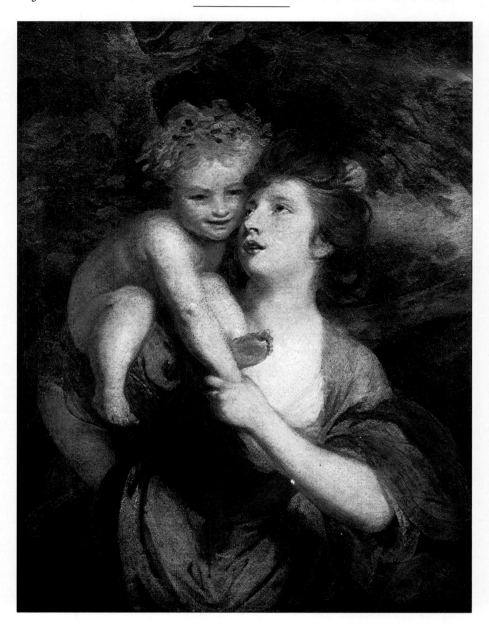

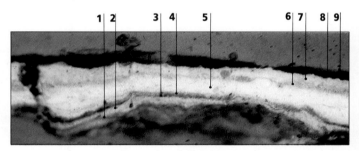

Joshua Reynolds was another enormously successful portrait-painter. Although he never matched Gainsborough's elegance and grace, he thought portraiture could be elevated by adopting classical poses and allusions, as in his portrait of Mrs Hartley and Bacchus *(1772).*

Cross-sections of most of Reynolds' paintings reveal a complex layering of pigment and media. Shown here, working from the bottom-most layers up, are: traces of a layer of size (**1**); thin whitish ground, perhaps in two layers (**2**); Prussian blue with black particles (**3**); lake pigment (**4**); thick opaque white (**5**); pale blue painted wet-in-wet to the previous layer (**6**); yellow with some vermilion and large white lumps (**7**); discoloured yellow-brown varnish (**8**); surface dirt and dust (**9**). This complex layer structure indicates that Mrs Hartley's drapery was originally violet in hue, made by superimposing a lake glaze (**4**) on top of blue (**3**). However, Reynolds changed his mind and applied a thick layer of white to obliterate it. He then painted on a very thin layer of pale blue (**6**), perhaps to serve as the shadow of a fold line, followed by a layer of brown-orange paint.

Reynold's brushes were up to 19in (47cm) long so that he could work standing well away from the canvas. He used an outmoded type of palette with a handle.

THE NUDE

*T*he female nude has a timeless association with fertility. In its most primitive form it spoke of procreation and the continuity of the species. In more sophisticated cultures, the associations are still with sexuality, but are more complex representations of woman.

In classical Greek and Roman art, the nude epitomized the ideals of god-like harmony and physical perfection in classical culture, but when interpreted by post-medieval Christianity, the female nude would be deployed as a contrast to the Madonna.

Where the Madonna was seen as a virtuous mother and symbol of gentleness and piety, the Renaissance revival of the Venus myth was to provide an alternative model of woman.

Venus would be naked where Mary was modest, seductive where Mary was decorous. Nudity represented human desire and temptation, symbolized by Eve, who first felt shame at her nudity after her fall from grace.

Botticelli's series of paintings of Venus were intended to accord with the ideas circulating amongst classical scholars at the Medici court, where Venus could combine the two aspects of archetypal woman – the divine and the earthly – Virgin Goddess and Earth Mother of mythology.

Here, the nude Venus was construed as the divine, the god-given, the immaculate being: Venus emerges from the waves in which she was created, the epitome of purity and beauty, idealized in concept but rendered in body in a sensuous form.

In the painting Primavera *(page 18)*, which is paired with it, she is clothed, dancing on the earth, a symbol of the fertility of nature and of the rebirth of the spirit

that accompanies spring. Ironically, the model for both of these paintings was the same, Simonetta Vespucci, Botticelli's mistress.

Many great artists have juxtaposed the ideal – the distant classical mode – and the image of sexual promise. Indeed, the furore over Manet's Olympia was triggered precisely because her sexuality was too blatant and undisguised – without artistic "decorum".

The Renaissance concept of the male nude holds to the Apollonian model: a god-like figure within a perfect body. This principle would be applied, in emulation of Michelangelo, through the centuries, even in Blake's representations of Satan. Not until the 20th century was a more vulnerable and fallible model evolved, reflecting self-doubt and anxiety.

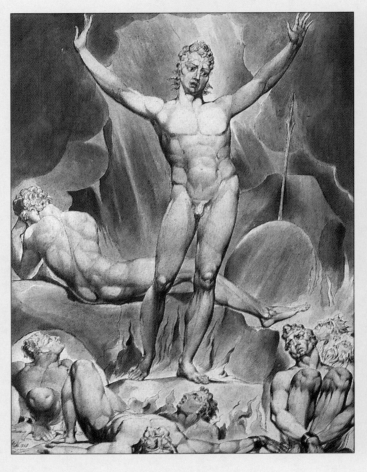

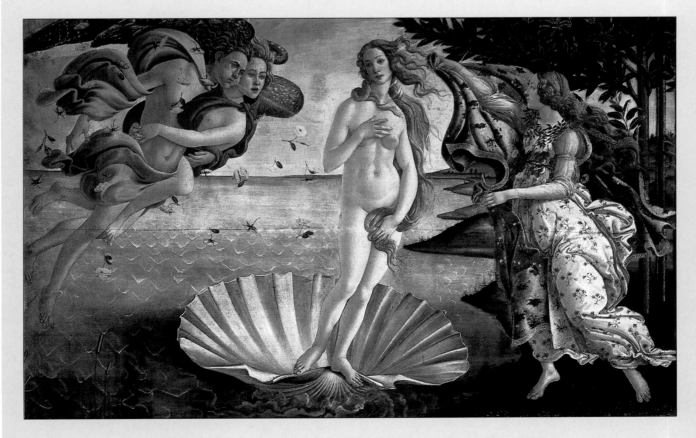

ABOVE LEFT
William Blake,
Satan and the Rebel Angels, 1808

ABOVE
Albrecht Durer, *Adam*, 1507

LEFT
Botticelli,
Birth of Venus, C1483

ABOVE Goya, *The Naked Maja*, 1797–1800

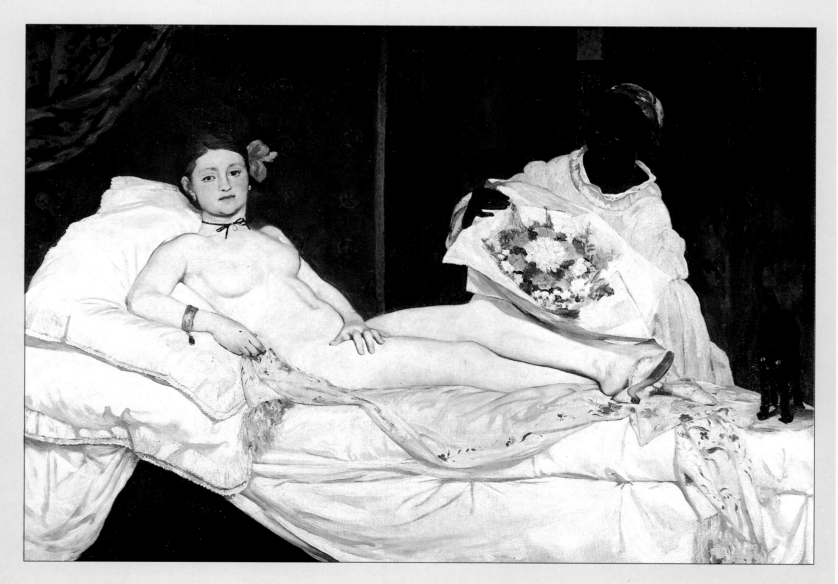

ABOVE *Edouard Manet*, Olympia, 1863

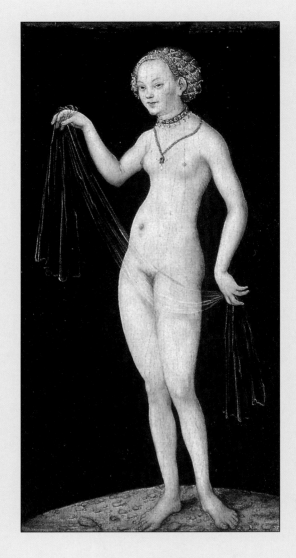

ABOVE *Lucas Cranach*, Venus, 1532

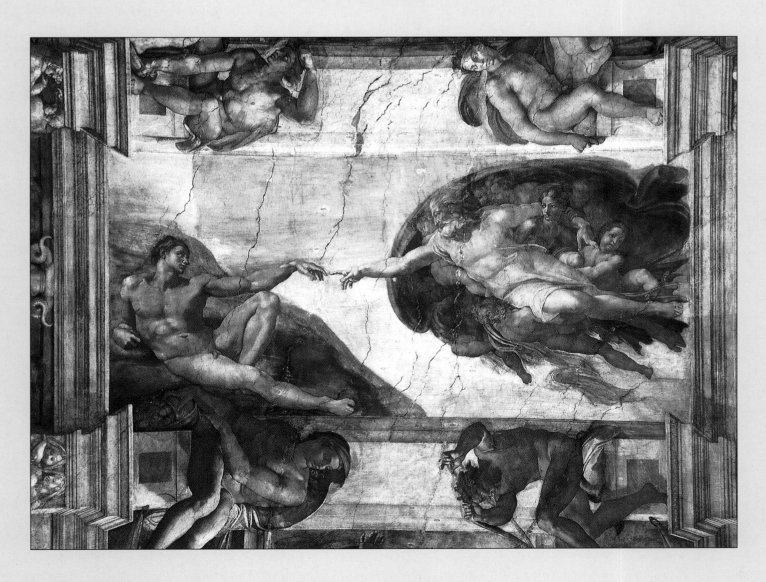

ABOVE Michelangelo, *The Creation of Adam*, 1510
(Sistine Chapel fresco)

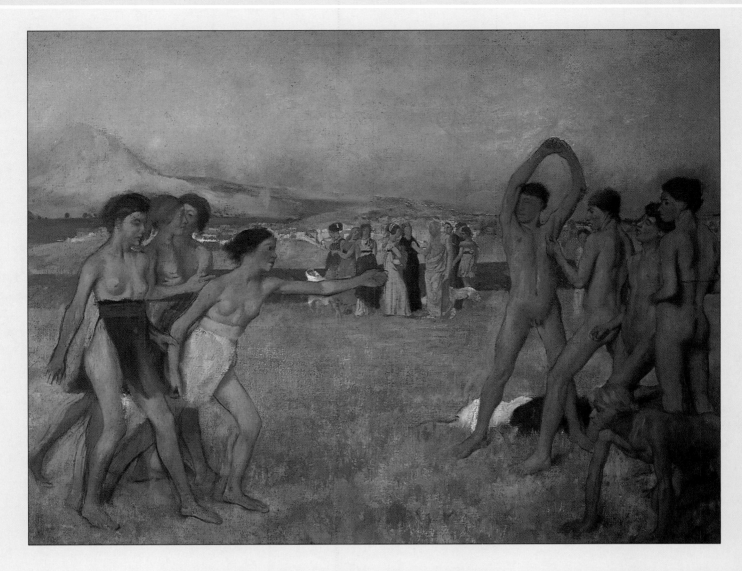

ABOVE Edgar Degas, *The Young Spartans,* begun 1860

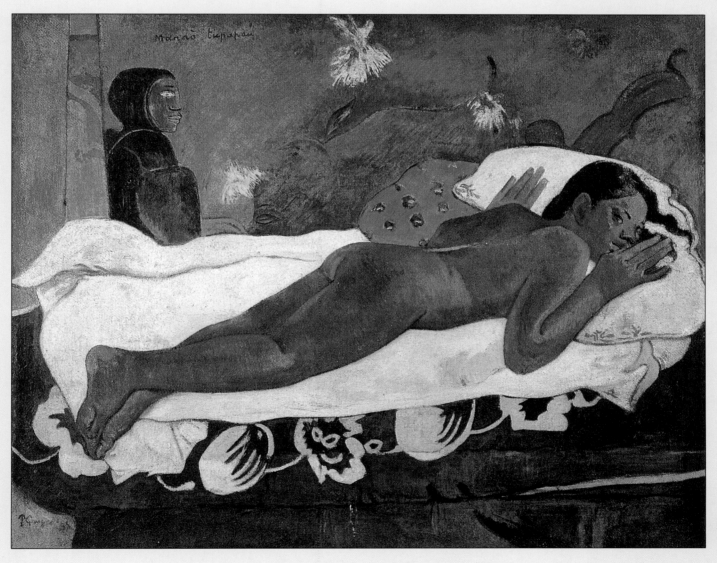

ABOVE Paul Gauguin, *Manao Tupapau: The Spirit of
the Dead Keeps Watch* 1892

The Marriage *(top)* and The Orgy *(below)*. William Hogarth used the stage-set formula for his rather melodramatic denunciations of social and moral wrongs in paintings that became extremely popularly as engravings. In the Rake's Progress series *(1735)*, the perfidious rake dissipates his wealth, and dies without dignity in The Madhouse.

a respect for history painting that was to shape his ideas about art for the rest of his life. Even though he could not satisfy his wish to paint the grand scenes he envisaged, he maintained a belief in the cultural importance of the Grand Manner. Reynolds was enormously prolific and his work is remarkable for its range and versatility. His studio, assisted by a costume painter and others, produced 150 portraits a year by 1758, and was earning the vast sum of £6,000 per year in the 1760s.

Founder member and first president of the Royal Academy, he delivered *Discourses* there, which set out his theories, and became the approved precepts for subsequent academic painting.

Reynolds' love of the classical world led him to promote the rational and the ideal over feeling and nature, and to develop an aesthetic based on these preferences that was to shape the hierarchy of English art. History painting was at the peak, portraiture somewhere below, and Gainsborough's favourite landscapes, along with other genre scenes, at the lowest level.

This relativity of status in subject-matter, going back to Renaissance times, left English artists of genre painting unable to gain acceptance. William Hogarth, Joseph Wright and George Stubbs knew that their work would never be treated as seriously as Academic art, nor would they achieve the corresponding rewards or status.

Reynolds had increased the prestige of art by his association with literary figures, much as the artists of the High Renaissance had done. His time was spent in the company of Doctor Johnson and Oliver Goldsmith. William Hogarth (1697–1764) also understood the particular cultural dominance of literature in English life. His interest in the new contemporary form, the novel, and his friendship with Henry Fielding are thought to have prompted him to paint serial works as a visual counterpart to the picaresque novel, nobably *The Rake's Progress* and *Marriage à la Mode*.

The sequence enabled him to fulfil a moral function; he thought that the role of art in society could be meaningful in promoting uplifting standards of behaviour, through narrative paintings reliant on literary modes set in real-life situations. This differs from Reynolds, who relied on an aesthetic morality, set in an ideal past.

Hogarth took his subjects from everyday life, and his characters are far from the timeless ideal that Reynolds recommended. The defects, vices, and affectations of his contemporaries were exposed to ridicule. Yet his individuality of vision helped forge the idea of an indigenous English art, rather than perpetuate the debt to Italian and French art that had prevailed for so long and was central to Reynolds' *Discourses* on aesthetics.

ABOVE *George Stubbs painted his monumental portrait of the stallion* Whistlejacket *(1762) in the period when he was preparing his famous book of plates,* The Anatomy of the Horse *(1766).*

BELOW *During the seventeenth and eighteenth centuries, artists kept their paints tied in small bladders. To extract some paint, the artist would prick the side with a sharp tack which had to be replaced to seal the hole.*

Nevertheless, Hogarth was the first to set up an Academy, which was a precursor of the Royal Academy, and to publish his own treatise on aesthetic theory, *The Analysis of Beauty*.

The reputation of George Stubbs (1724–1806) had also been diminished by the "animal painter" label. Categorized then as a mere sporting painter, he is now regarded as the equal of Gainsborough and Reynolds.

Stubbs' painstaking study of the anatomy of horses and his skill in rendering their appearance in paintings have a meticulous objectivity. He records the particular features of individual horses in the spirit of rational enquiry and scientific investigation characteristic of the age. Yet he renders them with a feeling for their beauty and grace, born from his long involvement with and understanding of horses.

As taste turned towards the overt emotionalism of Romanticism, Stubbs painted a series of dramatic paintings of a white horse attacked by a lion. The subject preludes the heights of Romanticism, as seen in the paintings of Delacroix some 70 years later, when the horse became a metaphor for human emotions and feelings.

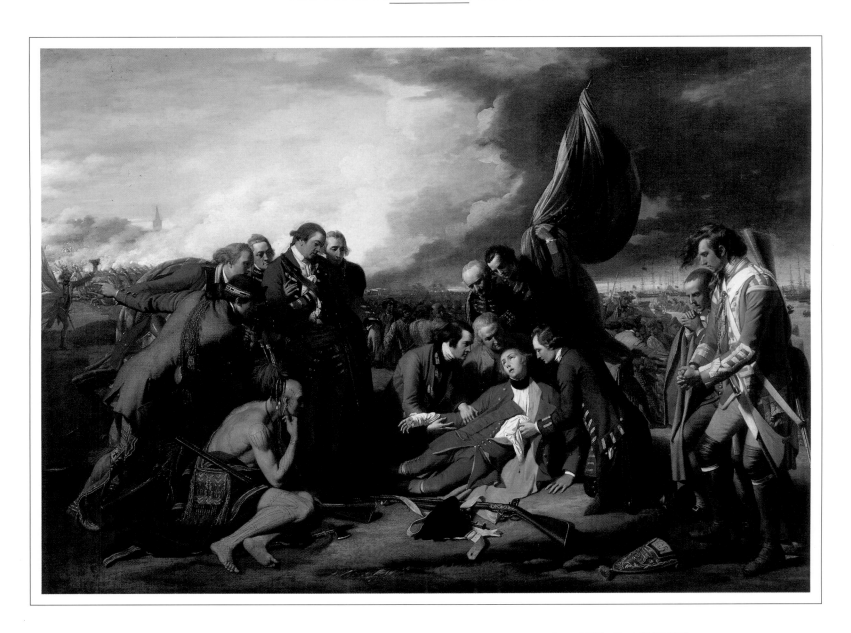

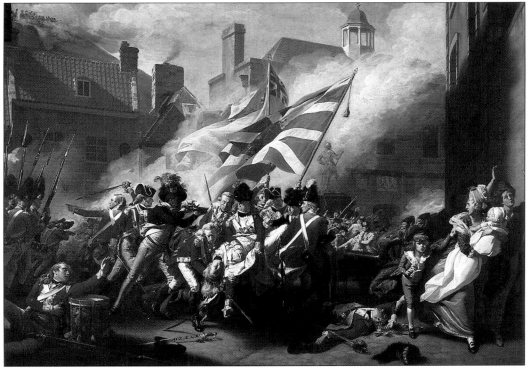

AMERICA

Amongst the artists who shared Reynolds' ambitions for art was Benjamin West (1738–1820), the first American painter to become internationally known. He spent three years in Italy, from 1760, and then arrived in London. His studies led him to paint history paintings in the fashionable neo-classical style so successfully that in 1772 he became historical painter to George III. A founder member of the Royal Academy, he became its second President, after Reynolds.

His most celebrated work is *The Death of Wolfe* (1770) where he painted the figures in contemporary dress, instead of in the classical garments which convention demanded to elevate the theme to one of timeless significance. This innovation was taken up by his countryman, John Singleton Copley (1738–1815), who also embarked on history painting, when he came to London in 1775, and initiated a trend for highly researched history paintings. These paintings documented the events and portrayed those present with a new immediacy, so that the contemporary spectator could feel that he was there, witnessing the important event.

SPAIN

Just as the Spaniard Velázquez had emerged as one of the giants of the 17th century, so his countryman Francisco de Goya (1746–1828) is regarded as perhaps the greatest artist of his time, certainly the most imaginative.

But where Velázquez's fluency had gained him early fame, Goya's career progressed slowly, with clearly defined phases. His early works filled with Rococo gaiety showed no sign either of the technical mastery of his mature period, or the terrifying power of his last works. It was in 1793, after a serious illness that left him deaf, that Goya began to work on nightmarish themes – published as a series of etchings, *Los Caprichos* ("Fantasies").

Like Rembrandt, Goya is as famous for his development of this print medium in its technical and expressive range, as he is celebrated for his paintings. He knew Rembrandt's work, but Goya's subjects led him to extend the range of the medium. Demons and bestial acts are manifestations of Goya's criticism of the extremes of human behaviour, especially the hypocrisy and brutality of the Catholic Church and the Inquisition's reign of terror, which still survived in Spain.

Los Caprichos has a cruel edge to the humour, morbid and menacing, a quality

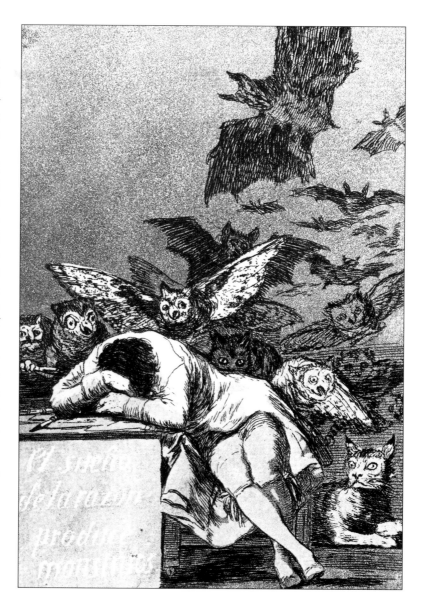

LEFT *After the illness that left Francisco de Goya deaf in 1792, he began to work on nightmarish themes. These were published in 1799 as a series of etchings called* Los Caprichos *("Imaginings").*

BELOW *At the beginning of the French occupation (1808–14), Goya witnessed the crushing of the popular uprising in Madrid. In his painting* 3rd May, 1808, *the horror of the execution of the defenceless men is caught with Goya's rage at such inhumanity.*

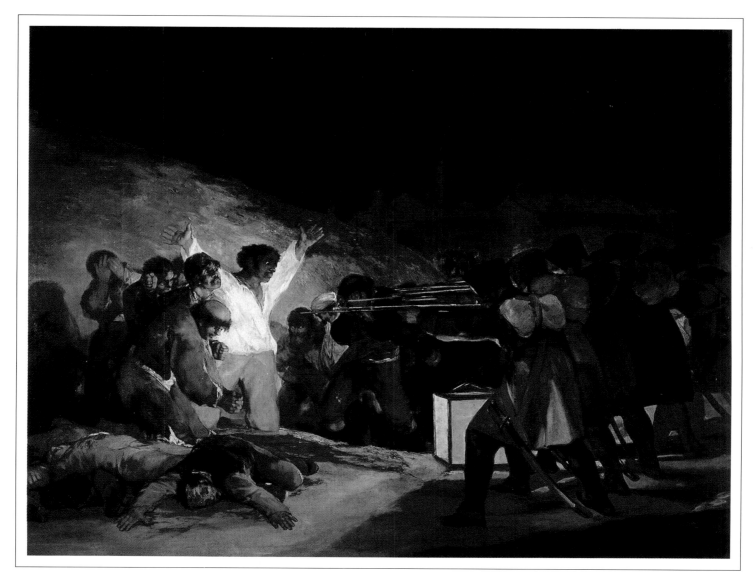

LANDSCAPE

While Italian artists of the 15th and 16th centuries had concentrated on perfecting the representation of the human figure in the image of God,

northern European artists had a tradition of closely observing nature and the world around them.

Where Italian art aspired to the divine, northern artists recorded their surroundings with meticulous fascination. Instead of the landscape acting as a complement to the figures or providing a suitable background to the main narrative, as it did for most Italian paintings, Bellini was to show that the landscape could set the mood of the painting. His poetic style, and rosy colouring, enabled those who came after him, like Giorgione, to exploit the expressive possibilities of landscape, investing it with magical or mythical status, which would enfold the figures, echoing their sentiments, and setting them apart from the time and space of everyday experience.

Landscape is an infinitely flexible subject onto which artists have projected their feelings about the world and their position within a cosmos of creation. While ecstatic religious intensity is shown in Samuel Palmer's pantheistic visions, a blank despair is seen in Paul Nash's epitaph for the futile sacrifice of trench warfare in the First World War.

ABOVE RIGHT Samuel Palmer, *The Cornfield*, C1830

RIGHT Giovanni Bellini, *Agony in the Garden*, C1459

BELOW JMW Turner, *Hannibal Crossing the Alps*, 1812

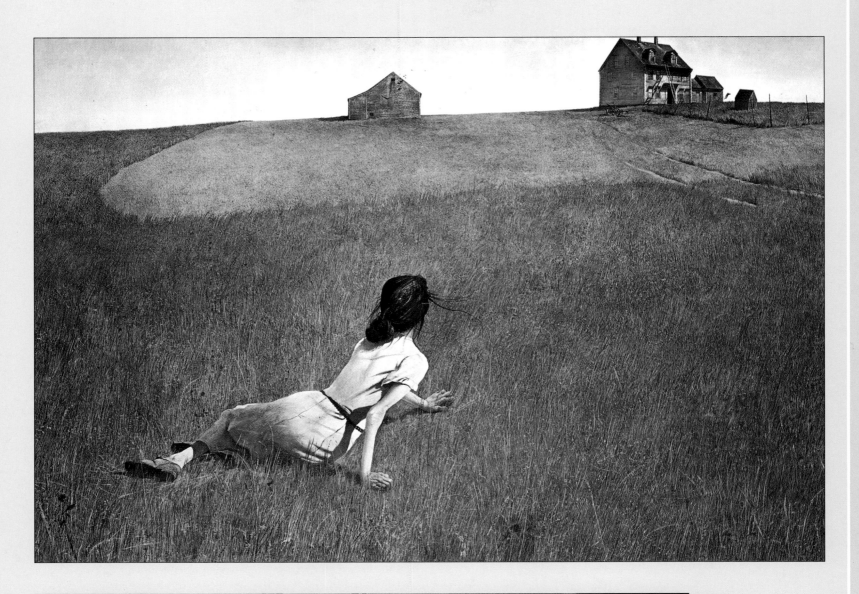

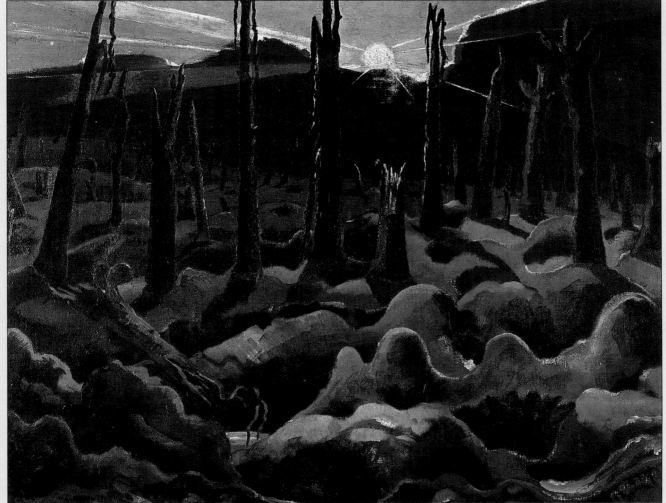

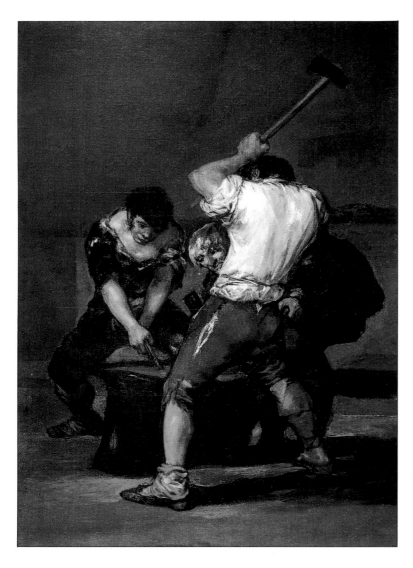

ABOVE The Forge (c.1812–15). Goya's originality was not merely a matter of technique: he also was one of the first artists to give a significant place to the labouring classes. His depiction of these workers shows a deep understanding of the skilled co-ordination of movement their activity involves.

that was to recur in the last great paintings. These have a more terrifying presence than the hellish scenes of either Bosch or Bruegel that were in the Spanish royal collection.

Goya, established as a fine portraitist, became First Court Painter to Charles IV, in 1799. The Velázquez portraits in the royal collection inspired him to embark on a lively and personal style, employing, like Velázquez, a fluid touch which subordinated detail to the overall conception. To this he added his own intensity of vision, giving each sitter vitality and a vivid presence.

Although Goya remained court painter under the French occupation of Spain (1808–14), he commemorated the invasion and the bloody suppression of popular revolt in his painting The 3rd May, 1808. During this period he painted Colossus, another subject of uneasy character, executed in the sombre colours of his last works, and with the same powerful freedom of handling. The subject may have political references, but it shares the nightmare mood of Los Caprichos, which was to manifest itself in the demonic last works.

This thread in Goya's work recalls a caption from Los Caprichos: "when reason sleeps, monsters are born". After another serious illness, Goya's later years were spent producing the "black paintings", which seem to despair of human nature, but at 78 he settled in Bordeaux, where he continued etching and painting with an increasing resignation until his death.

ROMANTICISM

Throughout northern Europe, the end of the 18th century and the beginning of the 19h century saw a change in the art market that was to have profound repercussions on the way artists painted, and on what they chose to paint. Just as the conditions in 17th-century Holland had led to a free market where artists had to compete and to adjust to clients' taste in order to sell their works, so artists in England and France would have to adapt. We have already seen how this limited the range of Gainsborough's work.

The art academies established in the 18th century dictated a standard of subject and style for art, which Reynolds worked so hard to uphold. But taste changed, and the poised arrangements so smoothly painted began to have a bland sameness that eventually provoked a change.

The art buyers were the increasingly influential and prosperous middle classes that were beginning to reap the benefits of the growth in commercial activity, driven by the industrial revolution and its cultural consequences. The new rich looked for subjects that were more relevant to their own lives – and that were attractive as well as accessible.

Annual art exhibitions were organized by the academies as a market-place for their wares. Such mass displays of art gave a competitive edge to the work of those artists who were different or eye-catching in subject or treatment. For the first time there was consumer choice, resulting in diversity of artistic approach which broke the monopoly of taste or convention decided by cultural shifts of history and national temperament.

The increasing enthusiasm for highly personal, emotional and dramatic themes in literature was to give a direction, and a name to the newly emerging style: the Romantic movement.

Predominantly a literary and musical movement, the Romantic poets, particularly Byron and Shelley, were to set the tone in England. Romanticism in art, as well as in music and literature, was opposed to everything that neo-classicism represented. Instead of reason, order and harmony, the tenets of the Age of Reason, the Romantics reinstated the autonomy of the individual, the primacy of the unfettered imagination and of unreasoned intuition, emotion and feeling – chaotic and exciting.

Instead of the collective ideal, the Romantic idea is represented by the isolated individual genius, set apart and impervious to the restraints and moral values of a sober society. And, in place of a stable artistic clarity, there was the fevered inspiration of feelings – personal visions expressed in vivid brushwork, free and loose in its exe-

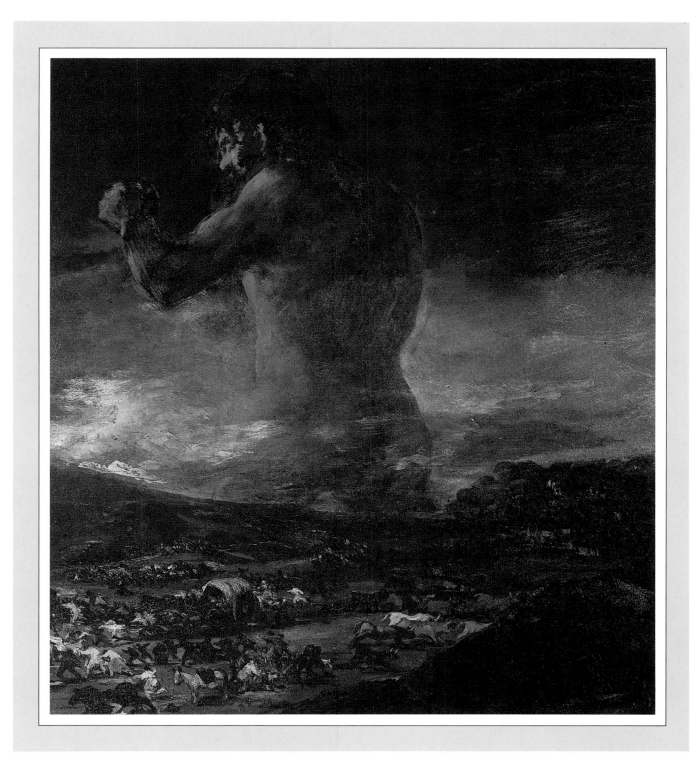

cution, rather than disciplined, tight and meticulously smooth and finished. Goya's *Colossus* and his late works are exemplary of this intense, personal vision.

The key elements that were to energize ideas about art and the artist and that persist to this day, were already present in Romanticism: that art is an expression of the individual spirit or a singular will, that is not necessarily God's will or society's, but that it is unique and essentially a private quest by which the artist pursues a path of inquiry. This self-willed approach isolates the artist and allows his creativity to undermine social and cultural norms.

None of the previous changes in the role of the artist had set him outside of these norms, although the academies consistently separated creative art from utilitarian work – whereby the superior status of artists could be maintained over artisans.

Romanticism gave artists freedom, but the price was that they would have to struggle and constantly prove themselves. In an expanding secular world of material and economic growth, art became less and less central to the concerns of society. Each artist was obliged to defend the value and integrity of his personal vision if he was to survive. Important patrons and collectors were the means by which fame and fortune were obtained; and those who ignored or spurned this patronage were doomed to obscurity and poverty – as befell William Blake.

If, however, they wished to guarantee success, the restrictions of the academies, and their formal constraints, still applied. To balance the needs of convention, and fulfil one's own aspirations, was a struggle that engaged Turner during the first half of his career. His desire to meet the requirements of history painting, and establish landscape painting as a subject worthy for serious consideration by patrons of art, was finally achieved later in his lifetime.

LANDSCAPE

A great period of landscape painting was opening in England, dominated by the pioneering efforts of Turner, and Constable. But the English art market did not share the Dutch enthusiasm for paintings of their own native countryside. In Holland, it has been suggested, the appeal of these local landscape subjects was stimulated by the lack of availability of real-estate: paintings could be surrogate "holdings".

The tradition of land ownership for the middle classes, aspiring to the status of the landed aristocracy, with their grand country houses set in landscaped parkland, was well established in England. William Kent and "Capability" Brown were commissioned by these new patrons as well as the old, to design actual landscapes, in preference to employing the painters of landscapes. Even

ABOVE Canaletto, famous for his views of Venice, gave his English views a Venetian flavour as in The Thames and the City of London from Richmond House *(1746).*

BELOW Returning to London in 1757 after six years in Italy, Welsh-born Richard Wilson, brought a look of Claudean scenery to British landscapes, as in Cader Idris.

so, these landscaped vistas were modelled on neo-classical visions as represented by the paintings of Claude and others.

For their acquisition of cultural status, therefore, the English preferred views of Venice as readily supplied by the Italians; Canaletto, Guardi, Longhi and others.

Canaletto (1697–1768) also applied his systematic vision to English scenes, giving a foreign accent to the native scene, as in *The City of London from Richmond House* or *View of London from Lambeth Palace.* Canaletto's accuracy and attention to detail were assisted by the use of the camera obscura. This optical apparatus was a precursor to the invention of photography which, at a later date, was to exploit the demand for topographical views of foreign lands.

Francesco Guardi (1712–93), although less successful than Canaletto in applying the technique of topographical realism, extended the genre. By the use of a looser technique, Guardi painted shimmering scenes of light and colour on water, where the architecture dissolves into an atmospheric haze, a prelude to Turner's evocative approach to landscape. However, Guardi's rapid, spontaneous effects were not to be popular until the later 19th century during the Impressionist period. He died in poverty.

Richard Wilson (1713–82), born in north Wales, was the first British artist to specialize in landscape inspired by Italian scenery, especially that of Venice. He travelled in Italy for six years from 1750, following in Claude's footsteps in the Roman Campagna. His style was influenced by Claude, and enabled him to sell many of his paintings to English "grand tourists".

On his return to England, Wilson applied the same pictorial style to the English land-

scape, producing Italianate views composed and painted in a manner that recalls Claude's timeless, sylvan serenity.

Wilson's importance rests on transcending the topographic recording of scenery, and his elevation of landscape as an art that is capable of sustaining intellectual and spiritual values and ideals. Such an achievement was to have a profound effect on Turner's later work.

Joseph Mallord William Turner (1775–1851) transformed landscape painting by his highly personal vision which invested the subject with a Romantic intensity. Turner admired the straightforwardness of Dutch

ABOVE *Joseph Mallard William Turner's* Dido buiding Carthage *(1815) pays tribute to the fame of Claude whose* Seaport *it was intended to complement.*

BELOW *The theme of sunlight on water was to recur throughout Turner's long career, varying in effect from the glare of morning sun in* Dido Building Carthage, *above, to the gilding of a Mediterranean sunset in* Ulysses deriding Polyphemus, *below, in which the intense brilliance of the sun highlights the critical moment when Ulysses taunts the giant.*

seascapes, but at the Royal Academy the influence of Reynolds' conception of the Grand Manner meant that landscapes as simple observed experience were unacceptable. A more elevated treatment was necessary, and Turner saw that Claude and Wilson had resolved the problem of bringing the same values to landscape painting that were prescribed for history painting.

His *Dido building Carthage* of 1815 was a direct homage to Claude, quoting from his *Seaport*. The classical language that Turner adapted from Claude was one where a historical or mythological scene provided the subject, set in the middle-distance of the

landscape, where it could be seen as distanced in time and space from the immediate present. The serene classical composition, with its antique architecture, was distanced further by the silvery treatment of the subject. All would be rendered ethereal in a silver or golden aura of light.

Again and again Turner employed the Italianate idealized landscape form, with banks of trees on either side framing a hazy view with water and figures, and classical subjects or allusions, but, from the age of 30 onwards, two aspects became increasingly dominant. The inheritance from Claude becomes a vehicle for dramatic subjects, or for brilliant effusions of light. Already in *Dido building Carthage* the architecture is dissolved in the intensity of the glare of morning sun on water. This theme was to recur throughout Turner's long career, from the gilding of the mythological subject, *Ulysses deriding Polyphemus*, to the late, *Sunrise, Norham Castle*, where the detailed scene of previous versions dissolves into a vapour of shimmering light.

Counterpointing this tranquil, luminous vein was another, increasingly influenced by Romanticism; dramatic, terrifying, violent subjects, according with Edmund Burke's recipe for the "sublime". Shipwrecks, avalanches and storms at sea pro-

ABOVE *Turner's later work relinquishes detailed description and drama in order to create luminous, hazy impressions which have, nevertheless, an intensity of vision.* Interior at Petworth (1835) *dissolves the subject in a veil of shimmering light, the product of a lifetime's study of colour and light.*

BELOW *Turner's paintbox shows some of the main equipment and materials he used. Powdered pigments were kept in glass bottles with cork stoppers. Prepared paint was stored in small bladders which can be seen at the back of the box. Metal tubes introduced from around the 1840s proved much more satisfactory. Turner seems to have used fairly large round and flat bristle brushes.*

vided an awesome heightening of emotional drama, and its equivalent in compositional treatment and execution.

This strand in Turner's work is represented by *Snowstorm: Hannibal crossing the Alps*, where the tiny human figures and even their elephants are dwarfed by the power and scale of nature. The snowstorm whirls in a vortex over the valley, blotting out the sun, and evoking the impression of man overwhelmed by the elements. Turner made rapid studies of weather and light effects throughout his life, and this painting draws on sketches he had made of a storm in Yorkshire. True to the spirit of Romanticism, the storm is symbolic of human emotions. Here, it presages Hannibal's ultimate failure, just as the Romantic poets used nature as a metaphor for human feelings.

Turner exhibited regularly at the Royal Academy, and won the patronage of art collectors, notably Lord Egremont whose house and estate he depicted. A public success, even if his personality was reclusive, Turner contrasts with John Constable (1776–1837), whose paintings of his native Suffolk countryside were much slower to achieve notice.

Like Gainsborough, John Constable never travelled to Italy, or aspired to the Grand Manner as Turner did. He concentrated

upon developing a truly vernacular subject-matter, without pretension or associations of a literary or classical nature.

Constable's close observation of nature, and the effects of English weather, owes much to Ruisdael and the Dutch 17th-century landscape tradition, but his importance lies in making significant art with the common-place subject. *The Haywain*, one of the Academy-sized canvases that he called his "six-footers", was exhibited at the Paris Salon in 1824, where it was awarded a gold medal.

Constable's freshness of approach and his innovatory brushwork were to provide an inspiration for Delacroix and, later, the Impressionists.

Because he worked directly from nature, Constable developed a style that caught quickly changing atmospheric effects – the glint of sun on water, or the sun breaking through rain-clouds to illuminate a patch of meadow. Today, in retrospect, it is difficult to recognize fully the revolutionary nature of his work at a time when the Claudean ideal was so dominant. Connoisseurs expected nature to be composed and coloured in Claude's manner, and Constable battled against this prejudice. He insisted that grass was green, not golden, and that pollarded willows or English elms should not be treated in the Italianate mode that Turner continued to employ through his life.

Constable's deep love of nature prompted him to write:

> "The sounds of water escaping from mill dams, willows, old rotten planks, slimy posts and brickwork, I love such things. These scenes made me a painter."

Constable's resolute observation of light and landscape was to have its most notable influence on French painting.

ABOVE *In works like* The Haywain *(1821), Constable struggled against the academic tradition with its Italianate landscapes. He worked extensively directly from nature, before the subject, painting rapidly, with separate strokes and blobs of paint to catch these transient effects.*

LEFT *John Constable,* Trees and a stretch of water on the Stour, *1836–7. In this ink wash we can foresee the influence that Constable's treatment of light was to have on the French painters.*

THE BODY OF ABEL FOUND BY ADAM AND EVE
BY WILLIAM BLAKE

1 For this "fresco", Blake used a mahogany panel. Good cuts of mahogany were readily available, and the wood usually made an excellent and stable support. However, this piece has since developed a marked convex warp.

2 Blake applied several layers of glue and whiting to the panel to cover the wood grain with an even, warm white, gesso ground. He probably rubbed the surface down and sealed it with more glue, as the surface is smooth and non-absorbent.

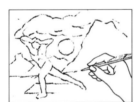

3 Next Blake drew a rough sketch probably with graphite pencil, working it up to a more precise drawing in heavier pencil, and black colour applied with a fine brush. A fine reed pen or quill may also have been used. There are no major alterations, and the drawing is clearly visible in the finished picture.

4 Blake then ground his pigments by hand in a dilute solution of the glue. The range of pigments was quite small and relied on traditional watercolour materials. The pigments seem to have been ultramarine, ochres, madder, black, Prussian blue, gamboge, vermilion and gold.

William Blake, poet and mystic, painted watercolour scenes from the Bible, realised with a truly visionary intensity, as in The Body of Abel *(c1824). An engraver by training, Blake worked on a small scale, but his figures remind one of Michelangelo in their passionate monumentality.*

5 The painting was built up by applying paint in small strokes, each little more than a stain on the white ground. The white highlights of exposed ground have been left, like the unpainted paper in a watercolour.

6 When the painting had almost been completed, a few details were re-worked and strengthened.

7 On drying, the paint would lose much of its shine, so Blake applied further layers of glue and then a spirit varnish. The varnish was probably mastic in turpentine which would give the painting a glossy surface and saturate all the colours.

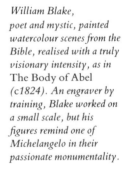

In this work, Blake used the following pigments: ultramarine (**1**), ochres (**2**), madder (**3**), black (**4**), Prussian blue (**5**), gamboge (**6**), vermilion (**7**), and gold (**8**).

VISIONARIES

One of the most remarkable figures of this period was William Blake (1757–1827), poet and mystic. From childhood he gave pictorial form to visions of an intensely spiritual nature. He despised established institutions, particularly the Royal Academy. Indeed, everything that was founded on reason and rationality became the focus, in engravings and watercolours, for his vividly realized ire. Sir Isaac Newton became Satan, crushing imagination and the life of the soul; and scenes from the Bible were enacted with a visionary intensity. Blake was trained as an engraver and his works are small in scale, though monumental in spirit. They show love of flowing linear pattern, perhaps derived from his early studies in the Gothic, although his figures are reminiscent of Michelangelo. Blake's originality and uncompromising nature condemned him to a life of rejection and near poverty, until John Linnell supported him from 1818. Linnell introduced him to the painter Palmer, who attracted a circle of like-minded artists called the Ancients.

Samuel Palmer (1805–81) had a visionary tendency even before he had met Blake, and it was intensified as a result of their friendship. His most characteristic works were produced in a short period in the later 1820s, when he lived in Shoreham, in Kent.

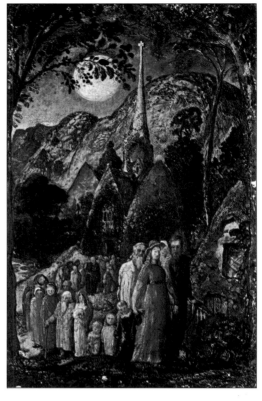

LEFT *Samuel Palmer's* Coming from Evening Church *was painted in the later 1820s when he lived in Shoreham, Kent. A friend and admirer of Blake, his own intense vision was nourished by scenes of nature rather than by Blake's Biblical metaphors.*

BELOW LEFT *Dante Gabriel Rossetti was inspired by his discovery of Blake and Palmer to initiate a mystical, romantic style. Rossetti was also a poet, and his greatest works, like* Proserpine (1874) *project a sensual and poetic image.*

BELOW *John Everett Millais's handling of* Autumn Leaves (1855/6) *infuses a sentimental allegory with a deeper feeling of melancholy.*

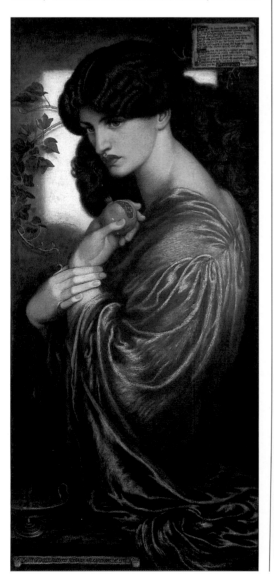

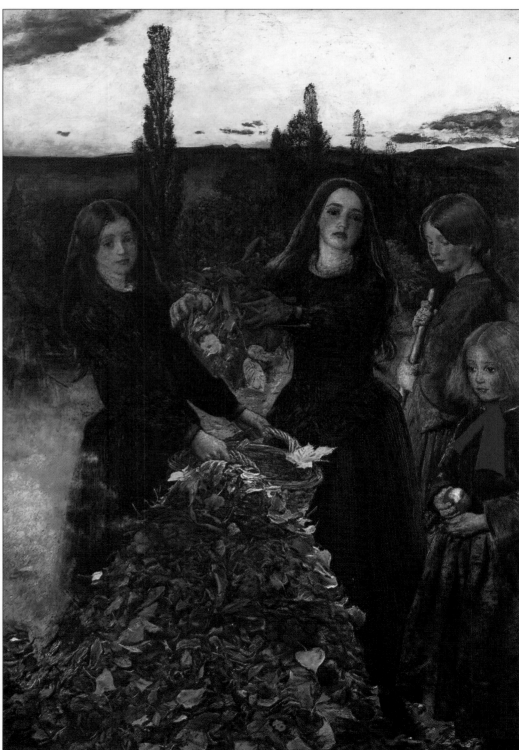

Here he painted intimate, crowded landscapes, charged with an intense feeling for every corner of God's creation. Coloured with a golden sunset glow, or silvery moonlight, these small works are charged with mystical potency.

The visionary, other-worldly qualities of Blake and Palmer inspired Dante Gabriel Rossetti (1828–82) to initiate an artistic frat-

ABOVE The Scapegoat (1854) by William Holman Hunt symbolizes the artist's obsessive nature and his love of allegory. He painted this picture by the Dead Sea, under a baking sun, so slowly that three goats died of heatstroke

BELOW The Stages of Life (c1835), one of Caspar David Friedrich's explorations of landscape with a "message", is peopled with isolated figures who interrogate nature as to the meaning of their lives.

ernity dedicated to a return to medieval values in life and art. With Holman Hunt and Millais, he called it the Pre-Raphaelite Brotherhood, to declare their allegiance to the simple piety and "pure" style of artists before the Renaissance, rejecting the sophistication of Raphael – the darling of the Victorian public.

Rossetti, also a poet like Blake, is considered to have produced his best work in the late series of portraits beginning with *Beata Beatrix*, a memorial to his dead wife. Painted in sombre, resonant colours, they are at once spiritual and sensual.

John Everett Millais (1829–1896) was gifted with a precocious talent and was briefly associated with the Pre-Raphaelites. His work, despite its virtuosity, is regarded as sentimental in the Victorian idiom. Perhaps the most atmospheric of his works, *Autumn Leaves* conveys an elegiac melancholy.

William Holman Hunt (1827–1910), the third founder member of the Pre-Raphaelite Brotherhood, remained true to its ideals, and painted subjects of a moral, symbolic nature in a minutely precise style using the vibrant new colours that had become available in the mid-19th century.

A similar dedication to a mystical Christianity lies behind the landscapes of Caspar David Friedrich (1774–1840), the greatest Romantic painter in Germany, where, as in England, Romanticism was primarily a literary movement. His introspective nature led him to pursue the idea of the spiritual significance of landscape in a life-long quest. The strong glow of moonlight, or the mists of dawn, envelope like a mystical veil the occasional figures in a silent, impassive isolation, as they commune with the spirit of nature.

ROMANTICS *VERSUS* ACADEMICS

In France, the 19th century saw a rivalry between neo-classical academicism, and burgeoning Romanticism similar to that in England. Jean-Auguste-Dominique Ingres (1780–1867) was a pupil in David's studio, and won the Prix de Rome in 1801. He worked in an incisive linear style, where colour was subordinated to line, and the paint-surface was characterized by a smooth evenness which he described as "like an onion skin".

His early portraits are given an icy coldness of surface, where even the "warm" colours have a bluish cast, and the flesh tones have an alabaster coolness, but which, moderated by the sensuously curving contours, give life and beauty to the paintings. The linearity of Ingres' method confers a flat, two-dimensional decorative surface on his work, despite the carefully graduated modelling.

During his 17 years in Rome and Florence, Ingres consolidated his style, and began to paint his favourite subject of bathers, alongside those of mythological inspiration. His repertoire was limited, as his technique was relentless in its perfection. These attributes were strongly criticized by the adherents of Romanticism, who considered his work sterile, and his learning and absolute discipline oppressive and ultimately stultifying.

The most vivid figure in French Romantic art was Théodore Géricault (1791–1824) whose life personified his ideals, and was the counterpart of his exciting painting.

BELOW *While in Rome, Ingres began to paint mythological themes, as in* Jupiter and Thetis *(1811). This is rendered with a glassy smoothness, in his relentless dedication to an ideal in form and subjects.*

RIGHT *Jean-Auguste-Dominique Ingres' "onion skin" technique gives an icy coldness of surface to* Mlle Riviére *(1805), moderated by the sensuously curving contours which give life and beauty to the painting.*

LEFT *In* La Grande Odalisque *(1814), Ingres again achieves a wonderfully smooth and sensual image.*

OEDIPUS AND THE SPHINX BY INGRES

Ingres, the first great radical of the nineteenth century, created a personal, sensual style that moved away from the grand manner of the late eighteenth-century Neoclassicists and evolved a new, individual idealization of form through an expressive use of line. Thus, despite a formal and academic training, Ingres' technique was unconventional and brought an intuitive and intimate grace to the stoic Neoclassical ideal.

1 A medium weight, irregular weave canvas was primed with a thin darkish red ground.

2 Ingres began with a graphite or chalk drawing to establish contours.

3 These were reinforced and thin shadows executed in a dark brown, probably raw umber. Also with this fluid wash the main features, such as the hair, were drawn in with a fine soft brush and fluid wash.

4 Modelling was built up in carefully gradated tones of light and shade. Flesh areas were smoothed and tones blended with a fan brush while the paint was still wet.

5 Highlights and individual accents of thick paint were added last.

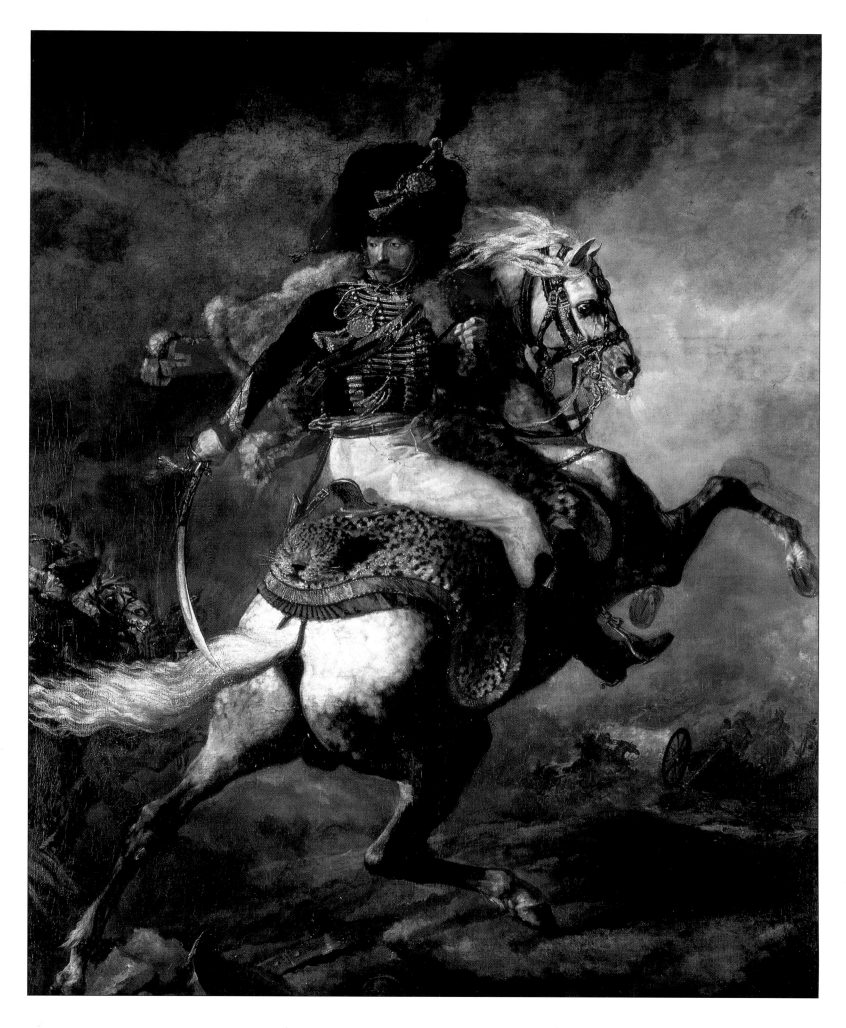

Like Byron, he lived life to the full, travelling widely, and absorbing the influence of Rubens, whose vigour, confidence and bravura handling were embodied in his work.

An Officer of the Chasseurs Charging, encapsulates the spirit and style of Romanticism. Géricault's passion for horses is evident in his portrayal of their spirit – the

ABOVE Théodore Géricault's extravagant An Officer of the Chasseurs Charging (1812), seems to be boiling with excitement. The horse symbolizes the romantic spirit, energy bursts out of the frame barely held in check by the rider, who represents man's rationality overcome by feeling.

horse is quivering with excitement and fear; the terrified eyes, flaring nostrils, and flowing mane raise the emotional pitch, and demand a response from the spectator. Ironically, Géricault was to die, just as his career was opening, as a result of a riding accident.

The painting demonstrates Géricault's love of dramatic action, vibrant colour and

swirling movement. The paint is applied energetically in the spirit of Romanticism, so different from Ingres' measured control. Géricault breathed life into his paintings using effects of light and atmosphere, and contrasts of tone and colour, that give immediacy to his compositions. Ingres' paintings are, by comparison, airless and mannered.

Géricault's most famous work, *The Raft of the Medusa*, provoked a violent reaction in Paris when it was exhibited, as it presented a recent event in horrifying emotional realism, depicting man *in extremis* – overwhelmed by the forces of nature beyond his control. Man is pitted against the elements, not in triumph but tragedy. As some die resolutely, others grieve silently, while some scream frantically into the abyss.

The macabre aspect, an element of Romanticism, is heightened by the dynamic composition, the dramatic lighting picking out the figures as in a spotlight. Their flesh has a waxen, deathly pallor, intensifying their helplessness before nature, and their ultimate fate.

Géricault's short career set the tone for Delacroix, who was to pit himself against the might of arid academicism and the bourgeois mediocrity that he felt Ingres represented.

Eugène Delacroix (1798–1863) shared Géricault's enthusiasm for Rubens, and for Constable, whose *Haywain* inspired them both to paint in a more spontaneous manner.

A visit to Morocco in 1832 provided Delacroix with material for exotic subjects. The Romantic thirst for adventure led many artists (and poets, like Baudelaire) to travel to the Orient, and North Africa, to immerse themselves in cultures that were seen as both visually rich and "barbaric". This "orien-

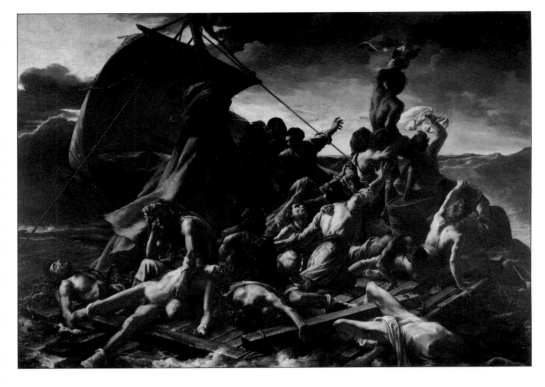

ABOVE *Géricault's sensational* The Raft of the Medusa *(1819), broke all the rules. Human fear and agony – and a pitiless fate – were painted without heroics or consideration for the viewer. The morgue-pale skin of the dead and dying intensified the morbid horror which was part of the "Romantic" sensibility.*

BELOW *The Romantic thirst for extremes of emotion and the exotic inspired Eugène Delacroix'* The Death of Sardanapalus *(1844).*

talism" has coloured Western perceptions of the East ever since.

This sensibility towards the exotic is vividly realized in *The Death of Sardanapalus*. The subject is violent, and shows horses and concubines at the moment of their execution. Sardanapalus had decreed that all his favourite possessions would die with him, and the canvas is filled with the dramatic swirling energy of slashing scimitars and desperate gestures. Like Géricault, he uses dynamic diagonals and vigorous brushwork to capture the turbulence of the moment to potent effect.

In his mature works, Delacroix applied paint in separate strokes of related colours, as Watteau had done, so that from a distance the surface shimmers brilliantly. This technique, and experiments with colour effects recorded in his notebooks, were later to lead to the developments in colour theory used by the Impressionists and Divisionists.

Arab on Horseback attacked by a Lion develops this technique, and demonstrates a confidence with complex figure groups that goes far beyond Rubens or Géricault. In this painting only the essentials are captured; everything else is left to the spectator's imagination – as is the outcome of the struggle.

Delacroix and Ingres were bitterly opposed, and if this painting is compared with Ingres' *Jupiter and Thetis* one can see why Ingres' insistence on clarity and candour were anathema to Delacroix, for whom colour and feeling were dominant. But in spite of their different approaches to painting, both shared a taste for the exotic, a distancing of aesthetic experience from the realities of the present. Both were true Romantics, projecting their vision into the past, or distant lands.

By the mid-19th century, French artists were to turn to the world around them for inspiration, just as Constable had done.

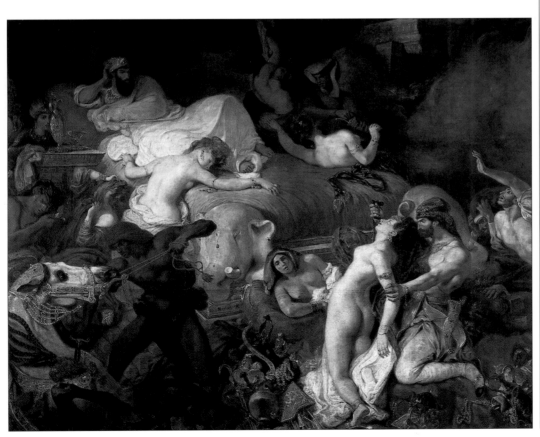

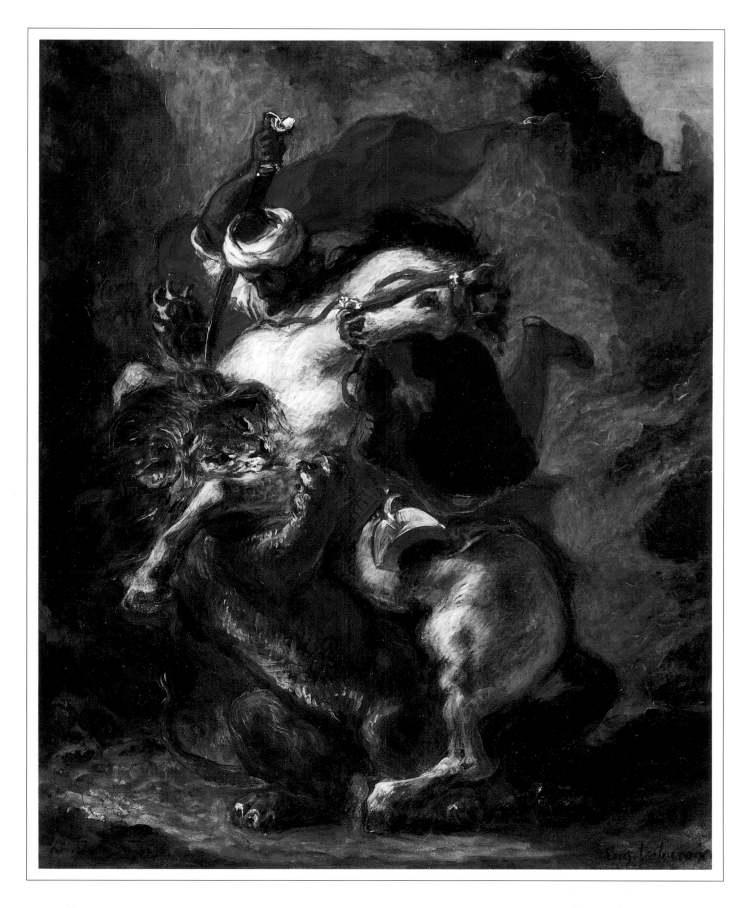

ABOVE *In* An Arab on Horseback attacked by a Lion *(1849), we see Delacroix' confident handling of complex figure groups – surpassing even that of Rubens or Géricault. Here Delacroix provides only the essentials – everything else, including the fate of the figures depicted, is left to the viewer's imagination.*

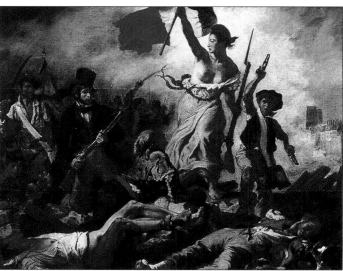

LEFT *Delacroix' enthusiasm for freedom extended from the personal to the national, in the Byronic Romantic style. His* Liberty Leading the People at the Barricades *(1830), is perhaps the most memorable tribute to the republican spirit.*

CHAPTER NINE
THE PURSUIT
OF MODERNITY
(1850–1900)

P aris had become the unrivalled centre of the art world in Delacroix' time, as aspiring artists from all over Europe and America came to Paris to study and, among other things, to see the paintings Napoleon had plundered from Italy. The dominance of Paris, with its influx of creative energy by artists, writers, intellectuals and musicians, was sustained until the occupation of Paris by the Nazis in 1940.

Artists who wanted to be taken seriously had to attain status in the Parisian art world, much as previous generations had made pilgrimages to Italy.

The spirit of Romanticism faded by the mid-19th century. The idealism of the past was replaced after the failure of the 1848 revolution and the subsequent oppressive rule of Napoleon III, by an era of realism. These events prompted a new air of pragmatic realism towards all aspects of life. In European literature, the social condition

ABOVE The Village of Avray *is typical of Corot's rejection of the idealized landscape. The landscape is realised with a clarity that anticipates Cézanne.*

OPPOSITE *Monet recorded the shifting effects of colour on the façade of Rouen cathedral at different times of day in a series of works painted in 1894. In each canvas the heavy grey stone façade seems to dissolve under a veil of refracted points of light. Colour dematerialises the surface, yet the dense impasto of the paint parallels the richly-carved stone. Limpid coolness is conveyed in* Harmony in Blue, *while the vigour of a bright mid-day shines through* Harmony in Blue and Gold *(detail opposite).*

became central to Dickens, Tolstoy and Dostoevsky, as well as to Stendhal and Balzac. In France there was overt criticism of bourgeois mores. Poetry and music had led the Romantic movement, yearning for the evocative and intangible, as personified above all by Chopin. Now it was the novel set in everyday experience and social reality – typically, Emile Zola's *Germinal* – that drove the Realist tendency in the second half of the 19th century. Balzac derides the Romantic artist in his *Chef d'oeuvre inconnu*, whose egotistical insularity and his fantasies and dreams cause him to lose touch with reality in his quest for perfection. Balzac saw that the pursuit of aestheticism could cut the artist off from society, and that this would render his work devoid of meaning. Zola, too, associated republicanism with naturalism. The social and political significance of Realism was acknowledged by the antagonism of the establishment.

RIGHT *Jean-François Millet – himself from a peasant family – gave the striding figure of* The Sower *(1850) a new dignity. Now that the artist had made the peasant heroic he unwittingly made him a potential revolutionary.*

REALISM PAVES THE WAY

Realism in painting was to be associated with revolution and change; whereas the all-powerful Académie des Beaux-Arts and its school, and the official exhibitions (the "Salon") stood for tradition, and the maintenance of stability, endorsing reactionary attitudes in politics, as well as in art.

Founded on scientific objectivity, the new realism meant clear-sighted impassivity and honesty, in place of airy ideals, or romantic fantasy. In art, as in literature, the new approach was focussed on truth to nature and experience. The art of description requires, in reality, choosing appropriate subject-matter.

Before this, Jean-Baptiste-Camille Corot (1796–1875) had already set an example of representing nature realistically, without idealizing his subjects. Remaining faithful to his aim "to reproduce as scrupulously as possible what I saw in front of me", he painted landscapes with an unprecedented directness of vision.

The Village of Avray is typical in its unremarkable subject. Corot was to have an enormous influence on artists for the rest of the century, both for taking a subject previously thought unworthy to represent on canvas, and for treating it in an uncompromisingly honest way, without emphatic gesture or focus. Without pointed signification or narrative, attention was drawn to the painterly marks and gestures themselves. Even in this work of 1840, Corot's flattening use of light produced a surprisingly modern-looking painting.

An equally low-key dedication to the faithful representation of nature, without literary, historical, or moral embellishment was practised by the Barbizon school.

Working near Fontainebleau, the group was inspired by the love of nature expressed by the 18th-century philosopher Jean-Jacques Rousseau. In addition to Corot's idea of truth to nature, this group evolved the practice of making rapid sketches in the open air that was to inspire Monet in the 1860s. The most notable painters in the Barbizon school were Théodore Rousseau (1812–67), and Charles-François Daubigny (1817–78).

Jean-François Millet (1814–75) joined them in 1849, and stayed for the rest of his

BELOW The Stonebreakers *by Gustave Courbet, leader of the Realist movement in art, were not studio models but real labourers observed by him as they worked in a field.*

life. Unlike other members of the Barbizon school, he painted large-scale figure compositions which have an idealizing and sentimental tone. Millet's substitution of peasants for kings or heroes in his attempt to make "the trivial . . . sublime" caused dismay amongst the Salon-going public. *The Winnower* was exhibited in the sensitive year of 1848, and subsequent works, like *The Sower*, and *Man with a Hoe*, alarmed a bourgeoisie in constant fear of revolution.

There was nothing overtly threatening about the demeanour of these peasants, but the large-scale figures towered over the Salon spectator since a low viewpoint was used; the sombre colouring of *The Sower* enhanced the powerful impact of the striding figure, who takes on a dignity absent in the genre of peasant paintings. Millet came from a peasant family himself, but in making the peasant heroic he unwittingly made him a potential revolutionary. For most of his own life Millet endured poverty, as it was clear that his paintings were not appreciated, or were even unacceptable, to the buying public at the Salon. He had great influence on both Pissarro and Van Gogh.

The work of Honoré Daumier (1808–79) was also intended to invest the common people with dignity and weight, but he achieved this by satirical attacks on the pretensions of those who held power and wealth. The subjects of his pitiless lithographic caricatures ranged from the hypocritical clergy to Louis Philippe, which led to his imprisonment in 1832. When the régime suppressed satire he turned to social commentary, returning to political subjects.

Daumier worked hard, making over 4000 lithographs during his lifetime. This daily grind drained his creative energy, although he went on painting until he lost his sight late in life. His unsentimental

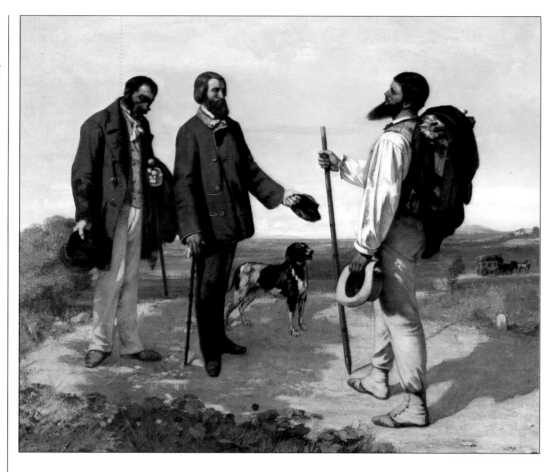

ABOVE *Gustave Courbet's iconoclastic and direct approach to the subject can be seen in* Good Morning, Monsieur Courbet *(1854), where he represents himself encountering a patron, without servility, as man to man.*

BELOW *The work of Honoré Daumier, as in* 3rd Class Carriage *(1862), demonstrates forceful, caricaturing style, and conveys his sympathy for the disadvantaged.*

observations of contemporary social life are in tune with his precept that art should "be of its time".

Gustave Courbet (1819–77) remains the dominant figure in this period. He was a controversial and vocal critic of the *status quo*, and set the pattern for the role of the artist-as-hero, pitting himself against "establishment" norms and behaviour.

The leader of the realist movement in art, he took for his subjects scenes and events of everyday life. He recorded the remorseless poverty of the *Stonebreakers*. The ragged clothes and the soul-destroying labour were shown unflinchingly by the closely observed detail of real stonebreakers in the field, not posed models in the studio as in previous practice. Courbet sympathized with the life of the common people, despised bourgeois privilege, and actively worked for a more democratic society. His stand led to imprisonment after the fall of the Paris Commune in 1871, and exile in the last years of his life.

His immediate influence was in the direct, brutal honesty of works like *The Stonebreakers*, and in the iconoclastic *Good Morning, Monsieur Courbet*, in which he represents himself encountering a patron. Both are in contemporary dress, like a modern history-painting. This statement of Courbet's confidence in his own place in the world is executed boldly, the whole scene flooded with bright sunlight, as though to dispel the gloom of academic canvases. He insisted that art should abandon historical and poetic subjects. When asked to paint angels in an ecclesiastical commission, he said: *"I have never seen angels. Show me an angel and I will paint one!"*

DÉJEUNER SUR L'HERBE BY EDOUARD MANET

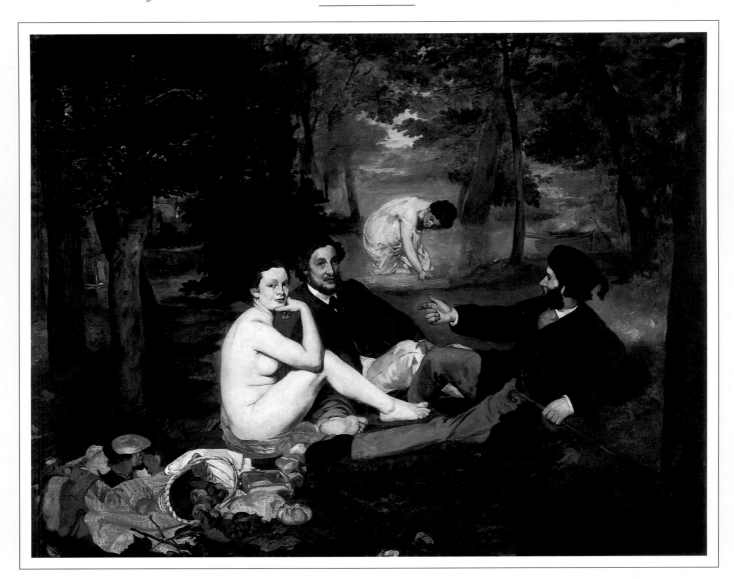

Edouard Manet's Déjeuner sur l'herbe, *painted in 1863 and rejected by the Salon, stirred up public outrage and won the attention the artist was seeking.*

1 A pale ground, apparently a creamy off-white, was used to create luminosity and flatness.

2 The lighting was full-faced to eliminate the half-tones in the modelling.

3 There is no evidence of underdrawing, and the figures may have been sketched in with a dark fluid umber.

4 Scumbles corresponding to the local colours were used to block in the figures and forms.

5 The build-up of the paint layer was concentrated on the central group of figures using a rich, oily paint.

6 The background and areas around the figures were reworked in translucent, thinly scumbled paint.

7 Curving, flowing brush-strokes were used to define the figures. The grass was painted around the figures after they were completed.

8 Manet would often scrape down the thick, impasted areas which he wished to rework. A thin, light varnish was painted over the completed work.

MANET AND THE SHOCK OF THE NUDE

Edouard Manet (1832–83) was also treated as a revolutionary because of his choice of subject-matter, but, like Degas, his impeccably bourgeois background led him to seek success through conventional channels, and to adopt the dress and demeanour of his class. Although he was regarded as breaking with the past, Manet intended his work to be exhibited at the Salon and to be taken seriously by using the only route to fame and success available at that time. Favourable Salon reviews could lead to prosperity. Rejection by the Salon jury or poor reviews could spell ignominy and financial failure.

By the end of the 1870s, this would change, but when Manet's *Déjeuner sur l'Herbe* was rejected in 1863 after his previous successes, he was seriously aggrieved.

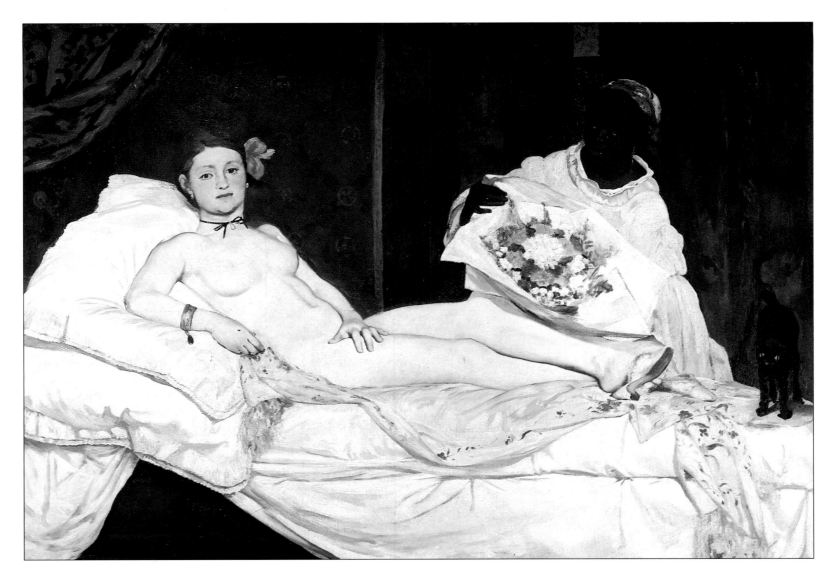

ABOVE *Manet's* Olympia, *shown in 1865, courted even more hostility, and the same gratifying publicity. Critics found the painting's art-historical pedigree all the more unacceptable because of its lack of "Old Master" gloss and conventions.*

Huge numbers of paintings were shown, displayed *en masse*, stacked high on the walls of the Salon. Such a presentation led to competitive strategies by artists vying for attention. It encouraged boldness of subject and visual treatment in order to catch the eye. Manet's work can be seen in this context – calculated to attract notice, and draw comment in the newspapers.

Déjeuner sur l'Herbe scandalized the Parisian public, and reviewers alike. A naked woman was set beside two men dressed in contemporary clothes. This brazen juxtaposition created outrage. The subject had been treated by Giorgione, in the *Concert Champêtre*, and the grouping followed a work by Raphael. These references were clearly established, and Manet was "quoting" them in this provocative work, but in a way that made the contemporary viewer uncomfortable. It was as though one might have intruded on an intimate scene in a public park in Paris and averted one's gaze. The overt sexuality was too immediate and apparent, set in the present, without the distance of time or mythological layering of earlier works.

Manet's treatment of nudes as real people, living and breathing, confronting the viewer by direct eye-contact, was too explicit. The availability of sex undermined the language and conventions of art and polite society, and mirrored the increasing prostitution in contemporary Parisian society.

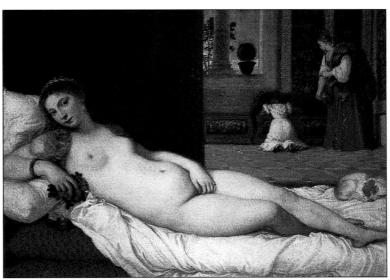

Even more problematic was *Olympia*, shown in 1865. A reclining nude, established as a convention of classical and romantic art, but set – to judge by its contemporary setting, and the explicit gaze of the naked woman – in a Parisian brothel. The quotations from art – historical precedent – Titian, Velázquez, Goya – made the work no more acceptable.

Yet Manet was in many ways a traditionalist – in that he composed the work from drawings and studies, and executed the final work in the studio. The novelty of his work was in fusing together a continuity with the past traditions in art, and an awareness of contemporary ideas current in Parisian artistic life which challenged the past.

ABOVE *Titian's* Venus or Urbino *(1538). Just as this painting was the model for Manet's painting,* Olympia *itself became an icon for subsequent painters.*

ABOVE *This sample of an ordinary weight canvas dates from about 1900. It has a white "absorbent" ground of the type preferred by Neo-Impressionist painters. This sample was primed probably with a single coat of glue and chalk based primer, and was widely sold by French colour merchants.*

BELOW *Chevreul's Chromatic Circle of Hues was first published in 1839. His experiments showed how colours opposite each other on the colour circle – complementary colours – are mutually enhancing.*

THE INFRASTRUCTURE OF ART

Demand was matched by a rapid increase in supply for this expanding art market. Unpretentious subjects were drawn easily from the Dutch genres. Beginning in the early 1860s, studios proliferated in Paris, followed by a network of dealers, colour-merchants and galleries.

Dye chemists were constantly improving the range and brightness of pigments available to artists. Synthetic colours began to replace the limited, and sometimes expensive, colours used by artists since the Renaissance. Ready-made paint in tubes reduced the craft element, and enabled the traditional layering of paint to be modified. Now paint could be applied more directly, and spontaneously. The portability of paints in tubes made outdoor painting of subjects far easier. Transient moments, movements and feelings could be captured thanks to the new technology.

Eugène Chevreul's systematic analysis of how colours affect each other, *Principles of Harmony and Contrast*, was published in 1835, and became increasingly influential as the decades passed. Ogden Rood, in *Modern Chromatics* (1879) elaborated theories of colours and Charles Henry's theories, too, were used as the scientific basis in the development of Impressionist and Pointillist techniques.

THE MARKET FOR ART

In 1863 the Salon was deluged with works, and unprecedented numbers were rejected, so many that Napoleon III ordered a *Salon des Refusés* to be opened, "so that the public could judge for themselves". There was a boom in the art market in Paris, parallel to the conditions that created artistic growth in 17th-century Holland. Napoleon III's régime, from 1848 to 1870, led to a climate of confidence and economic expansion, which advanced an explosion of artistic activity in Paris.

A sequence of conservative governments, despite occasional republican uprisings, worked in favour of middle-class interests, fostering economic and commercial growth. This in turn consolidated a mood of stability and well-being. Industrial and commercial activity was encouraged by increased investment and credit.

At the helm of this thriving economy was the bourgeoisie. As a group, its wealth increased enormously, and its members looked for ways to spend these surpluses that would give immediate pleasure and reflect their new circumstances.

In Paris, a whole spectrum of leisure and pleasure pursuits, ranging from rowing on the Seine to racing at Longchamps, from the theatre and opera to café life, expanded the places to go and to be seen. Fashion and shopping became an integral part of the spectacle of leisure. New shops, particularly in the display of affluence encouraged by the "department stores", made shopping a social and cultural event.

As in 17th-century Holland, an entrepreneurial class demanded a complementary culture, tangible and accessible. Visibility was important. New paintings, their public display at the Salon, and their private acquisition as status symbols and investment in contemporary culture, combined display with sensual gratification. Art, without learned references or daunting religious overtones, could readily be understood and "consumed". Art would give refinement to their reception rooms, or act as a conversation piece at the dining table.

BELOW *These scale pictures show typical nineteenth-century artists' brushes, taken from French colour merchants' catalogues of the period.*

ART "PUNDITS" OF THE PRESS

The apparently "revolutionary" art of the Impressionists was of, but ahead of, its time. At first much reviled, it was to be totally absorbed into the culture of Modernism and become the most accessible, and increasingly popular, art understood and appreciated in the 20th century.

In the first decade of the movement, however, the Impressionists' work met with hostility, both from the press and the public. The Académie des Beaux-Arts, the regulating body of official art, still promoted history-painting, and the Salon juries gave precedence to works according to the accepted conventions of subject-matter, and laborious academic execution. These taste-makers set a pattern which did not challenge the complacency of the bougeoisie. The press reviews of the day further exacerbated the public's contempt for the modern artist – frequently reviled as unstable and dangerous.

Newspapers and periodicals devoted a large amount of space to cultural debate, and reviews of art, music and literature, since the "free press" was limited in its political comment after Napoleon III introduced censorship. Discussion of art familiarized the general readership with the forthcoming theoretical debates, and famous literary figures lent their prestige to the level of discussion. When the poets Baudelaire and Mallarmé, or the novelist Zola wrote about realism, everyone took note. This climate of serious intellectual debate in France reached back to Diderot in the 18th century, and persisted until Breton's writings on Surrealism in the 1930s.

To attract public attention, however, many Salon reviews used a sensational tone, deliberately extreme for the sake of good "copy". The vilification of Manet's *Olympia* (1863) can be contrasted with the success of Alexandre Cabanel (1828–89), whose *Birth of Venus* was painted in the same year, and

exhibited at the Salon to rapturous acclaim. But who, today, recognizes the name of Cabanel?

Manet's painting was exhibited at the Salon des Refusés in 1865 where it immediately drew violently hostile criticism.

The critic Amédée Canteloube fumed:

> "Nothing so cynical has ever been seen as this *Olympia, a sort of female gorilla, an India-rubber deformity surrounded by black, lying on a bed, completely nude . . . her hand clenched in a sort of indecent contraction."*

The beginnings of "modern" painting can be seen in Manet's technique and unusual subject-matter. The poet and critic, Charles Baudelaire, the champion of Delacroix, had written, 20 years earlier:

> "The heroism of modern life surrounds and presses upon us. We are quite sufficiently choked by our true feelings for us to recognize them. There is no lack of subjects, nor colours, to make epics. The painter, the true painter for whom we are looking, will be he who can snatch its epic quality from the life of today and can make us see and understand, with brush or with pencil, how great and poetic we are in our cravats and our patent-leather boots."

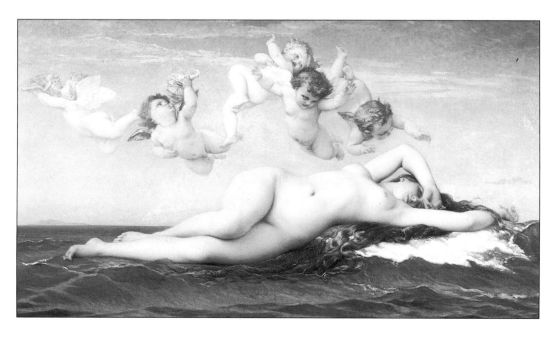

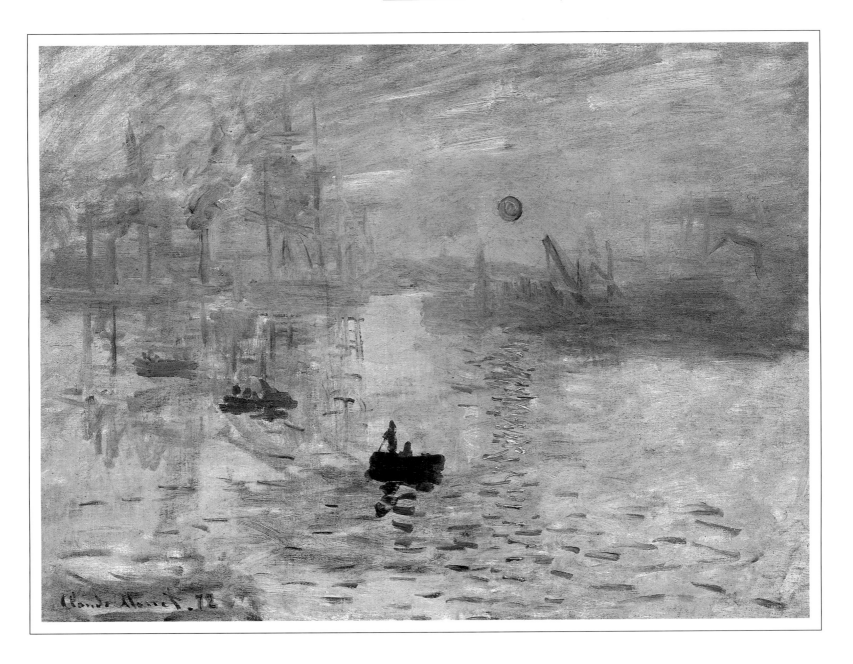

IMPRESSIONISM: LIGHT AND AIR

The group title "Impressionists" was originally intended as a derogatory term, by a critic who thought Monet's *Impression: Sunrise* outrageously sketchy and insubstantial when it was shown at the first exhibition of this genre in 1874.

The new harbour at Le Havre that it depicted at sunrise was not itself insubstantial, although the detail of cranes and ships is dissolved in the atmospheric light. The diffusion of light is rendered in fluid strokes of diluted paint which contrasts with the thick impasto of the glowing sun. Monet had responded directly to what he saw, with a directness few could equal.

For Claude Monet (1840–1926), the new approach to painting grew directly from the realism, not of Courbet, but of the Barbizon school. The method and technique of direct observation, and of faithfully representing the effects of light on canvas in an uncomplicated manner; images of nature without any cultural references or political overtones – appealed to Monet.

He and Frédéric Bazille (1841–70) painted in the open air, at Barbizon, in 1864; but as early as 1856, Monet had painted *en plein air*

ABOVE *Monet's* Impression: Sunrise, *shown at the first Impressionist Exhibition held in 1874, which provoked a disapproving critic to invent the group title "Impressionists"*

BELOW *Monet was immensely prolific and painted the effects of light and water in all weathers. When the ice on the Seine broke up in January 1880, he painted 17 canvases of the ice-floes in the few days during which the conditions lasted. Each canvas, as in* Break-up of Ice, *represents a distinct type of still weather: the orange sun glints , imparting a brilliant glow, but without warmth.*

with Eugène Boudin (1824–98) at Le Havre on the Normandy coast. Boudin pioneered rapidly executed scenes of the new middle-class pastime of excursions to the seaside. Like Baudelaire, he thought contemporary life a worthy subject for painting.

In Monet's *The Beach at Trouville*, the influence of Boudin and Manet can be seen: starkly contrasting tones and solid flat areas of rapidly applied paint emphasise the painted surface of the work.

ABOVE Monet developed
a practice of returning
again and again to a
subject, so that he could
closely observe the
changing effects of transient
weather and atmospheric
conditions, catching – in
Four Poplars (1891) –
the brilliance of sunlit trees
against a vivid sky.

LEFT The Beach at
Trouville (1870). One of
Claude Monet's rapidly
executed scenes which
developed the theme of
excursions to the seaside.

MONET AND RENOIR AT LA GRENOUILLIERE

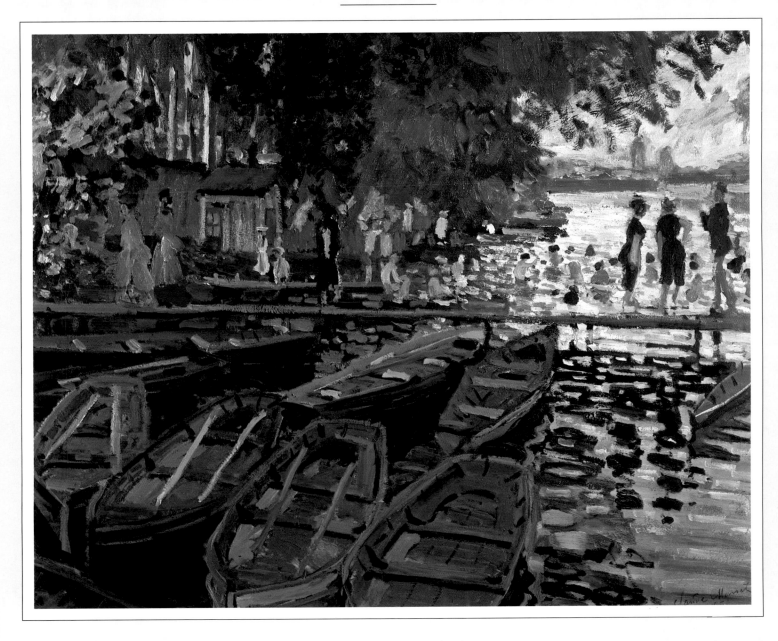

In the summer of 1869 both Monet and Pierre-Auguste Renoir painted scenes of leisure at La Grenouillère. Monet (above picture) unified the surface of his canvas into a shallow pictorial plane by the use of large, undisguised brush-marks over the entire surface. The bold, vigorous technique of his painting, originally intended as a sketch, distinguishes his work from the softer marks of Renoir (left) – and became the ideal of the Impressionist school: a rapidly executed work, painted all at once in front of the subject, en plein air ("in the open").

RIGHT *Renoir's later painting of a similar scene* The Luncheon on the Boating Party *(1881), demonstrates his assured handling of a complex group of figures who are brought up to the picture plane, so that the spectator seems to look across at them from the adjacent table. Viewed closely, the painting shows Renoir's Impressionist technique at its height, where gentle modelling is effected by the use of warm blues and lavenders, and the feathery brush-strokes refuse to confine forms too closely, giving them an additional "soft-focus" charm.*

In the summer of 1869, Monet and Pierre-August Renoir (1841–1919) painted scenes of leisure at *La Grenouillere,* a riverside beauty-spot on the Seine within easy reach for day-trips by railway from Paris. Here they experimented with techniques to convey the transient effects on a rapidly changing scene of sunlight and shade on water.

Renoir's version of the same subject is more conventional in its perspective, and the tones are more finely modulated. He focuses his attention, above all, on the social interaction and gestures of the people represented. Apparent here, this trait was to be later developed in a similar subject, *The Luncheon of the Boating Party* of 1881.

In this painting, and in Renoir's earlier *Ball at the Moulin de la Galette,* a key characteristic is the happiness of the scene. The sun always shines, and the women are always young and beautiful. Indeed Renoir defended the prettiness of this work and refused to paint the "unpleasant things in the world". This statement explains much of the appeal of Impressionist works. In a society based on pleasure and optimism, the scenes of sociable leisure seem to capture a carefree time that was all too evanescent.

RIGHT *Renoir's* Ball at the Moulin de la Galette *(1876), holds a movement of unspoilt enjoyment that might go on for ever, but which seems too good to be true, particularly when viewed now from the "age of anxiety".*

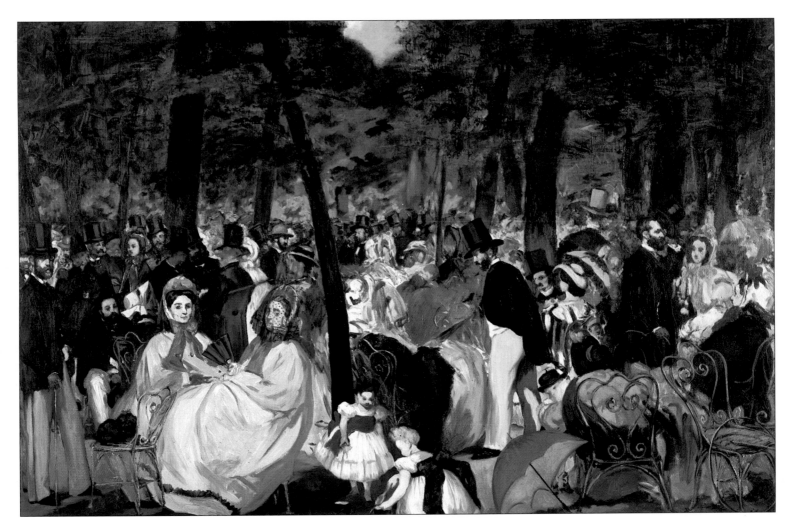

ABOVE *Manet's fluent brushwork in* Music
in the Tuileries Gardens *unites the complex
scene with a coherent disposition of tonal
contrasts that echo the mood of restrained
conviviality.*

RIGHT *Manet, Morisot's brother-in-law,
displayed a similarly emphatic use of paint as
the true subject of painting. The Grand Canal
is a scintillating example of vibrant
brushwork.*

BELOW *In* Argenteuil, *a later work, Manet
uses the bright palette and rapid notation of
brush-strokes that give the flickering effect of
light reflected from water. The couple here are
exhilarated by a day of boating and, like
Renoir's party, they seem to involve the
artist/spectator directly, in an unsophisticated
expression of hedonistic well-being.*

ABOVE *There is a charm and warmth in* Apple Picking *(1888) which may have been an attempt by Pissarro to make his work more popularly acceptable. At the same time, the painting reflects the trend in the 1880s towards the depiction of more solid and larger figures which dominate the scene, and the deployment of more "scientific" theories of colour, derived from the example of Seurat.*

Even Manet's restrained, genteel bourgeois types in *Music in the Tuileries Gardens* are assembled to enjoy themselves in a public place. Their principle aim is to acquire the easy nonchalance of a *flâneur* or dandy, as Manet was himself renowned to be.

Manet remained somewhat aloof from the rest of the Impressionists, with whom he refused to exhibit while adopting many of their practices.

Camille Pissarro (1830–1903) pursued a course more straightforwardly devoted to recording familiar landscapes and weather effects. Pissarro followed the early Impressionist principles of painting un-exceptional scenes as faithfully as his skills allowed, without interposing his own per-sonality between the subject and the viewer. Rainy days, in the country at Louveciennes, or at night in Montmartre, were of equal interest to Pissarro as well as delightful country scenes, which we see in his apple-picking paintings.

Despite being unrecognized by the art establishment in his lifetime, he was the mainstay of Impressionism in his later years.

ABOVE Hoar Frost *by Camille Pissarro, painted in 1873. The picture shows the old route d'Emery at Pontoise. The subtle tones and absence of deep shadows were applauded by Philippe Burty, while Castagnary, though he found the shadows cast by objects outside the painting bewildering, approved of Pissarro's "strong" and "sober" technique. For Leroy, however, the painting had "neither head nor tail, top nor bottom, front nor back." The painting was one of five works exhibited by the artist at the first Impressionist exhibition.*

BOATS ON THE SEINE BY ALFRED SISLEY

Creamy ground showing
warm against the roughly
dragged sky blues

Touch of vermilion slurred
into whites for additional
warmth

Fine strokes for mast and
rigging

White slurred wet into
pale blues

Cobalt violet in darks for
barge

Figure added sketchily

Canvas texture apparent

Bright vermilion

Dragged and wet slurred
colours

Broad horizontal strokes
for water surface

*Alfred Sisley's Boats on
the Seine (c1887) is
typical of his sensitive
touch, concentrating
attention on the quality of
his observation.*

TYPES OF CANVAS

*Reverse side of
prime* étude *weight canvas.*

Face-side of étude *weight
canvas, primed with one coat of*
ton clair, *a pale yellowish
tinted ground.*

*Demi-fine or half-fine weight
canvas primed with one coat
grey ground to give a grainy or*
à grain *face.*

*Half-fine canvas with two coats
grey priming to give smooth or
lisse face.*

*Unprimed face of twill weave
canvas, showing diagonal
texture. All these samples date
from c1900.*

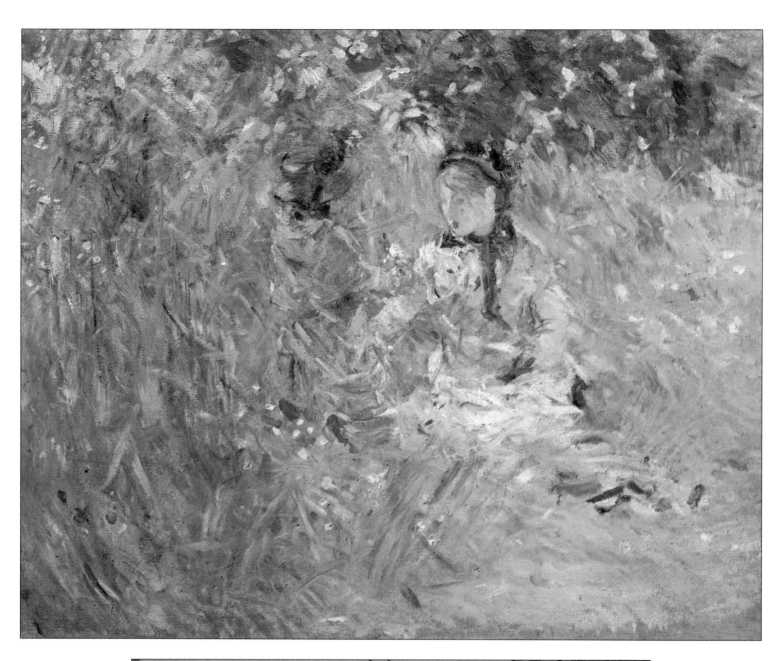

LEFT *In* Paris, a Rainy Day *(1877), Gustave Caillebotte suggests an ephemeral scene of everyday life, using strong tonality combined with subtle gradations of colour, and contre-jour lighting that would be exploited by photographers at the turn of the century.*

Alfred Sisley (1839–99) also painted understated landscapes, where a subtle sense of colour and a light, rapid touch enliven the paint surface. Berthe Morisot (1841–95) painted with a similar delicate, yet restless touch, giving spontaneity to her gentle subjects, and a liveliness that derived from the rapidity of her brush-strokes. A similar emphatic use of paint as the true subject of painting can be seen in the later works of Manet, Morisot's brother-in-law.

Gustave Caillebotte (1848–94) painted scenes that today seem extraordinarily photographic in their bold composition and deliberate asymmetry, and sense of capturing the "decisive moment", anticipating Cartier-Bresson, the celebrated French photographer of the mid-20th century.

RIGHT *Mary Cassatt retained a feeling for form and line, combined with bold, vigorous brushwork. As a woman artist (like Morisot) she was restricted by social conventions, and frequently took subjects from her own household, as in the portrait of her mother,* Reading the Figaro *(1883).*

PARIS: POVERTY AND SOPHISTICATION

It is Edgar Degas (1834–1917) whose highly unconventional composition is most often linked with photography, with his unusual viewpoints and abrupt cropping of his subjects by the edge of the canvas, as if by a camera viewfinder. The asymmetry of composition, too, gives an informality reminiscent of the snapshot effect. Degas' modernity may have been prompted by an attempt to catch the constantly changing spectacle of the urban life of Paris.

Mary Cassatt (1844–1926), an American in Paris, painted the low-key, often domestic, subjects characteristic of Impressionism. As a friend of Degas, Cassatt retained a

JAPANESE PRINTS

Japanese prints represented scenes from everyday life, rendered in a way that made French artists, accustomed to academic conventions, literally see the world anew. Unusual angles, flattened space, and figures cropped by objects or by the margins of the paper, were all unfamiliar, and a revelation – as was the wood-cut technique of strong linear contours enclosing flat areas of colour. LEFT *Ichiryusa Hiroshige,* Awa Province, Naruto Rapids *(1865).* MIDDLE AND RIGHT *Ando Hiroshige, two illustrations from* Thirty-Six Views of Mount Fuji *(1858).*

feeling for form and line, and shared his enthusiasm for print-making, inspired by the possibilities of Japanese wood-cuts.

Degas, perhaps more than any other Impressionist, was to take his subjects from city-life. Although Degas worked from urban subjects and experimented technically, he did not feel sympathetic to Impressionist ideas of spontaneity, or its loose transcriptions of atmospheric effects. He admired the sure, incisive line of Ingres, and remarked

> "No art was ever less spontaneous than mine. What I do is the result of reflection and study of the great masters. Of inspiration, spontaneity, and temperament I know nothing."

Later, Toulouse-Lautrec and Georges Seurat were also to concentrate on the artificial life of bourgeois leisure, but Degas charted this world from the Stock Exchange and the races, appropriate to his privileged class (he and Manet attended the races together), to café-concerts, and the lives of those who serviced the middle-class world – the dancers, the laundresses, bar-maids and prostitutes. Manet, with Baudelaire's encouragement, had made these subjects viable, but it was the new, burgeoning Paris that provided the subjects themselves.

In *At the Terrace of the Café*, Degas' disconcerting composition slices through the picture with vertical pillars which abruptly dissect the scene constituting a visual shock echoed by the daring subject-matter of prostitutes idling away their time waiting for clients.

ABOVE *Edgar Degas drew much of his subject-matter from the café-concerts, and the lives of those who serviced the middle-class world of leisure and entertainment.* In the Orchestra Pit *(1869–9) adopts an unusual viewpoint, where the dancers are cropped sharply by the frame, cut off by the emphasis on foreground musicians, in a composition influenced by the abrupt transitions of space seen in Japanese prints.*

LEFT *In* At the Terrace of the Café, *Degas' composition constitutes a visual shock echoed by the daring subject-matter – prostitutes waiting for clients. More troubling for the contemporary spectator would be the assumed continuity with the subject: to sit at the next table would be socially uncomfortable, if not morally anathema.*

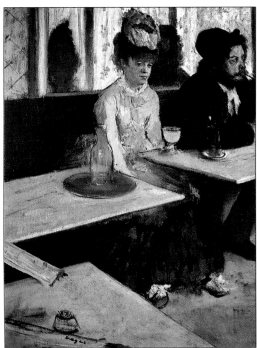

ABOVE *In* Absinthe *(1887), Degas invites the viewer to imagine a story, to fill in the emptiness in the woman's life, symbolized by her vacant expression and slumped pose, and to speculate on her companion, who looks pointedly away from her, out of the picture, as though underlining the blankness of what we can see. Degas conveys the subject's alienation by an unbalanced composition, spare line, and sombre colouring, as much as by her demeanour.*

In *Absinthe*, Degas treats another café subject, in which women are the victims of alcohol addiction in the new society. He also pin-points the isolation peculiar to cities: the woman typifies alienation, she is "lonely in the crowd".

In Manet's last great work, the *Bar at the Folies Bergère*, we see another isolated *demimondaine,* but here the spectator is confronted by the barmaid's reflective and unfocussed gaze. It was common knowledge that barmaids, like dancers and actresses, supplemented their meagre income by prostitution. As in *Olympia*, the viewer is placed – like a client – directly in front of the woman. The subject carries the implication of a life detached from the normal expectations: the barmaid has become a decorative object, like the roses and oranges in front of her.

Henri de Toulouse-Lautrec (1864–1901) was to concentrate on subjects drawn from the *demi-monde:* dancers, singers, and actresses who peopled a world of night-clubs and cafés. Lautrec's life, although privileged, was dissolute, and he participated in the life he depicted. The dreary monotony of the prostitute's life is conveyed in *The Salon in the Rue des Moulins*: the women have exhausted their conversation, as, sapped by ennui, they wait for their clients.

ABOVE *In Manet's last great work, the* Bar at the Folies Bergère *(1881), the barmaid's social detachment is signalled by the dislocated space: the mirror-image is enigmatic and disconcerting. The reflection of the girl and the customer at right are deliberately inconsistent with the viewpoint. The reflected scene is painted in a rapid notation of blunt brushmarks, contrasting with the freely painted but sensuously naturalistic treatment of the foreground, justly famed for its still-life of roses and bowl of oranges.*

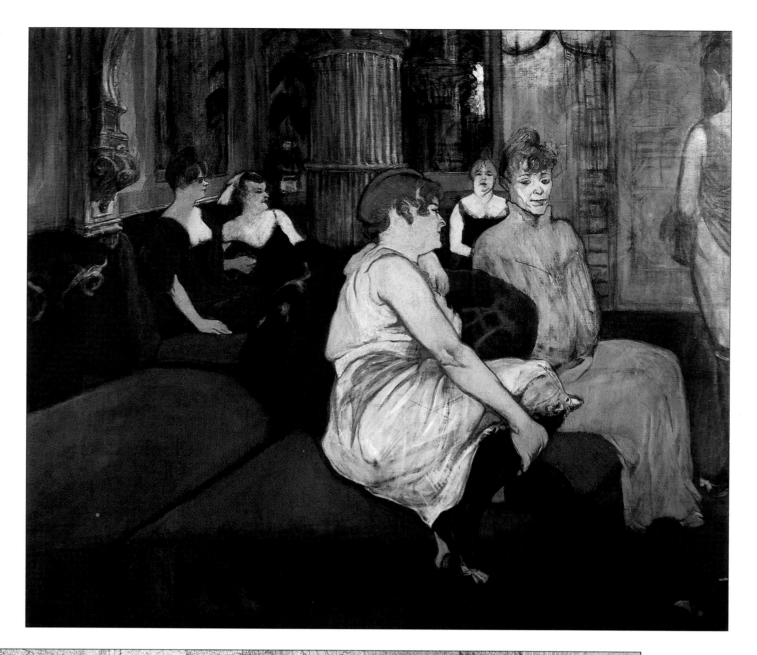

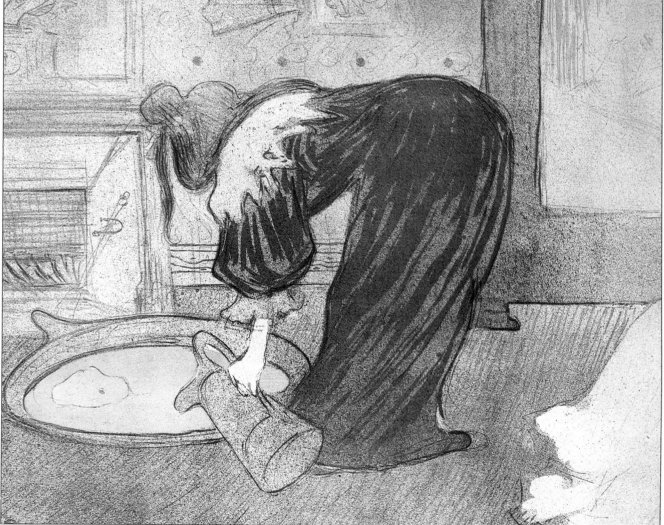

ABOVE *Henri de Toulouse-Lautrec,* The Salon in the Rue des Moulins, *1894. Lautrec has summarized the essential features of his subjects, adding only as much detail as is needed to capture the vital elements of personality and environment. The apathy and boredom of the prostitutes is conveyed precisely.*

LEFT *Henri de Toulouse-Lautrec shared Degas' enthusiasm for Japanese prints and the influence is apparent in the flat areas of colour and compression of depth. But Lautrec's line has a strength and movement that in* Woman Filling a Basin *(1896) energizes the picture surface. Like Degas, he turned increasingly to print making, and this example of his lithography has a simplicity and fluency of line which is all the more effective for being reduced to essentials.*

AESTHETICISM AND SYMBOLISM

The influence of Japanese prints is apparent in the flat areas of colour, and in the heavy contours, but Lautrec's line has strength and movement that energizes the picture surface. Like Degas, he turned increasingly to print-making, and his lithographs have a simplicity and fluency of line which is all the more effective for being reduced to essentials. He made many posters in this medium, and is responsible for the recognition of this area as a major art-form.

The cult of the Japanese prints and *objets d'art,* had a profound influence on James Abbott McNeill Whistler (1834–1903). When he came to Paris from the USA in 1855, he met Courbet and became friendly with Baudelaire and Manet. Although he moved to London in 1859, he often returned to Paris, and maintained an uncompromising belief in the autonomy of art, an "art for art's sake" aesthetic. In support of this, Whistler insisted on calling his works "arrangements" and "harmonies", alluding to the abstract formal constructions that he associated with music, especially that of Chopin.

Paradoxically, Whistler treated the subject of his elderly mother without sentiment. Entitled *Arrangement in Grey and Black: portrait of the Painter's Mother,* the painting is an austere, cool composition, balancing tones of black, white, and grey in a rectilinear arrangement of classical horizontals tempered by verticals. Its austerity was appreciated in France and the painting was bought for the French State, and Whistler was awarded the Légion d'Honneur in 1891. In a similar spirit Whistler entitled a portrait of his mistress Joe, *Symphony in White, No.2: the Little White Girl.*

His innovative style was not received sympathetically in England. Whistler painted many river views in London, favouring the atmospheric effects of dusk. *Nocturne in Black and Gold: the Falling Rocket* of 1875, caused a storm of protest in an England accustomed to meticulously detailed Victorian narrative painting. Accused by the art critic, John Ruskin, of "flinging a pot of paint in the public's face",

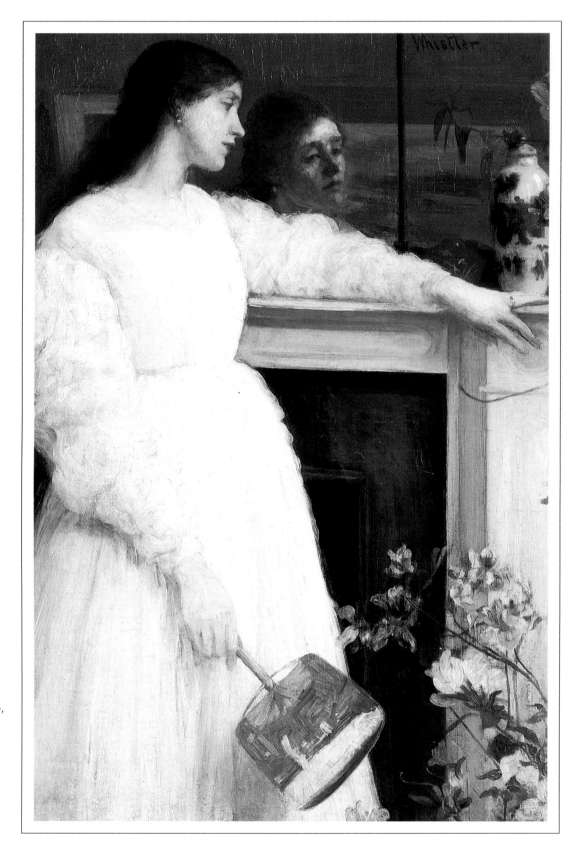

RIGHT *James Abbott McNeill Whistler entitled a portrait of his mistress Jo,* Symphony in White, No.2: the Little White Girl *(1864), in keeping with his belief that formal and emotional elements in his painting could be associated with the structure and "colour" of musical forms.*

RIGHT Nocturne in
Black and Gold: the
Falling Rocket *(1875)* –
with the painting's
appearance in England,
Ruskin accused Whistler of
"flinging a pot of paint in
the public's face". Whistler
sued, won derisory
damages, and was
bankrupted.

WHISTLER'S PAINTING METHODS

In *Valparalso,* Whistler used very
dilute pigment, thinned with a
mixture of petrol or turpentine.

The transparent dress in the portrait
of Miss Cicely Alexander was
finalized only after continual
rubbing down of previous attempts.

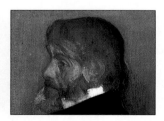

The head of Thomas Carlyle reveals
nothing of the anguished hours of
scraping down and reworking.

Whistler embarked on a notorious and
financially ruinous court case, in defence of
what appeared to be a very slight work.
The innovative treatment of the subject,
possibly derived from a print by the Japanese
artist Hiroshige, demonstrates Whistler's
continuing quest for a representation pared
to the essentials.

An idea central to Impressionism, that
the artist should paint what he actually saw,
drawn from everyday life and experience,
in an uninflected manner, was beginning to
fade. It was replaced by the notion that art
should *interpret* reality. The individual vision
of the artist would refine the retinal images
drawn from the visible world, in order to

CITY LIFE

Developments in art have centred on the burgeoning culture of a city at the centre of commercial and political power. Florence, Rome, Amsterdam, Vienna, Berlin, Paris, Moscow, London and New York, have been, at different times, the focus of the art world.

The Renaissance was facilitated by the concentration of surplus wealth in Florence, which left merchants and bankers with money to lavish on glorifying their city, a practice emulated in other Italian city-states. Compared to the hard life beyond the city walls, cities were thought to embody the highest achievements of civilization, just as they had done in classical times.

From the mid-19th century, Paris expanded in population, trade, and wealth and became the centre of European sophistication. It fostered an ethos of confidence and success, and the views of city life that were painted by the Impressionists show us a pleasure-loving, sun-filled, social existence. None of them followed Manet and Daumier in showing the underside of street life, that of the rag-pickers, alcoholics and beggars, and of the oppressed work-force, that Baudelaire had urged the artist and writer, to depict. Instead, his parallel appeal for an art that reflected bourgeois tastes and behaviour, to replace an outmoded historical aesthetic, is manifested in Renoir's Pont Neuf.

The bustle of city life, and a sense of purpose, is equally apparent in the Degas painting, where the subjects are propelled out of the Place de la Concorde, as by some unseen centrifuge that prevents them holding still long enough to have their portraits recorded.

The image of the city as a giant, self-regulating machine, was to recur, with increasingly sinister overtones. Grosz' Metropolis predicts a darkened world where man has become degraded, caught on a remorseless treadmill of amorality and greed. His image of Berlin represents a decadent society spiralling towards its doom.

For Léger the city would always be the site of man's greatest achievements: it would demonstrate the benefits of co-operative efforts, and project an altogether better world. The Builders (see page 159), perched on their scaffolding high above the city, are strong and self-reliant. It is they who make the city function. They are far from the powerless automatons of Grosz' painting, or of Fritz Lang's film of the same name.

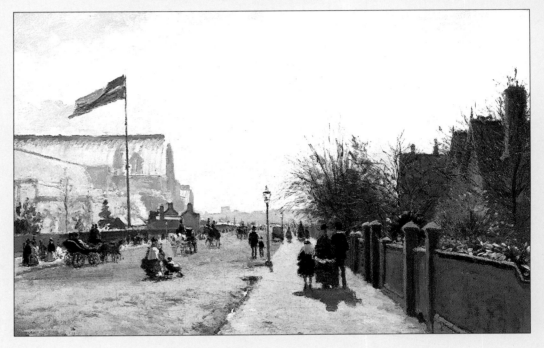

ABOVE Camille Pissarro, *The Crystal Palace, London*,
1871

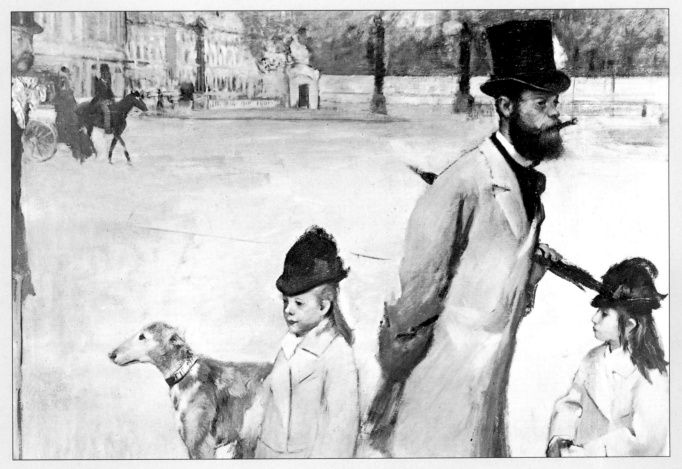

ABOVE Edgar Degas, *Vicomte Lepic and his Daughters,*
Place de la Concorde, C1876

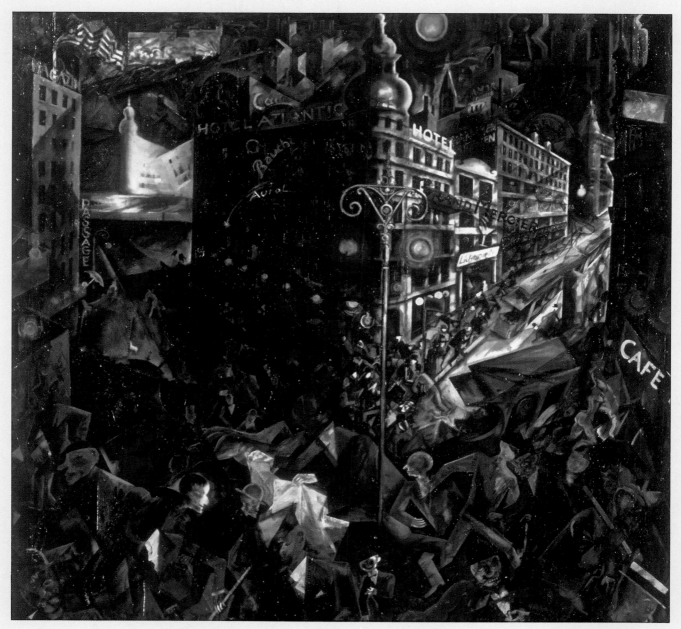

ABOVE *George Grosz*, Metropolis, 1917

ABOVE Umberto Boccioni, *Workshops at the Porta Romana*, 1908

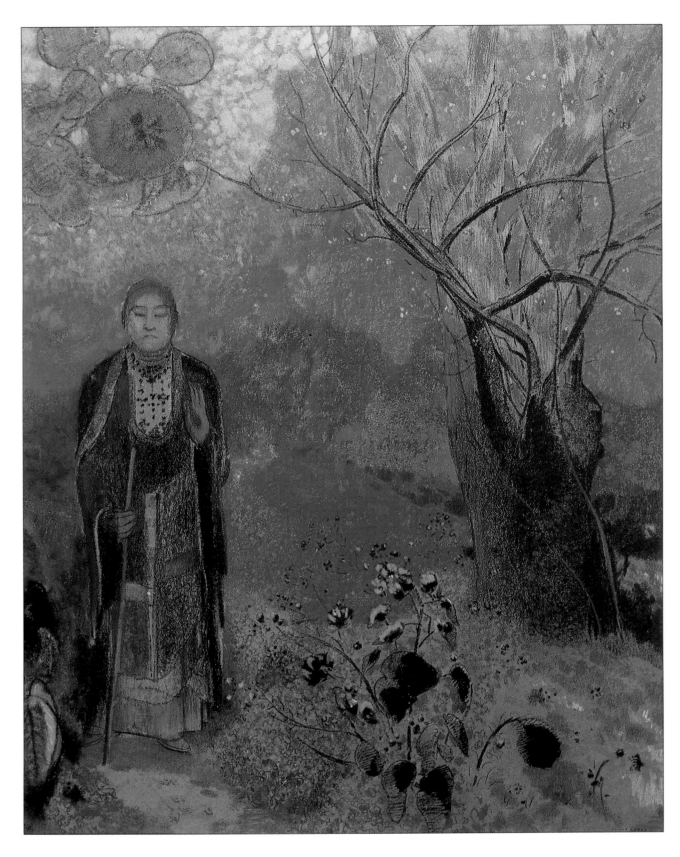

extract the essentials – as in the economical drawing of Degas and Lautrec – so as to express their own unique perception of that world, filtered through their own personal responses and temperament.

Whistler, and the "aesthetic movement" turned towards this strategy, while the French Symbolists explored an inner world where daylight never penetrated. As might be expected, with such a subjective intent there could be no single, unifying style as there had been in early Impressionism.

Still, the café discourses and debates, and current art practices, provided a shared basis for developments. Their common agenda was to find a form of art that could claim more permanence and solidity than the ephemeral effects of Impressionist reality.

ABOVE The French Symbolists developed an idiosyncratic style so as to express their own unique perceptions of a subjective world, filtered through their own personal responses and temperament. Odilon Redon evokes an other-worldly aura in The Buddha *(c1905), where he has used pastel for its luminous chalky colour.*

LEFT In Portrait of Mademoiselle Violette Heyman, *Redon achieves a fresh, glowing quality again in his handling of pastels, especially in the flowers.*

POINTILLISM

Where Impressionism had been sensate and unintellectual, the art of Georges Seurat (1859–91) was to evolve into a more rigorously ordered and analytical practice. As in the academic world, he spent two years refining an economical yet precisely observed style of drawing based on tonal values, that he was to apply to painting. Without linear outline, drawn edges of visual forms were indicated by sharp contrasts of tone, that gave the figures a clarity and volume impossible with Impressionist technique. Seurat's large-scale works, *Une Baignade, Asnières* of 1883–4 and its companion work *La Grande Jatte* of 1886, were organized on a mathematical system, originating in Poussin, that gives the compositions a classical harmony and feeling of timeless permanence.

Seurat's two panels contrast the recreation and leisure of two classes of society, located on opposite banks of the River Seine outside Paris. In *Une Baignade, Asnières*, tradesmen and workers from the factories seen in the background slump in uncommunicative exhaustion during their lunch-break. On the river a boat carries genteel folk a little way up river to the more salubrious *Grande Jatte*, where the fashionable bourgeoisie strolled, especially on Sunday afternoons. Yet this is too self-conscious a gathering for the figures to be relaxed. Seurat's strict geometric treatment of form has reduced them to mannequins, denying them character or individuality. The bourgeoisie are as trapped by their rigid social conventions as the workers are oppressed by the solid band of industrial buildings.

In technique, too, Seurat has systematized the application of paint. *Une Baignade, Asnières* began with a loose, Impressionist

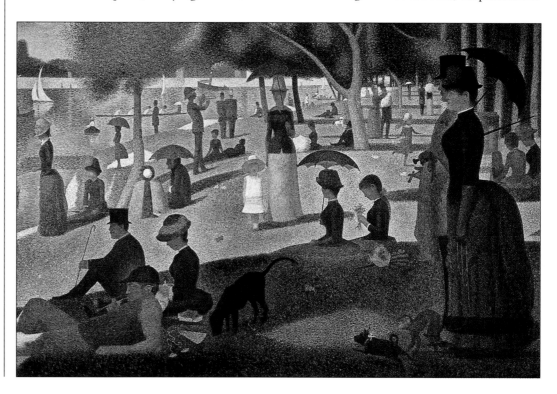

ABOVE La Grande Jatte *was a location for the fashionable bourgeoisie to mingle and to display the latest fashions amongst their peers. The woman at the right has the attributes of the courtesan, yet the demeanour of respectability. Seurat's developed approach is visible in his methodical application of colour, and in the increasingly rigid composition. The running child is trapped as rigidly as the small dog and the butterfly, frozen in immobility forever – as Seurat said – "like the art of the Egyptians".*

RIGHT *In Seurat's later work,* Le Chahut *(1889–90), he demonstrates and elaborates the colour theories of the times. The restricted colour range and stylized forms turn the night-club scene into a flattened decorative design conveying the artifice and brittle gaiety of Parisian night-life.*

UNE BAIGNADE, ASNIERES BY GEORGE SEURAT

For this painting Seurat's palette included: mixed orange (1), raw sienna (2), alizarin red (3), ultramarine blue (4), cobalt blue (5), violet (mixed from alizarin red and blue) (6), vermilion (7), emerald green (8), viridian green (9), cadmium yellow (10), yellow ochre (11). Seurat may also have used Cerulean blue (12).

RIGHT This detail of Seurat's Seated Boy with a Straw Hat (1883–1884), was a study for one of the seated figures in Bathing, Asnières. The black crayon drawing on coarse paper shows his rigorous tonal modelling technique. Instead of precise outline and distinct hatching, there are subtle gradations of tone, achieved by varying the pressure of the soft, dense caryon.

1 A strong, heavy canvas with a thin white or off-white ground was used to enhance the paint's luminosity.

2 Broad areas of local colour were blocked in. Figures and objects were indicated by thin outlines of paint.

3 The paint layer was built up slowly mainly in a wet-over-dry method to retain the purity of the colours.

4 Dryish paint consistency was used. Colours were mixed with white to add brilliancy.

5 The figures and garments in the foreground were heavily worked in opaque layers: the background is thinner, paler and softer.

6 Pointillist dots were added as contrast in 1887.

ABOVE Seurat's large-scale works, Une Baignade, Asnières (1883–4) and its companion Sunday Afternoon on the Ile de la Grande Jatte (1886), contrast the recreation and leisure of two classes of society. In Une Baignade, Asnières he heeds Baudelaire's call for the "heroes of modern life" to be treated with the dignity and grandeur of history painting. Both the compositional grid and the method of painting are less systematized than in the later painting.

THE DINING ROOM BY PAUL SIGNAC

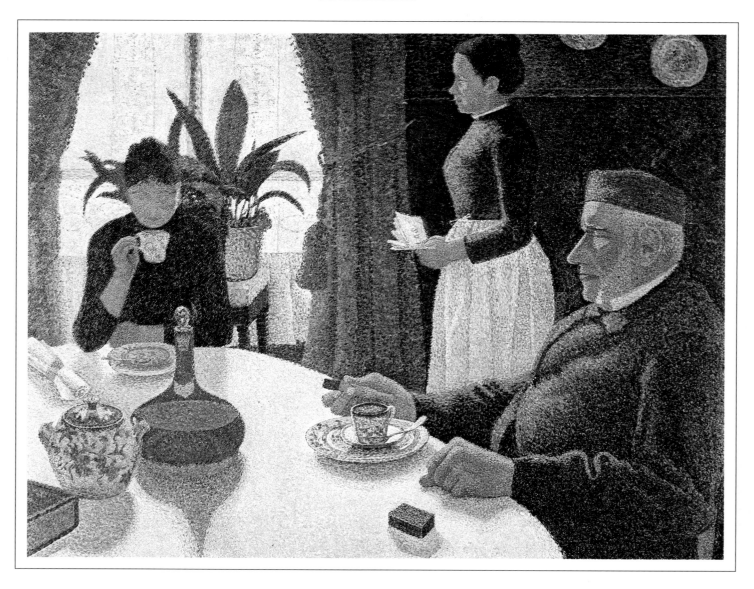

Virtually self-taught, Signac based his early techniques on Impressionist painting, until he saw Seurat's Bathing, Asnières *at the Independents' exhibition in 1884. The Neo-Impressionists, reacting against the "romantic" naturalism of Impressionism, sought to render a more universal and timeless record of contemporary life. In 1886, the year in which* The Dining Room *was begun, Signac adopted the "dot" brushstroke which Seurat had developed in his monumental canvas,* Sunday Afternoon on the Ile de la Grande Jatte *(1884–86). The technique enabled Neo-Impressionists to render minute variations in tonal value – the tonal gradation could be presented through the use of juxtapositions of pure colour.*

brush-stroke, which he later overpainted in places with tiny, more evenly applied dots of distinct colour. In *La Grande Jatte* this has become consistent, according to the current colour theories of Henry and Chevreul.

Seurat thought his rigorous dotting system was a scientific application of colour, which he called "divisionism", but which is often called "pointillism". He may have also followed the then new technique of colour separation in colour reproduction and printing, where all colours are rendered by the combination of three basic colours – magenta, yellow and cyan dots. Many of the Impressionists tried variations of "divisionism" for while, but only his small group of followers, the Neo-Impressionists, was to remain faithful to Seurat's precepts, principally Paul Signac (1863–1935).

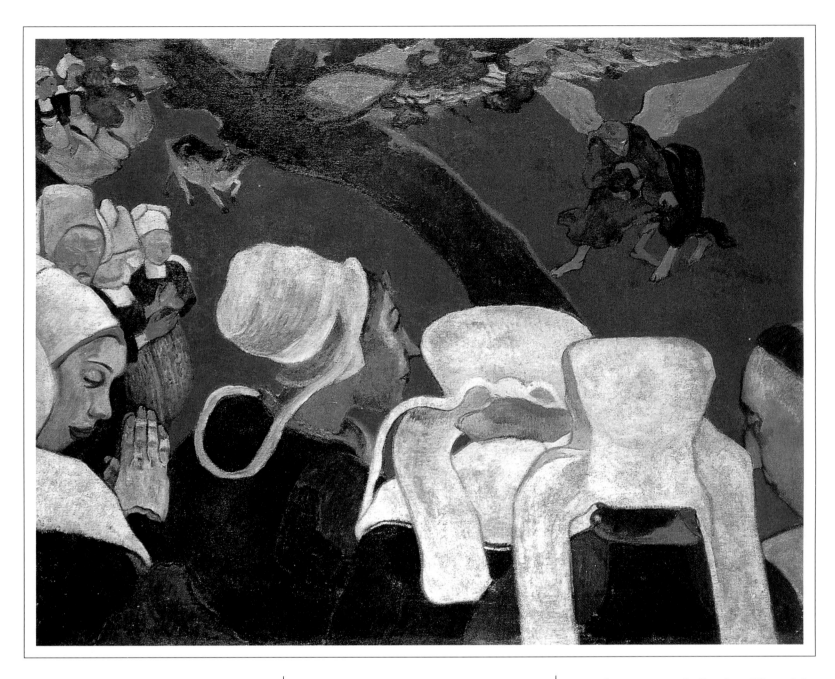

ART HEROES AND MARTYRS: GAUGUIN AND VAN GOGH

The popular outrage at Impressionism came about because people were *interested* in art. Art was still at the centre of mass culture, but before the end of the century, Aestheticism and Symbolism came to epitomize the deliberate turning away of the artist into his own world. After this period of intellectual theorizing, art became remote from everyday experience and would never again speak directly to the people.

This progress is apparent in the career of Paul Gauguin (1848–1903) who took up painting as an amateur after the art-boom of the mid-century. He adopted an Impressionist style, and was optimistic enough to give up his post as a stock broker after the economic crash of 1883. By the end of the decade, he had cast himself in the role of "outsider", despising conventional society and forging a self-image as a misunderstood genius. The generation of Baudelaire and Verlaine had created a bohemian image for writers and artists, pitted against social norms and cultural conventions, and pursuing a life of reckless abandon.

ABOVE Paul Gauguin sought a new style, informed by the colour and imagination of Symbolism, and freed from the tyranny of nature, which could be used expressively, as in Vision after the Sermon: Jacob wrestling with the Angel *(1888). The colour acts symbolically, too, in this work, marking off a supernatural "vision" from reality. Accompanied by the device, taken from Japanese art, of an abrupt diagonal, the apple-tree separates the Breton women, whose piety Gauguin admired, from the apparition that they see.*

Toulouse-Lautrec's dissolute life, and the tragic existence of van Gogh, enshrined the popular assumption that the artist was mad. But however dissipated, Lautrec and others had lived a distinctly *social* life. Increasingly the camaraderie of Parisian bohemianism now gave way to isolated artists pursuing their lonely courses with dogged resolution. Cézanne at Aix, and Gauguin in the South Pacific were both embittered and estranged from normal society and from the art world centred in Paris, which ignored them.

Gauguin's mature style developed in the later 1880s when he worked in an artist's colony at Pont-Aven in Brittany, that included Émile Bernard (1868–1941).

The poet Mallarmé had stressed the inner vision, the world as it was experienced, regardless of external forms. Another writer, Maurice Denis, insisted on the distinct identity of art, separate from life: Whistler's attitude. The apparently abstract tendencies of Japanese art provided Bernard with the basis for a new style. Flattened forms were enclosed in heavy black contours, reminiscent of stained glass windows; and colour was freed from a descriptive function.

Gauguin was quick to exploit this style to develop an expressive, personal art. In

TE REROIA BY PAUL GAUGUIN

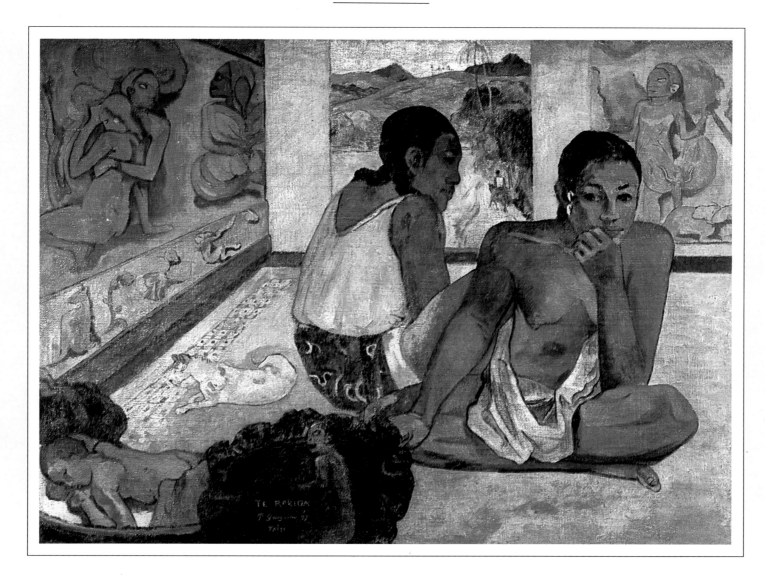

Premixed broken colours worked both wet in wet and wet over dry

Hessian texture strongly apparent at contours

Title, signature and date pick up vermilion and reinforce it across picture surface

Accent of muted vermilion on red earth

Thinly and flatly laid opaque colours

Tints in which yellow ochre predominates unifying background and floor colours

Paint applied with knife then reworked in thinly brushed paint

Prussian blue flowing lines strengthen contours

Although Gauguin's hope of finding an unspoiled "natural" paradise in the South Pacific was disappointed by the realities of colonial conditions on the islands, he created one

of his own in his great and imaginative paintings of Tahiti. In Te Reroia (The Dream, 1897) he borrowed themes from Indonesian culture for the carved frieze on the walls.

Gaugin's palette probably comprised of lead white (1), black (2), sienna (3), yellow ochre (4), cadmium yellows (5), red earth

1 2 3 4 5 6 7 8 9 10 11

(6), vermilion (7), Prussian blue (8), viridian (10) and chrome (11) greens, Cobalt blue (9) must also have been used.

his first major work *Vision after the Sermon: Jacob wrestling with the Angel* the cropping of the figures, and the flat, decorative treatment, are familiar from Japanese prints, but Gauguin has used them to create a work he described as "synthetic", where the effect resulted from an internal unity of colour, line, form and composition.

Gauguin was to adhere to this principle, rejecting modelling as a "moral deceit", and exhorting van Gogh not to paint too much after nature, but to paint from the imagination, when he joined him in Arles in 1888.

The most persistent stylistic influence was that of Cézanne, whom Gauguin admired so much that, when tacking up a new canvas, he would say "let's make a Cézanne". While working with Cézanne in 1881, Gauguin adopted the hatched brushstroke, and the use of directional marks to define form that were the basis of Cézanne's style.

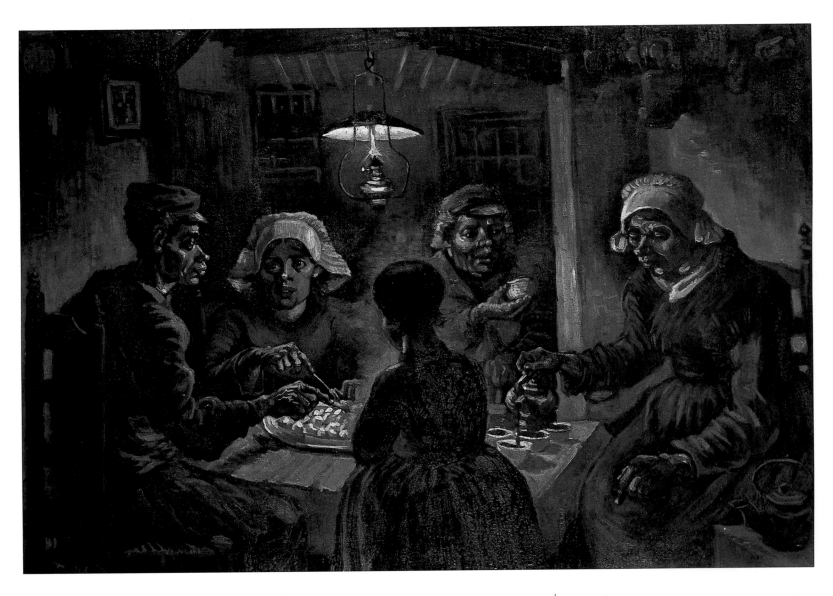

This can be seen in the painting of fruits in the portrait of *Charles Laval* (1886).

Gauguin's hopes of finding in Tahiti a primitive, innocent paradise were never realized. Christian missionaries, and French colonial rule had destroyed the indigenous culture, and Gauguin's paintings of Polynesian gods and rituals were gleaned from European textbooks that he took with him.

From these unpromising beginnings Gauguin developed a handling of paint and a treatment of the exotic subject that conveyed a sense of the "otherness" of Polynesian culture. The sinister symbolism of the murals and woodcarvings in *Te Reroia*, and the abstracted attitude of the two women, combined with unnatural but har-

ABOVE Influenced by Millet, Vincent van Gogh began to draw and paint peasants at work. Simplifying forms, he worked with the energy and forcefulness that endowed his figures with dignity. In the Potato Eaters *(1885), the colours are dark. He said that he would like to produce paintings that looked as if they had been painted with the soil of the fields. The paint has been applied in correspondingly thick, crude, unmodulated brushstrokes. The central light casts highlights over the figures, drawing them together in a simple intimacy that life denied van Gogh himself.*

monious colours, contribute to the quality of a dream. Gauguin wrote of it:

> "*Everything about this picture is dream-like: is it the dream of the child, the mother, the horseman on the track, or, better still, is it the painter's dream?*"

In this enigmatic painting, with its diffused light and floating figures, Gauguin has evoked a poetic vision of a Tahiti that the real world could not match. Gauguin was to die in poverty in the Marquesas Islands in 1903, without having achieved the worldly success he craved.

Vincent van Gogh (1853–90) was equally unsuccessful in his lifetime, and sold only one painting from his prodigious output. The majority of his works were executed in

THE PAINTING STYLE OF VAN GOGH

In this detail from *Peach Trees in Blossom* the cream-beige of the canvas priming is just visible between the thickly impasted brushstrokes.

Here, in the painting *Hospital Garden at St Rémy,* the brushstrokes describe the form of the tree and suggest the rough texture of the bark.

In the sky area of *Road with Cypress and Star* the brushstrokes are expressionistic, giving a feeling of restlessness and turbulence.

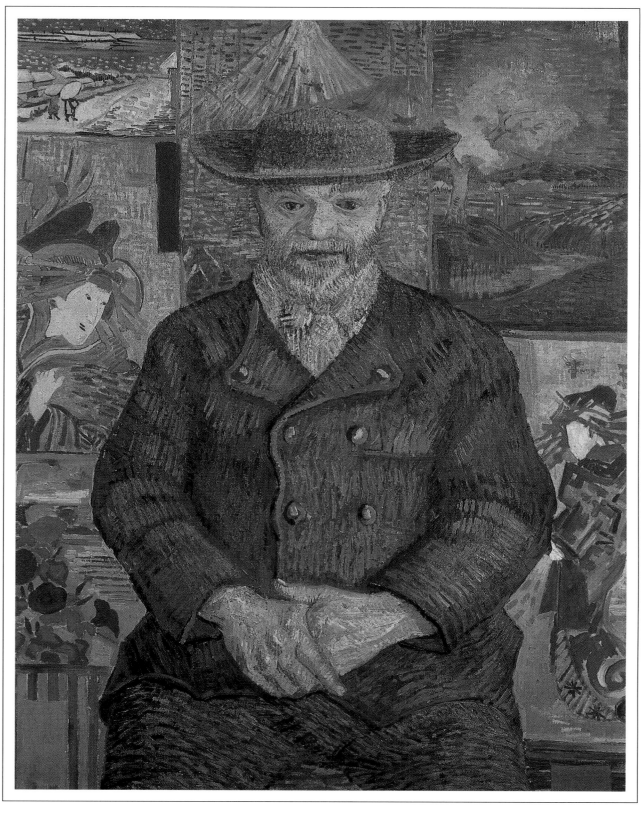

the last few tragic years of his life: in those last two years he painted 420 canvases, mostly in and around Arles, which represent the bulk of his most famous subjects.

Van Gogh's initiation into the world of art came from 1869 until 1875, when he worked in the picture-dealers Goupil and Co. at The Hague and then in London and Paris. However, it was in 1880, after being dismissed from his post as a pastor in the grim Belgian mining region called the Borinage on account of his excessive sympathy with the poor (to whom he had given all his possessions) that van Gogh dedicated his life to art.

He did so with the same terrifying zeal that he had shown in his religious work, recognizing that art was his vocation, and that through it he could communicate his feelings for humanity.

From 1881 to 1885 van Gogh lived in his native Netherlands, painting and drawing peasants at work, in a style influenced by Millet. This period culminated in the *Potato Eaters*, of 1885.

After his arrival in Paris in 1886, van Gogh began to read Zola, Dickens and Victor Hugo, and felt a deep affinity with their humanitarian compassion which was to remain with him for the rest of his life. He met the Impressionists and became familiar with their technique, as is apparent in his *Portrait of Père Tanguy*, of the following year.

He saw the expressive potential of their pure colours, and adopted Seurat's technique of applying separate strokes of different colours side by side, to create a visual shimmer. Père Tanguy sold artists' materials, and his customers' paintings; in addition, he sold Japanese prints. Van Gogh became

PEACH TREES IN BLOSSOM BY VAN GOGH

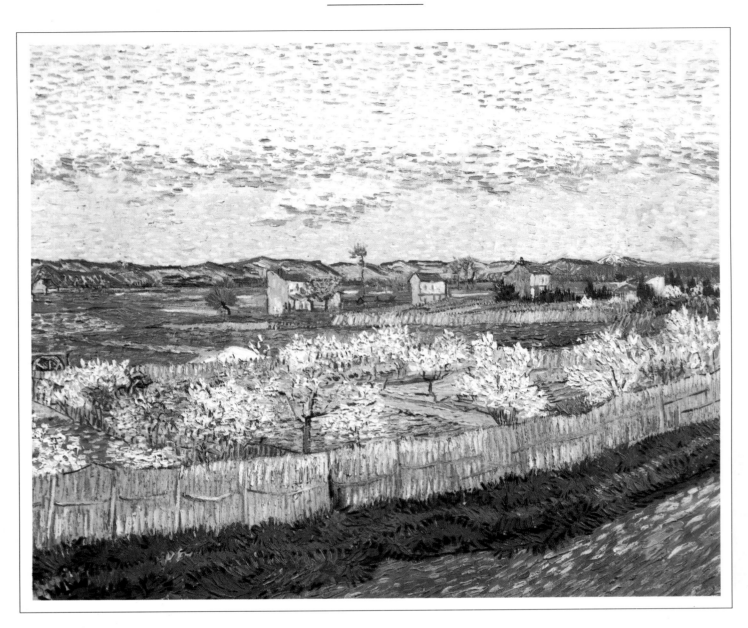

Van Gogh travelled south to Arles in 1888 to find the Mediterranean light that was to inspire his greatest work. His immediate response can be seen in Peach Trees in Blossom (1889).

Brushwork not very overt in rich blues to suggest distant mountains

Narrow horizontal bands of colour create recession in landscape

Tiny figure strongly delineated in Prussian blue

Vigorous splayed brushstrokes imitate grass

Dashes of bright colour over paler underlay

Slabbed, directional strokes of paint construct forms of buildings

Possibly burnt alizarin

Vertical strokes describe fence

Blue dashes added over dry earth tints

1 2 3 4 5 6

Van Gogh's palette probably comprised zinc white (1), raw sienna (2), yellow ochre (3), chrome yellows (4), red alizarin lakes (6), ultramarine (7) or cobalt (8), blues,

Prussian blue (9), cobalt green (10) and viridian green (11). Red earth (5) and emerald (12) and chrome (13) greens may have been used.

7 8 9 10 11 12 13

obsessive in his admiration for these images, as can be seen from the careful painting of each that he included in the background to this portrait. Van Gogh travelled south to Arles in 1888, in search of the brilliant sunshine that would inspire him to use bright intense colour. His aim was to parallel the strength of colour that he thought emanated from the Japanese sunshine in the prints that he treasured.

Gauguin stayed with him in the autumn of 1888, suggesting that he should work more from the imagination than nature. This method did not suit van Gogh temperamentally, who preferred the stimulation of sensual experience of colour and light. *Peach Trees in Blossom* demonstrates his lighter, brighter palette, which he described as ". . . absolutely colourful: sky-blue,

ABOVE *Van Gogh has used longer, expressive brushstrokes in* Road with Cypress and Star *(1890), transforming the surface of this work – as can be seen in van Gogh's paintings during his stay in the asylum at St Rémy – in a way that has been attributed to the series of breakdowns he had suffered.*

pink, orange, vermilion, strong yellow, clear green, pure wine red, purple."

After a stormy relationship, Gauguin left the following spring. By this time, van Gogh had achieved full maturity of style. In this optimistic period of his life, van Gogh developed a method of using colour that was expressive and symbolic:

> "Instead of trying to reproduce exactly what I have before my eyes, I use colour more arbitrarily so as to express myself more forcibly."

He also brought into use a variation in brush-marks for expressive effect, so that the materiality of the paint surface, its variety of textures, and the gestural marks vitalize the flat surface with emotional energy. This can be seen in *Sunflowers*, a subject he repeatedly depicted.

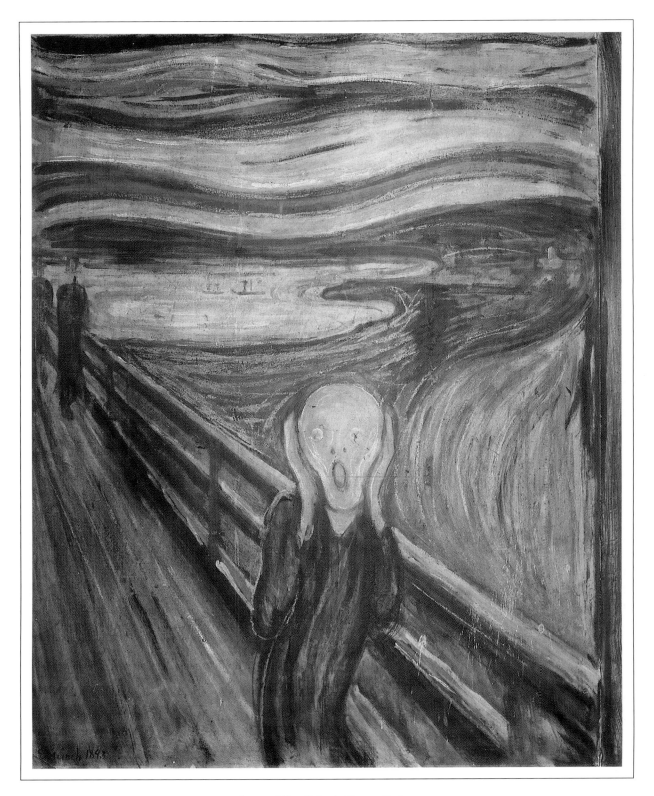

ABOVE *Edvard Munch, like van Gogh,
developed a style that was to combine
expressive use of colour and gestural
brushstrokes into a vehicle for intensely
subjective feeling, as in* The Scream *(1893).*

At other times, he worked over the whole surface with a weave of similar marks, as in *Road with Cypress and Star* of 1890, which unify the surface of the work into a restless and undulating totality. The increasingly expressive activity of surface, the oppressive, airless darkening of colour, and the increasingly vigorous brushwork during his stay in the asylum at St Rémy have been attributed to his troubled state of mind.

Crows in the Wheatfield, painted in Auvers outside Paris, was one of his last works. The darkened sky and the black crows have been regarded as symbolic of spiritual torment, and the absence of a human figure as indicative of his crushing loneliness. He had begun painting in order to communicate, to bring joy and solace to a trouble humanity, yet he felt his titanic efforts had been rejected, and he killed himself with a pistol shot. Van Gogh's qualities make him a heroic figure, with whom audiences in the 20th century can so readily identify.

Van Gogh and Edvard Munch (1863–1944) became the two central sources for Expressionist movements in the 20th century, setting a pattern for art driven by obsessive feelings and personal attitudes, and generally executed with the same vibrant palette, using open, gestural brushmarks which were characteristic of the individual hand.

STEPS INTO THE 20TH CENTURY: CÉZANNE

Paul Cézanne (1839–1906) was the single most influential artist in shaping 20th-century art movements, not only in his style, but in his single-minded resolve. As with the other Post-Impressionists, his aim was to find an enduring pictorial form that would make sense of the world around him, a world that had at first threatened to engulf him. His earliest style derived from a consuming admiration for Delacroix – an emotional outpouring of convulsive forms, violent colour and often lurid subjects, as in his tribute to Manet, *A Modern Olympia*.

The ridicule heaped on this work stung Cézanne and made him, with Pissarro's help, look for a more restrained Impressionist style. Cézanne's emotional nature – he was not coolly cerebral like Seurat – made him evolve over a long period of deliberation, a system based on intuition rather

ABOVE *The late versions of* Mont Sainte-Victoire *(1904–5) demonstrate Paul Cézanne's method of constructing interlocking patches of colour to create form and space.*

than theory. By perceptual analysis, he regarded the essential forms of nature to be the cylinder, the sphere and the cone. He considered the Impressionists' work to be merely transient forms of representation.

Instead of the rapid, lively brushstrokes of the Impressionists, Cézanne evolved a technique of applying parallel, even strokes that followed the surfaces they depicted. In this way Cézanne could convey a feeling of solid form, especially with a restricted palette in which warm, orange hues would seem to advance in space, and cool, blue-green ones would recede.

The Red Rock displays this technique, and the late version of *Mont Sainte-Victoire* of 1904–5, demonstrates Cézanne's analytical method of meticulously constructing interlocking patches of colour to create form and space.

Despite Cézanne's rigorous ordering of structural forms, he was always conscious of the tension between the implied pictorial

LEFT *Cézanne's lifelong pursuit of structure in painting led him to examine the same subject again and again. Often it was a familiar landscape, but – as in* Woman with Coffee Pot *(1890–5) – a patient model and simple still life were also analysed.*

depth, and the materiality of the flat surface of the canvas. Like van Gogh, he used similar-sized brushstrokes to unify the pictorial plane, and to compress depth, as can be seen in *Woman with Coffee Pot*. Here, the frontal pose implies depth, but while Cézanne's consistent treatment gives the figure volume, the compositional grid brings the wooden panelling, the table-top, and the woman's lap, into one ordered scheme.

For all his apparent familiarity with a particular subject – the most famous being *Mont Sainte-Victoire*, Cézanne kept on looking, spending long days in front of his subject. For him, the direct observation of nature was essential every time. He would apply his perceptual system to make the subject endure. As he said, he wanted to "do Poussin again, from nature". In this practice his attitude was quite distinct from Monet's. Where Monet painted the same subject many times in order to capture a series of fleeting, but different, atmospheric effects, Cézanne attempted to extract the essential forms by elimination of superfluous detail – to reveal the perceptual structure beneath.

Cézanne worked on three panels of *Bathers* until his death. In this choice of subject, and its large scale, he revealed his wish to stand alongside the Old Masters. It is

evident in the *Bathers* that Cézanne's willingness to distort objects, or change the viewpoint, to fix on an effective composition, is essential to his feelings for construction of forms.

Too diffident to use live models in his small provincial town of Aix, Cézanne painted the nude figures from previous studies and photographs. This must have made it easier to adapt the form of each to suit the demands of the overall composition of the *Bathers*.

Cézanne's legacy to 20th-century modernism was that artists abandoned naturalism in depiction, the representation of the "real", for a more *subjective* interpretation. He said the artist should look for "equivalents" to nature, based on the forms of pictorial language.

Cézanne finally acknowledged the redundancy of naturalism, which was not easy as he had admired Courbet, whom he had met through his childhood friend, Emile Zola.

By his example, Cézanne provided later artists with a new departure, whereby attention shifted from the perceptual rendition of subject-matter to pure form, the process of painting, and the formal language of art. Inspiration would no longer be centred on the visible world, but on ideas about the nature of art itself.

BELOW *The Provençal landscape provided the subject matter for hundreds of Cézanne's paintings, and* Mountains in Provence *(c1885) is a perfect summary of the preoccupations and achievements of Cézanne at the beginning of his maturity. Cézanne's concern to give expression to the qualities of the landscape was always balanced by an equal concern for the language of the painting. All the features in this composition have a clearly defined role and create an overall harmony in such a way that the removal of any element would destroy the equilibrium.*

LARGE BATHERS BY PAUL CEZANNE

Subtly modulated blues
applied in parallel strokes

Contours, or receding edges
of forms, worked in thickly
built-up blues forming
raised ridges

White ground exposed in
places left unpainted;
bottom edge extended by
7.5cm (3in) during painting

Incomplete top strip hidden
by frame – sky area reduced
by artist during execution

Monumental forms of
figures relate to powerful
handling of tree trunks

Altered but apparently
unfinished figure shows
modification in progress

*In Cézanne's mature style,
all pictorial elements were
subordinated to the overall
harmony of the unified
conception. He
relinquished naturalism in
the painting of the figures
in order to arrive at an
effective composition, and
this is particularly evident
in the* Large Bathers
*(c1905) – several versions
of which he kept working
on until his death.*

*Cézanne's palette for this
work probably comprised
lead white (1), chrome
(2), or cadmium yellows
(3), yellow ochre (4),
vermilion (5), red alizarin
lakes (6), cobalt blue (7),
viridian green (8), ultra-
marine blue (9), emerald
green (11), green earth
(terre verte) (13), Naples
yellow (14), red earth
(15), cerulean blue (10)
and chrome green (12) may
also have been used*

ABOVE *Picasso's* Les Demoiselles
d'Avignon *(1906–7) combines a number of
nude figures in a challenging composition. The
distortion of the mask-like heads so shocked his
contemporaries that the painting was not
exhibited for 30 years.*

CHAPTER TEN
THE AGE OF MODERNISM

In comparison to the leisurely pace of 19th-century French art and culture, the 20th century seems to embody a headlong race to meet the demands of "progress". Instead of the steady certainties of absolute belief in the value of a sound economy and in the benefits of science (personified in the art world by Seurat), the 20th century alternates between a heady materialism and a transfixing doubt – a doubt that leads to anxiety – about the existence of God, the role of man as the centre of his world, and the future of the world itself. In art, the pleasure-principle – all that was visually pleasing – shared by the artists of the 19th century, was to be replaced by self-consciously "ugly" work. This was not restricted to the visual arts but also appeared in music: Schoenberg and Hindemith replaced late Romantic harmonies by Mahler and Richard Strauss with jarring dissonance and strange tonalities. In literature, James Joyce substituted formal experiments in language for the familiar narratives of the 19th-century novel.

The world of the senses was doubted: intellectual purity alone could be trusted. Form, cleansed of the sensitive and decadent baggage of complacent bourgeois values, would provide a lucid framework – just as

ABOVE Collioure (1905) by Derain. The two main Fauves, Henri Matisse and André Derain worked together at Collioure in the south of France in the summer of 1905, in a productive partnership not dissimilar to that of Monet and Renoir in 1869. There they evolved their own distinctive contributions to the vibrant style which earned them the title "Wild Beasts" from critics later that year.

the plump velvet sofa would give way to the tubular steel chair.

The cultural change was not, of course, sudden. Many of the key factors had been present in the 19th century – in the threats to the dominant Positivist philosophy by a range of thinkers, including Nietzsche, who questioned the very structures of "civilization", calling it a deceit that masked man's real motives. His ideas undermined the notion of a civilization based on "sound moral values", as did Karl Marx, in his analysis of culture driven by economic materialism.

Both Charles Darwin and Sigmund Freud implied, in their studies of nature and mankind and its drives, that man's animality, rather than his nobility, marked his origin and his destiny.

What they had uncovered below the surface of humanity, and the thin veneer of civilization, was disturbing and threatening to the composure of every-day assumptions and appearances. Attempts were made by thinkers, writers and artists to penetrate below the 19th-century complacency and self-congratulation at Man's achievements.

New scientific discoveries about the atomic nature of matter further undermined the certainties concerning the very

ABOVE *Pierre Bonnard explored a private world of domestic subject-matter in secure bourgeois circumstances, where the surface animation of the works is derived from Gauguin's colour and Impressionist technique, as in* Interior at Antibes *(1920).*

1 Bonnard did not use a standard format canvas. He let the painting assume its own dimensions on a large piece of canvas tacked to the wall. He used a finely grained, closely woven canvas with a commercially prepared white ground.

2 Some areas were built up in several thin layers.

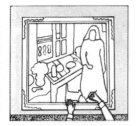

3 Others were painted in thick layers with emphatic brushwork and some impasto.

4 The finishing touches were added to the painting after it had been stretched and placed in its gold frame.

Light created from vermilion and scarlet lake worked wet-in-wet into yellow and green

Repetition of colour from exterior to interior

Edge of jug and saucer built up in white impasto to form highlights

Scraping down with palette knife

Ground showing through

Scumbles of blue on white cloth

stability of things. How could an artist strive, like Courbet, after the "truth" in the rendering of surface appearance, or find significance in Cézanne's depiction of form in the humble apple?

Affected by the new climate of scepticism, some artists attempted to change the direction of art, seek new subjects, and construct a new language.

Picasso and Braque were not intellectuals, but they were aware of modern concepts that were being debated in Parisian cafés. Their intellectual mentor, the poet Guillaume Apollinaire, was as enthralled by the first cross-channel flight by Louis Blériot in 1909, as he was by the prospect of poetry freed from the tyranny of rhyme and rhythmic metre. Picasso's rapidly changing styles are symbolic of the uncertainty of 20th-century art: as in the culture generally, nothing was fixed or sacrosanct.

The one continuing thread that unites all non-academic 20th-century art rests on *doubt* which resisted complacency. With the Post-Impressionists, each new style or movement had built-in obsolescence. As soon as one became fully developed, another would begin to take shape. However dissimilar they may seem, they all flow out of a continuous cultural source as well as from the wider cultural trends of society as a whole.

Paris was still at the centre – French art and theory continued to set the agenda, but after the intensely personal styles of Cézanne and van Gogh, and the debilitating, self-destructive residue of Symbolism, it was difficult to see what style or movement could now emerge that drew on any shared beliefs and practices.

Pierre Bonnard (1867–1947) and Edouard Vuillard (1868–1940), although originally members of a group called the "Nabis" (influenced by Gauguin's style), later worked independently on the heritage of Impressionism and Post-Impressionism, each exploring a private world of domestic subject-matter where the surface animation derived from the use of colour by Gauguin and the Impressionists would provide an endless variety of effect.

THE FAUVES

Henri Matisse (1869–1954) was approaching middle-age when these pressures motivated him to organize an exhibiting group in 1905, which would become known as the "Fauves" – like most group labels, this was originally a pejorative term, the instant reaction of a critic (Louis Vauxcelles) who described them as "wild beasts".

Most exhibits at the Salon d'Automne were far from Matisse's own style and technique, but he had seen the potential of exhibiting in the company of André Derain

(1880–1954) and Maurice de Vlaminck (1876–1958), whose deliberately crude, vividly colourful canvases would have a cumulative impact and surely attract notice.

At first the notoriety resulting from the outraged critics might have seemed damning, but 19th century precedents showed that the capacity of the avant-garde art world to absorb new trends was considerable: those who had jeered at the Impressionists had to pay many times over at the sale-rooms when these works later became highly desirable.

BELOW Portrait of Matisse, *painted in 1905 by André Derain when he and Matisse were working together at Collioure. Matisse appears intensely introspective in this dynamic study. His gaze is directed outwards but not focused upon the spectator. The angle of his head, pitched forward slightly and positioned high up on the canvas, emphasizes this mood.*

It was Matisse's portrait of his wife, titled *Woman with a Hat,* that attracted most comment, becoming a *succès de scandale*, because of the bold blue/green stripe running down the centre of the face. Ironically Leo Stein, whose wife, the writer Gertrude Stein, was a collector of avant-garde art, made outspoken criticisms of this painting when he first saw it, but was soon persuaded to buy it by the dealer Vollard, who had recognized its investment value.

Matisse's mature style was not yet established when he painted this portrait, demonstrating the impact that the 1901 van Gogh exhibition had on him, which was so influential on his style.

Although he lived through a crisis-ridden era, including two World Wars deeply affecting his native France, his work never reflected the anxiety that manifests itself in many other artists' work. He developed a cool, hedonistic style, describing his aim as "an act of balance, of purity and serenity devoid of troubling subject-matter . . . something like a good armchair . . ."

HENRI ROUSSEAU *THE DREAM* (1910)

This painting was the last one Rousseau sent for exhibition. A poem was attached to its frame: "Yadwigha in a beautiful dream/While sleeping peacefully,/Heard the notes of a pipe/Played by a thoughtful snake charmer./While the moon casts its light/On the flowers and verdant trees/The wild snakes listen/To the gay tunes of the instrument."

Rousseau is reported to have told Picasso "We are the two great painters of the age, you in the Egyptian style, I in the modern style", which must have accorded some kind of compliment towards Picasso's art. He thought less of Cézanne, venturing the memorable comment at the 1907 Cézanne memorial exhibition – "You know, I could have finished all these pictures."

Finish is most certainly one of the qualities of The Dream. Rousseau always began at the top of his canvas, and carefully worked his way down, working with one colour at a time and filling in all those areas where it was needed before turning to the next colour. There are over 50 variations of green alone in The Dream, and a painting of this scale would have taken Rousseau up to three months to execute.

The strong contrast in tonal values between the light flesh of the nude and the dark red of the sofa create an impression of a cut-out. Rousseau offered two reasons for the inclusion of the sofa, one lyrical and the other formal: "The sleeping woman on the sofa dreams that she is transported into the forest, hearing the music of the snake charmer. This explains why the sofa is in the picture" and "The sofa is there only because of its glowing red colour".

In The Dream, Rousseau contrives a magical balance between form and content, between complementary colours, and between detail and the evenness in the composition.

CUBISM

Georges Braque (1882–1963) was a member of the "Fauvist" group for a while, although temperamentally unsuited to their lack of restraint. In 1907 Pablo Picasso completed *Les Demoiselles d'Avignon*, a canvas so shocking in style and content that it would not be exhibited until 1937.

As in Cézanne's *Bathers* and Matisse's *Woman with a Hat*, it is the violent distortion of the human figure that is so disquieting in these paintings. The same artistic licence applied to still-life or landscape might not have provoked such hostility and emotional response.

Each attest to the two major inspirations of the decade, the influences that would provide the starting-point for Cubism. Firstly, just as the cult of Japonaiserie – Japanese art and artefacts – had swept late-19th-century Paris, so the early 20th century discovered an enthusiasm for primitive art from many cultures. Secondly, in much the same way as the 1901 van Gogh exhibition, the Cézanne retrospective of 1907 came as a revelation to many artists, particularly Braque. He immediately went to the south and began to paint landscapes in a Cézanne-like idiom of simplified, rather geometrical form, in a restricted colour range, and with a directional brushstroke.

Gauguin had prepared the way for an interest in exotic cultures, and the expansion of the French colonial empire and trade brought masks and sculptures to Paris from Africa and Oceania. Artists collected them avidly. Many of these displayed a stylization that was so extreme that heads and bodies were hard to identify as representations of the human form as conditioned by Western culture and Greek ideals. They provided a stimulus for the reduction of the human body to the brutally simplified planes that can be seen in Cubist paintings.

Picasso's *Les Demoiselles d'Avignon* (1907) is a prophetic canvas, since the progression of his experiments, from simple stylization to cubist decomposition, while the painting was in progress, have been left obvious for all to see. The flattening of space by integration of figure and ground, pioneered by Cézanne, has been further developed. The negative spaces between the forms are as solid and significant as the positive forms of the figures themselves. This fusion of forms, creating ambiguity of space operating from the picture-plane, would lead to a new departure – as critical to the language of art as the invention of perspective had been. Changes in culture and knowledge had shown that nothing is fixed, or solid; the new medium of cinematography described a world in movement, an impulse felt particularly in Paris where the new motor-cars gave the pace of modern life added urgency.

In 1909/10, Picasso and Braque worked closely together, depending on mutual support in their new venture, as Braque said, "like two mountaineers roped together"

This telling metaphor catches the risk and anxiety, and the loneliness, they felt while developing what came to be called Cubism. The period of development was made possible by contracts with the art-dealer Kahnweiler, which ensured both artists an income without having to produce works aimed at public exhibitions. Kahnweiler retained the canvases for many years before it was possible to realize their true value.

Encouraged by Braque, Picasso, too, painted landscapes in Cézanne's idiom. His early success, the adulation he received in Apollinaire's circle, and his natural extro-

BELOW The expansion of the French empire and overseas trade brought masks and sculptures from Africa and the Pacific to Paris, where they were avidly collected by artists. Many of these carvings displayed an extreme stylization that provided a stimulus for the reduction of the human body to the brutally simplified planes that fascinated Picasso.

PHOTOGRAPHY AND ART

Photography was invented in 1839 when an image was fixed onto a silver-coated plate. The daguerrotype, named after its originator Daguerre, was called "the mirror with a memory".

In spite of its difficulty of operation, the new process was exceedingly popular – 500,000 plates were sold in Paris alone in 1846 – and the prophecy that "from today, painting is dead" did not appear too exaggerated, at least for portraiture, which was its main use at that time.

Photography challenged the authority and exclusiveness of the artist and was seen as his deadly rival; although it was used by some artists as an aid, most considered it an ugly usurper.

The struggle for the accurate imitation of nature, which began with the Renaissance, reached a conclusion with the realistic representation made by light and optics that parallels our own perceptual system of seeing.

Immediately, artists were compelled to reassess their role in society and their visual strategies. Against the realism of the monochrome photograph, its objectivity, and its literalness, painting could offer subjectivity in its brush-marks; the texture and colour of pigments which animated the painted surface provided an element which the mechanically anonymous surface of the photograph could not.

In addition, as Baudelaire stated in criticism of the new medium, the painter was not restricted to that which merely existed, but could create images from the imagination.

However, artists did associate with photographers, and used photography themselves. Nadar, the most famous photo-portraitist in Paris, allowed his studio to be used by the Impressionists for their first exhibition in 1874. Degas used photographs of posed models, and emulated photographic effects in casual asymmetric compositions.

Light and colour became of paramount interest for the Impressionists: transitional effects expressing the flux of modern life as caught by photography were central to their practice.

An impression of movement, as revealed in the studies of animal locomotion by the photo-sequences of Muybridge and Marey in the 1880s, fascinated avant-garde artists in the early 20th century. These precursors of the invention of cinematography are clearly influential in the fragmentation of the single image in painting, as seen in Duchamp's Nude Descending a Staircase, and Balla's Futurist Dog on a Leash, and were a catalyst for the simultaneous vision of Cubism, which abandoned single-point perspective.

The effects and processes particular to photography created a photographic aesthetic, and were a stimulus to artists and an inspiration for photographers to establish the new medium in its own right – yet the art world was reluctant to embrace, or acknowledge any direct influence of it.

LEFT Daumier, *Nadar raising photography to the height of art*, lithograph, 1862

RIGHT John Heartfield, *As in the Middle Ages, So in the Third Reich.* John Heartfield developed the technique of photo-montage to create visually arresting images, in prophetic anti-Fascist illustrations for AIZ, the worker's press, in the 192s in Germany.

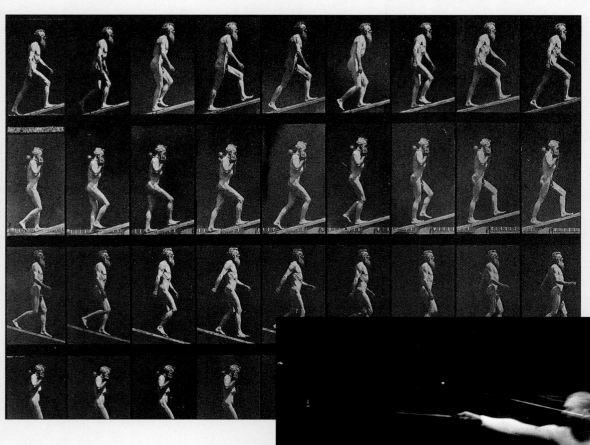

LEFT *Man walking down an inclined plane* by Eadweard Muybridge, the photographer who pioneered the recording of movement.

BELOW Etienne Marey developed the technique of chronophotography which became the source of inspiration for a number of artists. Duchamp made no secret of the fact that Marey's chronophotographs and subsequent diagrams provided the initial impetus for the paintings he produced which attempted to record movement, and also the passage of time.

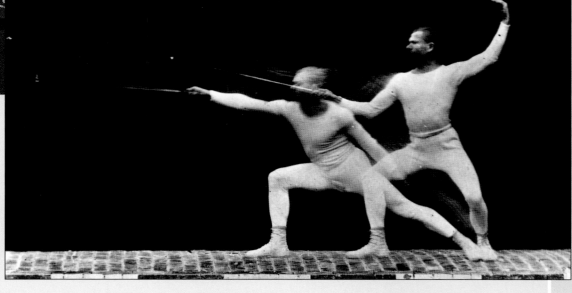

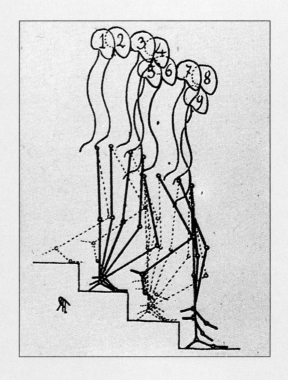

Marcel Duchamp used various references when working on *Nude Descending a Staircase*. Preliminary studies, left, and the painting itself, right, clearly show the influence of the work of Etienne Marey, Paul Richey and Eadweard Muybridge.

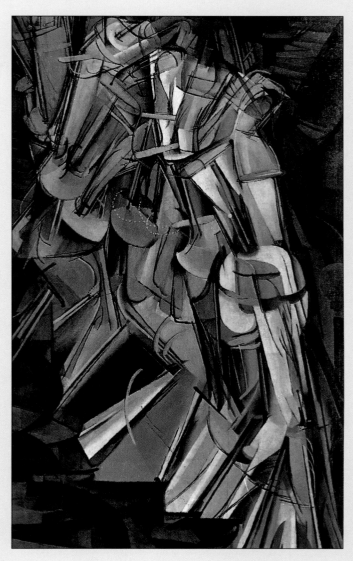

RIGHT
Marcel Duchamp,
Nude Descending a Staircase

ABOVE *In* The Portuguese *(1911),
Georges Braque adopted the principle of the
shifting viewpoints, applying it to everything
represented in his Cubist works.*

his guitar lower down, the indications of a bottle and glass at top-left, and the stencilled lettering of a poster, suggest the same café-subject-matter as that of Manet or Toulouse-Lautrec. The angular, inhuman forms which were to become the "language" of intellectual art for decades to come, symbolising both the scientific and the industrial character of the modern world, are rendered in dull monochrome which accentuates form and line, but further distances the subject.

Since there is little subject, and no narrative, in *The Portuguese*, everything, whether man, bottle or empty space, is woven into one integrated shallow space, parallel to the picture plane; yet implying enough depth for shadows to give volume. The depth is optical, as opposed to the kind of space the Renaissance artist created.

As if to emphasize the optical space, Braque introduced stencilled lettering (first seen in this painting) which defines the surface of the painting. Such flat forms insist on flat canvas surface: the numbers "10,40" deny the illusion of the white highlights.

Originally a house painter's apprentice, Braque introduced commercial techniques into his paintings; for instance, a combing effect to suggest wood-graining. Extending this idea, he took the lead in introducing pieces of other materials, like imitation marbled surfaces, sticking them onto the surface. Picasso developed the potential of Braque's techniques from his earliest *Still-life with Chair Caning* of 1912, to the imaginative uses of *papier collé*, or collage. This marked the beginning of a phase called "Synthetic Cubism", as opposed to the previous "analytical" phase and the inclusion of added materials and painted textures, in a denser, more decorative and colourful surface, persisted into the 1920s.

The decisive break with pictorial illusion had been made. In Synthetic Cubism the flat surface of the canvas is treated as solidly opaque, nothing penetrates below its surface into imaginary depth. Its opacity is further emphasized by the applied materials that often stood out from the surface. The artist's freedom from illusionary "representation" also brought another important change. Most of the "analytical" Cubist works had been developed from the observed and experienced subject, in accordance with Cézanne's practice; in the "synthetic" works the subject was less emphatic. Form, colour and medium would, Picasso claimed, dictate the subject.

Although the partnership of Braque and Picasso was close and decisive, it was short-lived; ending with Braque's enlistment at the outbreak of the First World War in 1914. Cubism had changed art forever in conception and definition. Its immediate effect was on other art movements like Futurism, but its longer-term impact has overshadowed 20th-century art.

vert wit, gave him the confidence to change, to experiment, and to follow his emotional whims as well as his artistic intelligence. Braque, on the other hand, was a serious, methodical worker devoid of excessive gestures, who built up his paintings carefully, step by step.

By 1911 their work was so similar that it was hard to distinguish one from another. In *The Portuguese*, Braque has literally constructed the image with his characteristic brick-like brushstrokes. The clear, almost tangible landscapes of 1909–10 have given way to forms that inter-penetrate and deny the solidity of things. These forms also differ from preceding paintings in implying a passage of time, not one moment frozen forever, and there is no one, fixed viewpoint. In the painting, the structural forms derived from Cézanne combine with the dynamic overlapping planes of shifting perspectives, and the use of directional brushstrokes give the impression of a world in flux.

The initially confusing impression can be understood with the help of the visual clues: the top hat and moustache of the man at top-centre, the strings and sound hole of

AFTER CUBISM

Of the artists who joined the Cubists, Juan Gris (1887–1927) contributed developments after 1912, and Fernand Léger (1881–1955) would use the pictorial language of Cubism to forge his own, personal style. Cubism was the first style to appeal to the informed intellectual mind, rather than to the senses, but Léger's egalitarian politics made him attempt to produce paintings that were very different from the inaccessible aestheticism of Cubism. He developed the "modern" and popular urban subject-matter first seen in Manet's work, yet peopled it with proletarian figures of monumental cast. Here, surely, are Baudelaire's "heroes of modern life". Léger shows an uncritical enthusiasm for the urban and mechanical

BELOW *Fernard Léger,* Les Constructeurs, *1950. Léger and the "Salon Cubists" attempted to imitate, often directly, the Analytic and Synthetic periods of Braque and Picasso. Léger was obsessed with machines and wanted to develop Cubist ideas into an artistic language to express the machine age. He felt modern life – which he saw as characterized by dissonance, dynamism and movement – could only be painted using contrasts of colour, line and form.*

world: the dark, simplified figure in his *The City* is no sinister robot, but a symbol of Léger's, and many others, belief, that industrialisation would lead to a better life, freeing humanity from degrading manual labour, and improving living standards.

A similar spirit of optimism led Robert Delaunay (1885–1941) to adopt an even brighter palette than Léger's pure primary colours, and combine it with cubist form and space, to create his own vision of a popular art.

Founded on the colour theories that had engaged Seurat, Delaunay developed a style he called "Orphism", and painted abstract colour arrangements from 1912 in this mode. Like Léger, he thought the modern world offered excitement and opportunity, and responded to it with his radiant vision.

FUTURISM

In the years before the First World War (1914–18), a group of Italian artists seized on the idea of an art which placed the achievements of technology and mechanization at the centre of modern civilization.

Making up for a late start, the hardware of industry appeared suddenly in Italy, and the shock was felt by the intellectuals of the middle classes, whose entrepreneurial members had initiated the economic changes, while stepping into the political dominance enjoyed until recently by the old aristocracy.

BELOW *Umberto Boccioni's* Fight in the Arcade *(1910) is a typical early Futurist composition that stresses the dynamic action of an unstable modern world. Marinetti's manifestos urged revoluton, violence and iconoclasm as the way forward for avant-gardists.*

Filippo Tomaso Marinetti (1876–1944), a writer, called for a new culture to accompany the newly emerging industrial state: away with the burden of Italy's history, the Roman ruins and the great museums! The new art must cast off all those ancient associations, and insulate it-self from contamination by any aspect of the dead weight of past culture.

The Manifesto of Futurist Painting (1910) condemned museums as cemeteries that dissipated the energy and contaminated the imagination of the artist. In an article in *Le Figaro* in 1909, Marinetti saw the future symbolized in the automobile, the train and

the aeroplane which epitomized "the beauty of speed":

"a racing-car whose hood is adorned with great pipes, like serpents with explosive breath – a roaring motor-car which runs like a machine-gun is more beautiful than the Winged Victory of Samothrace*".*

Thrusting aside the masterpiece of Greek sculpture, Marinetti set out his extreme iconoclastic position: "we wish to glorify war – the only true hygiene of the world ..."

At first it was a literary concept, and one that lent itself to outrageous stage performances that would ensure its notoriety. Later, artists led by Umberto Boccioni (1882–1916), participated, including Giacomo Balla (1871–1958), Carlo Carrà (1881–1966), Luigi Russolo (1885–1947) and Gino Severini (1883–1966). Marinetti's publicity skills blossomed, but the Parisian avant-garde remained sceptical especially when the Futurists poached Cubist and "divisionist" techniques to help the movement along.

Boccioni was the most creative and theoretical artist amongst the Futurists. He developed a wide range of pictorial and sculptural solutions to meet Marinetti's challenge, producing works of real power.

An early work, *The Fight in the Arcade,* demonstrates Boccioni's capacity to visualize scenes dramatically. Later he imbued the Cubist idiom with symbolic overtones, to convey an emotionally expressive effect, in his second *States of Mind* series.

When he died serving in the Italian Army in 1916, Futurism lost its driving force. Although members of the group continued to pursue ideas they had developed, Marinetti's call for violence and war that would cleanse society had a hollow ring in the aftermath of the war.

The Futurist dynamism combined with Cubist structure of Carlo Carrà's work, makes a potent visual statement. Balla went on exploring ways of suggesting continuous movement, using high-speed flash and stroboscopic techniques to analyse patterns of movement. He had adopted a repeating sequence in *Girl running on a Balcony* (1912) using the dotting technique and lightened colouring of "divisionism" to create a visual oscillation. In subsequent paintings, Balla used a device pioneered by Boccioni, known as "lines of force", to indicate the sweep of movement, perhaps derived from photographs of moving figures taken by Bragaglia.

The arresting potential of the technique was taken up by other avant-garde groups, including Russian artists, who used the thrusting diagonal shapes and dynamic compositions.

ABOVE *Cubism provided a framework for a more aggressive and dynamic Futurist style. In the composition of* Those Who Go *(1911) by Boccioni (the most creative artist amongst the Futurists) the dark colour and angular forms engulf the figures who will be swept along by the train – symbol of the modern mechanical world.*

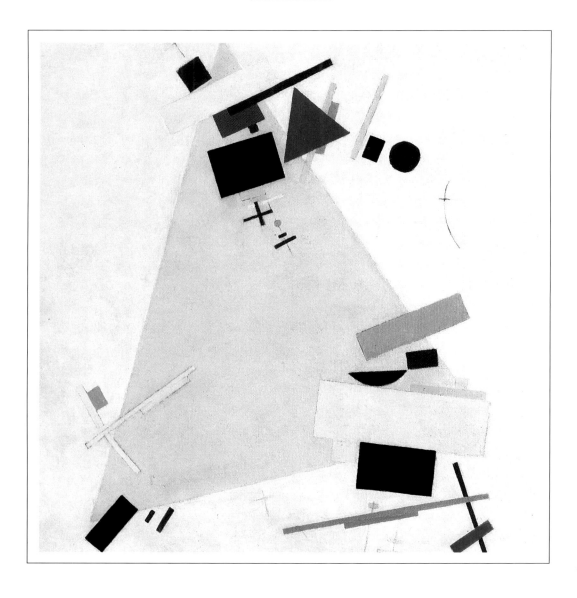

LEFT *Kasimir Malevich called this type of work "Suprematist". In such works as* Dynamic Suprematism *(c1915), his absolutely uncompromising intention is clear: a visual language of pure form would replace the heritage of 19th-century academicism.*

THE RUSSIAN AVANT-GARDE

Russia before the Revolution was an absolutist state, previously untouched by democratic reforms. Largely rural, its cities were small, and the culture of the aristocracy was imported, mainly from France. A few enlightened private collectors, notably Schukin, bought modern art from the Impressionists to Matisse, but there were not public collections and there was no tradition of progressive indigenous art. Young artists did, however, gain access to the private collections, and around the beginning of the 20th century some of them travelled to western Europe. A small group soon began to utilize Cubist and Futurist techniques, combining these with motifs drawn from native peasant art, and executing their works vigorously, with a deliberately crude finish.

Kasimir Malevich (1878–1935) demonstrates this approach, yet he soon became one of the first artists to develop a "non-objective" or abstract language of painting. He invented the term "Suprematist" for paintings like his *White on White* of 1915 or *Red Square* (see Introduction). In such works Malevich claimed that there was no reference to, or resemblance to, things of the visible world as opposed to abstract forms derived from, or abstracted from visible sources.

ABOVE *Kasimir Malevich called this type of work "Suprematist": In such works as* Dynamic Suprematism *(c1915), his absolutely uncompromising intention is clear: a visual language of pure form would replace the heritage of 19th-century academicism.*

Mystic intensity led Malevich from a culture where there were few visual images apart from folk art and the symbols and icons of the Orthodox Church, to an art where all the trivial and ephemeral aspects of the world were swept aside in order to arrive at representations of geometric forms that were essentially secular icons.

All the progressive Russian artists at first welcomed the Revolution and the new Soviet State (although Chagall disagreed with the authorities and emigrated in 1923, and Kandinsky had gone back to Germany in 1921). Many avant-garde artists adopted the "Constructivist" label, turning from aesthetic pursuits to designs for production. For instance, Vladimir Tatlin (1885–1953) designed workers' clothing.

Lissitsky's poster *Beat the Whites with the Red Wedge* (1919) used the abstract language of geometric forms to convey a political message to the largely illiterate masses. It was one of the few successful applications of the style, and, even here, the invasive red wedge is accompanied by words to reinforce its message.

But the Soviet economy was at the point of collapse and the pace of industrialization could not be speeded up to match developments in the West. Lenin commented succinctly that what the people needed was potatoes, not art.

From Lenin's point of view, the only useful art was one that could mobilize the

ABOVE *El Lissitsky's poster* Beat the Whites with the Red Wedge *(1919) used the symbolic language of abstract geometric form to get its message across – although words were added to make the meaning clear.*

popular will to greater efforts for the collective good, and the kind of art that did this best was uncomplicated "Social Realism". Artists who valued the creative, the inspirational and abstract in art above their social commitment, left for Western Europe and the USA. Of those who stayed, Alexander Rodchenko (1891–1956) turned to industrial design, and Malevich – against all his convictions – to a kind of "realist" painting, in response to the cultural purge of Stalin, which ended all their idealist goals.

THE INTERNATIONAL STYLE

In the West, intellectuals and artists sought a universal language that would communicate to all people, from any culture, in a decade – the 1920s – that was over-shadowed by nationalist and ideological conflict, in the aftermath of the mass-destruction of the First World War. This idealism was variously manifested in the *De Stijl* group in Holland – centred on Mondrian and Theo van Doesburg (1883–1931): Delaunay and the architecture of Le Corbusier in France; "Unit One" in England, with its publication *Circle*, of which Ben Nicholson (1872–1949) was the editor as well as the

leading abstract artist; and most influentially, in the Bauhaus school of art and design at Weimar and later at Dessau, in Germany. The Bauhaus pioneered an integrated programme dedicated to Modernist theory and practice, incorporating architecture, industrial design, craft, and fine art. The International style was dominant in architecture and design. Characterized by clinical austerity and rationalism, it adopted the principle "form follows function", and the edict of Adolf Loos, "ornament is crime". (Loos was an architect who rejected the excessive symbolism of late 19th- and early 20th-century Viennese buildings, in the Art Nouveau style. The moral aspect was an important tenet: the societies of the future would be egalitarian, and good design and production could enable everyone, however humble, to benefit. Innovative designs for workers' housing with their interior fittings and furnishings, would be produced by major architects.

Art had lost its place at the heart of Western culture during the 19th century, but the International style of the 1920s seemed to offer the chance for art to articulate the possibility of a new and better society, in the way that David summed up the cultural direction of the French Revolution.

COMPOSITION WITH RED, YELLOW AND BLUE
BY PIET MONDRIAN

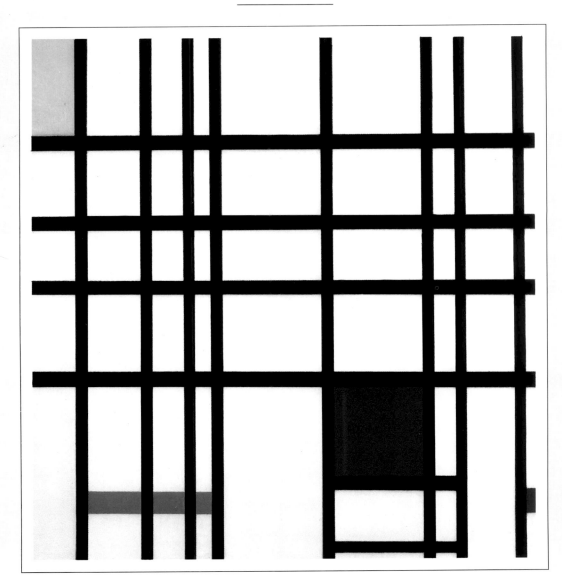

Piet Mondrian's mature works are governed by a rational, ordering spirit, which, for him, encompassed serenity and purity – a kind of perfection that the real world could not match. Composition with Red, Yellow and Blue (c1937) is constructed from horizontals and verticals on a background where space is only intimated by the properties of the primary colours.

1 Mondrian did not use a standard French format canvas. He favoured a vertical measurement which would divide into eight equal units of 9cm (3.5in).

3 The projected grid structure, usually based on small sketches, was drawn on the canvas in charcoal.

4 The 4 main horizontal lines, based on the division into 8 squares, were then painted in. Mondrian probably used strips of tape, possibly adhesive, to help him position the lines.

5 The 8 vertical lines were painted over the 4 horizontal lines and minute adjustments were made to ensure correct positioning.

2 The finely woven linen canvas was attached to the stretcher by iron tacks and tape. A commercial ground of size and oil was then applied evenly over the whole canvas.

6 The cadmium yellow rectangle was brushed vertically and the main red square was brushed horizontally, as were the strips of cobalt blue and cadmium red, probably added later.

MONDRIAN, AND "NEO-PLASTICISM"

The early symbolist works of Piet Mondrian (1872–1944) were of a pantheistic intensity, which led him to pare down natural images in order to discover their inner reality. His formative years were spent refining images inspired by the Dutch landscape, trees and water, the vertical and the horizontal, to arrive at the expression of a universal harmony in his *Ocean and Pier* series. He gradually refined and reduced descriptive detail, increasingly abstracting the image to basic marks and structures. It is easy to see how *The Red Tree* of 1908, and *The Grey Tree* of 1912 could ultimately lead to the austerely geometric forms of his mature style in *Composition with Red, Yellow and Blue*, constructed from horizontals and verticals on a background where space is only intimated by the properties of the primary colours.

Like Léger and Delaunay, Mondrian threw himself whole-heartedly into the modern urban world. When he moved to New York he lived in a world of rectilinear modernist design that seemed to echo his paintings. *Broadway Boogie-Woogie* (see Introduction) is reminiscent of an aerial view of the grid of streets (rationally numbered rather than named), the noise of traffic, and the sound of jazz which Mondrian loved.

His universal vision of pure form and colour did not include the curve or the colour green. The story is told that Mondrian, when dining with a friend in a Paris restaurant overlooking a typical boulevard, asked to change places so that he would not have to view the avenue of trees – such was his aversion to nature! Nature represented chaos, threatening the structures of a rational culture and intellectual order.

GERMAN EXPRESSIONISM

German Expressionism arose as a revolt against a repressive culture, in which both society and art were deeply conventional.

After the defeat of France in the Franco-Prussian War in 1870–1, and the foundation of the German Empire, official art was patronized by the militaristic ruling class, which exploited the potential of art for propaganda. The unity of the new Germany could be strengthened by works which commemorated national heroes in an academic realist style.

The term "Expressionism" can be applied to any art that gives the subjective and the personal precedence over neutral or dispassionate observation, although it generally refers to the use of distortion for emotional effect. Van Gogh applied paint in thick gestural marks and accentuated the effect

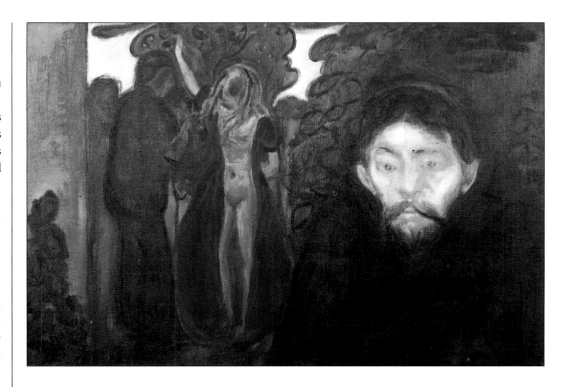

ABOVE *Edvard Munch, Norway's greatest painter and one of the major precursors of Expressionism, is remembered above all for a thematically related group of paintings executed in the 1890s which he called, after 1918, his* Frieze of Life. Jealousy, *painted in Berlin in 1895, is part of the series. Here, complex and conflicting mental states and ideas are conveyed through the subtleties of his techniques.*

by using intense, vibrant colours, freed from accurate depiction or description. His example inspired the Norwegian painter Edvard Munch (1863–1944), who worked for a time in Berlin, and the group called "die Brücke" ("the bridge") founded in Dresden in 1905, by Ernst Ludwig Kirchner (1880–1938), Karl Schmidt-Rottluff (1884–1976), Erich Heckel (1883–1970) and Fritz Bleyl (1880–1966).

"Die Brücke" was envisaged as a reaction to the *status quo*, seeking freedom of life and action against established, older forces. The movement clearly draws on the heritage of Romanticism in its pursuit of the freedom of the individual, and its emotionalism, although a more direct inspiration was gleaned from Nietzsche's *Thus Spake Zarathustra* in which artists are called on to seek "new freedoms" from the constraints of conventional society.

The members of "die Brücke" were architectural students, with no artistic training so their paintings lack sophistication. The range of subjects and moods tended towards the joyful and exuberant, in paintings of their friends in the countryside in summer.

The works have an idyllic cast about the colouring, influenced by Gauguin and the Nabis. "Die Brücke" participated in the very German cult of naturism among artists and intellectuals, who in the summertime emulated the simple bohemian life along

the forest-lined lake-shores, near Dresden and many paintings were the result of these hedonistic vacations. Kirchner's paintings display the admiration for German wood-cuts of the Gothic period, together with an enthusiasm for primitive art.

Like the Fauves, these artists valued the strength and directness of primitive sculptures, examples of which they saw in the Dresden Ethnological Museum, but they added an aggressive element in form and execution, and dissonant colour combinations that conveyed a sense of anxiety. This was quite foreign to the sensual responses of the Fauves.

The neglected German technique of the woodcut, dating back to the heritage of Dürer, was revived by the "Brücke" artists in a cruder form, with more emotional impact. They used the same simple and direct technique as Gauguin, who in Tahiti produced woodcuts activated by rhythmic patterns, without attempting to conceal his tool-marks. The vertical striations by Emil Nolde (1867–1956) in his *Prophet* testify to Gauguin's example.

The group moved to Berlin, but by 1913 internal dissent led to a break-up. Before that, Kirchner, who had led the group, painted scenes of Berlin low life during 1912–3, which seem to sum up the concerns of German Expressionism. The street-scenes are indicated with shallow depth, and rendered with an aggressive angularity

ART IN THE MACHINE AGE

*M*achines and machinery inspired progressive artists from the beginning of industrialization. They symbolized scale and power, and – as new and challenging subjects – represented change. They seemed to offer in themselves the means by which society could be transformed for the better.

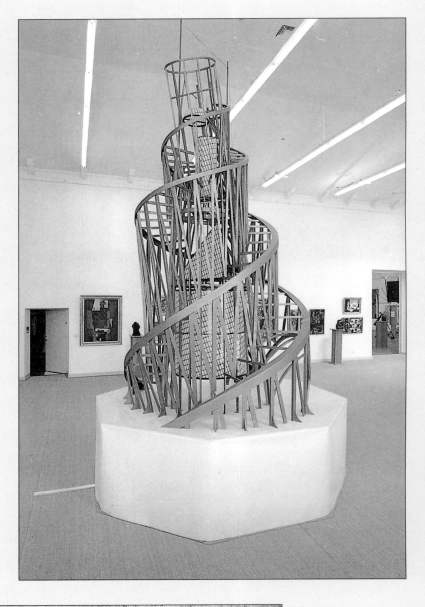

For Turner, the steam train was a metaphor of the modern age. The noise, speed and unprecedented strength of the locomotive was likened to a fiery monster. Undaunted by rain and wind, the train matches the speed of a hare seen on the track; and is counterpointed by the group of boatmen, far below the viaduct, remote in their leisurely arcadian idyll, and soon lost far behind.

Monet painted many railway bridges, trains and stations as part of his enthusiasm for the contemporary world, but also because clouds of steam offered interesting visual possibilities. His Gare St-Lazare series demonstrates the pictorial solutions to the subject dissolved in clouds of vapour, suffused by shadow or sunlight.

The Futurists, too, saw trains, as well as motor-cars and aeroplanes, as key actors in the modern drama. Boccioni used the cubist idiom, and blended it with expressive, symbolist elements in his States of Mind series, which represented a manifesto for a revolution in thinking.

Yet more ambitious use was made of the metaphor of the machine by avant-garde artists in Russia and in northern Europe. Elements of machine forms and movements were incorporated into sculpture and kinetic art.

Tatlin's gigantic tower was intended to have revolving auditoria and other moving parts in its structure. Like many other grandiose projects, it remained an idea only realized as a model: inspirational rather than practical.

This utopian vision faded into disillusion, as machine technology was turned to instruments of mass-destruction in two World Wars. The machine, it was soon realized, was not to be a universal panacea. Laborious toil and poverty would not be so easily eradicated unless by the collective will of society.

ABOVE
Vladimir Tatlin, model

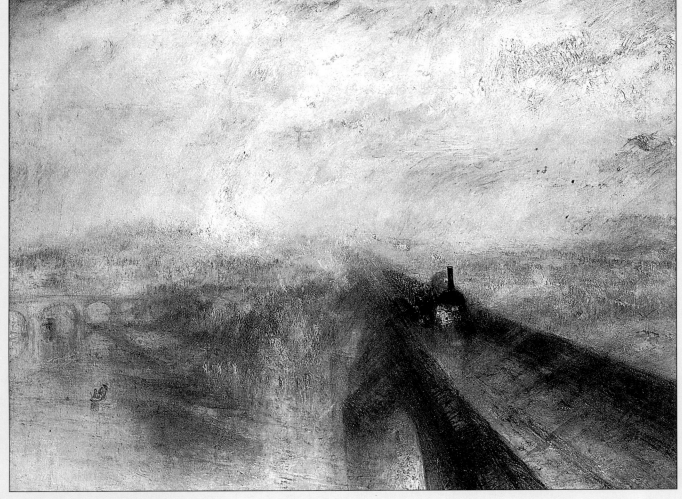

LEFT
JMW Turner, *Rain, Steam and Speed*, 1844

that creates oppressive, threatening contexts for his brittle sophisticates. There is a morbid eroticism about the paintings of prostitutes in this violent, almost frenzied style, that brought Kirchner notoriety.

This period in Kirchner's work was abruptly ended by the outbreak of the First World War. His febrile temperament caused him to have a total breakdown during the war, and he never returned to his angst-ridden vision of the pre-war period. In 1937 his paintings were condemned by the Nazis, who held an exhibition entitled "Degenerate Art", to underscore their contempt for Expressionism. As a result, Kirchner entered a state of depression, resulting in his suicide in 1938.

A second grouping with very different attitudes, styles and intentions, called "der Blaue Reiter" ("The Blue Rider", after the title of a painting by Kandinsky) was launched in Munich in 1911. As a platform for publicity, Wassily Kandinsky (1866–1944) and Franz Marc (1880–1916) published a collection of essays and illustrations drawn from a wide range of cultures, to represent

their position, which was expressionist, coloured by a form of spiritualism.

Kandinsky was the driving force of the group, and generated the theory that was to give a notional common purpose to the "Blue Rider", although it was centred on his own, very personal, understanding of visual language. He wanted to combine the theory of a language of abstract form with a colour theory derived from Goethe, in which every colour stood for values parallel to those in music. In his book *On the Spiritual*

BELOW *Ernst Ludwig Kirchner's* Street Scene *(1913) is characteristic of his disturbing Expressionist style. The angular forms are threatening, and there is a morbid eroticism about the prostitutes, doomed to be victims, when painted in this violent manner.*

in Art (1912) Kandinsky wrote:

> "the kind of creative artist who wants to, and has to, express his own inner world – sees with envy how naturally and easily such goals can be attained in music, the least material of the arts today."

This universal visual language would, like music, transcend national and cultural boundaries – an idealistic project, very much of its time in western culture. A glance at *Battle of the Cossacks* (1910) clearly separates Kandinsky's work from the absolutism of

Malevich's Suprematist works, or the symbolic codes employed in El Lissitsky's poster.

While Mondrian eliminated anything that he felt hinted at a personal or individual feeling, Kandinsky claimed that his work was generated *entirely* by feeling.

Kandinsky (like Mondrian) was profoundly influenced by Theosophy, which directed both of them towards an absolute and spiritual realm. Most progressive artists of this period could not embark on an abstract or non-objective path without a theory or spiritual impetus to start them off and give them confidence.

After his return to Russia in 1914, Kandinsky was exposed to exciting pre-revolutionary ideas and practices. Practical difficulties, and the opposition of functionalist ideologists, however, soon made his position untenable. He returned to Germany and was accepted readily at the Bauhaus where he taught under Walter Gropius, and he became immensely influential. Subjected to rigorous theories, Kandinsky's original, freely painted plumes of colour were reduced to a more geometric system, and the potency of the original colour was enclosed and contained in works of cerebral refinement. A similar cool, geometric refinement is noted in the work of Lyonel

ABOVE *Franz Marc's gentle, unworldly soul is apparent in his paintings of animals which combine avant-garde techniques with an untarnished innocence.* Red Bull *shows his belief in nature as the source of all existence and meaning. His pantheism led him to invest animals with mystical knowledge and serenity – a purity no longer accessible to urban man.*

Feininger (1871–1956), an American who contributed to the Bauhaus ethos.

The close friends, Franz Marc and August Macke (1857–1914), were also members of the group. Together, they were discovering an Expressionist use of symbolic colour which was to be the core of Marc's painting of animals. Animals, he felt, were closer to the mystical centre of existence, in touch with feelings man had blunted through his urban, artificial life. Marc's lyrical paintings, with their rhythmic shapes and blended shafts of pure colours, were an attempt to express the animals' perceptions of existence.

After 1912, when Marc met Delaunay in Paris, his compositions became more abstract, but increasingly indicated anxiety, reaching a climax of conflicting forms in 1914, which was to prove prophetic. Marc and Macke both perished in the First World War.

Max Beckmann (1884–1950) and Otto Dix (1891–1969) were both profoundly affected by their experiences in the First World War. Beckmann's subsequent work reflects them in the horrifying subject-matter and disquieting distortions of the human form that are associated with German Expressionism.

Beckman's paintings are allegories of human vices and failings, executed in a bitter mood, intensified after losing his post under the Nazis in 1933.

A more explicit detailing of man's bestiality is seen in Dix's work. Utter disillusionment pervades his vision, whether of the horrors of war, or the decadent society of Berlin, with its hapless prostitution.

In the 1920s, Dix was a major figure in the *Neue Sachlichkeit*, or new Objectivity School, which depicted the visible world, urban and social, in a precisely cool, realist manner, as a restrained response to the excesses of emotive imagery of the Expressionist movement.

A denial of objectivity can be seen in the earlier work of George Grosz (1893–1959), who was to become a leading member of the movement. His expressive line and

BELOW *Study for* Je Suis un Appareil Photo *by George Grosz (c1952). One of the original contributors to the Dada movement in Berlin, Grosz forged a satirical style that persisted long after he was forced to take refuge in the United States in 1933.*

satirical lack of neutrality are depicted in his brutal portrayal of militaristic types, his attacks upon a corrupt society, and his exposure of the hypocrisy of the bourgeoisie whose greed sustained the right-wing régime of the Weimar Republic.

Grosz' work served a political purpose, intended to stir the masses into revolt against an unjust society. His drawings were published in the left-wing press, and were contemporaneous with the powerful photomontages of John Heartfield (1891–1968), whose fearless attacks on militarism and exploitation, and later on the Nazi regime, led to prosecutions, and to his eventual exile in London.

Like Grosz, he had anglicized his name during the First World War as a protest against the manipulation of public opinion: for both artists, the enemy was not the

British, but the industrialists who controlled the huge munitions works in the Ruhr. Grosz, like the idealists of the Russian Revolution, envisaged a key role for artists in a new society, and he despised Expressionists like Kandinsky for retreating into the "exile" of esoteric art practices, describing them as "scrubby bohemian anarchists". In *Art is in Danger* (1925) Grosz wrote:

"There are still artists who deliberately and consciously attempt to avoid all politically committed art (Tendenzkunst), *remaining silent in the face of social events, not taking part, not accepting responsibility. As far as art is practised for its own sake, it propagates a blasé indifference and irresponsible individualism . . . A detached stance, above or on the side-lines, still means taking sides. Such indifference and otherworldliness, supports automatically the class in power in Germany: its bourgeoisie . . ."*

Kandinsky had indeed written in 1904 of the beauty of his work becoming apparent only to "the sensitive observer", who would divine the "inner content", which must "never be too clear and too simple", and he openly admired the "Art for Art's sake" ideals of the Symbolists, with the observation, in *Whither the New Art?* (1911), that "Art, as it were, turns its back on life . . ."

Kandinsky's Swiss colleague at the Bauhaus, Paul Klee (1879–1940), had known him since the "Blaue Reiter" years, and they shared a belief in the expression of individual vision through art.

Klee, too, used colour to convey mood, but his work had a lightness and wit and was not burdened with theory or ideology. He did not abandon figurative art, but employed the style best suited to each concept.

Like Kandinsky, he was very interested in music as a metaphor for his art, and his colour harmonies with his imaginative lyricism divorced him from the *Angst* associated with German Expressionism. The increasingly oppressive political climate of the 1930s finally culminated in his removal from a post at the Düsseldorf Academy in 1933 by the Nazis. Conditions became unbearable in Germany by the mid-1930s and Klee returned to Switzerland. This led to a bitter mood in his later work, accompanied by a darkening of his colour in many of his paintings.

Kandinsky had gone to France, and other avant-garde artists, many Jewish, had fled to America before it was too late. Most would hear that their work had been exhibited in the Nazis' propagandist "Degenerate Art Exhibition" of 1937. Many artists were persecuted and forced to leave Germany or stop working (except secretly) – especially those who combined social criticism with a brutal Expressionist technique. Picasso was to combine the Cubist idiom with Expressionist feeling in his anguished indictment of fascism, *Guernica* (1937). It was perhaps the last great painting to become internationally recognized as a committed political statement.

BELOW *In Kandinsky's* Battle of the Cossacks *(1910) it is still possible to recognize vestiges of subject matter – horsemen, and citadels on hilltops, reminiscent of the elements of Russian folk- tales. The scene is rendered vivid by Kandinsky's use of freely painted colours, which enliven the whole picture surface.*

SURREALISM

After World War I, the art world in France was split between two styles, each linked to opposing ideologies: "Purism", which promoted a "return to order", in art and society, and "Surrealism" which proposed a revolutionary new society.

After the material destruction and the fear of losing national identity brought about by the protracted war against Germany, there was a movement to rebuild shattered traditions and restore social order. The art associated with this spirit was clear but aloof, in accordance with the programme set out by the architectural theorists Le Corbusier (1887–1965) and Amedeé Ozenfant (1886–1966) in their publication *L'Esprit Nouveau*.

Purism saw itself as the natural successor to Cubism at the leading edge of the avant-garde but its claims were contested by a dissident group of intellectuals who rejected conventional culture, regarding it as the outward face of a moribund society. The writer André Breton constructed a body of theory in 1924, as much to out-manoeuvre the Purists as to propose a radical alternative.

The early 20th century had seen the concept of an avant-garde, applied to art. It was assumed that new, progressive art would be the province of a small group of pioneers and would be understood only by an equally small circle of those "in the know". An attitude of contempt for the bourgeoisie was built in and an increasing familiarity with theory was demanded – the theory often being provided by writers and intellectuals rather than by practising artists. The dependance on theory carried two corollaries: first, that art could not be understood directly, and to receive its full meaning it had to be interpreted or explained; secondly, that art was without obvious purpose, unless theory provided one.

ABOVE *Picasso's* Guernica *was the outcome of a commission from the Republican government of Spain for a mural at the World's Fair in 1937. At the end of that year, the Basque town of Guernica was bombed. Picasso paid tribute to the victims in what is perhaps the most famous painting of the 20th century, both in its historical context with its sinister prophecy of World War II, and stylistically. We see here the culmination of years of experimentation since the* Demoiselles d'Avignon *of 30 years earlier, in the distorted figures and symbolic references to suffering and aggression. The horse and bull, too, are motifs familiar from earlier works, now become more abstract.*

From the Cubists onwards, avant-garde art became esoteric, speaking only to the informed, or (as certain Modernist critics like Clive Bell put it) to the "sensitive". The days when the general public would flock to the Salon in its tens of thousands to see the latest works of art had long gone.

Léger had already recognized that the Purist style offered him little. Minimal subject matter, where even colour was understated, was not a recipe for popular acclaim.

Breton started out from "Dadaist" ideas and practices, rejecting everything that bourgeois culture held dear. Dada had emerged in neutral Zürich in 1915 in reaction to the First World War. Its mentor was the poet Tristan Tzara, whose ideas of the absurd, of an incoherent and often iconoclastic art led artists to experiment with new forms, including collage, montage and "ready-mades" – an idea invented in 1914 by Marcel Duchamp. Breton sought to build a positive, constructive function onto a cathartic one, for Dada had been a negative idea. Culture would be constructed anew.

Dadaist techniques emphasized the role of chance in art, as in Hans Arp's "chance compositions", the visual equivalent of the nonsense poem. Breton incorporated all of this into a philosophy, informed by his enthusiasm for the psychoanalytical studies of Freud, and Marx's critique of capitalism.

Freud's theories of the subconscious inspired Surrealists to experiment with creative processes that would unlock the unconscious, the Id, freed from the repression of civilizing Ego, and the moralizing force of the Superego. Once the rituals and conventions of everyday life had been exposed to ridicule by avant-garde artists and writers, it would be obvious to all how artificial and "false" civilization had become, and would open the way to the possibility of a more "rational" (that is, socialist) society as the ultimate goal.

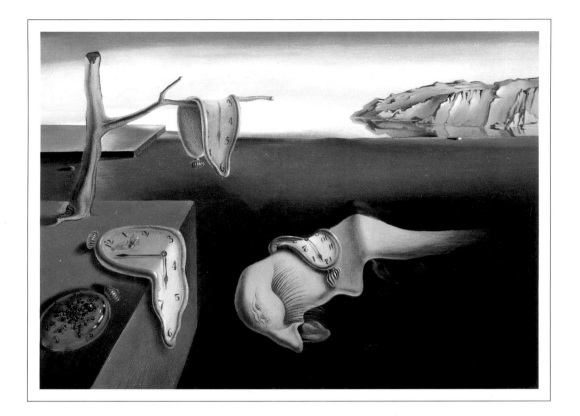

ABOVE *Salvador Dali combined de Chirico's dream – such as clarity of forms in space – with disconcertingly distorted shapes, in works made all the more compelling by the academic, smoothly-worked painted surface and the highly-detailed rendering, as in* The Persistance of Memory.

These ideas were not shared by all the artists involved in the Surrealist movement, which was itself confused and contradictory. It contained anarchic and mystical elements opposed to the restrictive intellectualism of Cubism and Purism, as well as partisans of political programmes. Salvador Dali (1904–1989) and Joan Miró (1893–1983) were individualists who used Surrealist ideas for their own religious, magical or revelatory ends – stressing the poetic in the face of the banality of everyday existence.

A key inspiration had been the re-discovery of the poet Lautréamont (1846–70), whose line, "Beautiful as the chance encounter of the sewing machine and the umbrella on the operating table", provided the imaginative rhetoric for Surrealist practice, an access to the "royal road to the unconscious".

Assemblages would be constructed from bizarre combinations of images and objects, isolated from their origins in daily life; elevated to the status of art, and invested with what Breton called a "super-reality".

Essentially two kinds of painting emerged. One was based on the dream concept, and utilized a conventional landscape perspective, in which the incongruous object would be set – as in the work of Salvador Dali, and other like Yves Tanguy (1900–55) and René Magritte (1898–1967). The other employed experimental new techniques of collage, and "automatism" to create chance encounters by bizarre juxtaposition.

In the first of these strategies, inspired by the sinister and enigmatic paintings of Giorgio de Chirico (1888–1978) and Carlo Carrà (who had been a Futurist, but took up de Chirico's "Metaphysical" painting in 1915), the method was to create imagery that rendered the strangeness of dreams. Realist conventions of space, light and

meticulous detailing, unnerving in their illusion, brought on a sense of hallucination.

Dali produced a series of obsessive works, exhibiting what he described as his "paranoic-critical method", in which a repertoire of images recurs in different combinations, but always executed in a smooth academic manner. While Tanguy painted empty landscapes with a lunar coolness, Magritte explored the potential of Lautréamont's poetic idea of irrational juxtapositions. Familiar objects take on a new meaning and presence with Magritte, when divorced from the logic of function. He raises questions about logical expectations, and conditioning and the role of visual perception in the language of art, which remain thought-provoking today.

In the second strategy, Dadaist processes employing the element of chance, practised by Hans Arp (1887–1966), and Kurt Schwitters (1887–1948), were developed into an activity entitled "automatism", through which ideas and images repressed by the conscious mind could emerge.

Joan Miró (1893–1983) explored the possibilities of automatic drawing, as a means to initiate motifs and compositions, and Max Ernst (1891–1976) used a range of experimental processes involving rubbings from rough surfaces (frottage). He also developed new ways of exploiting collage and photomontage, with banal 19th-century engravings, to achieve a curious mixture of the whimsical and the frightening.

As a coherent movement Surrealism was short-lived, but it had an immediate influence on other artists, notably Paul Nash in England, and the artists of the New York School. Its influence also pervaded popular culture from the 1930s onwards. Today it is a commonplace in the rhetoric of advertising, film and television.

VOX ANGELICA BY MAX ERNST

Max Ernst experimented with a wide range of mediums and techniques, by means of which he would subvert the expectations of the viewer, producing challenging works with apparently arbitrary or poetic titles, as in Vox Angelica *(1943).*

1 *Vox Angelica* sums up all the main techniques with which Ernst was associated. Collage is referred to parodistically to the illusionistic painting of the leaf, for example, which has been painted so that it appears to be stuck on.

2 Frottage also features in a parodistic way. The appearance of floorboards was created by painting rather than by rubbing through paper with a soft pencil.

3 Ernst adapted the technique of decalcomania. The technique involves pressing a sheet of paper or similar material onto the paint-covered surface and peeling the sheet off again.

4 Grattage involves scraping pigment over canvas which has been placed on a heavily textured surface.

5 Ernst may have used adhesive tapes to create the straight, overlapping lines.

6 Oscillation involves paint being dripped from a can swung on the end of a piece of string.

Vox Angelica was painted on four canvases assembled in the same way as had been the parts of Grünewald's masterpiece, the *Isenheim Altarpiece*, from a section of which Ernst's work took its name.

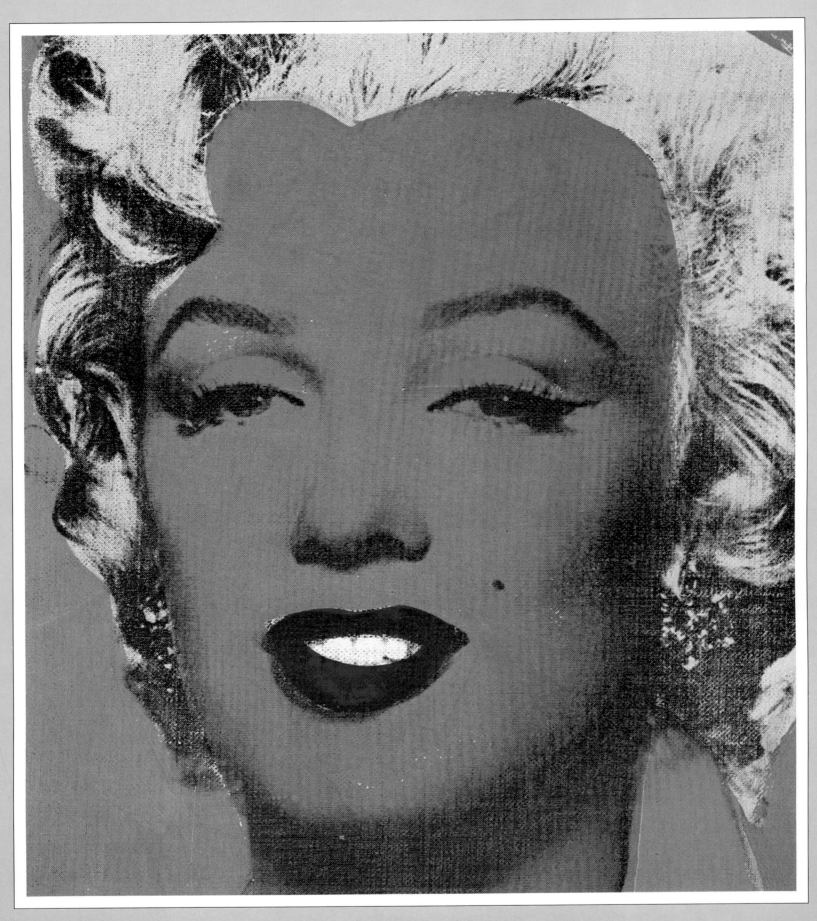

ABOVE *In the 1960s, photographs began to be used as the basis of the image on the canvas. Warhol's Marilyn Diptych (1962) is made up from 50 silk-screened images (detail above). The image is taken from a publicity photograph by Gene Korman, used for the 1953 film Niagara. By 1962 Marilyn Monroe was famous, not only through her films, but also through the manipulation and dissemination of printed images. Warhol introduced a new era of portraiture with this work. Not only did he successfully infuse a traditional genre, the portrait, with immediacy and power, he also brought to it new materials and techniques, acrylic paint and silkscreen printing.*

CHAPTER ELEVEN
NEW-WORLD PERSPECTIVES

America was to take centre-stage in the mid-20th century, just as 17th-century Holland had stimulated artistic activity at a time when the Italian States declined as a trading force – or as in the 19th century, when French imperial power and commercial expansion had made Paris the cultural capital of Western art. The rapid growth of commerce and industry in the USA made it an increasingly important economic force, and, despite the Wall Street Crash of 1929, it was the major economic power of the Western world long before the 1930s.

New York, along with its stock market and imposing skyscrapers which so visibly represent the power of market capitalism, was the cultural capital of America. By the second half of the 20th century New York's towering monuments to corporate finance replaced the Eiffel Tower as the symbol of Modernism.

Culturally, New York was dependent on waves of dissident, mostly Jewish, immi-

ABOVE *Lichtenstein and Warhol introduced an anti-Expressionist regime, subordinating the handling of paint to "commercial" techniques. Pop art drew upon certain Dada precepts and much that had been introduced by Marcel Duchamp. It provided accessible, recognizable images in comparison to the remoteness of "High Art" and, above all, suggested that art could be fun and culturally relevant to its time. Whaam! (1963) by Roy Lichtenstein began as an idea for two separate images which Lichtenstein combined (the right canvas is shown above). The subject-matter probably comes from a magazine he often used as source material – Armed Forces at War. The strong, controversial subject-matter is in stark contrast to the dispassionate techniques used.*

grants to enrich the levels of high culture, alongside the more popular culture of the entertainment industries and mass media. Yet many intellectuals were appalled by these indigenous forms of culture and kept looking to a European model.

French art came to America in two waves. The first was in the late 19th century when Paris had been a Mecca for American writers and artists who went there to meet other artists and absorb new ideas. Whistler was one. Another was Mary Cassatt (1844–1926), who was instrumental in transporting the taste for Impressionist painting across the Atlantic, persuading her rich friends to buy into a trend that was consolidated when the Parisian art dealer Durand-Ruel opened a branch in New York in the 1880s.

The Armory Show of 1913 was the major turning-point, introducing Cubist and other avant-garde styles to collectors and artists beyond the reach of Parisian circles. Earlier, in 1905, the influential photographer, Alfred Steiglitz, opened his Photo-Secession

Gallery "291" Fifth Avenue, which became a focus of new avant-garde ideas from Paris where he had studied. He was the first to exhibit the works of Rodin, Matisse and Picasso, amongst others working in Paris. His art magazine *Camera Work* pioneered European ideas concerning art and new thinking about photography. He also promoted the starkly individual work of Georgia O'Keeffe (1887–1986), an early American Modernist, whom he married in 1924.

One who was influenced by the Armory Show, and later introduced Cubist elements and abstraction into his work, was Stuart Davis (1894–1964). However, his urban scenes of American life, incorporating poster-style flatness and colour, exhibit a genuine American dynamic.

Others looked to their American roots. Traditional "American Scene" painters in the 1920s and 1930s, distanced themselves from European influences. The Regionalist school depicted in a realist style the contemporary rural life of the Mid-West, celebrating small-town America. The idiom is characterized by the work of Thomas Hart Benton, a spokesman for the group, and others like Edward Hopper and Ben Shahn (1898–1969) or Andrew Wyeth who worked in tempera, a medium suited to highly detailed representational work, as it was composed of layers of minute brushtrokes.

In the 1920s the "Société Anonyme, Inc" , was founded by Katherine Dreier to promote contemporary art in a more consistent way, with the first museum to be devoted to modern art. Here, the works of Malevich, Klee and Miró were exhibited. Later, Miró's influence, in combination with André Masson (1896–1987), was considerable upon American art.

However, it was not until the late 1930s that an indigenous American modern style emerged. Even then, it was reliant on European prototypes. France still ruled the avant-garde art world, but apprehensions about the coming war now generated anxiety. A trickle of artists began to arrive in America, and they were not all French. The rise of Nazism in the 1930s had driven many of the most creative and innovative German artists into exile, in the same way that Lenin's increasingly hard-line policy had provoked Kandinsky and other radical artists to leave Russia in the 1920s, well before the Stalinist purges.

The prevailing movement was European Surrealism. Masson and Ernst arrived in New York with the confident demeanour of successful artists: one of the key components they gave to Abstract Expressionism was as much this professional assurance, as the processes and techniques associated with creating "unconscious" imagery.

Masson used the Surrealist process of automatic drawing, and other chance effects to produce a spontaneous design which he subsequently developed by adding textured matter like sand, to the paint. Similarly, Ernst's experimental handling of media had an enormous influence on the young American artists looking for new directions.

Arshile Gorky (1905–48), an Armenian who emigrated to the USA in the 1920s, was directly influenced by the type of Surrealism that used "biomorphic" forms (organic, rather than geometric, in shape).

The invasion of France in 1940 turned this exodus into a flood. Many important intellectuals, writers, musicians, filmmakers, and avant-garde artists fled from Europe and eventually arrived in New York. It was the second and biggest wave of French art to reach America, and America was ready for it. The Federal Art Project, instituted under Roosevelt's New Deal policies in 1935, gave American artists an assured income, allowing them to paint full-time and develop new ideas and techniques free from even a gallery's benevolent pressure to produce for an established market.

BELOW The Moon-Woman Cuts the Circle (1943) exemplifies the increasingly abstract mode and deliberately crude techniques of Jackson Pollock's work in the early 1940s. He employed the mythological and sinister themes favoured by many American artists at this time, testifying to surrealist influences.

JACKSON POLLOCK

As a national programme to give work to the unemployed after the Depression, the FAP's schemes included commissioning paintings and murals for public buildings. Jackson Pollock (1912–56) was among those who worked on these projects. He, like all of the artists involved, became accustomed to working on a large scale designed to have an impact within a setting of imposing public architecture. This experience undoubtedly lay behind the scale and ambition of Pollock's work, once his mature style evolved.

Initially he had worked in the Regionalist idiom of Thomas Hart Benton, but came under the influence of the Mexican muralists, David Siquieros (1896–1947) and Diego Rivera (1886–1957), who executed enormous wall-paintings on themes drawn from the human condition.

During the 1940s Pollock's increasingly abstract mode and deliberately crude techniques were accompanied by the use of mystical subjects, with classical references and poetic titles like *The Moon-Woman Cuts the Circle* (1943) or *Pasiphaë*. Pollock's experimental techniques led, by 1947, to the "drip" paintings. He generally laid the canvas on the floor, and worked around it, pouring and dripping fluid paint from a can. Sometimes the paint would become densely overlaid, building up an impasto

with added sand, broken glass, or other materials. The heavy, vigorous brushwork of his earlier work is replaced by the manipulation of the paint with sticks or other tools, all part of a rejection of the "Fine Art" aesthetic.

The process had much in common with Surrealist "automatic drawing". The critic Harold Rosenberg termed this spontaneous process "Action Painting", drawing attention to the importance of the process over the resulting art-work.

Pollock was taken up by the influential art critic Clement Greenberg. The gallery exposure of his work drew media attention to his style but his apparently incomprehensible images led to him being nicknamed "Jack the Dripper".

He had achieved fame, or notoriety, but was a deeply insecure personality, whose alcoholism and depression demanded constant advice from Greenberg. By the mid-1950s representational elements had returned to his work, in an open, fluid style, inspired by Picasso. Indeed, Pollock said "Picasso was God". Greenberg, who saw Modern

ABOVE Willem de Kooning painted in a style derived from Expressionism. His violent gestural technique resulted in surfaces that were often reworked repeatedly, demonstrating his exploratory approach to the medium. The series of works entitled Woman *(1950/1) caused an outcry when exhibited. The brutal crudity of the forms, combined with ferocious brushwork, provoked antipathy because it seemed so alien to vulnerable human flesh. In his feeling for colour and in his brushwork, de Kooning is regarded as perhaps the greatest painter of his time, "a painter's painter", much admired by his peers.*

art in terms of increasing abstraction and continuous progression, withdrew much of his support from Pollock, whose depression increased, culminating in his premature death in a car-crash in 1956.

THE ABSTRACT EXPRESSIONISTS

Pollock was the most famous member of the group that became known as the Abstract Expressionists, who, although their styles and philosophies varied widely, were united in their revolt against conventional art, and in their commitment to a spontaneous freedom of expression.

Willem de Kooning (1904–) painted in a style that was certainly Expressionist, but never abstract. De Kooning emigrated from Holland in 1927, becoming a friend of Gorky in the 1930s, and experimenting with various styles before settling on the violent gestural manner for which he is celebrated.

The series of works entitled *Woman* caused violent reactions when exhibited in 1953.

As with Picasso's *Demoiselles d'Avignon*, the brutal crudity of the forms, combined here with ferocious brushwork, provoked antipathy because it seemed so alien to the Romantic conception of representations of female forms, which still persists to this day.

Other artists worked in styles that were abstract but not Expressionist, notably Mark Rothko (1903–70) and Barnett Newman (1905–70). Both consolidated an individual approach that featured large areas of single colours. Newman's mature style breaks extensive areas of unmodulated colour into sections, using stripes, or "zips" of other colours, that activate the surface and accentuate the large scale of the canvas.

Like Pollock, Newman worked on a scale that would overawe the spectator, on a canvas which extended to fill the visual field. A more appropriate term was later applied to this kind of painting: "Color Field" painting.

Rothko's paintings are invested with a mystical intensity intended to facilitate contemplation. Their considerable scale provides a keynote of tranquility, unlike Newman's austerity and the effect is one of amorphous forms floating in front of the canvas, or of a gateway through which the transcendent spirit may pass. Rothko was quite insistent that these paintings should not be regarded as empty arrangements of abstract form, but equivalents for feelings associated with Greek tragedy. From a rich palette, pulsating with intense, life-enhancing colour, Rothko turned to the more sombre maroon hues, and, finally, to the darker grey shades that characterize the works preceding his tragic suicide.

Rothko was an intellectual, quite unlike Pollock or Gorky, reflective not impulsive, introverted rather than active: yet the paintings convey controlled emotion, and deep humanity, that draws the spectator in, instead of confronting him.

Robert Motherwell (1915–) like Rothko, was originally an academic, who studied aesthetics at Stanford and Harvard, before taking up painting. He wrote extensively, giving the movement intellectual weight, and investing his own work with literary and historical parallels. His most famous

works are a series entitled *Elegy to the Spanish Republic*, a homage to Picasso's *Guernica*.

During the period in which a recognizably independent American school of painting developed, pioneers of American music and dance were also developing new perspectives, formal and technical, seen in the work of John Cage and Merce Cunningham.

The Abstract Expressionists, or New York School as they are also called, broke new ground, and other artists came along to develop their innovations. Helen Frankenthaler (1928–) developed colour-stain painting from colour-fields, by soaking very thin paint into the canvas, thereby integrating the colour with the material, so that the resulting shapes of colour would not be apprehended as forms in themselves, but as modulations in the integral whole. Other major artists of this generation are Kenneth Noland (1924–), Ellsworth Kelly (1923–), Morris Louis (1912–62), Frank Stella (1936–) and Jules Olitski (1923–).

Robert Rauschenberg (1925–) also painted rather low-key minimalist paintings in the early 1950s, but by the end of the decade had began to make assemblages out of junk, and to stick objects onto paintings, in what he called "combine paintings", in which the detritus of the consumer society is incorporated. In 1959, he exhibited *Monogram*, a stuffed goat, with an automobile tyre around its middle. He also silk-screened found images taken from newspaper photographs onto his art works. These strategies were a reaction against the detached grandeur of Abstract Expressionism.

The unexpected combination of ordinary objects, and their shock effect in a gallery, recalls Dadaist philosophy, but Rauschenberg's paintings were visually chaotic, and emotionally "hot", the paint splattered about with abandon in the gestural manner of the Abstract Expressionists.

SPAWN BY MORRIS LOUIS

Trail of primary layer visible through subsequent pourings

Circular edge achieved by rubbing possibly with a cloth

Central "depot" of paint, dark where colour layers accumulate

Capillary zone dilutes the colour of the adjoining veil

Off-centre core, wiped and brushed, produces a dull sheen

"Straight" edge produced by sharp change of tilt direction

Fuzzy prong-endings as paint seeps into the weave

Funnel of resin draining downwards

ABOVE *The technique of colour-stain painting was employed by Morris Louis from the mid-1950s, as a part of a second wave of American art, called by the critic Clement Greenberg, Post-Painterly Abstraction, to distinguish this kind of painting from the gestural brushwork of Pollock, Gorky and de Kooning. Louis' canvases are carefully composed and controlled, and his rich colour has a freshness that contributes much to the lyrical beauty of works like* Spawn *(1959–60).*

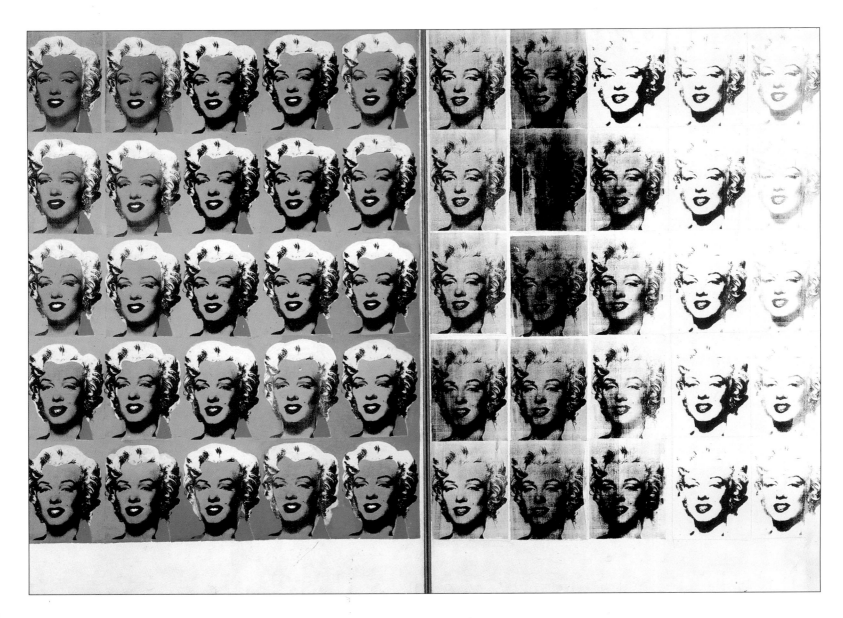

ABOVE *Andy Warhol endowed the common-place with the status of original art when he repeated images using the commercial medium of silk- screen as in the* Marilyn Monroe Diptych *(1962).*

POP ART

The work of Jasper Johns (1930–) in his use of popular imagery from everyday life, is a bridge, a further stage in the development of Pop Art, of which Rauschenberg was a precursor.

Johns had been a commercial artist, and his series paintings rework simple icons of the market-place – turning beer cans, or a coffee tin containing brushes, into culture archetypes like the *Stars and Stripes*. By casting them in bronze he was conferring on them the status of high art. Similarly, his treatment of the flag was ironic.

From this transformation of ordinary objects, it is a short step to the re-creation of everyday scenes: George Segal (1927–) and Ed Kienholz (1927–) cast life-size figures in plaster of Paris, producing works representing scenes from gas-stations, coffee-bars, supermarkets and even art-galleries. They are reminiscent of Edward Hopper paintings made real, except that there is an unease at the lifelessness and anonymity that pervades the figures of both sculptors. Their work is unnerving, and provides a disturbing commentary on human loneliness and alienation.

Rauschenberg and Johns enshrined the everyday in the enclosed world of the gallery, elevating the world of popular culture, of packaging and advertising, to that of art-object. Roy Lichtenstein (1923–) and James Rosenquist would similarly transform comic-strips to the scale of history-painting.

In Lichtenstein's work the two-dimensional comic-strip imagery, and the clichéd fragments of dialogue, are rendered all the more phoney and sentimental when blown-up on a monumental scale. At the same time, Lichtenstein turns the enlarged graphic dots which compose commercial colour reproduction into a visual rhetoric, turning the seriousness of art into a visual joke. The artist's role in the history of western culture is examined with thought-provoking irony.

FLAG BY JASPER JOHNS

The work of Jasper Johns marks a further stage in the development of "Pop Art", of which Rauschenberg was a precursor. Johns' series based on the American flag, such as Flag (1955), employed the ancient Egyptian technique of encaustic (adding wax to the pigment), giving a heavily worked surface texture, but increasing the lustre of the colour.

1 The painting was begun in either enamel or oil paint on a bed sheet.

2 Johns was unsatisfied with this approach and changed to encaustic painting. The colours were made by mixing pigments with molten beeswax.

3 The colours were kept fluid and applied with either brushes or spatulate instruments.

4 Johns also used collage, applying cut and torn pieces of newspaper with the hot wax. Paint was also applied using the collage material.

Encaustic colours are made by mixing pigments with modern wax and, perhaps, a little resin. They are kept fluid and applied with either brushes or a palette knife. When all the colours have been applied, the panel or canvas is set face-up on a table and the colours are fused into an even film using a radiant heat source, such as an electric fire. As the paint cools, the resin helps to harden the paint film which can be given an extra gloss by polishing it with a soft cloth. Johns' technique, however, omits the thermal treatment. Johns chose to use this technique because of its speedy drying properties, so that he could superimpose brushstrokes quickly without those underneath being altered.

THE ARTIST

*T*he portrait of the artist gives us an opportunity to "meet" the originator of the image, as if see in a mirror. More than any other type of portrait painting, the self-portrait engages the spectator's curiosity.

Our eyes meet and we are in the presence of the artist-genius, whether Leonardo or Dürer. We observe their demeanour, their manner and personality, what they looked like at a moment in their lives, how they were dressed, and their circumstances.

Whether there is openness or dissimulation in the representation, such paintings communicate directly to us. The unique characteristic of the self-portrait is that it was made for the artist himself: not for sale, and generally not for public viewing. It shows him as he saw himself, or as he wished to be seen.

The fascination of Rembrandt's long series of self-portraits tells a story of his self-evaluation: from ambitious and precocious young artist – to wealthy, worldly burgher – to destitute old man, whose loss of material wealth is compensated for by his increased humanity and personal integrity.

Van Gogh's self-portraits are thought to chart his psychological state, mirroring his emotions. Yet they convey as strong a sense of presence as any other portrait. In them van Gogh scrutinized his appearance, candidly and clear-sightedly, without self-pity or deception.

Conversely, when Gauguin painted van Gogh, in the same year, Gauguin made van Gogh resemble himself, in a bid to dominate him, consciously or unconsciously.

The Impressionists produced images of social life lived in the public gaze. Their paintings of each other are mutually reflective. They tell us of a particular way of life and demonstrate an attitude to their art, and their environment. None of the paintings of Monet attempts more than cursory resemblance, and certainly no psychological insight is provided: like bourgeois life, the describing takes place on the surface.

Both Vermeer, and Velázquez in Las Meninas, withhold their identities from the viewer, preferring to remain enigmatic, shadowy figures. In contrast, the self-confidence of Picasso emanates from all of his many self-portraits.

Not only this, but they could endow ephemeral events, seasons and human lives with immortality, by fixing them in paint.

ABOVE
Raphael, *Self-portrait*, C1505

ABOVE
Rembrandt, *Self-portrait*, 1629

LEFT
Jan Vermeer, *The Painter's Studio*, C1665–70

WHAAM! BY ROY LICHTENSTEIN

Roy Lichtenstein would also draw on popular culture, reworking comic strips to the scale of history paintings. By the simple device of enlarging the canvas to billboard size, and using the themes and language of pulp literature, Lichtenstein questioned the relationship between "fine art", represented by easel painting, and mass culture, as in Whaam! (1963).

1 The artist first made a small pencil drawing which served as a guide for the major lines of the composition and colouring.

2 When the small drawing was transferred to the canvas, changes were made – two panels were used instead of one. The plane and burst of flames were greatly enlarged and the colours indicated on the drawing were altered.

3 The dots were applied next. The areas which were not to receive the dot pattern were masked off.

4 A perforated metal screen was placed on the canvas. The screen had regularly spaced holes through which the paint was brushed with a toothbrush.

5 Lichtenstein then painted the areas of solid colour, beginning with the lightest and working through to the darkest. For this, Lichtenstein used the primary colours associated with the comic strip.

6 Finally, the black lines were painted over the primary colours and dots.

Lichtenstein used a metal mesh screen to create the dot pattern in *Whaam!* The screen was laid on the canvas and the paint brushed through the holes in it. When the screen was lifted off, the dot pattern was revealed.

The techniques of commercial art were also familiar to Andy Warhol (1928–87), who was a successful graphic-artist before turning to avant-garde activities in the early 1960s. His repeated images of Campbell's Soup cans and Brillo-Pad boxes, using the commercial medium of silk-screen endowed the commonplace with the status of original art, and gained him notoriety and fame – to which he insisted everybody would be entitled "for 15 minutes".

Images of celebrities, like Marilyn Monroe and Jackie Kennedy, were given the Warhol silk-screen treatment. It is a medium that gives a precise and impersonal "mechanical" image easily and in multiple reproduction. In this way unique images of cult-status, like the "Mona Lisa" are reduced by replication to the status of a postage-stamp. Warhol's technique and themes undermined assumptions about art practice, the uniqueness of the artists' "mark", the authenticity of the art-object, and the value of art as a market-commodity.

Compared to the remoteness of Minimalism, Pop Art provided accessible, recognizable images in the late 1950s, and 1960s. Above all, it suggested that art could be fun and culturally relevant to its time.

In post-war Britain, after years of aus-terity, restrictions and rationing, the appeal of American culture was irresistible to many young artists. The glamour of Hollywood films and the cornucopia of consumer goods, from Cadillacs to Hoovers, was seized upon by artists like Richard Hamilton (1924–), Eduardo Paolozzi (1924–) and Peter Blake (1932–) with others – artists, critics, architects and a photographer – they set up an informal "Independent Group", which met at the Institute of Contemporary Arts, to exhibit and discuss projects.

Their version of Pop Art was essentially different in motivation from its American model. In Britain, the American Dream was seen as the celebration of an unattainable vision – a projection culled from the "dream factory" of Hollywood – a vision of youth culture where its tackiness was idealized (with hardly a trace of irony) to the state of icon, and where Levi jeans were totemic.

David Hockney (1937–), a talented draughtsman and colourist, began painting in a Pop idiom, in a witty, irreverent style. In the late 1960s he reverted to a more traditional approach to exploit his skill, developing clarity of line and use of pastel colour tonalities, in a clear continuity with artists such as Ingres, Matisse and Picasso.

NEW DIRECTIONS

Instead of the spontaneous outpourings of gesture and feeling in Abstract Expressionism that were the result of Surrealist automatic processes, the work of the next generation was clearly planned and executed in a more detached way. Noland, Kelly and Stella's work is also called "Hard Edge painting", because of the very precise mechanical-looking edges to the areas of paint, which further distinguish them from Abstract Expressionists.

Stella's reductionist attitude is summed up in the statement that "a painting is a flat surface with paint on it – nothing more". A more complete contradiction of Rothko would be hard to imagine.

His minimalist approach is manifested in work where regular lines restate the shape of the canvas. To emphasize this process, he began to experiment with shaped canvases in the 1970s, where the lines continue to echo the bounding surface shape. Stella employed a correspondingly neutral method of paint-application, similar to another new "ism" in modern art, "Minimalism".

Minimalism was an attempt to rid art of everything personal, emotional or associative of past references, in much the same way as modernist design theory in the 1920s had embraced the "machine aesthetic" at the Bauhaus. The practitioners were mainly sculptors, who included Don Judd and Carl André (1935–).

The underlying problem with the Minimalist aesthetic, and its subsequent and related movement of Conceptual Art in the 1960s and 1970s, was the "dematerialization" of the art object. The art was contained in the idea, while the substance of the material was minimized or even redundant.

The Conceptualists were committed to eliminating ordinary emotions by making art interrogate itself rationally through the use of theory and language, to reveal inconsistencies and paradox. An example of this trend was "Art Language", an influential group of British Conceptualists who used words rather than expression to replace the image as the vehicle of thought. The language they used was syntactically dense and exclusive. Their work became increasingly remote even from the gallery-going *cognoscenti*, who had little to see and experience.

The general public had long since abandoned avant-garde art as too esoteric. For the most part, avant-garde art was ignored by the media, except when it became notorious, as when Carl André's pile of bricks sculpture, *Equivalent VIII*, was bought by the Tate Gallery.

The objection was to the cost of a work made only from an assemblage of bricks "that anyone could make". André's retort was that anyone *didn't* do it, but he, as an

A constant gap of about 5mm (1.5in) of unprimed canvas is revealed between the lines

The spiral of stripes disrupts the placing of the third diagonal

The acrylic colours are mixed without white or black and brushed on without any modulation of tone within each stripe

A red-green complementary pair of stripes is arranged so they meet a similar pair of different hue and thus create a continuation rather than abrupt change

The cadmium yellow strip is the brightest colour used and acts as a light source as it resonates against the red and blue primary colours next to it

ABOVE *Frank Stella's work has a cool and austere minimalist presence.* Hyena Stomp *(1962) is representative of his philosophy that painting should not depend on associations, but on its identity as paint on canvas, alone.*

artist had, and *first*. That alone made it art. This idea was not new. Duchamp had introduced it in 1917. The work is in fact both minimal and conceptual – and has an aesthetic formality. Much of André's work is based on assemblage of identical units, ordered formally into a single entity. The mechanically reproducible components are made into the unique art-object – which anybody else can then make, or reproduce.

Earthworks, also called "Land Art", were a reaction to the intangible nature of conceptual art, and to the boredom induced by minimal sculpture, with its austere industrial anonymity. In this case, artists would manipulate natural materials, not in the studio but in the landscape itself, exposing the art-work to the elements.

Richard Long takes walks in remote landscapes in Britain or in other parts of the world, where nature is untouched by humans, and only the solitary artist is present. He makes mark-lines by walking up and down the same path, or arranges stones to make simple archetypal forms. These works have no function, however, other than to be art. They are not seen by the gallery-going public, and they are not permanent; they are part of the vastness of nature, and acknowledge its eternity. Photographs taken on site, or installations in the galleries, provide the interested spectator with accessible versions of these works.

Performance art has had various manifestations since the 1960s, but its origins are in the events staged by the Futurists and Dadaists at the beginning of the century. It is another attempt to depart from the static, silent, museum-sited notion of the art-work, and challenge the constraints of the art market. Combinations of activities derived from theatre, music and the visual arts provide the basis for exploring the boundaries of art.

Gilbert and George, whose animated tableaux record the banal and unremarkable, present a very different concept from that of the German artist, Josef Beuys (1921–86), although in both cases the artist *became* the art-work. Beuys's most famous performance was *How to Explain Pictures to a Dead Hare* (1965), which he described as:

> "A complex tableau about the problems of language, and about the problems of thought, of human consciousness, and of the consciousness of animals."

It also raised issues about art and its incomprehensibility, as well as the prejudiced role of the critic as interpreter of art. It is impossible to "explain" art completely. It was also a bid for the artist to take art to the people, to give it a social role once again.

POST-MODERNISM AND NEW EXPRESSIONISM

Post-Modernism stands for eclecticism in all the arts; enabling the artist to draw ideas, imagery or styles from any culture of any period, and re-present them afresh – even as pastiche, without historical reverence.

Mixtures of historical architectural styles, puns and parodies, playful cross-cultural references, use of decoration and pastel colours reminiscent of stage or film-sets, were a reaction against the purity and asceticism of the "modern". The archetypal models of suburbia, the supermarket, and Las Vegas were "almost right", according to the originator of this idea, Robert Venturi.

After the Conceptualists, who seemed to announce an art that was "the end of art", traditional painting thus returned in the shape of oil-paintings of figurative subjects. Not only are there references to the human figure, but the paint is visibly worked by the artist. One effect of this appears to be an increasing conservativism, the preference for the traditional values which brings skill and craftsmanship back into the frame.

The credit side of Post-Modernism can be seen in a new openness, a willingness to re-assess the art of the past, and not to subject it to single, dominating theories. The implication is that artists are not compelled to work in one consistent, pervasive style, but can pursue their individual paths.

The debit side is that, without an idealistic and optimistic sense of direction, art may not be going anywhere. The innovative and challenging art of the past was inspired by ideals of progress in art and society. Now that these have been undermined, taste and the changing modes in art are not led by the artist or the critic, but are dictated by market-forces. Post-Modern artists may paint in a neo-classical style (just as architects currently design neo-Palladian façades that recall the certainties and power of empires), but here they are divested of meaning. They are just another style.

The New Expressionism can be regarded as an aspect of Post-Modernism. In place of the austere, and apparently alienating, geometricized architecture, design and painting of Modernism, there is a revitalized art of emotion.

In painting, the gestural intensity of German Expressionism and Abstract Expressionism is witnessing a reprise, in the work of German artists like Anselm Kiefer, and George Baselitz's upside-down world. The theatre for new art has re-centred itself in Europe, particularly in Germany. The avant-garde has returned to its roots – except that the concept of the "avant-garde" has itself fallen a victim to Post-Modernist thinking, which denies the idea of a clear, linear progression towards a known goal.

BELOW *Gilbert and George created animated tableaux recording the banal and unremarkable, where the artist became the artwork.*

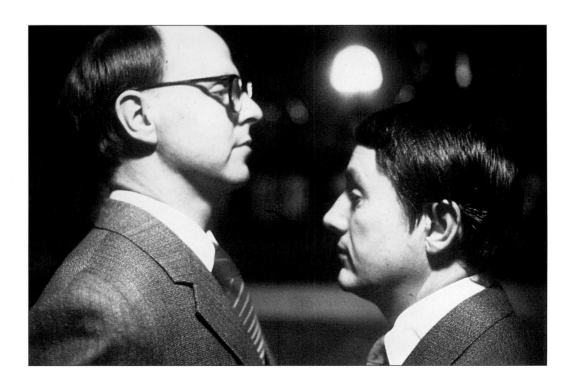

KEY

Florence
Siena
Venice
Northern Italy
Spain
Northern Europe

1270 Salisbury Cathedral completed
1304 Petrarch born
1337 Hundred Years War starts
1347 Plague in Europe
1431 Joan d'Arc burnt at stake
1434 Cosimo de' Medici born

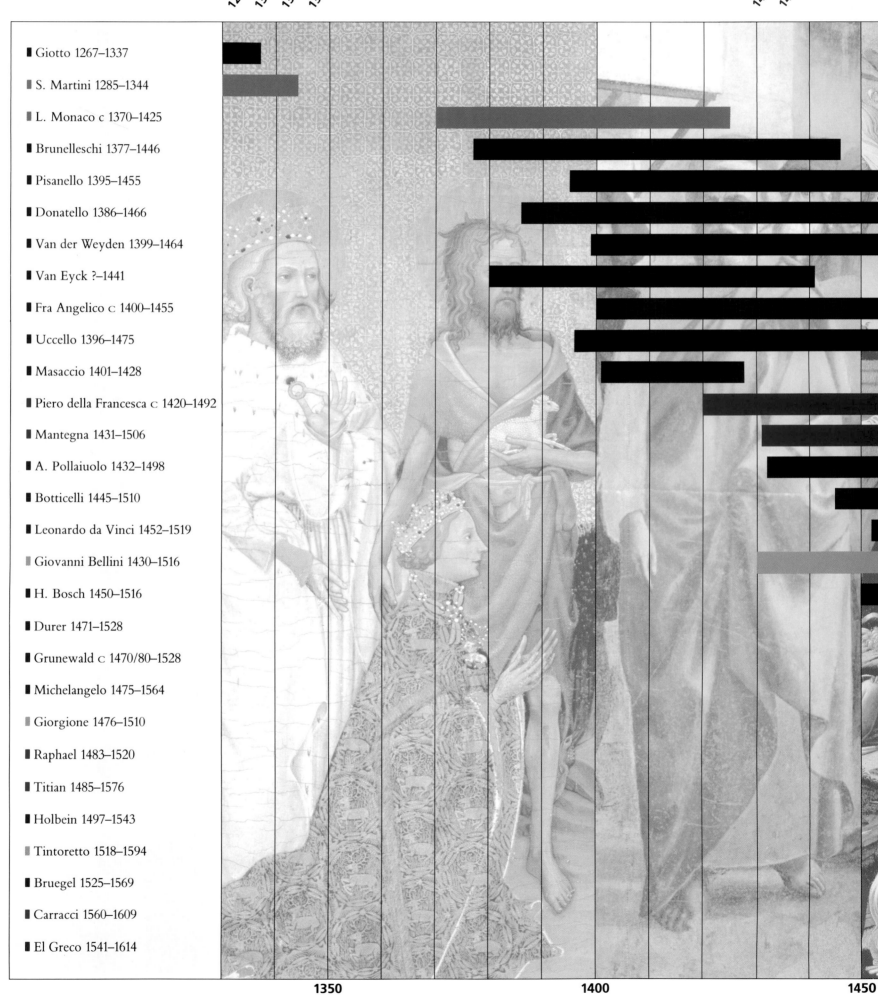

Giotto 1267–1337

S. Martini 1285–1344

L. Monaco c 1370–1425

Brunelleschi 1377–1446

Pisanello 1395–1455

Donatello 1386–1466

Van der Weyden 1399–1464

Van Eyck ?–1441

Fra Angelico c 1400–1455

Uccello 1396–1475

Masaccio 1401–1428

Piero della Francesca c 1420–1492

Mantegna 1431–1506

A. Pollaiuolo 1432–1498

Botticelli 1445–1510

Leonardo da Vinci 1452–1519

Giovanni Bellini 1430–1516

H. Bosch 1450–1516

Durer 1471–1528

Grunewald c 1470/80–1528

Michelangelo 1475–1564

Giorgione 1476–1510

Raphael 1483–1520

Titian 1485–1576

Holbein 1497–1543

Tintoretto 1518–1594

Bruegel 1525–1569

Carracci 1560–1609

El Greco 1541–1614

1350 1400 1450

1451 Gutenburg Bible printed
1469 Lorenzo de' Medici rules Florence
1476 Caxton's printing press
1492 Columbus discovers America
1498 Savonarola burnt at stake
1521 Martin Luther excommunicated
1532 Pizarro conquers Peru
1543 Copernicus treatise on cosmos published
1558 Queen Elizabeth I crowned
1564 William Shakespeare born
1568 Netherlands revolt against Spain
1584 Graphite pencil invented
1588 Spanish Armarda defeated
1609 Galileo invents telescope

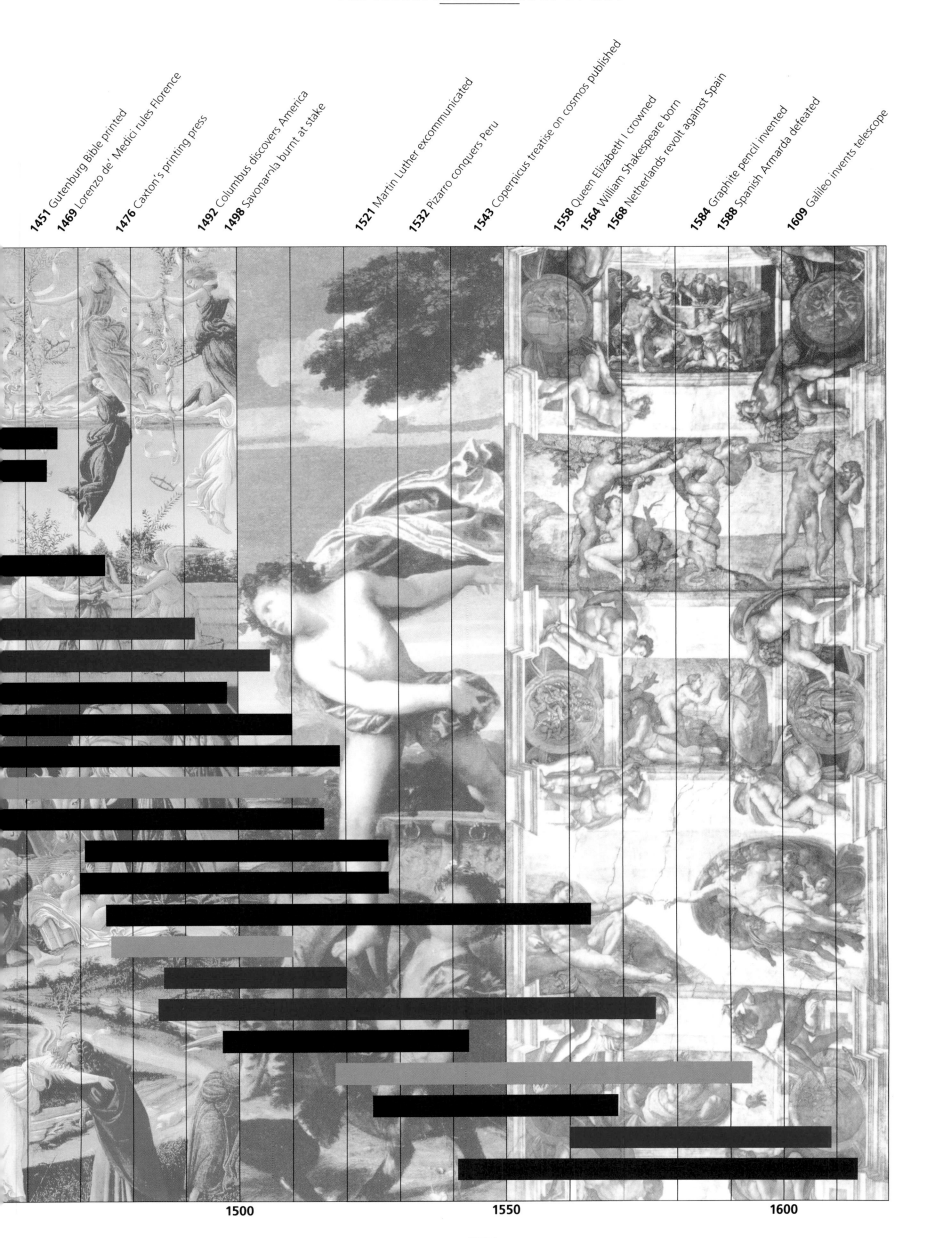

1500

1550

1600

KEY

▬▬▬	France
▬▬▬	Holland and Flanders
▬▬▬	Spain
▬▬▬	England
▬▬▬	Italy

1611 King James Bible

1620 First newspaper printed

1642 English Civil War begins

1660 Charles II restores monarchy

1666 Fire of London

▮ Caravaggio 1571–1610

▮ Rubens 1577–1640

▮ De la Tour 1593–1652

▮ Poussin 1593–1665

▮ Velázquez 1599–1660

▮ Claude 1600–1682

▮ Hals 1580/5–1666

▮ Rembrandt 1606–1669

▮ Kalf 1619–1693

▮ Vermeer 1632–1675

▮ Ruisdael 1628/9–1682

▮ Watteau 1684–1721

▮ Tiepolo 1696–1770

▮ Hogarth 1697–1764

▮ Canaletto 1697–1768

▮ Chardin 1699–1779

▮ Boucher 1703–1770

▮ Stubbs 1724–1806

▮ Reynolds 1723–1792

▮ Gainsborough 1727–1788

▮ Fragonard 1732–1806

▮ J. Wright 1734–1797

▮ Goya 1746–1828

▮ David 1748–1825

▮ Blake 1757–1827

▮ Ingres 1780–1867

▮ Turner 1775–1851

▮ Constable 1776–1837

▮ Géricault 1791–1824

1600

1650

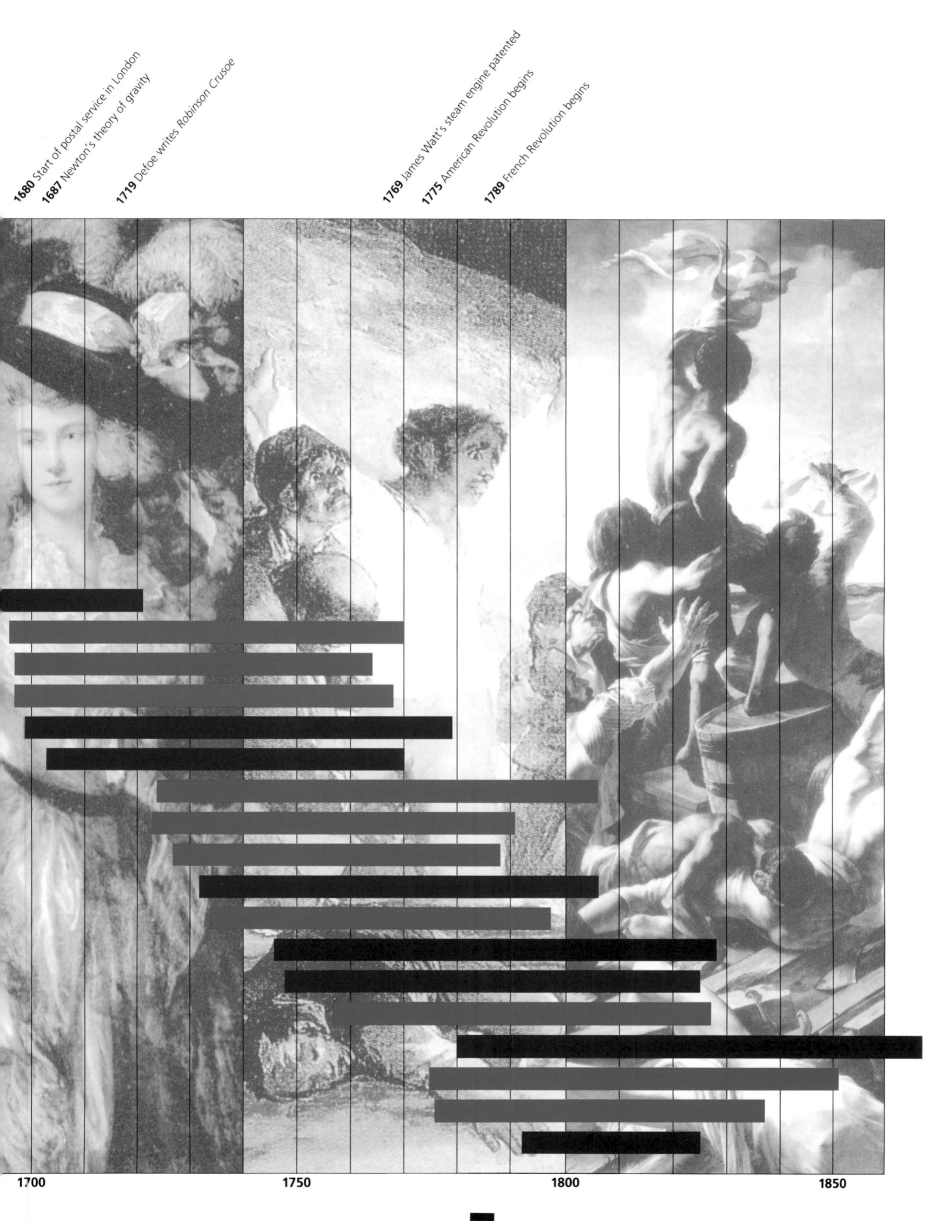

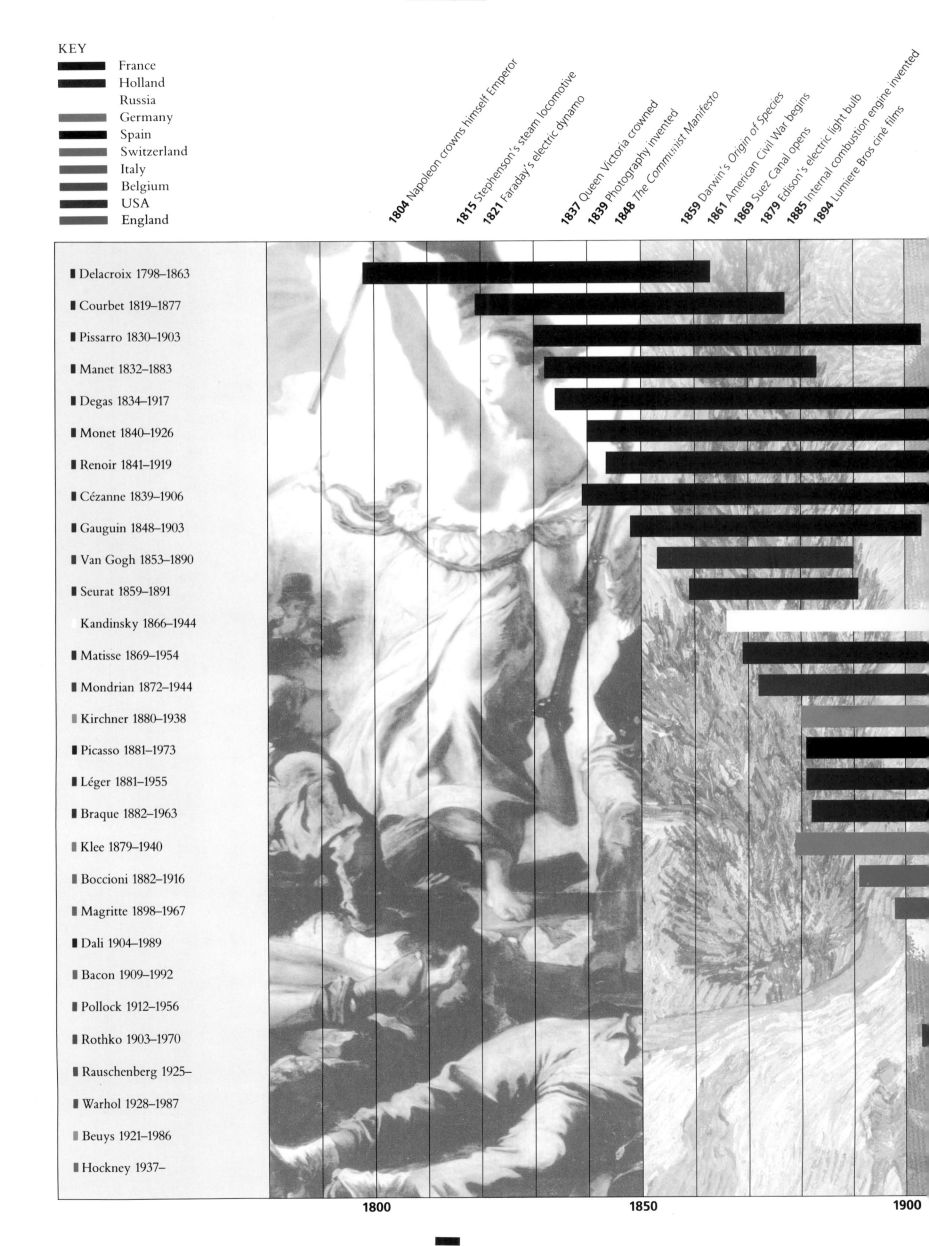

KEY

France
Holland
Russia
Germany
Spain
Switzerland
Italy
Belgium
USA
England

1804 Napoleon crowns himself Emperor
1815 Stephenson's steam locomotive
1821 Faraday's electric dynamo
1837 Queen Victoria crowned
1839 Photography invented
1848 *The Communist Manifesto*
1859 Darwin's *Origin of Species*
1861 American Civil War begins
1869 Suez Canal opens
1879 Edison's electric light bulb
1885 Internal combustion engine invented
1894 Lumière Bros ciné films

Delacroix 1798–1863
Courbet 1819–1877
Pissarro 1830–1903
Manet 1832–1883
Degas 1834–1917
Monet 1840–1926
Renoir 1841–1919
Cézanne 1839–1906
Gauguin 1848–1903
Van Gogh 1853–1890
Seurat 1859–1891
Kandinsky 1866–1944
Matisse 1869–1954
Mondrian 1872–1944
Kirchner 1880–1938
Picasso 1881–1973
Léger 1881–1955
Braque 1882–1963
Klee 1879–1940
Boccioni 1882–1916
Magritte 1898–1967
Dali 1904–1989
Bacon 1909–1992
Pollock 1912–1956
Rothko 1903–1970
Rauschenberg 1925–
Warhol 1928–1987
Beuys 1921–1986
Hockney 1937–

1800 1850 1900

1900 Freud's *The Interpretation of Dreams*
1903 Wright Bros first flight
1917 Russian Revolution
1922 Italian Fascists seize power
1929 Stock Market crash in America
1936 Spanish Civil War starts
1945 First atom bomb dropped on Japan
1951 First satellite launched (USSR)
1961 Berlin Wall built
1969 First moon landing (USA)
1982 First heart transplant
1989 Berlin Wall comes down
1991 Break-up of USSR

1950

2000

MAJOR STYLES AND MOVEMENTS

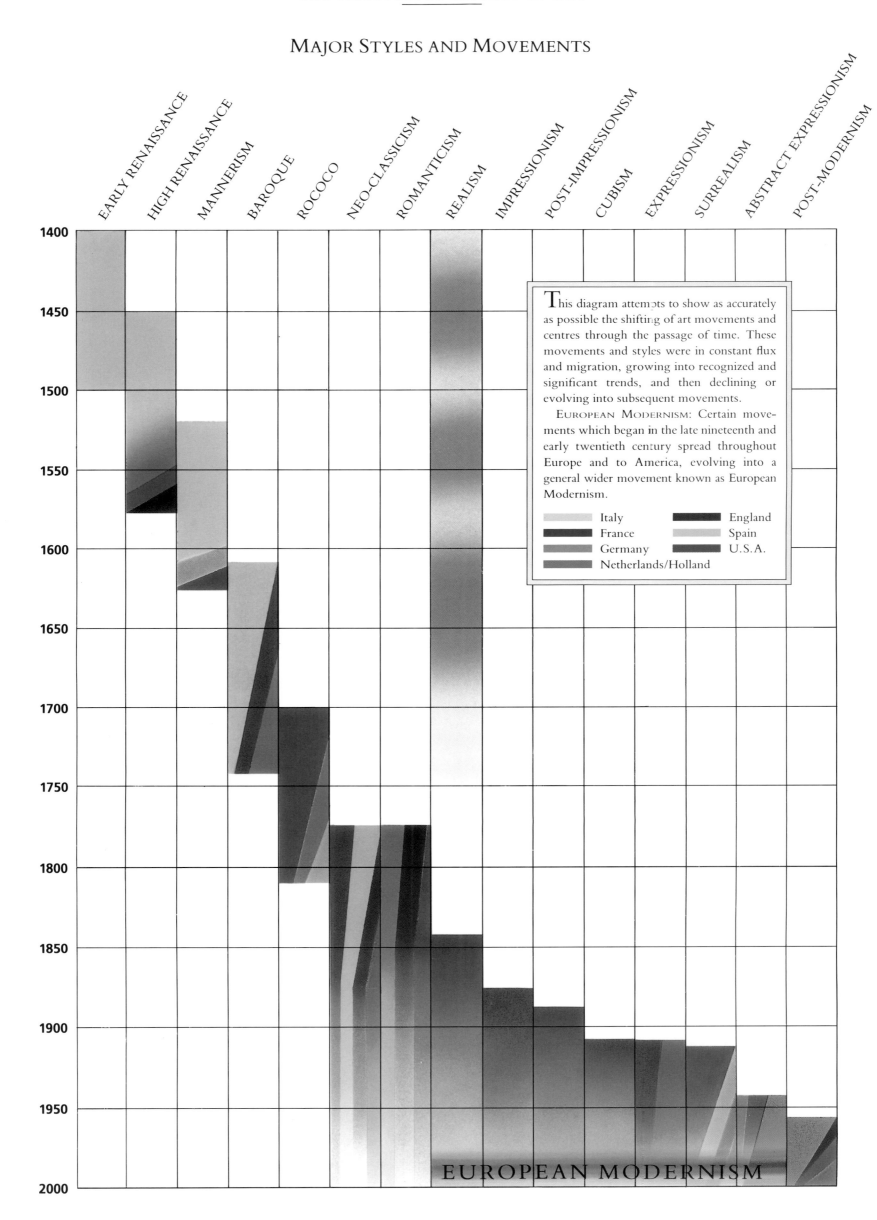

This diagram attempts to show as accurately as possible the shifting of art movements and centres through the passage of time. These movements and styles were in constant flux and migration, growing into recognized and significant trends, and then declining or evolving into subsequent movements.

EUROPEAN MODERNISM: Certain movements which began in the late nineteenth and early twentieth century spread throughout Europe and to America, evolving into a general wider movement known as European Modernism.

	Italy		England
	France		Spain
	Germany		U.S.A.
	Netherlands/Holland		

EUROPEAN MODERNISM

BIBLIOGRAPHY

ADAMS, S. *The World of the Impressionists* (Thames & Hudson, 1989).

ALPERS, S. *The Art of Describing* (Penguin, London 1983).
Rembrandt's Enterprise: the studio and the market (Thames & Hudson, 1988).

BARR, A.H. *Cubism and Abstract Art* (MOMA, 1986).

BARRELL, J. *The Dark Side of the Landscape* (Cambridge University Press, 1983).

BATTOCK, G. *Idea Art: a critique* (Dutton, 1973).

BAXANDALL, M. *Painting and the Experience in 15th-century Italy* (Oxford University Press, 1986).

BERENSEN, B. *The Italian Painters of the Renaissance* (Fontana, 1975).

CALLEN, A. *Techniques of the Impressionists* (Tiger Books, 1989).

CLARK, K. *Landscape into Art* (John Murray, 1973).

CLARK, T.J. *The Painting of Modern Life* (Thames & Hudson, 1985).

ECO, U. *Art and Beauty in the Middle Ages* (Yale University Press, 1986).

EITNER, L. *An Outline of 19th-century European Painting* (Harper & Row, 1987).

ELLIOT, D. *New Worlds: Russian Art and Society 1900–1937* (Thames & Hudson, 1986).

FOUCAULT, M. *This is not a Pipe* (University of California Press, 1983).

GABLIK, S. *Has Modernism Failed?* (Thames & Hudson, 1984).

GREENBERG, C. *Art and Culture* (Thames & Hudson, 1973).

GOLDING, J. *Cubism* (Faber & Faber, 1988).

GOMBRICH, E.H. *The Story of Art* (Phaidon Press, 1988).
Art and Illusion (Phaidon Press, 1977).

HAUSER, A. *The Social History of Art: 4 Volumes* (Routledge & Kegan Paul, 1989).

HESS, H. *Pictures as Arguments* (Sussex University Press, 1975).

HONOUR, H. *Neoclassicism, Style and Civilisation* (Penguin, 1968).
Romanticism (Penguin, 1979).

HUGHES, R. *The Shock of the New* (London, 1980).

HUIZINGA, J. *The Waning of the Middle Ages* (Penguin, 1976).

ICA *The Independent Group: Post-war Britain and the aesthetics of plenty* (MIT Press, 1990).

JANSON, H.W. *History of Art* (Thames & Hudson, 1977).

JEFFREY, I. *Photography: a concise history* (Thames & Hudson, 1981).

JENCKS, C. *What is Post-Modernism?* (Academy Editions, 1989).

LEIGHTEN, P. *Re-ordering the Universe: Picasso and Anarchism – 1897-1914* (Princeton University Press, 1985).

LEVEY, M. *Rococo to Revolution: major trends in 18th-century painting* (Penguin, 1967).
High Renaissance (Penguin, 1975).

LUCIE-SMITH, E. *Art Today* (Phaidon Press, 1989).

LYNTON, N. *The Soul of The Eye* (Harper Collins, 1990).

MEISS, M. *Painting in Florence and Siena after the Black Death* (Harper & Row, 1964).

MOSZYNSKA, A. *Abstract Art* (Thames & Hudson, 1990).

NAIRNE, S. *State of the Art* (Chatto & Windus, 1987).

NOCHLIN, L. *Realism* (Thames & Hudson, 1971).

PANOFSKY, E. *Renaissance and Renascences in Western Art* (Paladin, 1970).

PEVSNER, N. *The Englishness of English Art* (Peregrine, 1988).

PREZIOSI, D. *Rethinking Art History* (Yale University Press, 1989).

RENWALD, J. *The History of Impressionism* (London, 1973).
Post-Impressionism (London, 1978).

ROSEN, C. & ZERNER, H. *Romanticism and Realism* (Faber & Faber, 1984).

ROSENBERG, H. *The Anxious Object: art today and its audience* (London, 1965).

ROSENBLUM, R. *Modern Painting and the Northern Romantic Tradition* (Thames & Hudson, 1975).

RUSKIN, J. *Modern Painters* (edited by D. Barrie) (Andre Deutsch, 1987).

SAUNDERS, G. *The Nude – a new perspective* (The Herbert Press, 1989).

SCHARMA, S. *The Embarrassment of Riches: an interpretation of Dutch culture in the golden age* (Fontana Press, 1987).

SCHARF, A. *Art and Photography* (Penguin/ Allan Lane, 1974).

SCHAPIRO, M. *Modern Art: 19th and 20th century* (London, 1980).

STICH, S. *Made in USA: an americanization of modern art in the '50s and '60s* (University of California Press, 1987).

TAYLOR, J.C. (ed) *19th-century Theories of Art* (University of California Press, 1989).

TISDALL, C. & BOZZOLA, A. *Futurism* (Thames & Hudson, 1978).

VARNEDOE, K. *A Fine Disregard: what makes modern art modern* (Thames & Hudson, 1990).

VARNEDOE, K. & GOPNIK, A. *High and Low: modern art and popular culture* (MOMA, 1990).

VASARI, G. *The Lives of the Painters* (Penguin, 1978).

WALKER, J.A. *Art in the Age of the Mass Media* (Pluto Press, 1983).

WIEDMANN, A. *Romantic Roots in Modern Art* (Gresham Books, 1979).

WILLETT, J. *The Weimar Years* (Thames & Hudson, 1984).

WOLFFIN, H. *Classic Art* (Phaidon Press, 1986).

WOLLHEIM, R. *Painting as an Art* (Thames & Hudson, 1990).

ZERI, F. *Behind the Image: the art of reading paintings* (Heinemann, 1990).

INDEX

PICTURE CREDITS
AND ACKNOWLEDGEMENTS

QUINTET PUBLISHING would like to thank the following for their help with this publication and/or for the loan of illustrative material: Archiv für Kunst und Geschichte; Artists Rights Society (ARS); Bridgeman Art Library; Design and Artists Copyright Society (DACS); The National Gallery; SCALA, Milan; Visual Arts; London Underground; National Gallery of Canada; Tate Gallery.

The following works of art reproduced by permission:

Beck, London Underground Map, 1931 © London Underground;
Bonnard, *Interior at Antibes,* © ADAGP/ SPADEM, Paris and DACS, London, 1992;
Braque, *The Portuguese,* © ADAGP, Paris and DACS, London, 1992;
Dali, *The Persistence of Memory,* © DEMART PRO ARTE BV/DACS 1992;
de Kooning, *Woman 1,* © ARS 192;
Derain, *Collioure,* © ADAGP, Paris and DACS, London 1992;
Derain, *Portrait of Matisse,* 1905 © ADAGP, Paris and DACS, London 1992;
Duchamp, *Mona Lisa,* © ADAGP, Paris and DACS, London 1992;
Duchamp, *Nude Descending Staircase,* © ADAGP, Paris and DACS, London 1992;
El Lissitzky, *Beat the Whites with the Red Wedge,* 1919, Collection Stedelijk Van Abbemuseum, Eindhoven, The Netherlands;
Ernst, *Vox Angelica,* 1943, © ADAGP/ SPADEM, Paris and DACS, London 1992;
Grosz, *Je Suis un Appareil Photo,* © DACS 1992;
Grosz, *Metropolis,* © DACS 1992;
Heartfield, *As in the Middle Ages, So in the Third Reich,* © DACS 1992;
Hockney, *A Bigger Splash,* 1967, © The Artist;
Hockney, *Mr and Mrs Clark and Percy,* 1970, © The Artist;
Johns, *Flag* 1955, © Jasper Johns/DACS, London/VAGA, New York 1992;
Kandinsky, *Battle of the Cossacks,* 1910 © ADAGP, Paris and DACS, London, 1992;
Kirchner, *Street Scene,* 1913 © Dr Wolfgang and Ingeborg Henze, Campione d'Italia;
Leger, *Les Constructeurs,* 1950 © DACS 1992;
Lichtenstein, *Whaam!* 1963 © Roy Lichtenstein/DACS 1992;
Louis, *Spawn,* 1959–60, Private Collection, London;
Magritte, *The Use of Words,* © ADAGP, Paris and DACS, London 1992;
Mondrian, *Composition with Red, Yellow and Blue, c.* 1937 © DACS 1992;
Motherwell, *Elegy to the Spanish Republic,* 1953 © Robert Motherwell/DACS, London/ VAGA, New York 1992;
Nolde, *The Prophet,* 1912, Nolde-Stiftung Seebüll;
Picasso, *Guernica,* 1937 © DACS 1992;
Picasso, *Les Demoiselles d'Avignon* © DACS 1992;
Picasso, *Portrait of Ambroise Vollard* 1909–10 © DACS 1992;
Picasso, *Woman and Child on a Beach,* © DACS 1992;
Pollock, *The Moon – Woman Cuts the Circle,* 1943 © ARS 1992;
Warhol, *Marilyn Monroe Diptych,* 1962 © 1992 The Estate and Foundation of Andy Warhol/ARS NY;
Warhol, *Mona Lisa* © 1992 The Estate and Foundation of Andy Warhol/ARS NY.

While every effort has been made on the part of the Publisher to acknowledge all sources and copyright holders, Quintet Publishing would like to apologise if any ommissions have been made.